looking in
the art of viewing

Critical Voices in Art, Theory and Culture
A series edited by Saul Ostrow

See the back of this book for other forthcoming titles in the Critical Voices series.

mieke bal

essays
and afterword

looking in
the art of viewing

introduction
norman
bryson

Australia · Canada · France · Germany · India · Japan · Luxembourg · Malaysia
The Netherlands · Russia · Singapore · Switzerland

G+B
ARTS
INTERNATIONAL

Copyright © 2001 OPA
(Overseas Publishers Association) N. V.
Published by license under the G+B Arts International imprint,
part of The Gordon and Breach Publishing Group.

Amsteldijk 166
1st Floor
1079 LH Amsterdam
The Netherlands

British Library Cataloguing in Publication Data

Bal, Mieke, 1946 –
Looking in : the art of viewing. – (Critical voices in art,
theory and culture — ISSN 1025-9325)
1.Art - History
I. Title II. Bryson, Norman, 1949 –
709

ISBN 90-5701-112-3

contents

introduction to the series

CRITICAL VOICES IN ART, THEORY AND Culture is a response to the changing perspectives that have resulted from the continuing application of structural and poststructural methodologies and interpretations to the cultural sphere. From the ongoing processes of deconstruction and reorganization of the traditional canon, new forms of speculative, intellectual inquiry and academic practices have emerged that are premised on the realization that insights into differing aspects of the disciplines that make up this realm are best provided by an interdisciplinary approach that follows a discursive, rather than dialectic, model.

In recognition of these changes, and of the view that the histories and practices that form our present circumstances are in turn transformed by the social, economic, and political requirements of our lives, this series will publish not only those authors who already are prominent in their field—or those who are now emerging—but also those writers who had previously been acknowledged, then passed over, only now to become relevant once more. This multigenerational approach will give many writers an

opportunity to analyze and reevaluate the position of those thinkers who have influenced their own practices, or to present responses to the themes and writings that are significant to their own research.

In emphasizing dialogue, self-reflective critiques, and exegesis, the Critical Voices series not only acknowledges the deterritorialized nature of our present intellectual environment, but also extends the challenge to the traditional supremacy of the authorial voice by literally relocating it within a discursive network. This approach to text breaks with the current practice of speaking of multiplicity, while continuing to construct a singularly linear vision of discourse that retains the characteristics of dialectics. In an age when subjects are conceived of as acting upon one another, each within the context of its own history and without contradiction, the ideal of a totalizing system does not seem to suffice. I have come to realize that the near collapse of the endeavor to produce homogenous terms, practices, and histories— once thought to be an essential aspect of defining the practices of art, theory, and culture—reopened each of these subjects to new interpretations and methods.

My intent as editor of Critical Voices in Art, Theory and Culture is to make available to our readers heterogeneous texts that provide a view that looks ahead to new and differing approaches, and back toward those views that make the dialogues and debates developing within the areas of cultural studies, art history, and critical theory possible and necessary. In this manner we hope to contribute to the expanding map not only of the borderlands of modernism, but also of those newly opened territories now identified with postmodernism.

Saul Ostrow

introduction: art and intersubjectivity

for E. van A.

The problem for theory is how not to surrender to the tyranny of humanism which will only recognise the products and epochs of art in their singularity, their individuality; and which considers illegitimate, even inadmissable, any inquiry into the invariants, the historical and/or transhistorical constants from which the plastic fact lets itself be defined in its generality, its fundamental structure.

—Hubert Damisch[1]

The very terms we are using here, I and you, are not to be taken as figures but as a linguistic form indicating "person." Now these pronouns are distinguished from all other designations a language articulates in that they do not refer to a concept or an individual.

—Emile Benveniste[2]

MIEKE BAL'S WRITING ON VISUAL culture differs from classical or "normal" art history in several crucial respects. In the first place, there is a reformulation of where the work of art (by Vermeer, Rembrandt, Caravaggio) stands in time. In classic art history, the labor of the historian consists in restoring the work to its original temporal horizon, the social and cultural context of its first appearance.[3] The essential problem is to establish how the work came into existence, and what forces made it assume the form that it did. In principle there is no limit to the number of determining factors the account may

adduce—provided that they are all found to "converge" in the work of art. From this perspective, which is dominated by a concept of *causality,* the work appears at the end of the line; here all the chains of determination join and terminate. In more recent art historical discussion this causal mode of analysis has, to be sure, undergone some important revisions: the work of art is recognized as not only reflecting its context but mediating it, reflecting up*on* it; and the work is understood as not simply passive with regard to the cultural forces that have shaped it, but active—it produces its own range of social effects, it acts upon its surrounding world. Nevertheless, these concessions still unfold within the tense that Benveniste called "historical":

> Events that took place at a certain moment of time are presented without any intervention of the speaker in the narration. ... We shall define historical narration as the mode of utterance that excludes every "autobiographical" linguistic form. The historian will never say *je* or *tu* or *maintenant,* because he will never make use of the formal apparatus of discourse, which resides primarily in the relationship of the persons *je: tu.* Hence we shall find only the forms of the "third person" in a historical narrative strictly followed.[4]

Whatever is said about works of the past must be viewpointed to the third person, the period observer; it must never appear to emanate from the discourse of art history, here and now. But for Mieke Bal, the art of the past exists undeniably in the present, where it continues to generate powerful cultural effects. The "historical" tense, lacking as it does the means to place the speaker within the narration, is structurally disequipped to describe such effects. Yet the present life of images is part of their ongoing history; if we cannot describe *that,* our sense of the span of images in history will be drastically truncated. The problem with the historical tense is that it is not historical *enough.* A truly historical art history must have the means to be able to say *je, tu, maintenant.* Which is where Bal makes her intervention in art history.

The essays in this collection part company with the discipline of art history in another respect as well: there is a different understanding of the scope—and the limits—of the work of art's meaning. Classic art history based its account of meaning on what was then, in the period when art history emerged as a modern discipline in the early part of the century, the leading model of communication—*expression:* by means of certain signs a

speaker (or artist) conveyed his or her thought to a listener (or viewer). It was the task of the art historian to retrieve that original intention, standing behind the work; an intention which, at the moment of its expression, would have had a clear outline and form.

Bal's work on visual art begins from a later, semiotic understanding of symbolization that profoundly problematizes each step in the seemingly simple series *speaker: message: hearer*.[5] The fact that works of art occupy a different kind of space from the space of other objects in the world—a space which in the case of painting is marked by the four sides of the frame—means that the work is built to travel away both from its maker and from its original context, carried by the frame into different times and places. The frame establishes a convention whereby art is marked as semantically mobile, changing according to its later circumstances and conditions of viewing. Each later viewer brings to the work his or her specific cultural baggage, and it is through viewing codes now brought to bear on the work in its new situation that it is seen and interpreted. Yet this state of being "completed" by the viewer is not only a result of the work's journey through time: even in its original context, different viewers would have responded to the work in varying ways. Since paintings involve highly saturated, dense, and complex patterns of signification, there is no way that even in the year of a work's first appearance any specific viewer would have been able to exhaust the sum of possibilities it contains.

Rather than being a "relay" conveying an intention from artist to viewer, the work is thus an occasion for a performance in the "field" of its meaning—where no single performance is capable of actualizing or totalizing all of the work's semantic potential. However coherent or persuasive a given interpretation may be, there will inevitably be a remainder not acted upon, a "reserve" of details that escape the interpretative net. This can be true, by the way, of the image as well. When a painting represents, say, the story of Danaë, or Bathsheba, or Narcissus, its version of the received story activates some, but not all of the story's semantic potential. Although the picture may "direct" the story along a particular path, again certain details will escape the net. To the viewer of art such details can be highly significant, despite or even because of their marginal status; they can become the basis for a quite different understanding of the painting.

Pressing on details, especially when these have been marginalized, is an essential feature of Bal's interpretative style.[6] In this, her writing goes against the goal most art historians believe they are pursuing: the central, most plausible interpretation, the one that covers and gives order to the greatest possible number of visual elements. That dominant style of art-historical writing recognizes, of course, that there may be a remainder in the picture which the interpretation does not presently deal with. It may even acknowledge that a great many alternative accounts are possible, laying no claim to the final word. But in its own construction and trajectory it is obliged to pursue the "central form" (in Reynolds's phrase) of explanation, the account that absorbs the maximum number of details into a coherent and unitary interpretation. Bal begins and stays with the detail, where the devil is: what has had to be relegated to the margins of the image, for its coherence to be maintained? what details do *not* fit prevailing explanatory patterns? This makes for some sharp observation of paintings.

Few viewers, I would guess, have paid much attention to the strange depressions in the plaster above the picture of the Last Judgment that hangs on the wall in Vermeer's *Woman Holding a Balance* (National Gallery, Washington, D.C.). Yet in a painting whose subject is balance—twice over, in the scales the woman holds in her hand, and in the heavenly judgment above—the way a picture is balanced may indeed be critical. Hanging a picture on a wall is no easy task, as anyone who has done it knows. It is hard to get things right the first time; you have to move the nail, and the mark of its previous position is a permanent reminder of the picture's having once been *out* of balance.

Bal notes that Vermeer's careful recording of how the *Last Judgment* was once, in this room, out of balance, introduces an antithetical note into the scene. For unlike many contemporary pictures on the subject of the woman with the scales, this one does not incline toward any obvious allegory. The woman in the Vermeer is not greedily inventorizing worldly goods—which would make a pointed contrast between her (female) vanity and the (male) spirituality of the picture behind her, where souls are weighed. Nor does the picture detain us anecdotally with *what* she is balancing, as it would if it wanted to present a genre scene of daily life. The emptiness of the scales is an

invitation to reflect on what "balance" is, on how priorities are made. Is this a representation of the sacred as having a greater value than the profane? or is it the opposite: is the sacred a dim and secondary realm, is it the actuality of this everyday room and of this evidently pregnant woman standing within it that counts as the immediate, even the higher, value? The detail that discloses "imbalance" in the picture opens up interpretative possibilities which this particular Vermeer seems unwilling to foreclose. The marginal detail can become the center of the picture; it can infiltrate its whole surface with provisionality. And in turn, reading for detail, as Bal does in "Dispersing the Image: Vermeer Story" (chapter 2), can become a model of the non-curtailability of interpretation.

This might seem a recipe for finding infinitely "open" texts—yet Bal's approach differs from that of Derridean deconstruction. Works of art cannot, Bal argues, signify indefinitely in all directions, for the reason that it is *particular* viewers who activate their potential, in their specific circumstances. Meaning-making is an activity that always occurs within a preexisting social field, and actual power relations: the social frame does not "surround" but is *part* of the work, working inside it. Which leads to a third point of difference between Bal's writing and orthodox art history, besides its understanding of the work of art's temporality, and the fundamental polysemy of its signs. The meaning of a work of art does not, for Bal, lie in the work by itself but rather in the specific performances that take place in the work's "field": rather than a property the work has, meaning is an event; it is an action carried out by an *I* in relation to what the work takes as *you*. Despite art history's rhetoric of professional impersonality, even the most "historicist" account of a work of art is rooted in an encounter with the work in the present. Bal's objective is to acknowledge this encounter, to describe it, and, above all, to personify the encounter in writing. What is the best way to write about art in a manner that problematizes the use of the "third person" as the compulsory, the one and only, agent of sight? And what occlusions and repressions occur in the visual field, when the latter is understood as centered on the third person, not only in art history or in curatorial practice, but in the conceptual models we use to think through questions of power in vision, questions of the gaze?

There can be little doubt that in the past two decades of scholarship on visual representation, much of the most innovative and energetic writing about spectatorship has derived, directly or indirectly, from the work of Laura Mulvey.[7] Although the impact of Mulvey's ideas was immediately felt in film studies, before long art historians began to realize the enormous potential that the theory of the gaze possessed in relation to the "fine arts." The particular appeal of Mulvey's thinking to art historians lay partly in the feeling that here, at last, was what had been missing for a long time from the modern discipline, a theory of the viewer—and one that was deeply grounded in social history.

Modern art history had no trouble investigating the *makers* of art. Ever since the development of connoisseurial studies after Morelli and Berenson, and even more so with the rise of the monograph on individual artists as the principal form of writing for professional art historians, the focus on the artist had become a central and seemingly inevitable feature of art-historical inquiry. Yet there was little by way of a corresponding focus on the function of spectatorship. The way viewers experienced their encounter with works of art, and the way that social and cultural forces directed their response, had been generally neglected, or (worse still) consigned to the history of "taste."

There were exceptions. Riegl's account of the Dutch group portrait, for instance, had been centrally concerned with the ways in which the interplay between collective and individual identity, which was dramatized in the group portrait, proposed and assumed a viewer who negotiated that interplay at the level of the picture's perception.[8] Riegl's text in fact opened up the whole question of the historicity of viewing practices, and his emphasis on painting's interaction with spectators might, in a different evolution of the discipline, have led to an emphasis on the historical investigation of reception, on a par with the study of art's makers. In the more recent past, Michael Fried's fascinating book *Absorption and Theatricality* had placed the picture's relation to its audience at the center of his study of French painting of the eighteenth century.[9] Analyzing a picture's way of addressing the spectator, Fried distinguished between a "theatrical" mode—in which the picture directly addressed the viewer, as though fully cognizant of being displayed to its audience—and an "absorptive" mode, where the picture adopted the

fiction that none of the depicted figures were aware of being on display, so that the viewer seemed not to be addressed at all, but entered the scene as an invisible, undetected observer. In another domain of the discipline, social historians of art increasingly turned to period documentation that recorded particular audiences' reactions to exhibited works of art: T. J. Clark and Thomas Crow, especially, made brilliant use of *Salon* reviews in order to establish how a painting's initial audience may have understood the work before them.[10]

It was not that art history had *no* theory of spectatorship. But it was impossible to ignore that next door to art history, film studies was developing an understanding of spectatorship that was capable of attending to the *inward* process of viewing, and at levels of depth and detail unattainable with the models that art historians currently had at their disposal. Film studies recognized that viewers brought to their experience of visual culture much more than iconographical knowledge—the ability to distinguish between a Nativity and a Pietà, or to identify particular saints and emblems.[11] They brought with them their deepest desires and anxieties, their whole history of having been socialized according to the specificities of gender and sexuality. Art history's grasp of spectatorship lacked this dimension almost entirely (although certain social historians of art, notably T. J. Clark, were beginning to bring concepts of desire and the unconscious to bear on the instances of spectatorship they analyzed, in ways that paralleled Mulvey's own account).[12] In comparison with film studies, the existing art-historical literature on spectatorship seemed ingenious yet remote. Residual theories of spectatorship from early in the century, like Riegl's, or midcentury phenomenological accounts that analyzed viewing in terms of cognitive psychology (Arnheim, Gombrich), paled against the immediacy of Mulvey's model of the gaze. And in pedagogical terms, Mulvey's "Visual Pleasure and Narrative Cinema" simply eclipsed the alternatives: Riegl's text might be known to a few art history graduate students, but Mulvey's essay was read, it seemed, by students all over the humanities. It answered exactly to the growing awareness of gender as a primary dimension of social life, and of visual representation. In its stark and explicit geometry, "the Gaze" (the word is given an uppercase initial when it refers to the Gaze as an explanatory concept, lowercase when referring to an actual instance of

vision) possessed enormous explanatory power. It did not take long to grasp its essentials, and it opened up vistas on every side. For many teachers of art history it was hardly necessary to put Mulvey's essay on the reading list; students knew it already. At times it seemed they were born knowing it.

Mieke Bal is one of the few art historians to have ventured an alternative to "the Gaze". Interestingly, although Bal's approach differs from Mulvey's in all its basic steps, its commitment to a feminist analysis of visual representation means that in many ways it *re*-converges with Mulvey. Both writers seek to explore the ways that sexual difference and the signs of difference profoundly shape our experience of the world, and of visual culture. But Bal's work has a different basis: when it comes to understanding how vision unfolds in the field of power, Mulvey's theory is *optical*, Bal's is *rhetorical*.

Mulvey's optical bias can be quickly sensed if one thinks of her basic *mise-en-scène* of looking. In a darkened movie theater, vision is locked on screen. Only the dim cone of the projector beam and the bright surface of the screen are visible. The audience's visual activity is divided between an active pole—the (male) look or gaze; and a passive pole—the (female) image on screen. One can analogize this primal scene of cinema in a number of ways. The form of its space is that of Albertian perspective, with its fixed viewpoint and pyramid of rays emanating from an apex at one end to the pyramid's "base" on the screen. It is also much like the visual field as organized by almost any optical instrument—camera, microscope, telescope, binoculars: a sight line passes from the fovea of the eye outward, past lenses that open it up into a triangle, toward the plane of inspection. It is difficult, in fact, to imagine any technology of vision that does not conform to this fundamental set: the triangle with its apex, its equilateral sides, and its base. Mulvey's model recapitulates centuries of optical speculation in the West, faithfully retracing its perennial geometry: the retina, the lens, and the plane of representations.

Part of the persuasiveness of the Gaze comes from its sheer familiarity and inevitability, its staging of sight as optics: Bal's *mise-en-scène* is otherwise: sight is figured not as scenic but as semiotic. The first step is to postulate signs rather than scenes as the basic stuff of vision. When we recognize something in the world, it is because we treat it as a visual sign, part of a vast

field of discourse which, as sign-using subjects, we are all competent to deal with. The space is that of discourse rather than projective geometry: of any human language where there are signs for *I, you, she, he*—and where there exist stories, *narratives* (perhaps the key term in all of Bal's work).

The advantages of Bal's sense of the image as visual narration—as distinct from scenic *view*—begin to emerge when one considers the interpersonal nature of visual representation that this first step proposes. In the Mulveyan portrayal of the Gaze, there exist only two poles: active (the subject of cinema, or painting) and passive (the object of representation). The viewer is *I*, the figures on the screen are *he, she, or them*—out there, removed, external. Between viewer and image only a few relations are deemed possible. Either the *I* takes the figure on the screen as object (of visual pleasure), or the *I* becomes the object on screen, through identification. In the case of scopic pleasure (gendered by Mulvey as male), the stance taken toward the (female) figure is that of subject to object: the gaze objectifies, reifies, and dominates an *it*. In the case of female spectatorship, either the viewer comes to identify masochistically with the objectified, reified image on screen, or else she stays with the gaze, identifying with its (masculine) point of view. The implacable dualism of the scene should alert us to an unusual and extremely powerful feature of Mulvey's analysis: the bipolar scene of *optics* has been mapped on to a scene of (post-Kantian) *epistemology*. The eye at the apex of the visual triangle is named as the subject of knowledge, while the image has been aligned with the object of knowledge.

I used to think that the problem with Mulvey's model was that although it achieved powerful explanatory and political effects, it was limited in its sense of who, and who alone, gets interpellated as the subject of the Gaze. Why not multiply the points of view? Wasn't there a way that Hollywood cinema also proposed and assumed the gaze of women on women? Was it so inconceivable for women in the audience to take pleasure in identifying with women on the screen as subject-to-subject? Might not a female spectator enjoy identifying with, say, Bette Davis, as a fictional character possessing a subject-position, and not only the position of object in relation to the camera? Why shouldn't it be possible for her to relate to the star directly, as *I* to *you:* why must it be thought that interfeminine identification had always

to pass through the relay of the male gaze? I could imagine that when one woman looked at another, it must always be (since both are gendered) in *some* relation to men: one could agree with Mulvey that the transaction was heavily triangulated, with both women assuming positions relative to an implicit male gaze. But could the transaction *never* be female-to-female, that is, homosocial—or lesbian?

Similarly, when the movie proposed that, as a man in the audience, I now identify with, say, John Wayne or Mel Gibson, did I *have* to do it, did I have no choice? What if I resisted the identification, thinking how much I loathed to identify with the limited sense of the masculine preferred by the John Wayne character? What if, as a gay man, I took Mel Gibson not as the subject but as the object of my gaze? Obviously what was in order was a revised and amplified table of multiple gazes. Such a scheme would start, indeed, from Mulvey:

A: male views female; the latter in the position of object
B: male views male; the latter in the position of subject
C: female views female; the latter in the position of object
D: female views male; the latter in the position of subject

But why stop there? One thought of female fans of Valentino, or Elvis Presley; or of the audience at my local cinema (at that time, the Castro Theater in San Francisco) saying Bette Davis's most famous lines *along with* the star ("It's going to be a bumpy ride"). Why not this:

E: female views male; the latter in the position of object
F: male views female; the latter in the position of subject
G: male views male; the latter in the position of object
H: female views female; the latter in the position of subject

It was undeniable that possibility F existed whenever I identified with a female character; and didn't cinema exactly permit, if it did not actively incite, precisely that kind of identification, just as the novel had done in the past? (I thought of Diderot's description of how he had wept along with Clarissa, or of Diderot's novella *La Religieuse,* where Diderot tricks his friends by writing them letters in the persona of a nun.) It seemed generous of Mulvey eventually, in her "Afterthoughts" essay, to concede at least possi-

bility D: that women might sometimes identify with the male characters on screen—though mean-spirited of her then to qualify such a relation as a tomboyish regression to an infantile "phallic stage." Why shouldn't that kind of identification be completely adult? (Calling it infantile sounded like homophobic parents bullying their butch daughter into agreeing it was all "just a phase.") But it seemed stranger still for Mulvey to deny that female audiences had ever taken pleasure in looking at the male stars of the silver screen: why pass up such a great opportunity for acknowledging female spectators as active and empowered agents of their own pleasure? Not least in the resistance they might feel rising within them when Hollywood was enjoining them to admire some unacceptable model of manhood, or when they found themselves admiring some unrecognized, even vilified, model of the masculine.

The problem seemed, in short, to be the weird rigidity that clamped down on half the permutations that Mulvey's own analysis so wonderfully opened up. Wasn't cinema far more capacious in its scope of identifications than this impoverished schema? And why confine identification only to the characters on screen? For Freud, identification with the scene of the fantasy was entirely possible ("'A Child Is Being Beaten'").[13] Since cinema is art of the scenic (establishing shots, landscapes, interiors, sets), why should my pleasure in cinematic fantasy not come from seeing myself in *that* place, that location *x*, where, for an hour and a half, I could beam myself through the projector's transporting rays?

Running through these permutations is a way of strengthening, if not Mulvey's actual case, then a general theory of the Gaze that might be imminently elaborated from it. A more inclusive and multiple theory of identifications seems entirely appropriate, given the instrinsic mobility both of fantasy ("Now I am in the place of another than the one I am") and of the cinematic (an art of *movement* if ever there was one, and in this quite different from the static Albertian quadrature within which the Gaze, as a concept, was held).[14] One didn't have to be naïve or utopian about this "mobility," either—whether in fantasy or in film. Clearly some permutations were forever being thrust at viewers, and especially the "straight" range, A through D (straight readers may find it hard to imagine the exasperation of the gay man or woman forced for the trillionth time by standard Hollywood

fare to assume compulsory heterosexual identifications). All the rest (Mel Gibson—or the stars and set of *Star Trek*[15]), as fantasy objects, were forced by Hollywood into the closet of stolen views. Expanding the Gaze from four to eight (and why end there?) not only acknowledged the mobility of fantasy, it revealed the immobilizing pressure of dominant psychic scripts—and the possibility of resisting them.

But it also revealed something else, an essential property of the Mulveyan universe, even in expanded form: that whatever happens in spectatorship must be filtered through the subject-object polarity. Multiplying the possibilities showed up, in fact, the monotony of a theory of identification that resulted from an epistemology restricted to only those terms. Could you never be moved by a film character's plight as *hers* or *his?* Did it always have to be made *mine?* And what about *you*, and *we?* Did cinema have no vocative resources, no art of address *to* its audience, no way of speaking to me as *you?* In discourse, we speak from within fields of address; in narratives, we tell a *you* about a *him* or *her* or *they*. Narrative fields are faceted, polygonal, many-voiced. The optical field, by contrast, knows only two sides (image, look), and in the end only one of these—the look—counts: the monologic and monolithic *I* of sight, poised forever opposite its Other, behind the proscenic frame.

Bal's originality as a historian and critic of visual culture is that her opening move is to consider visual art as *narrative*. From this there follow a number of consequences, each of which departs from what is normally assumed in the concept of the Gaze.

All narratives involve a certain "aspect" from which the events in the story are told; there is no narrative that does not entail particular selections and omissions, emphases and evasions. From the simplest to the most complex, narratives are structured by what Bal terms *focalization*, the focusing of the story through specific agents or points of view.[16] Perhaps the easiest focalizer to identify is the narrator. Even when a narrative aspires to be neutral and objective, closer scrutiny reveals the presence of a voice or viewpoint with distinct characteristics. Should we identify this viewpoint with the author—or painter? Literary criticism accepts that authors and narrators are frequently quite distinct: the narrators in *Wuthering Heights*, or *Lord Jim*, or

The Turn of the Screw, are clearly not "transparent," neutral figures. And yet in art history, which has thus far developed no systematic way to study visual narrative, the two are typically conflated.[17] In this early methodological step, Bal is already *separating* the elements or terms of the Gaze.

Focalization begins with the narrator, but it does not end there. It is possible for the narrator, in turn, to viewpoint the story to one or more of its characters, and to present its events from their point of view. A famous fictional example can help clarify this point about the "embeddedness" of fictional narrative. In *The Ambassadors,* Henry James adopts the voice of a narrator who, in the third person, relates a series of events that take place in Europe as they are witnessed by the principal character, the elderly American, Lambert Strether. Strether's pained and patient reflections on the events around him are, in fact, the stuff of the novel: "All the other people in the book face towards him, and it is that aspect of them, and that only, which is shown to the reader" (Percy Lubbock).[18] Since we are made to look through Strether's eyes, we have much less "distance" on Strether than we do on the other characters; those we see, but Strether we see *through.* Yet in the course of the novel the reader gradually becomes aware of Strether's limitations, his preoccupations, his habitual turn of mind, and also his growing discontent with that turn of mind, his wish to see and think differently. The key scenes in the novel pass, then, through a complex set of refractions: the reader follows Strether's perceptions from within Strether's consciousness, but the narrator also presents Strether as a character in his own right—a character whose personal journey and transformation are the heart of the book.

Now consider a similar case in visual art, Rembrandt's paintings of Lucretia (the subject of chapter 3). To a remarkable extent, both of Rembrandt's versions of *Lucretia* (1664, National Gallery of Art, Washington, D.C.; 1666, Minneapolis Institute of the Arts) narrate the story from Lucretia's point of view. This is hardly true of Rembrandt's principle source, in Livy. There, the central event is what Lucretia's rape led to, the foundation of the Roman Republic. Lucretia herself is largely a counter within situations of intermale exchange: her husband's boasting about her virtue, Tarquin's revenge on him, then Brutus's deposing of the Tarquin royal house (which inaugurates the Republic). In Rembrandt's portrayals of Lucretia this story

seems to go into reverse, for what they show are the consequences of Tarquin's rape for Lucretia herself: her sense of personal annihilation, and her inability to tell of the rape except on masculine terms.

Not only is the viewpointing *to* Lucretia, but the decision to viewpoint the story in this fashion begins to cast an outline around the visual narrator who has reworked the inherited story in this intense and inverted way. Overturning the masculinist priorities of the story implies a narrator quite different, for example, from the "Rembrandt" who in 1632 had represented the *Rape of Proserpine* and the *Rape of Europa,* without any apparent qualm or self-distancing from the act of rape. A crucial event of the narrative is the narrator's turning round *against* the kind of masculinist focalization present in those earlier pictures. Alongside the story of Lucretia is played out a second, Strether-like drama, of the narrator's own questioning of the male prerogatives that shaped the received story, as they had also shaped the *Proserpine* and *Europa.*

Who is this elusive and seditious narrator? Do we call him Rembrandt? In biographically oriented analyses of the painting, that would seem the inevitable move: to assume that the narrator and the historical figure Rembrandt can be elided within the same authorial gaze. But that is precisely the kind of elision that Bal refuses: the narrator of the Washington *Lucretia* is not the same as the narrator of the *Lucretia* in Minneapolis, or of the *Proserpine* and the *Europa.* To identify all these narrators with the biographical figure, the man Rembrandt, is in fact to abolish the concept of the narrator, and to collapse it into *another* story, the story of Rembrandt the man. Bal's way of analyzing the picture goes against the alignment of author with narrator with story, such that each becomes transparent to the next in a single, monological gaze.

The concept of the Gaze is like some great conjunction of planets: artist, story, narrator, and character all line up together; or like the successive lenses in an optical instrument through which a single sight line passes. Bal's narratological approach to the image *dis*aligns this unitary gaze, pushing the different points of view away from one another, dispersing them into a "field," which the viewer then enters from yet another position. If the Gaze, as a concept, is based on the equals sign (artist = narrator = viewer), Bal insists on the opposite: Rembrandt the man is not equal to the narrator of

Lucretia; the narrator may viewpoint the image to Lucretia, but he remains a focalizer in his own right. The different points—painter, narrator, received story, revised story, viewer—form an interactive and interpersonal force field that is characterized not by the perfect alignment of its elements but by their separability.

In the Gaze, a single viewpoint contains the scene, and the viewer has no choice but to line up either inside it, as its subject, or as its exterior, its object, its victim. Resistance, as they say, is useless. Bal's reading agrees with Mulvey's and post-Mulveyan accounts of the Gaze in its sensitivity to vision as determined within institutions of masculinist, even rapist, power—yet the strategic outcome is different. Resistance is built into each point of the image's field: the narrator "Rembrandt," Lucretia, the viewer. That each point possesses powers of resistance creates a far more complex and volatile arena of power in vision than the Gaze, as a concept, has been able to suggest: power not as a monolith, or pyramid (the "visual pyramid"), or a possession of the powerful, but rather a set of relations or a "swarm of points" (Foucault) such that the possibility of reversing the power relation is present at each node of the image's focalization.

As an optically based representation of vision, the Gaze has only two poles, subject and object. As a rhetorical theory of vision based on the structures of discourse, Bal's work presents a more complex and multiple understanding of where, in the universe of communication, the agents of discourse stand—and of the ways they may interrelate. To grasp the difference, it may help to return to Benveniste:

> What then is the reality to which *I* or *you* refers? It is solely a "reality of discourse," and this is a very strange thing. *I* cannot be defined except in terms of "locution," not in terms of objects as a nominal sign is. *I* signifies "the person who is uttering the present instance of discourse containing *I*."[19]

What Benveniste is arguing against in this passage is the realist notion that first an ego or person appears and then it is given by language the proper name *I*. On that view, the *I* would refer to an object already present in the world, like a tree. But the instances of the use of *I* do not constitute a class of reference, since there is no "object" definable as *I* to which these instances

can refer in identical fashion. Unlike the word *tree*, the word *I* is referentially empty: it cannot point to anything outside of the locution in which it appears. Rather the *I* is defined by the relation it holds in language with the pronouns *we, you, him, her, they*. In Arabic grammar, Benveniste remarks, the names given to the pronouns are especially precise: "the one who speaks" (first person), "the one who is addressed" (second person), and "the one who is absent" (third person).

Benveniste was the first to notice that between the first and second persons taken together and the third person, there is no "symmetrical" relation. Let us stay, for a moment, with *I* and *you*. These are inherently *reversible*. The *I* can only say *I* to a *you*, and the *you* thus addressed is thereby given the right to lay claim to the first person in reply. It is important to grasp that these "persons" are, however, only artifacts of discourse, not "human beings"; basically they are "points of direction" given to discourse as it moves. Now consider the third person. This one is different from the others. *I* and *you* are directions, or vectors, inside the discourse where these words appear—they exist there and only there. But the third person stands outside the discourse. The third person can be referred to in his or her absence (like a tree). Not only *can* third persons be talked about when they are not there, they are permanently and logically absent from the utterance that names them. Which builds into the intersocial field of pronouns a place where persons are named, *but not as subjects* (since the third person can never lay claim to the only place for a subject to exist, at the word *I*). The two axes of the pronouns are *a*symmetrical. One *presides* over the other: one group speaks, the other is spoken *about*.

The implications for visual culture of this fundamental asymmetry of discourse are worked out in Bal's two essays devoted to the topic of the museum, on the American Museum of Natural History (chapter 4, "On Show: Inside the Ethnographic Museum") and on the Gemäldegalerie in Berlin-Dahlem (chapter 5, "On Grouping: The Caravaggio Corner").[20] The essential job of the museum is to elaborate the expository sentence: *I* speak to *you* about *them*. Yet the museum goes about this task in a highly specialized way, *deforming* the sentence at critical points. First, it is a peculiar characteristic of the museum that the *they*, though absent, are made present *visually*, as it were *in effigiem*. In the American Museum of Natural History

such non-Western peoples as prehistoric Siberians, Eskimos, and Pygmies are shown transfixed, in the "natural" setting of the dioramas. Second, the *you* is silenced. Visitors to the museum cannot take the position of *I*, cannot answer back to the museological narrative. Third, the *I* that speaks the museum's story obscures itself, presenting the displays in the museum as if they spoke for themselves.

How the *I* of the museum achieves this effect of invisibility is closely monitored in Bal's "walking tour."[21] Partly the discourse of "science" steps in to conceal the narrator's voice; since scientific knowledge claims to be true regardless of persons, its whole rhetoric is structured around the unavailability or the irrelevance of the first person. And in part the apparent neutrality of the museum's displays is a matter of their intense and high-fidelity realism. It is a typical feature of realist representations that they efface the traces of their own production: realism claims that its products are "found," not "made." The museum is, we know, an institution, and also a gaze. Bal's description explains that it is something else as well, a discursive instrument brought into being by radically modifying the position of the "persons" in its field of operations: *I* vanishes, *you* is silenced, *they* are present in effigy. Having thus built its expository machinery, the museum is free to relate its various, dismal stories: of "exotic" peoples as mediating between human and animal life, of noble Greeks escaping nature into history, of Africa as seen through missionary eyes.

What alternatives does Bal have in mind? Certain practical suggestions are argued for—a greater emphasis on the museum's own history (the "meta"-museum), concerted investigation of the narratives on offer in key international museums, curators laying their cards on the table. One can imagine many "new" curators coming to exactly the same conclusions.[22] Yet Bal's real intervention occurs within the field of the subjectivity that the museum calls into play. The invisible *I* of curatorial narration is unmasked or "undraped." In place of a silenced *you*, Bal creates a *you* that vociferously, outrageously, answers back. And instead of focusing on the third person, her writing invents a discourse that bypasses the third person almost entirely. *I* and *you* are now by themselves, the display and its viewer alone in the gallery, intimately together: a discourse of seduction.

I do not want here, in this introduction, to give the plot away—to tell the reader in advance what exactly Bal finds going on in "The Caravaggio

Corner" (chapter 5). The essay is by any standards an amazing record of a particular response to painting. What I would like instead to trace are the conceptual moves that Bal's essay makes. Art historians need not in this case reach for the eject button, and take Bal to task for being "ahistorical." The essay is scrupulous about exactly where it stands in time and space— right now, in a particular room in Berlin. Bal is not writing, at least here, about how to place Caravaggio in past history; what she wants to know is "what happens—in the strongest possible sense of that verb—when one painting, in a particular museum room, ends up next to another, so that you see the one out of the corner of your eye while looking at the other?" (p. 161). In particular, what is the effect of the curatorial decision to place Caravaggio's powerfully homoerotic *Amor* against his *Doubting Thomas*— and against Giovanni Baglione's other amorous scene, *Heavenly Amor Defeats Earthly Love*?

Bal is surely right to see the Berlin grouping as ahistorical: there may be one or two connections between the paintings in their own period, but this would only be a "historicist" pretext for what is clearly a strong proposition coming from the museum's narrator. In fact, many art historians dislike museums on just these grounds, for the bizarre and distracting connections that the syntax of the museum forces upon individual works. So be it. Bal's point is that such features of display are intrinsic to the museum (which can hardly exist without walls); and in this case the juxtaposition is sufficiently provocative to warrant an extensive *I-you* exchange. Though the Caravaggios in Berlin are certainly present as the occasion for discussion, Bal makes sure that they do not exist in the way things do in constative or expository narration. The essay refers not once to a biographical artist called Caravaggio who is separable from the works themselves, nor to the "original" milieu of their production. If third-person narrative classically proceeds by positing the one-who-is-absent as a referent, Bal's prose undoes that ostensive function. Caravaggio's paintings exist only in the here and now of viewing, at this one place. Where the American Museum of Natural History obscured the *I* and *you*, speaking only of *them*, Bal's writing highlights *I* and *you*. The whole discussion shifts away from the "non-personhood" that characterizes third-person narratives (Benveniste), into the what one might call the *I:you* axis of *intimacy*.

Is this visual fascination a variant on the Gaze? Possibility E, perhaps: a female spectator gazing with full powers of subjectivity at the male body? Of course it is: the essay can be thought of as living proof of the way that the concept of the Gaze, once set in motion, releases out of itself the potential for its own multiple refractions. And yet the conceptual moves do not conform to the logic of the Gaze, but rather of discourse, enunciation, and voice. For one thing, the relations of "person" or "voice" that the essay dramatizes are not *visible,* as power is in the Gaze. The meanings that Bal finds in Caravaggio's paintings do not reside *in* them, in what we see, but in the way they are focalized or embedded in the actual discursive situation.

The sixth essay in the collection, "Vision in Fiction: Proust and Photography," opens on to the same problematic of intersubjectivity as "The Caravaggio Corner": the difficult intersection between the axes of (first and second) intimacy and (third person) objectification. In this case the relationship between the axes is rather more complex. Bal begins with an astute observation: that at key moments, and around certain specific characters, Proust's text produces striking tableau-effects, somewhere between still photography and photography of motion. At times the effect conveys the idea of social exclusion, for instance when the narrator is describing a dinner at the Verdurins'. Here the visual description freezes the action in the scene, making it seem framed and distant, as though the narrator can no longer place himself within the Verdurins' salon as an insider. At other times the photographic effect expresses a gulf between persons that cannot be crossed, as with the description of the death of the narrator's grandmother (who indeed has a photograph taken in her final illness, so that the narrator may keep her likeness). In this case, the photograph marks the pull between two intense but irreconcilable feelings: estrangement, watching the grandmother slowly die, but also love, the narrator's love of his grandmother that floods the photograph with a feeling of poignancy and loss. The fullest expression of the photographic effect, however, comes when the text deals with the narrator's own desire, a homoerotic desire which, in the narrator's closeted world, can never be declared.

Bal points out that the effect of staccato movement, as though of an action photographed a great number of times in quick succession, becomes

heavily pronounced at moments when the narrator comes face to face with sexuality. Here is Robert de Saint-Loup, the narrator's idealized love object, emerging onto the street after a visit to a house of (unnamed) pleasure:

> Something, however, struck me: not his face, which I did not see ... but the extraordinary disproportion between the number of different points which his body successively occupied and the very small number of different points within which he made good this departure which had almost the air of a sortie from a besieged town. ... This military man with the ability to occupy so many different positions in space in such a short time disappeared.[23]

Bal compares this multiply arrested scene, and others like it, to the photography of Muybridge and Marey, where motion is analyzed into a series of independent, adjacent frames. Why this curiously stuttering or stammering visuality? And what might it have to do with the kinds of knowledge that circulate around the closet?

The answer has everything to do with the prohibition that surrounds every aspect of male-male desire in the Proustian milieu. The legal and scientific discourse around homosexuality that was developed in Proust's period is an instance of third-person narrative at its most brutal: gay men as a reviled and stigmatized *they*, who cannot, must not come anywhere near the axis of *I-you* exchange. The third person is the voice reserved for those who are banned from assuming the position of subject—for to do so would mean that *they* would come close to the one who says *I*; it would mean that the position of *I* could be interchanged and mixed up with the "accursed" *them*. And it is as an exaggerated third-person narrative that the text attempts to deal with Saint-Loup's sneaky exit from Jupien's hotel, across its many devices of denial—especially physical distancing (as though the episode is seen through a telephoto lens), incomprehension (suddenly the figure of Saint-Loup, who elsewhere in the text elicits the narrator's admiration for his handsome face and carriage, becomes barely recognizable), and abstraction ("different points," "positions in space").

Yet this denial that generates the "Muybridge" effect is not only, of course, a matter of the third person. The narrator looks to Saint-Loup as to a highly glamorous incarnation of masculinity, and to the extent that the narrator idealizes he also narcissistically invests the ideal with the ego's own self-love

and male self-admiration. Though relegated to an extreme visual and episte-mological distance, Saint-Loup also bears the erotic investments of the first-person narrator. As a gay subject who has internalized his period's homophobic discourse, the narrator sees Saint-Loup as an objectified *it* and at the same time as a longed-for *you*. The two axes—of objectification and denial, versus contact and intimacy—conflict utterly, and in their opposition pull the field of vision in two directions: into "scientific" objectivity, the eye of the camera; and into erotic fantasy and idealization. Hence the bizarre, Muybridgean staccato of the narrator's closeted gaze. Its broken, multiple views focus on the erotic image, but in the moment when the narrator's own desire begins to surface, the internalized ban is automatically triggered: vision swerves away from the scene, and suddenly Saint-Loup is expelled, turned into representation, into serial photography.

Why not still photography, one might ask? Perhaps it is because the still photograph can, in a sense, fully capture its scene, possessing it and bringing it close to the viewer. Muybridgean or serial photography stands for a visual-ity unable to interact with the object of love. The gaps between the frames that distinguish serial from still photography indicate the very action of repression as it beats down on same-sex desire: the narrator sees Saint-Loup, his desire almost surfaces, but instantly the mechanism of internalized homophobia sets in, blanking the figure out. In the next frame desire again resurfaces, and is once more driven back. The gaps between the Muybridge-like frames act out the terms of a desire that must not be allowed to survive—just as they also enact the failure of repression, the desiring subject's return to the object of love, the ineradicable nature of desire even here.

Bal's essay is extremely sensitive to the unavailability or loss of the possibil-ity of love that Proust's text expresses. If, in the essay's concluding remarks, the argument tends to map this loss-in-desire on to the text's modernist writing strategy ("There is one narrative reason for this, the one that defines this work as modernist," p. 211), I would perhaps wish to emphasize its "period" aspect, and the text's relation to the social institutionalization of homophobic dis-course that occurred in the late nineteenth century. Bal's gesture is to take what might otherwise be construed as a local or parochial history of oppres-sion—perhaps of interest "only" to gay men and women—and to make it

paradigmatic for modernist fiction as a whole. This "universalizing" strategy is in its own way important, and necessary: it constitutes a move that opposes the closet, by opening it onto a larger literary and social field. My only concern is that gay men and women be allowed to keep their history, which was lived out in specific and painful terms, and not to have it absorbed (and maybe neutralized) by a general history of modernist writing. Obviously, both the "universalizing" and "minoritizing" approaches are valid; it is perhaps only a question of differing emphases.[24] Here I will just briefly sketch the ways in which same-sex desire in Proust's novel, and his world, were shaped by a quite specific historical situation. Bal's essay opens up the whole question of interactions between vision, desire, and prohibition that are specific to Proust's time and place.

The connection between these terms is indeed close. The late nineteenth century is the period when male-male sexuality is no longer, as we know, a matter of homosexual *acts,* but homosexual *persons.* In the words of Michel Foucault,

> The homosexual became a personage, a past, a case study, and a childhood, in addition to being a type of life, a life form, and a morphology, with an indiscreet anatomy and possibly a mysterious physiology. Nothing that went into his total composition was unaffected by his sexuality. It was everywhere present in him: at the root of all his actions because it was their insidious and indefinitely active principle, written immodestly on his face and body because it was a secret that gave itself away.[25]

The construction of the medico-juridical category of the homosexual person brought in its wake an intensely diagnostic visuality: the homosexual person is known, his essence stands revealed, at certain stigmatic points—the wave of a hand, an inflection, a tone of voice, the flash of a ring. But at the same time, for the operator of homophobic discourse there is something hallucinatory and uncanny about the mode of the stigma's appearance.[26] Unlike comparable markers of, for example, race or gender, the homosexual stigma has the diabolical property of being able to disappear, like a message written in invisible ink: the homosexual can *pass,* can melt into the crowd. The stigma does not announce itself in clear and distinct characters: it is elusive, oblique. Perhaps some are able to make it disappear almost com-

pletely—and if so, how many of those are there? To which Proust, of course, gives his tremendous and paranoid answer: *they* are everywhere,

> a freemasonry far more extensive, more effective and less suspected than that of the Lodges, for it rests upon an identity of tastes, needs, habits, dangers, apprenticeship, knowledge, traffic, vocabulary, and one in which even members who do not wish to know one another recognize one another immediately by natural or conventional, involuntary or deliberate signs which indicate one of his kind to the beggar in the person of the nobleman whose carriage door he is shutting, to the father in the person of his daughter's suitor, to the man who has sought healing, absolution or legal defence in the doctor, the priest or the barrister to whom he has had recourse; all of them obliged to protect their own secret but sharing with the others a secret which the rest of humanity does not suspect.[27]

This elusive mark has another property which, for the operator of homophobic discourse, is no less disturbing than its ability to vanish. It is unlike the *honest*, undelible marks of race or criminality that so exercised nineteenth-century taxonomists: facial configuration, cranial capacity, earlobes, etc. (Lambroso, Galton, Tardieu). Those are objective characteristics, science understands them; they belong clearly to the third person (*I* and *you* cannot share in these features). If the marks by which homosexuals are supposed to recognize each other are invisible to the eyes of decency, this is because they are *vocative*, intimate, reversible. They are addressed to the *you* who is also one of *us*. It takes one to know one. The moment when the stigmatizer thinks he sees the sign of infamy is accordingly perilous in the extreme, for in recognizing these oblique clues and indices the stigmatizer has *left* the universe of third-person discourse, with its taxonomic certainties and hygienic distance from danger, and has entered the forbidden zone of homoerotic intimacy. The mark is not only fugitive and liable to evaporate; in the moment of glimpsing it the stigmatizer is no longer able to draw the line between himself and *them*. At the very moment of detection, the line of protection, the cordon sanitaire, collapses.

Proust's narrator is constantly in this position: observing gay men as alien, a *race maudit*; then with a sudden and overwhelming collapse of distance he is right there, in the same place of subjectivity as they; and then he is again recoiling, repressing that subjectivity, blanking it out. The serial

photography or "Muybridge" effect enacts this double bind in precise terms. In the strange oscillation between a third-person narrative of distantiation, and a first- and second-person narrative of desire, the narrator behaves in basically the same way as the discourse of homophobia itself. Both are on the lookout for quasi-hallucinatory signs, and both go into panic the moment the signs are seen. While agreeing with every detail of Bal's analysis of the "Muybridge" effect, I would like to insist on the genesis of this effect in homophobia and its internalization as the basis of erotic subjectivity in Proust's era and text.

What would happen if visual art sought to play down its powers of depiction and instead were to organize itself around its address to the viewer? What would art that tried to escape expository or constative functions look like?

Bal's answer is that it would look *baroque*. The term is famous for its slipperiness. Does it refer to art produced in a limited historical period? Or is it a stylistic term (meaning: embellished, dynamic, painterly, etc.)? Should we associate it with the Counter-Reformation, or can we find it in antiquity—or outside the West? As Bal employs it, the term acquires narratological accuracy (baroque art foregrounds first- and second-person discourse), while still corresponding to the loose, vernacular sense that the word has outside art history, of theatricality and spectacle. It locates, within art that most people would agree to call baroque (though many art historians probably find the term too imprecise to be useful), visual operations that are quite precise.

Baroque is known, for example, for its radical reworking of perspective; it shifts both viewpoint and vanishing point to new and unusual positions. There may be exaggerated foreshortening, so that the viewer is longer thought to occupy a neutral, "objective" standpoint before a clear, unobstructed view. In Tintoretto's *The Finding of St. Mark's Remains* (Pinacoteca, Milan), the vanishing point has moved to the extreme left of the composition, making everything appear obliquely. In ceiling paintings where the heavens open, the saints appear not as they would to themselves but to viewers who crane their necks to take in the aerial display (Correggio's *Assumption of the Virgin*, Parma Cathedral), or else they tumble out of the frame altogether, riding on the backs of clouds (Giovanni Battista Gaulli's

Worship of the Holy Name of Jesus, Il Gesu, Rome). Sculpture begins to play to the angle of view. The best way to approach Bernini's *David* is to walk right around it, and at each step David's form strikingly changes. Such effects activate the sense of the work as existing for-you and from-you, in the here and now of actual viewing.

Hubert Damisch has demonstrated the special significance to baroque art of the cloud, as a signifier opposing the lucid, constative geometry of linear perspective. In Brunelleschi's original experiment with perspective, every-thing concerning the architectural space of the Baptistery in Florence was reproduced exactly to scale, so that viewers looking through the apparatus that Brunelleschi set up in the square of the Duomo would have seen repre-sented in the picture exactly the same prospect as the one before their eyes. But the space above, of clouds and sky, was left unrepresented, replaced by a strip of silver foil that reflected back the real sky overhead. What this reveals, Damisch contends, is the set of limits for the experiment, which concerned only forms that could be captured in linear drawing—the orthogonals, flagstones, walls and cornices of architectonic space. The experiment in fact "makes perspective appear as a structure of exclusions whose coherence is founded on a series of refusals that nonetheless must make a place … for the very thing that it excludes from its order."[28] Linear perspective was keyed to the outline and the edge, and not at all to the problem of the *informe* that the cloud presented. Was it only the cloud's imprecise boundary that so chal-lenged a visual system based on the central observer? Or did this difficulty point to a deeper reason for the exclusion: that the cloud is a form that pro-poses no particular viewpoint as "correct?" All views, from all sides, are equivalent. Which is to say that the subject who views the cloud is not the prospect's organizing principle, but simply *what comes to the point of view* (Deleuze).[29]

A similar indifference to the preestablished viewpoint is to be found in related signifiers of the baroque, for instance in its treatment of stone. Consider the marble walls that flank Bernini's *Saint Teresa* in the Cornara Chapel (Sta. Maria Della Vittoria, Rome). The rich patterns revealed in the stone through cross section have arisen in the course of the stone's history of geological accident, without regard to any eventual act of viewing. What, then, is this cross section, if not an arbitrary cut into a material whose

composition gives no especial indication as to where the cut is to be made? The viewpoint from which we see into the marble makes visible its interior, but no matter how clear-cut the section, its orderly geometry can do nothing to organize the formless, indifferently curving veins within. If semiprecious stone abounds in chapels of the baroque, we underestimate the significance of this if we explain it as a mere effect of opulence. What is crucial is the subject-position that cut stone proposes for the viewer. In Brunelleschi's experiment the forms converged symmetrically on the spectator; they placed him squarely at the center of the urban panorama or *veduta*. Like the cloud, veined stone presents the opposite idea, that no privileged angle of view has been anticipated. All views are "subsequent"; they come into being from the spectator's side.

At the same time, the view is only one possible cut from an infinite number of alternative cuts that might have been made. It is the view opened up now, in *this* cut, for *this* act of viewing. When Bernini combines the *informe* of marble with that of the cloud that supports the swooning figure of Saint Teresa from below, the idea is redoubled: that this particular outline and silhouette of the cloud-marble refers to our unique point of view, it comes entirely from our side. Now consider what happens when Bernini carves the cloud-marble into the folds of Saint Teresa's robe. In a sense the figure is all folds: where a century earlier fabric had draped itself obediently around the body, revealing and conforming to its contour, now the wrapping around the body abolishes contour—except as the wildly irregular outline that is seen from our particular point of view. In this drapery whose folds and angles shoot out lines in all directions, an infinity of possible views is implicitly held. And the drapery is executed in a white marble so polished, in comparison with the rough and unfinished cloud below the saint, that to the irregularity of its folds is now added that of the veined stone itself. The polished cut into the marble that is made at each fold discloses a veined interior world which we can only see into from here, where the cut is made. The folds, radiating in all directions, like the golden rays of light above the saint and the angel, are *intersected* by our sight to form this particular configuration, the one that comes into appearance only where we stand.

The cloud, the veined stone, the cut, the fold: isn't the coherence of baroque not only a matter of its theatricality, its exaggerated sense of spectacle (which it shares with any number of other spectacular art forms)? Isn't it to do with its mathematics—and with its sense of the kind of subjectivity that mathematics proposes and assumes? It is not yet to grasp the coherence of the baroque ensemble—the highly specialized topology that is common to cloud, stone, cut and fold—if we simply think of each of these elements as ostentatious. What is important is the repetition, across these individual elements, of an idea of space that is radically unlike the space of linear perspective. There, a fixed viewpoint rules the world. Before its magisterial gaze the entire prospect is mastered, represented, objectified. The whole order of the city arrays itself before the central subject who orders and possesses it, turning everything within the scene into statements of fact, the inventory of things and people paraded before the *I*/eye who looks, as through a window, at *those* and *them*.

Baroque is much more mysterious. It is fascinated not merely by "opulence" but by materials whose nature is to extend equally in every direction (marble, cloud, rays of light) and which are then cut into or *sectioned* so as to reveal only one from an infinite number of alternatives. Whereas Brunelleschi's experiment contained all things within a single view, the view is now a mere fraction, an incremental cut into infinite space. Things exist *outside* the gaze, and the gaze sees into them not infinitely but infinitesimally. And what the gaze apprehends is not in any sense absolute, but relative to the position that the viewer assumes, in the actual, physical conditions of viewing *now,* from this angle.

The cloud, the stone, the cut, the fold: what concerns us here is the way their shared topology constructs the viewing subject for such forms. Dislodged from the absolute point of knowledge that linear perspective proposes, the viewer is addressed in relative terms: everything viewers see is the outcome of their position *with regard to* the form. This amounts to a radical displacement in the axes of discourse, since the only place in discourse where relativity may exist is in the vocative or *I-you* axis. Now *you* are the source of the view: the work extends itself toward you, it embraces you. Baroque, in Bal's analysis, is the visual language of intimacy. "Each utterance

is performed by an 'I' and addressed to a 'you'... . Conversely, the 'you' becomes an 'I' as soon as the perpective shifts" (p. 217).

Deriving as it does from a relation between voices in discourse, Bal's "baroque" is by no means confined to art of the baroque period, and indeed in her recent work the term is used to describe a whole range of practices in contemporary art.[30] Bal's essay on David Reed (chapter 7) finds in this painter's work a return to baroque that reactivates many of the features of baroque as a *pragmatics*—with the sense this term has in linguistics, of referring to the immediate context of discourse, its instantiation in actual speech conditions. Another term traditionally used in linguistics to designate the here and now of utterance is *deixis*, and it may help to place Bal's account of Reed if we briefly examine this concept.

Once again, Benveniste: "The essential thing is the relation between the indicator (of person, time, place, object shown, etc.) and the *present* instance of discourse."[31] The great class of expository statements of the form "Solon accomplished his mission," "the marquise went out at five o'clock," "Freya boarded the plane," contain no "autobiographical" element; they are historical, in the "historicist" sense of describing a past from no detectable location in the present. Words such as *here, there, now, today, yesterday, tomorrow,* by contrast, orient the information surrounding them to the space and time of ongoing speech. In "baroque" expression these deictic markers are everywhere amplified and multiplied. How does this work when deixis takes the form of a painting by David Reed?

Bal points out that what strikes the viewer at once in Reed's *#275* is a certain self-distancing from abstract expressionism. Reed's strokes stand in obvious contrast to Pollock and de Kooning. Let us concentrate here on the specifics of the pictorial surface. In abstract expressionism, the strokes are *layered*. It is impossible to conceive of individual strokes as other than consecutive, that is, as *dividing* the surface. Such strokes are "expressionist" in the sense that they refer to their source in individual gestures of the painter during the time the painting was made—a time, however, to which we have no direct access. Whenever the painter pauses or interrupts the work of painting, in the time *between* consecutive strokes, he ceases to appear within the field of the painting. The gaps between successive strokes stand for this

absent origin that is known to us by the strokes emanating from their *concealed* source. The subject of the work expresses himself "across" the strokes understood as relays or conduits between the viewer and the unseen subject of expression.

Reed's strokes are different; not so much layered as smeared. Of course, there are limits to this process, as Yve-Alain Bois has remarked: "Certainly, short of covering over the entire surface with a roller, like a house painter, and producing a monochromatic canvas, there is no way of avoiding a consecutive placement of the strokes of color on the canvas, no way of eliminating a certain residue of division."[32] Yet Reed comes close to doing just that. The strokes do indeed suggest the action of a blade rather than a brush; and the application of paint in wide, sweeping arcs pulls the separate elements into a single wave. Though individual "peaks" and "valleys" of this wave are apparent, essentially the stroke has been transformed into a continuum— with profound repercussions for the kind of subject that is implied as having made this wave, as well as for the viewing subject it addresses.

Since no gaps or layerings are apparent, we can no longer imagine a subject *leaving* the surface of the work (going away from us, into the occlusion or seclusion of a subjective center from which the strokes are supposed to emanate). Because the act of dividing the surface has been replaced with its opposite (*fusing* the strokes), the subject of utterance (of the painting), exists only in what we see on canvas. No expressive *I* stands behind that surface; we have only an I-within-discourse, a narrator "Reed" rather than David Reed (just as, in Bal's Lucretia chapter, we have "Rembrandt" rather than Rembrandt). This deictic narrative has a further move: it reaches out toward the viewer. The "crests" and "troughs" do not stay in a vertical plane, like water seen in a glass tank. They curve out in looping or lasso-like motions toward the viewer's own space; the sense is of their coming out to embrace and enfold the spectator.

This aspect of projecting outward into the viewer's actual situation is reinforced by the way the paint is not just a top surface, but has a fibrous thickness, like tissue. As Hannah Loreck notes at certain points, "the skin of paint has been peeled back, permitting a view of the 'inward' … one looks at the flow of color that, like desire, circulates unfixably."[33] Just under the stroke's "skin," fibers or strands of pigment appear in skeins or bundles, as in

fiber optics. Then sensation is not only of an embrace, but an embrace that leads to an exposure, and the exploration of an interior. In the close analogy this quickly forms with erotic invitation, the painting almost literally seduces the viewer; it is "sensuous beyond belief."

Are Reed's paintings so different from myriad others where the represented content of a scene—its scenographic dimension—seems to "come forward" to the spectator? Don't I notice the same effect of figures coming forward onto the picture plane in almost everything I see (in Veronese, in Manet, in Matisse)? Can I in fact see *pictures* in any other way than this?

Here it is important to distinguish Bal's sensitivity to deixis from the master narrative of modern painting's "discovery of the picture plane" (Greenberg: from Manet to Picasso to Pollock and beyond). Compare Reed, for example, with Matisse (especially as described, with much insight, by Bois).[34] When Matisse broke with Seurat's and Signac's divisionism, the method he rejected was essentially atomistic: each stroke in Seurat had the same size and shape, with a thousand identical strokes filling the canvas until, at the end of the process, the image came together as a general color-synthesis and color-harmony. For Matisse, this method stood in the way of a very different possibility: that each stroke on the surface, *as it was being laid down*, might refer to the *totality* of the surface bounded by the four sides of the frame. "In my quick drawings," Matisse remarked, "I never indicate a curve ... without an awareness of its relationship to the vertical [of the frame]."[35] In Seurat the final sum of the individual strokes was obtained only at the end, when the picture was complete. With Matisse the totality is measured against each ongoing stroke. Lay down a color, and then a second; between them is a clash that is resolved through the addition of a third color. Now add a fourth and see its relation to the whole; continue in this way until the whole canvas is covered.

Now, Matisse's calibration of each mark in relation to the totality of the surface may indeed bring everything forward to the surface, but the important point (in relation to Reed) is that this "all-over" does not project *beyond* the surface. That surface, in Matisse, has an even, all-over tension—like the surface tension in a drop of water. The placement of forms is determined by the surface tension, and must not conflict with it or go against it (or the result will be, in Matisse's word, "jumpy").[36] Matisse's discovery of "flatness"

is, of course, the opposite of flat housepaint on a wall (which exactly lacks this surface tension). But by the same token it is not the projective, undulating, lasso-like space of Reed, which is that of fluid moving slowly out into the viewer's space, a fluid thickened by luminous strands. And that projective movement is not merely formal or spatial. The wave of paint, the enfolding of the viewer, the peeling back of the skin, the disclosure of an interior full of energy, lubrication, color—all that resonates with the deixis of painting as an erotic provocation.

In the last of the essays in the present collection, "The Knee of Narcissus," Bal moves to the discourse of epistemology, the branch of speculative philosophy that asks the question: how do subjects come to knowledge of the world? Two especially rich stories of the subject's relation to the world are singled out, Lacan's paper "The Mirror Stage,"[37] and Caravaggio's *Narcissus* (Galleria Corsini, Rome).

Ovid's version of the Narcissus myth makes it into a Platonic sermon against art: the mistake Narcissus makes is that of being taken in by a representation (*quod petit est nusquam*). In Alberti's similarly platonizing view, the reflection in the pool again stands for art's capacity to deceive the senses: "What else can you call painting but a similar embracing with art of what is presented in the surface of the water in the fountain?"[38] Narcissus' error would be that of failing to recognize a sign when he sees it, like a naïve realist reader of images. Yet the straightforward moral—beware of representation's powers to deceive!—comes close to turning into its opposite, even here: if read against the grain of the Platonic moral, Ovid's and Alberti's stories of Narcissus are like a homage to the power of representation to take the senses over, to absorb the viewer body and soul into the world of representation. It is this feeling of the image's ability to captivate or capture[39] the subject that leads Bal to Lacan's paper on the mirror stage, for there the myth of Narcissus is everyone's life story.

Though Lacan's story of the mirror can be developed in a number of other directions, for Lacan himself it seems that this process of building the self on a ground outside the self is basically a disaster, a tragedy of alienation. From the moment when the child jubilantly assumes the mirror's image of himself as *moi*, he condemns himself to a life of servitude. As Lacan

tells the tale, when the child enters the mirror stage[40] his body so far lacks the unified outline and muscular coordination that his counterpart in the mirror seems to possess. His own body is a mere jumble of disparate sensations from various sense organs; it occupies no coherent contour or space. Over there, in the mirror, appears a superior being who has precisely what he lacks; by identifying with this ideal being, the child literally pulls himself together—but at enormous cost. For in surrendering his real if disorganized body to the imago whose splendor he desires for himself, the child embarks on a lifelong journey toward an "alienating destination,"[41] installing the first in a series of idealized self-images which he will continue to chase forever, but will never reach. The coherence which the subject desires will become, in Lacan's phrase, "the armour of an alienating identity."[42] He will always measure himself against the idealized imago, and be found wanting. "The libidinal tension that shackles the subject to the constant pursuit of an illusory unity," Lacan writes elsewhere, "is surely related to that agony of dereliction which is Man's particular and tragic destiny."[43]

There is something strangely inconsistent about the way Lacan seems to interpret the mirror stage, and the train of identifications that follow in its wake, in such disastrous terms. The process of surrendering to an image that is other than the self could only be construed as an "alienation" if a self were already there, a self that now places itself in bondage: but the story insists that no such anterior self exists.[44] As a result, the whole Lacanian vocabulary of *aliénation* and *méconaissance* seems to have been imported from some other (Hegelian, Marxist) conceptual universe.[45] Similarly the gap between the ideal whose lineaments are glimpsed in the mirror, and the wretched sack of flesh the subject feels he really is, cannot exist either, at least not here. If anything, the story is about a protean subject that establishes itself by mimicry, absorbing into itself this imago from the world, and then the next one, and the next—while never experiencing any of the devoured or incorporated identities as alien.[46]

The radical strangeness of the story probably lies in the way the subject of the mirror stage has no grounds for experiencing any of his morphological transformations as other than completely authentic. To him, they are not even disguises. Compare Lacan's story with almost any classic transforma-

tion scene. When Dr. Jekyll becomes Mr. Hyde, when the boy becomes a werewolf, we picture the scene as involving a violent buckling of the skin and face; the subject knows all too well that he is changing, but he cannot help it. Lacan's radically shape-shifting subject has no basis for experiencing the transition as in any sense abrupt. There is no "original" self that is subsequently "distorted." At each new point in the suite of identifications the subject of the mirror stage comes into its *own*; it "morphs" continuously.

Lacan's mirror-stage story has the interesting property, then, of being poised between two equally monopolistic versions of the process it describes. Either the story is about the self being tragically alienated from its true nature, from the moment when its socialization begins—a sort of Rousseauian parable of society as an irresistible corrupting force, only without Rousseau's consolation of childhood as a brief interlude before the corruption sets in (for it is where corruption starts). Or else the story is about the self as a shape-shifter so adept at mimicry that its disguises are indistinguishable from the real thing. One way, the self is colonized by the other completely and tragically; the other way, the self colonizes the world, annexing this identity and then the next one—and doing so blamelessly, "jubilantly," since it cannot know the self/other distinction on which ideas of *meum* and *tuum* are based.

Bal's reading of Lacan's weirdly volatile and reversible fiction proposes, however, a different development, across a different relation between the terms *self* and *world*: in her view these come into being at the same time, they are (in the key word of the essay) "co-eval." The self can only know where it stands in space if it acquires a sense of boundary, of where the self ends and the world begins, and such knowledge has to come from the outside, from the gaze of another being. In her rewriting of Lacan's narrative across Caravaggio's painting of Narcissus, the "real" body of Narcissus, which we see above the pool, is a disorganized and fragmentary *corps morcelé*; "the knee looks as if it is detached from the body and floating in space" (p. 247), as does the upper body (the shoulders and arms seem to have no torso to join). Reflected in the pool is Narcissus' unified image. So far, the story is basically the same as Lacan's. The difference is that Caravaggio's painting introduces another person into the scene: the viewer.

For Caravaggio's Narcissus is not alone. His body projects forward toward and into the viewer's space (like Reed's #275). Hence the extraordinary, "baroque" foreshortening of Narcissus's famous knee—a foreshortening so drastic that you have to make some mental adjustments to be able to recognize it as a knee at all. The knee of Narcissus assumes a form that can be known only from *our* viewpoint; it is essentially keyed (like the cloud, the cut, the fold) to a *you* whose angle of view generates the image that Narcissus takes as the basis of his identity.

One should not underestimate the disagreement here between Bal and Lacan in their respective accounts of how subjectivity is to be pictured. Bal insists that in the Caravaggio there exists a dimension of intersubjectivity—the *I-you* exchange—that is deeply unavailable in Lacan's account of the subject formed by the triad of the Symbolic, the Imaginary, and the Real. There is no evidence to suggest that Bal has any particular dispute with Lacan's idea of a Real lying beyond human efforts to produce a meaningful universe. But over the terms *Symbolic* and *Imaginary* there are major differences.

Lacan's description of the Symbolic order models it, above all, as the field of the third person. It is the domain of language and of all discursive activities, where "nothing exists except on an assumed basis of absence."[47] Entering the Symbolic means leaving behind the order of the *I* and assuming one's place as a proper name. Inveterately social, the Symbolic is a "*res publica* that does not allow any one of its members to be himself, keep himself to himself or recreate in his own image the things that lie beyond him" (Malcolm Bowie).[48] Lacan's description of the Imaginary, on the other hand, models it as the field of the *I*: here the subject refers all persons and events within his lived horizon to the central point of the ego. The grammar of Lacanian subjectivity seemingly admits of no other pronouns than the first and the third; the *you* is radically absent. Hence, perhaps, the way Lacan's story of the mirror stage oscillates undecidably between a description of the self as tragically alienated, "third personed"; and as jubilantly colonizing the world, turning it all into first-person sameness and self-replication. Lacan's account of subjectivity would seem to have no other positions for the subject to assume. In particular, it lacks the constitutive intersubjectivity of the *I-you* axis which Bal's writings highlight at every turn.

Obviously, Bal's work does not ignore third-person narrative (see, for instance, the essay on the American Museum of Natural History). But her interest in deixis, in *I-you* reciprocity, the address to the viewer, and painting's enfolding of the viewer's space, is a way of indicating what may be incomplete in Lacan's formulation of the Symbolic and the Imaginary as exhausting all possible positions the subject may take up in discourse. The same is true of Bal's implicit critique of the Gaze. The objection is not that the concept is invalid, rather that it is one-sided. The Gaze takes what is, in fact, an explanandum—the nature of third-person discourse in the visual field—for its own working method; becoming as a result less a theory about the gaze, than a theory which assumes the gaze—thereby reinforcing it in the domain of theory. The significance of Bal's work for others engaged in projects of cultural analysis is that it points to places where some of the models that currently guide critical thought may unwittingly reproduce the very master/slave dialectic they seek to oppose—and it maps ways out of the impasse.

Let us end with a figure that Bal mentions in the conclusion to her essay on David Reed, and take it here as a muse presiding over her own work: Scheherezade. The sultan wields powers of life and death, every night killing another of his wives once his pleasure with them is done. Scheherezade knows all about masters and slaves. But she also knows that even "the most powerful subject's subjectivity is as much in need of confirmation as the weakest, most dependent subject's is" (p. 236). For as long as she can still address the sultan as *you,* and as *I* to *you* can weave the stories that make up the *Arabian Nights,* she knows she can survive.

Cambridge, Massachusetts
August 1997 Norman Bryson

notes

1 Hubert Damisch, *Théorie du nuage: pour une histoire de la peinture* (Paris: Editions du Seuil, 1972), 143; translation of the quotation from Christopher Wood's book review in *Art Bulletin,* vol. 77, no. 4 (1995), 680. See also Ernst van Alphen's "Moves of Hubert Damisch: Thinking about Art in History," in Hubert

Damisch, *Moves: Playing Chess and Cards with the Museum* (Rotterdam: Museum Boijmans Van Beuningen, 1997), 97–123.

2 Emile Benveniste, from "Subjectivity in Language," in *Problems in General Linguistics,* translated by Mary Elizabeth Meek (Coral Gables, Florida: University of Miami Press, 1971), 225–6.

3 For a critique of the "context" idea in art history, see an essay largely inspired by Mieke Bal's work on Rembrandt: Norman Bryson, "Art in Context," in *The Point of Theory: Practices of Cultural Analysis,* ed. Mieke Bal and Inge E. Boer (Amsterdam: Amsterdam University Press, 1994), 66–78.

4 Emile Benveniste, "Tense in the French Verb," in *Problems in General Linguistics,* 206–7.

5 For a general introduction to the relation between semiotics and visual art, see Mieke Bal and Norman Bryson, "Semiotics and Art History," *Art Bulletin,* vol. 73, no. 2 (1991), 174–208; reprinted in Mieke Bal, *On Meaning-Making: Essays in Semiotics* (Sonoma, California: Polebridge Press, 1994), 137–203.

6 In her strategy of attending to the detail that exceeds, or falls outside of, dominant patterns within a work, Bal's approach comes close to Naomi Schor, in *Reading in Detail: Esthetics and The Feminine* (New York and London: Methuen, 1987).

7 Laura Mulvey, "Visual Pleasure and Narrative Cinema," *Screen,* vol. 16, no. 3 (Autumn 1975), and "Afterthoughts on 'Visual Pleasure and Narrative Cinema' inspired by *Duel in the Sun,*" *Framework,* vol. 6, nos. 15–17 (1981); reprinted together in Constance Penley, ed., *Feminism and Film Theory* (London and New York: Routledge, 1988), 57–68 and 69–79.

8 Alois Riegl, *Dashollandische Gruppenportrat* (Vienna: Osterreichische Staatsdrucken, 1931). See also Margaret Iverson, *Alois Riegl: Art History and Theory* (Cambridge, Mass., and London: MIT Press, 1993).

9 Michael Fried, *Absorption and Theatricality: Painting and Beholder in the Age of Diderot* (Berkeley: University of California Press, 1981).

10 See T. J. Clark, *The Painting of Modern Life: Paris in the Art of Manet and his Followers* (New York: Alfred A. Knopf, 1985); and Thomas Crow, *Painters and Public Life in Eighteenth-Century Paris* (New Haven and London: Yale University Press, 1985).

11 See Erwin Panofsky, preface to *Studies in Iconology: Humanistic Themes in the Art of the Renaissance* (New York: Harper & Row Publishers, 1962).

12 See in particular T. J. Clark, *The Painting of Modern Life,* chapter 2 ("Olympia's Choice"). In the view of some feminist art historians, however, Clark's account failed to give sufficient weight to the gendering of the visual field it described; see Griselda Pollock, "Modernity and the Spaces of Femininity," in *Vision and Difference: Femininity, Feminism and the Histories of Art* (London and New York: Routledge, 1988), 50–90.

13 Sigmund Freud, "'A Child Is Being Beaten': A Contribution to the Study of the Origin of Sexual Perversions," in *The Standard Edition of the Complete Psychological Works of Sigmund Freud*, vol. 17, edited and translated by James Strachey (London: The Hogarth Press, 1958), 179–204. See also Kaja Silverman's analysis of "'A Child Is Being Beaten'" in *Male Subjectivity at the Margin* (New York: Routledge, 1992); and Constance Penley, *Feminism and Film Theory*, 23–30.

14 On the possibilities of "multiple identification"—and also the limitations placed upon it—see chapter 1 ("The Bodily Ego") of Kaja Silverman, *The Threshold of the Visible World* (New York: Routledge, 1996), 9–38.

15 See Constance Penley, "Feminism, Psychoanalysis, and the Study of Popular Culture," in *Visual Culture: Images and Interpretations*, edited by Norman Bryson, Keith Moxey, and Michael Ann Holly (Hanover and London: Wesleyan University Press, 1994), 302–24.

16 See Mieke Bal, *Narratology: Introduction to the Theory of Narrative*, translated by Christine van Boheemen (Toronto: University of Toronto Press, 2nd ed., 1997), 5.

17 It is interesting that the original title for Bal's book on Rembrandt was *Reading "Rembrandt": Beyond the Word-Image Opposition* (1991); her study took the distinction between the artist and the visual narrator "Rembrandt" as its point of departure. The quotation marks were, however, thought by the publisher to be too confusing in an art history publication, and were "smoothed out."

18 Percy Lubbock, *The Craft of Fiction* (New York: Charles Scribner's Sons, 1955), 161.

19 Emile Benveniste, from "The Nature of Pronouns," in *Problems in General Linguistics*, 218.

20 For a complete account of the consequences of this asymmetry for all acts of "exposition"—in curatorial culture, but also in humanities scholarship—see Mieke Bal, *Double Exposures: The Subject of Cultural Analysis* (New York and London: Routledge, 1996).

21 It should be understood that Bal's narrator is not to be identified with the *ideological position* of the museum (imperialist, racist, sexist, etc). Nor is the narrator to be identified with the *curators* who, in their long line of succession since the museum was founded, have been responsible for its displays. Rather, the *I* here—as in all instances of discourse—is the focalization that "directs" the flow of information within the museum. In Benveniste's words (from the epigraph to this introduction), the *I* does "not refer to a concept or an individual."

22 See, for instance, Reesa Greenberg, Bruce Ferguson, Sandy Nairne, eds., *Thinking about Museums* (New York: Routledge, 1996); and *The New Museology*, edited by Peter Vergo (London: Reaktion Books, 1989).

23 Marcel Proust, *A la recherche du temps perdu* (Paris: Gallimard, 1954); English translation *Remembrance of Things Past* by C. K. Scott Moncrieff and Terence Kilmartin (New York: Vintage, 1982), vol. 3, 838.

24 On "universalizing" and "minoritizing" discourses around same-sex desire, see Eve Kosofsky Sedgwick, *The Epistemology of the Closet* (Berkeley: University of California Press, 1990), 1. Sedgwick notes that a crucial feature of such discourses is the contradiction between "seeing homo/heterosexual definition … as an issue of active importance for a small, distinct, relatively fixed homosexual minority (what I refer to as a minoritizing view), and seeing it on the other hand as an issue of continuing, determinative importance in the lives of people across the spectrum of sexualities (what I refer to as a universalizing view)."

25 Michel Foucault, *The History of Sexuality,* vol. 1, *An Introduction,* translated by Robert Hurley (New York: Vintage, 1980), 43.

26 See Lee Edelman's brilliant essay "Homographesis," chapter 1 of *Homographesis: Essays in Gay Literary and Cultural Theory* (New York and London: Routledge, 1994), 3–23.

27 Proust, *Remembrance of Things Past,* vol. 2, 639–40.

28 Hubert Damisch, *L'origine de la perspective* (Paris: Flammarion, 1987); *The Origin of Perspective,* translated by John Goodman (Cambridge, Mass.: MIT Press, 1995), 444; and *Théorie du nuage: pour une histoire de la peinture* (1972; note 1 for details of publication). See also Ernst van Alphen's discussion of Damisch's writings on perspective, in "Moves of Hubert Damisch," 103–14.

29 Gilles Deleuze, *The Fold: Leibniz and the Baroque,* translated by Tom Conley (Minneapolis: University of Minneapolis Press, 1993), 19; cited by Mieke Bal.

30 See Mieke Bal's book, *Quoting Caravaggio.*

31 Benveniste, *Problems in General Linguistics,* 219.

32 Yve-Alain Bois, *Painting as Model* (Cambridge, Mass. and London: MIT Press, 1993), 47.

33 Hannah Loreck, "Explication," *David Reed* (Cologne: Kölnischer Kunstverein, 1995), 78; cited in Bal (1999, 194).

34 Yve-Alain Bois, "Matisse and 'Arche-drawing,'" in *Painting as Model,* 3–64.

35 Henri Matisse, cit. in Bois, "Matisse and 'Arche-drawing,'" 24.

36 Probably for polemical reasons, Yve-Alain Bois's exceptionally observant essay does not deal with the complications that arise if we consider the relation in Matisse between "surface tension" and the "push-and-pull" effects that result from such factors as scenographic depth, and from "advancing" and "receding" colors. Nevertheless, the essay anticipates a place for such effects in its own analysis: in Matisse, effects of depth, of forms and colors advancing or receding, are maintained in relation to the extreme surface tension of the picture surface as a whole. One should perhaps think of the "surface tension" as elastic, and capable of sustaining movements "into" and "out from" the surface itself.

37 Jacques Lacan, "Le Stade du miroir comme formateur de la fonction du Je," *Revue française de psychanalyse,* no. 4 (October–December 1949), 449–55; "The

Mirror Stage As Formative of the Function of the I," in *Ecrits: A Selection,* translated by Alan Sheridan (New York: Norton, 1977), 1–7. On the textual history of Lacan's paper, see *Ecrits,* xiii.

38 Leon Battista Alberti, *On Painting,* translated by John Spencer (New Haven: Yale University Press, 1977), 64; cit. in Stephen Bann, *The True Vine: On Visual Representation in the Western Tradition* (Cambridge: Cambridge University Press, 1989), 128. Bann's account of the Narcissus story in painting from antiquity to the modern period makes an excellent companion piece to Bal's essay (*The True Vine,* chapters 4 and 5).

39 Both senses—to captivate and to capture—are present in Lacan's word *captation.*

40 Or "mirror-arena": Lacan plays on both meanings of *stade.*

41 "Thus, this *Gestalt* … symbolizes the mental permanence of the *I,* at the same time as it *prefigures its alienating destination*"; "The Mirror Stage," 2 (my emphasis).

42 "The Mirror Stage," 4. "In fact, [the first analysts] were encountering that *existential negativity* whose reality is so vigorously proclaimed by the contemporary philosophy of being and nothingness"; "The Mirror Stage," 6 (my emphasis).

43 Lacan, "Some Reflections on the Ego," *International Journal of Psychoanalysis* 34 (1953), p. 15; cit. in Kaja Silverman, *The Threshold of the Visible World,* 21.

44 "… the *I* is precipitated in primordial form, *before* it is objectified in the dialectic of identification with the other"; "The Mirror Stage," 2 (my emphasis).

45 For discussions of *aliénation* in *"The Mirror Stage,"* see Malcolm Bowie, *Lacan* (Cambridge, Mass.: Harvard University Press, 1991), 24–25; Kaja Silverman, *The Threshold of the Visible World,* 21–22; and Catherine Clément, *The Lives and Legends of Jacques Lacan,* translated by Arthur Goldhammer (New York: Columbia University Press, 1983), 88–89.

46 On the "mimetic desire" that, in his view, both Freud and Lacan repress in their accounts of ego-formation, see Mikkel Borch-Jakobsen, *The Freudian Subject,* translated by Catherine Porter (Stanford: Stanford University Press, 1988), 53–126; and Didier Anzieu, *The Skin Ego,* translated by Chris Turner (New Haven: Yale University Press, 1989).

47 Malcolm Bowie, *Lacan,* 92.

48 Ibid., 93.

dispersing the gaze: focalization[1]

introduction (1997)

THROUGH ONE OF LIFE'S ACCIDENTS, I started out in the literary profession, specifically, as a narratologist, with French as my foreign language and structuralism as my training. Superficially, it may seem today that the kind of structuralist-inspired narratology I practiced so enthusiastically then has gone out of style. We have moved on to other things: feminism, postcolonialism, the study of images. The point of narratology, it seems, is no longer clear. However, the point of narratology, defined as reflecting on the generically specific, narrative determinants of the production of meaning in semiotic interaction, is not to construct a perfectly reliable model to "fit" all texts. Such an aim not only makes unwarranted claims about the generalizability of structure and the relevance of general structures for the meaning and effect of texts; it also presupposes the object of narratology to be "pure" narrative. Instead, narrative must be considered a discursive mode that affects all semiotic objects to varying

degrees. Once the relationship of entailment between narrativity and narrative objects is abandoned, there is no longer any reason to favor narratology as the approach to texts traditionally classified as narrative.

The following is a compilation of fragments taken from several of my earlier writings on narratology that deal specifically with a concept that I have probed, redefined, and used all along: focalization. As will become clear, my fascination with focalization is not only fundamental to my contribution to narratology. It also accounts for the cross-disciplinary move I made in the late eighties from literature to visual art. As I see it, at the heart of focalization, and hence, of both linquistic narrative and visual art, is a hub that shifts and destabilizes the gaze.

narratology for beginners
(1979)

Whenever events are presented, they are presented from within a certain "vision." A point of view is chosen, a certain way of seeing things, a certain angle, whether fictitious events or "real," historical facts are involved. One might try to give an "objective" picture of the facts. But what does this involve? An attempt to present in some new way no more than what is seen or perceived. All comment is shunned and implicit interpretation avoided. Perception, however, is a psychosomatic process, strongly dependent, for example, on the position of the perceiving body in relation to the perceived object. A small child thus sees things totally differently from an adult, if only because of their difference in size. The degree of familiarity with what one sees also influences one's perception. When the inhabitants of Buchi Emecheta's allegorical country Shavi saw white people for the first time, they saw albinos: normal black people with a skin defect. Other factors that affect perception are the way the light falls, the distance between the perceiver and the perceived, and the perceiver's previous knowledge of or psychological attitude toward the object.

Perception, in fact, depends on so many factors that it is pointless to strive for objectivity. All of these factors affect the picture one forms and may pass on to others. In a story, elements of the fabula are presented in a certain way. We are thus confronted with a vision of the fabula. But what is

that vision like and where does it come from? These are the questions I will ask in the following sections. I will use the term "focalization" to refer to the relationship between the elements presented—that which is "seen" or perceived—and the vision through which they are seen or presented. By using this term, I wish to consciously dissociate myself from a number of other terms currently in use in this area. There are several reasons for my wanting to do so.

Narrative theory, as it has been developed during of the course of this century, has produced various labels for the concept of "focalization." The most common one is "point of view" or "narrative perspective," although "narrative situation," "narrative viewpoint," and "narrative manner" have also been used. More or less elaborate typologies of the different narrative "points of view" have been developed. All have proved useful to greater or lesser degrees. They are, however, all unclear on one point. They make no distinction between the vision through which the elements are presented and the identity of the voice that is verbalizing the vision. To put it more simply: they make no distinction between those who see and those who speak. Nevertheless, it is possible, both in fiction and reality, for one person to express the vision of another. In fact, this is a key feature of language. It happens all the time. But when no distinction is made between these two agents in a text in which something is seen and that vision is narrated, it is difficult to adequately describe the technique of the text. The imprecisions of such typologies can thus sometimes lead to absurd and unrefined formulations or classifications. For example, to claim, as has been done, that Strether, in Henry James's *The Ambassadors,* is "telling his own story," whereas in fact the novel is written "in the third person," is as nonsensical as to claim that the sentence:

a Elizabeth saw him lie there, pale and lost in thought.

is narrated, from the comma onwards, by the character Elizabeth; this would imply that it is spoken by her. What this sentence does is present Elizabeth's vision clearly: after all, she does see him lying there.

If we examine the terms currently in use from this point of view, only the term "perspective" seems to offer any clarity. It covers both the physical and psychological points of perception. It does not refer to the agent performing

the action of narration, nor should it do so. Nevertheless, my preference lies with the term "focalization" for two reasons. The first has to do with tradition. Although the word "perspective" reflects precisely what is meant here, in the tradition of narrative theory it has come to indicate both the narrator and the vision. This ambiguity has clouded its specific sense. Moreover, the way it is used in art history differs too much from the way it is used in literature to maintain it in a theory that also has applicability to visual images.

My second objection to this term is a more practical one. No noun can be derived from the word "perspective" that can indicate the subject of the action; nor is the verb "to perspectivize" customary. In a subject-oriented theory such as this one, in order to describe the focalization of a story we must have terms from which both a subject and a verb can be derived. Despite understandable objections to the introduction of unnecessary new terminology, these two concerns seemed to me significant enough to justify my choice of a new term for a not completely new concept.

The term "focalization" also offers a number of extra, minor advantages. It has a technical flavor. With its roots in photography and film, its technical nature is emphasized. Since any "vision" can have a strongly manipulative effect and is, therefore, difficult to extract from the emotions—of the reader as well as of the focalizer and the character—a technical term will help us keep our attention on the technical aspect of such manipulation. Admittedly, "technicality" is just another tool, but it is a strategically useful one.

the focalizer

At Mahabalipuram, in southern India, is what is said to be the largest bas-relief in the world, Arjuna's penance, dating from the seventh century (fig. 1). At the upper left, the wise man, Arjuna, is depicted in a yoga position. At the bottom right stands a cat. Around the cat are a number of mice. The mice are laughing. It is a strange image—unless the spectator interprets the signs. The interpretation runs as follows: Arjuna is in a yoga position and is meditating in the hopes of winning Lord Shiva's favor; the cat, impressed by the beauty of Arjuna's absolute calm, imitates him; now, the mice realize they are safe; they laugh. Without this interpretation, there is no relationship between the parts of the relief. Within this interpretation, the parts form a meaningful narrative.

Figure 1. *Arjuna's Penance*, sketch by Fransje van Zoest, from bas-relief from Mahabalipuram in southern India, seventh century.

The picture is quite amusing and the comical effect is evoked by its narrativity. The spectator sees the relief as a whole. Its contents depict a succession of events through time: first, Arjuna assumes the yoga position; then, the cat imitates him; finally, the mice start laughing. These successive events are logically related in a causal chain. According to every definition I know, this means that this is a fabula.

But there is more. Not only are the events in chronological order and do they have a logical causal relationship. They can only occur because of the semiotic activity of the actors. And the comical effect can only be explained when this particular mediation is analyzed. We laugh because we can identify with the mice. Seeing what they see, we realize as they do that a meditating cat is a contradiction: cats hunt, only wise men meditate. If we follow the chain of events in reverse, we can also deduce the preceding event through

perceptual identification. The cat has brought about the event for which he is responsible because he has seen Arjuna do something. This chain of perceptions also takes place in time. The wise man sees nothing since he is totally absorbed in his meditation; the cat has seen Arjuna and now sees nothing more of this world; the mice see the cat and Arjuna; this is why they know they are safe. Another possible interpretation is that the cat is imitating Arjuna. But this doesn't weaken my explanations. It only adds an element of suspense to the fabula: the mice are laughing because of that very fact, because of finding the imitation a ridiculous undertaking. The spectator sees more: s/he sees the mice, the cat, and the wise man. S/he laughs at the cat, and s/he laughs sympathetically with the mice, whose pleasure is comparable to that felt by a successful scoundrel.

This example clearly illustrates the theory of focalization. It also suggests the relevance of narratological concepts to the analysis of visual narrative without subordinating the image to verbal abstraction. We can view the picture of the relief as a (visual) text. The elements of this text— the standing Arjuna, the standing cat, the laughing mice—have only spatial relationships to one another. The elements of the fabula—Arjuna assumes a yoga position, the cat assumes a yoga position, the mice laugh—do not form a coherent whole as such. The relationship between the text (the relief) and its content (the fabula) can only be established by the mediation of an intermediary layer, the "view" of the events. The cat sees Arjuna, the mice see the cat, the spectator sees the mice who see the cat who has seen Arjuna, and the spectator sees that the mice are right. Every verb of perception (to see) in this report indicates a focalizing activity. Every verb of action indicates an event.

Focalization is the relationship between the "vision," the agent that sees, and that which is seen. This relationship is a component of the story, of the content of the narrative text: A says that B sees what C is doing. Sometimes the difference is nonexistent, for example when the reader is presented with a vision as directly as possible. In this case the different agents coincide, cannot be isolated. This is a form of "stream of consciousness." But the speech act of narrating still differs in kind from the vision, the memories, the sense of perceptions, the thoughts that are being conveyed. Nor can that vision be conflated with the events they focus, orient, or interpret.

Consequently, focalization belongs to the story; it is the layer between the linguistic text and the fabula.

Because focalization refers to a relationship, each pole of that relationship—the subject and the object of the focalization—must be studied both separately and together. The subject of focalization, the focalizer, is the point from which the elements are viewed. That point can lie within a character (i.e., it can be an element of the fabula) or outside it. If the focalizer coincides with a character, that character will have an advantage over the other characters. The reader watches with that character's eyes and will, in principle, be inclined to accept the vision presented by that character. In Harry Mulisch's *Massuro,* we see with the eyes of the character who later also writes an account of the events. The first symptoms of Massuro's strange disease are the phenomena which the other perceives. These phenomena tells us about Massuro's condition; they tell us nothing about the way he feels about it. Such a character-bound focalizer brings with it both bias and limitations.

In Henry James's *What Maisie Knew,* the focalization, whenever it is character-bound, lies almost entirely with Maisie, a little girl who does not understand much about the problematic relationships with which she is surrounded. Consequently, the reader is shown the events through the limited vision of the girl and only gradually does he realize what is actually going on. But the reader is not a little girl. She does more with the information she receives than Maisie does; she interprets it differently. Where Maisie sees only a strange gesture, the reader knows that she is dealing with an erotic one. The difference between the child's vision of the events and the adult reader's interpretation of them determines the novel's special effect. But the narrator is not a child. James was perhaps a most radical experimenter, whose purpose was to demonstrate—to use the terminology of this book—that narrator and focalizer are not to be conflated.

(1997)

A special case of focalization, and perhaps the best justification for the distinction I am making, is "memory." "Memory" is an act of "vision" of the past, but as an act it is situated in the memory's present. It is often a narrative act: loose elements come together and cohere into a story so that they

can be remembered and eventually told. But, as is well known, memories in relation to the fabula are unreliable, and when put into words, are rhetorically overworked so that they can connect to an audience, for example to a therapist. The "story" the person remembers is thus not identical to the one that happened. This discrepancy becomes dramatic and, in the case of trauma, incapacitating. Traumatic events disrupt the capacity to comprehend and experience them at their time of occurrence. As a result, the traumatized person cannot remember them; instead, they recur in bits and pieces, in nightmares, and cannot be "worked through." The incapability that paralyzes the traumatized person can be situated on both the story and textual levels. The events can be so incongruous at the moment of occurrence that no fabula can be "identified" which is "logical" enough to make sense of them. Later, at the time of remembrance, the subject cannot shape a story out of them. The two moments fail to provide a framework for a meaningful act of focalization. On the textual level, even if, thanks to efficacious therapy or other forms of help, memories have been formed, or a story has come to cohere, the subject "lacks words."

Memory also links time and space. This is especially true of stories set in former colonies: the memory of a past in which people were actually displaced from their homes by colonizers can become a past in which they did not yield. Going back to a time when the space was a different kind of place is a way of countering the effects of the colonizing acts of focalization that can be called "mapping." Mastering, looking from above, dividing up and controlling is an approach to space that ignores time as well as the density of space's lived-in quality. In contrast to such ways of seeing space, providing a landscape with a history is a way of spatializing memory that undoes the later killing of the space. In *Texaco*, Chamoiseau's fictional or allegorical recuperation of Martinique, he has his converted urban planner say, when he gives up destroying the city to build the road "Pénétrante Ouest" (!):

> Razing Texaco, as I was asked to do, would amount to amputating the city from one part of its future, and especially from the irreplaceable richness of memory. The Creole city, which has so few monuments, becomes a monument itself by virtue of the care it puts into the sites of its memory. The monument, here as in all of America, does not rise up monumentally: it irradiates. (369)

Marginal as the site is, it must be preserved, the former urban planner con-
cludes, because it is the site of the memory of the slaves' art of survival on
which this space now bases its future. In this passage, "rising up monu-
mentally," as much as the allegorically named road "Pénétrante Ouest,"
embodies the result of a focalization that destroys the past, and hence, the
future. "Irradiation" is the alternative way of belonging to the space which is
focalized from within. As Edouard Glissant, a theorist who influenced
Chamoiseau's writing, argued: "[the] landscape in the work ceases to be merely
a décor or a confidant in order to inscribe itself as constitutive of being" (199).
This idea of a historically meaningful, heavily political investment of space
can help in the interpretation of stories in which a narratological analysis
reveals the intricate relationship between characters, time, and space.[2]

(1979)

Character-bound focalization can vary, shift from one character to another
even if the narrator remains constant. In such cases, we may be given a clear
picture of the origins of a conflict. We are shown how differently the various
characters view the same facts. This technique can result in neutrality toward
all characters. Nevertheless, there is usually no doubt in our minds which
character should be given the most attention and sympathy. Depending on
the distribution, for example, the fact that a character focalizes the first
and/or the last chapter, we label him or her the hero(ine) of the book.

When focalization lies with one character who participates in the fabula
as an actor, we can refer to "internal focalization." By means of the term
"external focalization," we can also indicate when an anonymous agent,
situated outside the fabula, functions as focalizer. This, then, is an external,
non-character-bound focalizer. In the following fragment from the opening
of Doris Lessing's *The Summer Before the Dark,* we see the focalization move
from the external narrator to a character.

> b A woman stood on her back step, arms folded, waiting.
> Thinking? She would not have said so. She was trying to catch hold of
> something, or to lay it bare so that she could look and define; for some time
> now she had been "trying on" ideas like so many dresses off a rack. She was
> letting words and phrases as worn as nursery rhymes slide around her tongue:

for towards the crucial experiences custom allots certain attitudes, and they are pretty stereotyped. A yes, first love! … Growing up is bound to be painful! … My first child, you know… . But I was in love! … Marriage is a compromise… I am not as young as I once was.

From sentence two onwards, what the character experiences is described. A switch thus occurs from an external focalizer, residing with the narrator, to an internal one, residing with the character. This alternation between external and internal focalizers can be found in many stories. A number of characters can also alternate as character-bound focalizers. It is also possible for the entire story to be focalized by an external focalizer. The narrative can then appear objective, because the events are not presented from the point of view of the characters. In these cases the focalizer's bias is not absent, since there is no such thing as "objectivity," but rather remains implicit.

the focalized object

It is often wise to ascertain which character focalizes which object. The combination of a focalizer and a focalized object can to a large degree be constant or it can vary greatly. It is important to analyze such fixed or loose combinations because the image we receive of the object is determined by the focalizer. Conversely, the image a focalizer presents of an object also says something about the focalizer. Where focalization is concerned, the following questions are relevant:

1. What does the character focalize: what is the object of its attention?
2. How does the character do this: with what attitude does it view things?
3. Who focalizes the character: whose focalized object is it?

The degree to which a presentation includes an opinion can, of course, vary; the degree to which the focalizer points out its interpretative activities and makes them explicit can also vary. Compare, for instance, the following description of place:

c Behind the round and spiny forms around us in the depth endless coconut plantations stretch far into the hazy blue distance where mountain ranges ascended ghostlike. Closer, at my side, a ridged and ribbed violet grey mountainside stretches upward with a sawtooth silhouette combing the white

cloudy sky. Dark shadows of the clouds lie at random on the slopes as if capricious dark-grey pieces of cloth have been dropped on them. Close by, in a temple niche, Buddha sits meditating in an arched window of shadow. A dressing-jacket of white exudation of bird-droppings on his shoulders. Sunshine on his hands which lie together perfectly at rest. (Jan Wolkers, *The Kiss*)

d Then we must first describe heaven, of course. Then the hundreds of rows of angels are clad in glorious shiny white garments. Every one of them has long, slightly curly fair hair and blue eyes. There are no men here. "How strange that all angels should be women." There are no dirty angels with seductive panties, garterbelts and stockings, not to mention bras. I always pictured an angel as a woman who presents her breasts as if on saucers, with heavily made-up eyes, and a bright red mouth, full of desire, eager to please, in short, everything a woman should be. (Formerly, when I was still a student, I wanted to transform Eve into a real whore. I bought her everything necessary, but she did not want to wear the stuff.) (J. M. A. Biesheuvel, *The Way to the Light*, "Faust")

In both cases, a focalizing character is clearly involved; both focalizers may be localized in the character "I." In c, the spatial position of the focalizing character ("I") is especially striking. It is obviously situated on a high elevation, given its panoramic view of the surroundings. The words "around us," combined with "in the depths," stress that high position. The proximity of the niche with the Buddha status makes clear that the focalizing character ("I") is situated in an Eastern temple (the Borobudur, in fact), so that "the round and spiny form" (must) refer to the temple roof. The presentation of the whole, the temple roof and the landscape, seems fairly impersonal. If the focalizer ("I") had not been identified by the use of the first-person personal pronoun in "at my side" and "around us," this would have seemed, on the face of it, an "objective" description, perhaps taken from a pamphlet or a geography book.

On closer analysis, though, this reading turns out to be deceptive. Whether the focalizer ("I") is explicitly named or not, the "internal" position of the focalizer is, in fact, already established through expressions such as "close by," "closer," and "at my side," which underline the perceiver's proximity to the place. "Behind" and "far into" indicate a specification of the spatial perspective (in the pictorial sense). But there is more happening here.

Without appearing to do so, the presentation interprets. This is clear from the use of metaphors. Their use points to the fact that the focalizing character ("I") attempts to reduce the objects it sees, which impress it greatly, to human, everyday proportions. In this way, the "I" is undoubtedly trying to fit the object into its own realm of experience. Images such as "sawtooth," "combing," "capricious dark-grey pieces of cloth," and clichés like "mountain ranges" bear this out. The "dressing-jacket of white exudation of bird-droppings" is perhaps the clearest example of this. Actually, the image is also interesting because of the association mechanism it exhibits. With the word "dressing-jacket," the Buddha's statue becomes human, and as soon as it becomes human, the white layer on its head could easily become dandruff, a possibility suggested by the word "exudation." The realistic nature of the presentation—the "I" "really" does see the landscape—is restored immediately afterwards by the information about the real nature of the white layer: bird-droppings. Thus, what we see here is the presentation of a landscape that is realistic, reflecting what is actually perceived, and, at the same time, interpreting the view in a specific way, so that it can be assimilated by the character. To a certain extent example d exhibits the same characteristics. Here, too, an impressive space is humanized. However, the focalizing character ("I") observes the object less and interprets it more. It is a fantasy object with which the "I" is sketchily familiar from religious literature and painting, but which it can adapt as much as it wishes to its own taste. This is what it does, and its taste is both clear and specific, i.e. gender-bound. Here, too, an association mechanism can be observed. From the traditional image of angels implied in the second or third sentence, the "I" moves to the assumption that angels are women. In this, the vision already deviates from the traditional vision in which angels are either asexual or male. In contrast to the image thus created of asexual male angels, the "I" creates its own female image.

Even before the reader realizes that through this change a link has been made with another tradition, that of the angel-whore opposition in which "angel" is used in a figurative sense, the word "whore" itself appears in the text. In this, the interpretive mode of the description clearly manifests itself. The solemn "we" used early in the text contrasts sharply with the personal turn the description later takes. The humor here is based on the

contrast between the solemn/impersonal and the personal/everyday. (Humor may make one feel uncomfortable if one is not happy with what is being laughed at, but it is still humor.) The interpretive focalization is emphasized in several ways. The sentence in quotation marks is presented as a reaction to the sentence preceding it. Here, the interpreting focalizer makes an explicit entrance. Later, this is stressed again: "not to mention" is a colloquial expression that points to a personal subject expressing an opinion. "I always pictured an angel as …" accentuates this even more strongly.

The way in which an object is presented gives information about the object itself and about the focalizer. These two descriptions give more information about the focalizers ("I") than about the object, more information about the way they experience nature (c) or women (d), respectively, than about the Borobudur temple and heaven. In this respect, it doesn't matter whether the object "really exists" or is part of a fictitious fabula, or whether it is a fantasy created by the character and thus a doubly fictitious object. In the above analysis, the comparison with the object referred to served only to motivate the interpretation by the "I" in both fragments. The internal structure of the descriptions provides in itself sufficient clues about the degree to which the one "I" is similar to and differs from the other.

the point of visual narratology (1997)

I would like to introduce the idea of visual stories by citing, not the innumerable readings of classical paintings as "word-for-word" translations of well-known biblical and historical narratives (roughly, the tradition known as iconography), but a case of the reverse relationship. In a wonderful book of short stories called *Silent Please!,* eleven authors have published widely divergent narratives. The only thing their texts have in common is the inspiration they took from the visual work of the contemporary Spanish artist Juan Muñoz. The collection is all the more significant as Muñoz's work is known as antinarrative. His installations of architectural structures within which sculpted figures are grouped in such a way as to not communicate with one another invariably entices critics to call his work "silent." The

stories in the volume do not describe his work, are not verbal "illustrations" of a visual text. Nor do they talk about it, or adopt its themes. Instead, they create stories that somehow emanate the same visual qualities as Muñoz's work: isolation, finesse, what the editors called "staged contingencies," episodes in which "the sculpture is implicated."

As well as being relevant to film narratology, I see three other areas in which visual narratology can be usefully embraced. First, the analysis of visual images as narratives in and of themselves can do justice to an aspect of images and their effect that neither iconography nor other art historical practices can quite articulate. Second, the comparison of narratives and films based on them can be developed as a form of cultural criticism that does not give precedence to the literary "source." Third, and perhaps most unexpectedly, attention to visuality is tremendously enriching for the analysis of literary narrative.

visual narratology in a nutshell
(1989)

Briefly, in order to make the concept of focalization operational for visual art, it is best to provisionally forget the mythical or historical fabula and start instead with the work itself. The following must be kept in mind:

1. In narrative discourse, focalization is the direct content of the linguistic signifiers. In visual art, it would thus be the direct content of visual signifiers, such as lines, dots, light and dark, and composition. In both cases, focalization is already an interpretation, or subjectivized content. What we see is in our mind's eye; it has already been interpreted. In *I'm Six Years Old and I'm Hiding Behind My Hands* (fig. 2), Ken Aptekar's narrator foregrounds this subjectivitiy by subtly distorting the "faithful" copy of Boucher's *Allegory of Painting*. This allows for a reading of the complex structure of focalization, whose most conspicuous feature is the perspectival slant of the copied painting's frame.

2. In linguistic narrative, there is an external focalizer who is distinct in function but not identity from the narrator. Embedded in the external focalizer can be an internal, diegetic narrator. For the analysis of narrative, this relationship of embedding is crucial. In visual art, the same distinc-

Figure 2. *I'm Six Years Old and I'm Hiding Behind My Hands*, Ken Aptekar, 1996.
Courtesy of Jack Shainman Gallery.

tion between external and internal focalizer can be made, but it is not
always easy. For example, the pointing that goes on in Aptekar's *I'm Six
Years Old* can be considered the focalizing activity of an external focal-
izer. But the pointing of the hand of the female figure in the copied
Boucher painting is definitely that act of a character-bound, internal
focalizer. The reverse ordering in the copied Boucher—with the allegor-
ical woman turning her back to the text but also being situated closest to
it—is an act of the external focalizer. The various gazes of the four
depicted figures foreground the internal focalization that helps establish
the fabula. Two of the three putti exchange looks with the Allegory of Art
herself, thus mirroring, within the embedded story, the confrontation
between the son and the mother in the linguistic text: "My mother seems

worried. I see it in her eyes." The third putto does not look at the viewer, as might be expected, but into the distance, outside the frame, as if to predict the future of the six-year-old. Interestingly, this look can be construed as a double focalization, hinging between internal and external and thus connecting the two worlds that the work brings together.

3. In narrative, the fabula is mediated, or even produced, by the focalizers. Applying the same concept to visual art implies that the event represented has the status of the focalized object that is produced by the focalizer. In the case of the internal focalizer, the "reality"-status of the different objects represented is variable and contingent upon their relationship to the focalizer. This aspect, too, is forcefully enhanced in Aptekar's work, which is strongly self-reflexive or meta-narrative in this sense. The six-year-old boy of the autobiographical story could be worried about his "irreality" if he were to see the doubly fictionalized child on the allegorical figures' drawing. For the embedded Art Teacher draws the attention of the "real" children, the putti, to that sketch. With every act of pointing, the child becomes less "real," more fictional, but also, happily, more "artistic."

4. Thus, the same object or event can be interpreted differently by different focalizers. The way in which these different interpretations are suggested to the reader is medium-bound, but the principle of meaning production is the same for both verbal and visual art. In *Madame Bovary,* the heroine's eyes are variably dark, black, blue, and gray, according to the internal focalizer through whose eyes we see her. The words conveying these incompatible descriptions do not themselves betray differences between the focalizers. Flaubert could simple have been indifferent or careless. But in order to make sense of the work as it is, only the hypothesis of different focalizers, which can be substantiated through textual analysis, can account for these differences.

5. As we have seen in narrative discourse, the identification of the external focalizer with an internal one can produce a discursive conflation called Free Indirect Discourse. This conflation can also occur at the level of focalization, and could be called something like Free Indirect Thought or Perception. The identification of an external focalizer in a visual image

with an internal focalizer represented in the image can also give rise to such a conflation, and would strengthen the appeal being made for identification. This seems to me to be the function of the gaze of the putto who is holding the crown in Aptekar's copy of Boucher's work.

novels and films

The relationship between a truly visual story and what art historians call "iconography" is clearly relevant for the comparative analysis of novels and films based on them. Again, this is not a matter of "illustration" or "faithfulness." The "translation" of a novel into a film is not a one-by-one transposition of a story element into an image, but a visual working-through of the novel's most important aspects and their meanings. For instance, if a novel addresses political issues in a specifically powerful way, the film, through totally different means, and without necessarily following the visual indications offered in the novel, may address the same issues with comparable power. The examination of whether this has been done successfully or not requires a narratological analysis on the part of the critic as well as an affinity with film as a visual medium. The following example offers a reflection on the relationship between narratology and iconography. Through it I hope to suggest some ways of articulating criticism in this domain, without endorsing the hierarchical subordination of visuality to language which has so long plagued the study of art.

Why did I, and so many other critics, consider Steven Spielberg's film *The Color Purple* an ideological and artistic failure, despite its obvious appeal to the general public? I believe this was because the movie failed to represent the iconographic basis of the combative ideological position proposed by Walker's novel and its narrative sources. By ignoring iconography, it ignored the novel's embeddedness in, and response to, a deeply narrative cultural tradition.

Alice Walker's best-selling novel *The Color Purple* refers directly to the double tradition of abolitionist and self-assertive literature, to Harriet Beecher Stowe's *Uncle Tom's Cabin,* and to the tradition of slave narratives.

For example, when *The Color Purple* addresses the problem of education it evokes both slave narratives and *Uncle Tom's Cabin:*

> "Why can't Tashi come to school?" she asked me. When I told her the Olinka don't believe in educating girls she said, quick as a flash: "They're like white people at home who don't want colored people to learn". (1962)

The theme of learning is represented in *Uncle Tom's Cabin* in the same way as it is in slave narratives. This is astutely discussed by Frederick Douglass in his autobiography, who shows that the very existence of slave narrative as the exemplary genre of persuasive texts points to the function of writing and reading for emancipation.

But while *The Color Purple* refers directly to *Uncle Tom's Cabin* and indirectly to slave narratives, it does not merely "repeat": it puts the religiosity of *Uncle Tom's Cabin* in its place by juxtaposing it to elements of black religious culture. And, insofar as the characters in *The Color Purple* are imitations of those in *Uncle Tom's Cabin,* they are critically feminist rewritings of them. Celie is a female Tom ("I ain't never struck a living thing"). Her attempt to spare her little sister Nettie, from rape by their father by offering herself to him, is her version of Tom's Christlike self-sacrifice. Nettie is the female George, who rises above humiliation, and, like him, travels to Africa. The almost lifelong separation of Celie from Nettie, and of Celie from her children, is a repetition of the plot around George and Eliza, and Eliza's mother and sister, who are reunited as in the comedy-based romance. And Celie's husband has much of Legree, Tom's cruel master, including the flicker of hope for conversion toward the end. Sophia, with her strength and sense of humor as weapons, incarnates Cassie, the proud slave who manages to save herself with Tom's help. All this is not a matter of visuality but of intertextuality.

But the allusions to *Uncle Tom's Cabin* and to all it stood for are more subtle and complex than just the cast of characters indicates. The language, events, and conversations all respond to the choices made by Stowe and reveal both the limits and the radical potential of Stowe's choices. The novel is effective because it balances and critically intertwines the discourse of modern popular culture, the context of the double oppression of black women, with the antecedent of the particularly effective "sentimental" social

novel. How to visualize that critical engagement in a film: that was Spielberg's challenge.

We can now see that Spielberg's film simplifies and alters all these connections. Because of this, as a visual representation of Walker's novel, it is arguably both racist and sexist, as the representation of the character of Sophia alone demonstrates. The film provides visual instances of those generic conventions of the social novel that link the genre to sentimentality. Thus, on the level of external focalization, it visualizes "sentimentality" in bright colors, counter-light, soft focus, and picturesque settings. Those characteristics of the social novel which Walker uses polemically to critically portray the relationship between sexism and slavery are stripped of their critical content, and merely repeated, endorsed, without any subtlety, sense of humor, or critical perspective. Most importantly, they are repeated without resonance of the other texts.

Having rejected the idea of a visual narratology, one could be led to argue that the visual medium of film—and the popular nature of Spielberg's film—make it impossible to work with reference to Walker's critical allusions. I don't believe this. It is by ignoring what made the novel critical that the film became uncritical. It now supports negative ideological positions. Two examples will illustrate how Walker's attempts to connect racism and sexism have been turned, in the film's visualization, into the very racism and sexism her novel critiqued through focalization.

Seen as a twentieth-century documentary view, Walker's representation of Africa is rather naïve. What made it effective was not its realistic adequacy but its relationship with the combative pre-text. Stripped of this relationship, it is open to imperialist recuperation: with Spielberg, Africa comes to lie under a enormous orange sun; visually represented in this way it is consistently focalized as unreal. Reduced to a postcard, Africa cannot fulfill the function of the object of melancholic longing and of utopian desire that it fulfills in Walker's novel through its intricate relationship with *Uncle Tom's Cabin*. The slave narratives and the critical response to contemporary taste that replaced realism in Walker's novel disappear. We are left with kitsch, which, under Spielberg's direction, easily picks up a connotation of black folklore as seen through white prejudice.

The representation of black sexism without reference to slavery allows for disidentification, which results in the all too eagerly adopted view that blacks are more sexist than whites. The father-daughter rape that informed the novel from the start is hardly present in the film, nor is the alternative that the novel proposed—the erotic friendship between Celie and Sug, the wife and the mistress. That these themes have been sacrificed for the sake of reaching a wider audience may be justifiable. But these gender relations form the background for other elements that are then over-emphasized in the film. Thus the figure of Sophia, who recalls the insubordinate Cassie, Tom's more combative and female alter ego, has changed dramatically in the film compared to what it was in the novel. Without the intertextual relationship to Tom on the one hand, and the contemporary context of the questioning of gender relations on the other, Sophia's insubordination is an easy target for cheap and sexist comic visual effects. Spielberg introduces her as a gigantic woman, an overwhelming mother figure who is dragging her husband-to-be like a child through the fields as they are on the way to introduce her to his father. The scene is focalized from afar and from above and accelerated for comic effect. In this way the allusion to Charlie Chaplin and the silent comedy supersedes the allusion to Cassie and thus to *Uncle Tom's Cabin* as a whole. From the start, Spielberg's Sophia is hopelessly ridiculous, and so too, then, are her insubordination, her husband, and her revolt. Visual effect is used to neutralize the critical potential of the novel. Seen in this way, the film can be criticized in its own right as visual artifact, while its flaws can be illuminated through comparison with its narrative pre-text. Yet, such a comparison respects the specificity of each medium.

Thus, the point of comparing novels and their filmed versions, or, more generally, linguistic and visual texts, is not to make aesthetic assessments about "faithfulness" to the source. Rather, if they are seen as being equally embedded in the culture in which they function, a comparison of them can help to articulate what each, through their own narratological makeup, have to say to their audiences. Their relationship is an intertextual as well as an interdiscursive one.

vision in language

Finally, let me briefly point to the importance of visuality as a motor of narrative, especially in focalization. Whereas the nineteenth-century novel can be

characterized by an increasingly elaborate appeal to visual display—Flaubert and Zola are striking examples—modernist literature is particularly visual. As I have suggested, modernism's interest in questions of knowledgeability or epistemology lends itself to an exploration of vision. The following passage from Proust's *Remembrance* blends this concern with vision, with a fore-grounding of focalization, as a subjectivizing technique. It therefore seems appropriate to end this chapter with this example. The passage demonstrates that the question of "Who sees" is made dramatically meaningful by the com-plementary questions of "Whom is being seen?", "Who is not seeing?", and "What kind of act of seeing is at stake?". It is also a good case for the way narratological analysis can make periodization much more meaningful.

Entering the room without announcing his presence, the narrator tells us "I was there, or rather I was not yet there since she was not aware of my presence, and ... she was absorbed in thoughts which she never allowed to be seen by me" (2:141). The protagonist-narrator is paying an unexpected visit to his grandmother who, unbeknown to him, is near death. This is a critical examination of visual focalization. It is also a good example of what Kaja Silverman calls "heteropathic identification," identification based on going outside the self, as opposed to idiopathic or "cannibalistic" identification, which absorbs and "naturalizes" the other. Heteropathic identification is associated with the risk of alienation but enables the subject to identify beyond the normative models prescribed by the cultural screen, and is thereby socially productive. This identification never stops appealing to the narrator-protagonist, even though it exposes him to obvious risks.

The narrator-protagonist is examining his own status as a witness, his own specific kind of focalization:

> Of myself—thanks to that privilege which does not last but which gives one, during the brief moment of return, the faculty of being suddenly the spectator of one's own absence—there was present only the witness, the observer, in travelling coat and hat, the stranger who does not belong to the house, the photographer who has called to take a photograph of places which one will never see again. The process that automatically occurred in my eyes when I caught sight of my grandmother was indeed a photograph. (2:141)

Proust's use of photography to articulate this theory of vision makes this passage an appropriate allegory for the relationship between modernism,

vision, and narrative focalization. The contemplation of the spectacle afforded by the other is a photographic act. For a brief instant, the looking I/eye wavers between the disembodied retinal gaze of linear perspective and the colonizing mastery it affords, and the heteropathic identification that takes him out of himself, body and soul, to "become" other. The *specter*—both spectacle and phantom refer to "lost time"—this is exactly what the subject inevitably is himself.

The voyeur is constantly in danger, since alienation robs him of his "self." The passage gradually develops a more hostile, if not violent, language, leading at the end to the description of the mental photograph that will always be with the narrator:

> I saw, sitting on the sofa, beneath the lamp, red-faced, heavy and vulgar, sick, vacant, letting her slightly crazed eyes wander over a book, a dejected old woman whom I did not know. (2:143)

The "truth" of photography is this stranger, this unknowable person, cut off by photography from the familial, affective gaze. Thus, Proust's story is a sharp analysis of the very focalization it deploys. But, the theory of this itself takes a visual, photographic form. In the very middle of the passage on the mental photograph of the grandmother we find this strange comparison, which both explains the photographic effect and embodies it:

> But if, instead of our eyes, it should happen to be a purely physical object, a photographic plate, that has watched the action, then what we see, in the courtyard of the Institute, for example instead of the dignified emergence of an Academician who is trying to hail a cab, will be his tottering steps, his precautions to avoid falling on his back, the parabola of his fall, as though he were drunk or the ground covered in ice. (2:142)

The comparison mercilessly dramatizes what remains of the puppet that is the other, divested of the protection of perceptual and affective routine. The wonder at the photographic look also historicizes this particular act of focalization. What better cautionary word could we hope to find in this, one of literature's richest and most visual narratives, than the passage at the end of this chapter that underscores the relevance of a disabused, politically alert analysis of focalization.

The dynamics of focalization are at work in every visual work that contains traces of the representational work as seen and interpreted by the viewer, since it is precisely in those traces that the work becomes narrativized. In principle, all works contain such traces, but some display them more openly than others. Focalization helps to disperse the encompassing gaze of the viewer/reader, who, "distracted" by what happens, vision-wise, within the story, can no longer pretend to take it in, as in one *Augenblick*.

notes

1 This chapter is a compilation of fragments from the revised 1997 edition of my old textbook *Narratology,* chapters 4 and 5 of *Reading "Rembrandt,"* and *The Mottled Screen.*
2 This example was suggested to me by Nathalie Melas.

dispersing the image: vermeer story

2

Conservatism, in the sense of a dread of consequences, is altogether out of place in science, which has, on the contrary, always been forwarded by radicals and radicalism, in the sense of the eagerness to carry consequences to their extreme.

—Charles Sanders Peirce[1]

light

LIGHT IS A TYPICAL PARERGON.[2] BOTH outside, in illuminating the object represented, and inside, constituting the very visibility of that object; it is marginal and yet centrally important; the final touch that makes the painting glow and the indispensable beginning; both necessary and irrelevant. "To see the light" is a strange expression: one does not see the light, but the light makes one see. Let me see.

Vermeer's *Woman Holding a Balance* (National Gallery of Art, Washington, D.C.) depicts a woman in a blue dress holding a balance above a table. On the wall in the background is a painting of the Last Judgment. Light streams in through a stained glass window at the upper left. It is a strikingly still painting. It avoids narrative, both anecdotal and dynamic. Instead, it presents an image in terms of visual rhythm, equilibrium, balanced contrasts, and subtle lighting (fig. 1). As Arthur Wheelock Jr. remarks, the painting stands in marked contrast to other works from the period on

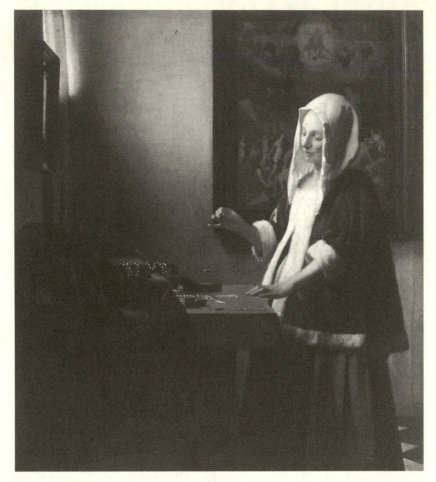

Figure 1. *Women Holding a Balance*, Vermeer, ca. 1664. Courtesy of the National Gallery of Art, Washington, D.C.

related themes.[3] In these works the woman tends, for example, to look greedily at the precious objects on the table, whereas here she is self-absorbed, or the pans of the balance, here empty, tend to be heaped with gold or pearls so that action is implied.[4] These other works are more narrative, have more movement. Here, the parallel between *The Last Judgment* hanging on the wall behind the woman and the woman's act of weighing/judging is elaborated on the basis of similarity, not on the basis of a narrativized contrast between density and agency or between spiritual and material values.

Light here is fluid, dense (to use Goodman's terms), soft.[5] It also points, marks, indicates; like an arrow, a Peircean index, it directs our gaze. How can this light illuminate the major issues of art history, the discipline of the humanities which, according to some, is in crisis, and, according to others, is a master discipline?[6] I will argue that light does exactly this, but that the illumination does not lead to insight, neatness, and clarity. Rather, it makes art history messy, which is all for the better. I will argue this by "disseminating" this painting, or, if you wish, by letting the light disseminate the painting. But it is agency that is the key question here, thus undermining art history's search for origins—for original meanings, original audiences, original intentions. Derrida's concept of dissemination is a powerful tool for breaking open the monolithic discourse of origins that appears to be the stronghold of the discipline, whether in iconography (origin of motifs), connoisseurship (origin of the work as art), or patronage studies (origin of the conception of the work).

Who does what in this painting? Light takes over: it determines and disperses meaning. But it can only do so through the language of philosophy, in this case through the Derridean concept, which I have used to make the light "work." Yet the notion of "using" a concept to "apply" to visual art partakes of the very logocentrism Derrida set out to critique; it is another form of disciplinary neatness that inevitably subordinates visual experience to verbal abstraction. Why should the visual field obey rules imposed by language? I would at least like to give Vermeer's light a chance to talk back and to challenge, in its own right, the concept just proposed in order to establish the importance of light itself. The concept of dissemination implies just such a challenge to itself by virtue of its supplement—its addition and stand-in— the hymen.

In this essay, rather than commenting on Derrida's own work on visual art, as others have done, I would like to "do" Derrida: to work with the concept that I consider central to his critical practice and theory, and to examine it for its radical implications. Dissemination is based on three tenets related to the interplay of contemporary semiotics and deconstruction that challenge art history's pursuit of origins: intertextuality, entailing the dispersal of origins; polysemy, entailing the undecidability of meaning; and the shifting location of meaning, entailing the dispersal of agency. Although

commonplace in literary criticism, these tenets each have a slightly different status in the practice of art history.

intertextuality

Intertextuality refers to the readymade quality of signs, that quality that the maker of images finds in earlier images and texts produced by a culture. The concept may seem close to that of iconographic precedent. Iconography seems to be nothing other than the examination of the reuse of earlier forms, patterns, figures. As it happens, though, light is not of much use to iconography, which is more interested in shapes and things, motifs and divisions. This resistance to light in favor of distinct elements implies a resistance to dispersal as the production of meaning.

In fact, three features distinguish intertextuality from iconographic precedent. In the first place, iconographic analysis sees the historical precedent as a source that virtually dictates to the later artist what forms can be used. By adopting forms from the work of a predecessor or from tradition, the later artist declares his allegiance and debt to, and eventually competition with, a prestigious predecessor, whose trace is inscribed in the later work. This is how H. Perry Chapman explains Rembrandt's use of forms in his self-portraits of the middle period: they are taken from Raphael and Titian.[7]

Michael Baxandall has already pointed out that the passivity-activity relationship implied in this perspective should be reversed. The work of the later artist should be seen as an active intervention in the inherited material. This reversal, which amounts to a variant of the well-known deconstruction of the relationship between cause and effect, already challenges the idea of precedent as origin, and thereby makes the claim of historical reconstruction problematic.[8] This line of argument effects the discipline of art history more profoundly than is generally acknowledged.

A second difficulty in the juxtaposition of intertextuality and iconography is the status of meaning. Iconographic analysis generally avoids making statements about the meaning of borrowed motifs, since visual artists may borrow motifs without borrowing meaning. "Meaning" is implicitly supposed to be language-bound while "pure visuality" is supposed to resist meaning.[9] By contrast, the concept of intertextuality, indifferent as it is to

authorial intention, implies that the adopted sign necessarily comes imbued with meaning. This meaning may have been changed, but the new meaning that replaces it will carry the trace of its predecessor. The later artist may reject or reverse, ironize or deconstruct, pluralize or marginalize the meaning of the borrowed motif, but that meaning cannot be undone, ignored, or canceled out. In her iconographic study of Artemesia Gentileschi's *Susanna* for example, Mary D. Garrard sees precedents as signs whose meanings have been displaced to such a different context that their previous meaning is not canceled but rather renewed and emphasized.[10] Thus, in the pose of the aggressive elder in Rembrandt's *Susanna* (Gemäldegalerie, Berlin), which refers to Dürer's *Melancholia I,* the artist cannot help bringing in the *possibility* of the quite unsettling meaning of that precedent—say, that melancholy is paralyzing—suggesting that illegitimate and abusive looking paralyzes the transgressor himself.[11]

A third difference resides in the *textual* character of intertextual allusion. By reusing forms taken from earlier works, an artist both carries with him the text from which the borrowed element has broken away and constructs a new text with the debris. Reusing a pose found in an earlier self-portrait, Rembrandt inserts the discourse of self-portraiture into his *Bellona* of 1633 (Metropolitan Museum of Art, New York).[12] Thus, the image of a female figure that another iconographic tradition has signified as formidable is traversed by an identificatory meaning that disrupts the monolithic tradition of misogyny. The new text—call it a mythography—is contaminated by the discourse of its predecessor, and thereby fractured, ready to fall apart at any time. The fragility of the objectifying, distancing device of mythography in which Bellona is the woman/other is challenged by this taint in the discourse of "first-person" subjectivity. To use Benveniste's terms, the historical narrative is inflected by subjective discourse.[13] Such a view has obvious consequences for any interpretation of this painting in terms of gender.

Vermeer's *Woman* is part of a dense network of interconnected discursive practices. It is articulated by the parergonic light. The presence in it of the painting *The Last Judgment*—itself borrowed from a representational paradigm which differs from the embedding painting—which from the start complicates the *Woman*'s generic position as a household interior with an allegiance to realism, can be seen as a guiding principle suggesting inter-

textual relations.[14] Svetlana Alpers (1983), I assume, would call Vermeer's *Woman* a descriptive painting. It is a painting that emphatically appeals to primary visuality. It stands within the discursive clashes between seventeenth-century epistemologies and seems to side with the descriptive positivists. Hence, it already makes an interdiscursive claim to a certain concept of realism. But, by the same token, no concept stands alone. Siding with the descriptivists also implies making a case for Alper's opposition to the Italian infatuation with narrativity: claiming descriptive status is disclaiming narrative status. Any attempt to read the paining as a narrative can only lead to misreading it. This bringing together of realism and description—the light barely skims the painted surface, inscribing details and darkness into the image—articulates a proposition about the bond between these two modes of representation. The bond is, of course, by no means inherent, only semiotically signified, repeated, and, in the end, naturalized. It is a surface carefully balanced for visual experience, where the appeal to visuality is worked out in the tiniest details, thus indicating an allegiance to realism.

The light serves to mark the syntax of this complex proposition about visuality as bound up with realism, thus inscribing the materiality of the work through an "excess of syntax over semantics."[15] On the white wall in the upper left corner of the painting, near *The Last Judgment*, is a nail, and near that nail is a hole in the wall. The minutely detailed work that painting entails is so highly emphasized in these tiny details that we can see a shadow both inside the hole and next to the nail. The soft, warm light streaming in through the window on the upper left lightly touches these two irregularities in the wall, as if to demonstrate that a realistic description of the visible world knows no limits. Intertextually, the light fixed at this "point de capiton," calls to mind other cases of extreme realism, varying from the anecdote about Zeuxis's competition to the two-sided lemon peel in Dutch still-life paintings.[16]

But here we lose our grasp. Intertextuality can no longer be traced because it is so overwhelming, and dissemination begins. The light, which I hold responsible for allowing me to see the hole and the nail, also generates other details in the overall darkness of the painting. To begin with, it makes the darkness itself visible. And what is not dark becomes "enlightening." Most obviously, light foregrounds the woman's dress underneath her mantle.

Between the two fur rims a slice of orange tissue protrudes, revealing the color of the dress which is otherwise in shadow.[17] While the dress may be in keeping with the fashion of the day, as Salomon affirms, "the woman's pregnancy is an undeniable fact of the painting and one which cannot be dismissed as a misunderstanding of costume or fashion" (217). Hence, for some viewers today, several questions persist: why this soft light, why the striking color and shape, and why the light falling where it does?

polysemy

This leads to the second tenet on which dissemination is based, that of polysemy. It has been convincingly argued that since viewers bring their own cultural baggage to images, there can be no such thing as a fixed, predetermined, or unified meaning. In fact, the very attempts to fix meaning furnish, among other things, the most convincing evidence for this view. The most characteristic attempts are those that take an obvious meaning that is unpleasant and firmly insert into it notions like irony or contrast. In this painting, for example, the obvious similarity between the poses of the woman and the divine judge, who almost form a continuum, is frequently seen as a contrast in which the woman, who is frivolously weighing pearls, is condemned in contrast to God, who weighs souls. Or, in an even more convoluted argument, the woman's position in relation to God is similar to Saint Michael's, and thus the latter's role as a weigher of souls is replaced by her own less lofty weighing.[18] In such cases, the denial of polysemy goes together with the very practice of it.

Struggles over meaning are fought in a social arena in which power structures are in place. A good example of this mechanism to enlist rhetoric to eliminate disturbing meanings is allegory, the interpretation of, say, a mythical story and its representation so that it refers to something other than itself.[19] On the one hand, allegory demonstrates the fundamentally polysemous nature of signs. If images and stories can mean something entirely outside of themselves, then, one would think, there are no limits, no constraints. This freedom is viewed positively by Paul de Man, for example.

I wish to call for some caution, though. Over and over again the same stories and myths tend to be seen as "allegorical": stories of rape, for

example, are more often than not alleged to "really" be about tyranny and the establishment of democracy. Intertextual analysis would bluntly refuse such a denial of meaning imported from the borrowed sign: if rape means political tyranny, then the bodily, subjective experience of the raped woman cannot be divorced from the politics at stake. The myth of Lucretia, for example, is allegorical, with a vengeance. De Man develops his argument around the root *allos*, other, and thus allegory itself becomes an allegory for the acceptance of otherness within. This also holds true in the case of Lucretia: the *allos* of allegory is, after all, not only "other" but also "within." In this Vermeer painting and/or its reception, the allegorical reference to *vanitas* represents a denial of the woman's central place in the picture, and of her possibly positive role, not as the opposite of the divine Judge but as his stand-in. The basis of such interpretations, the act of weighing, is significantly empty: the scales are empty; there is no act of weighing, no narrative, only balance.

This problem with allegory is, in turn, allegorical for a larger problem implied by polysemy. Since Derrida's concept of dissemination is the most radical endorsement of the view that no one interpretation can be favored over any other, it is this concept that I will take to task. It is a very attractive concept, especially as a corrective to the positivism still so pervasive in art history. The question to which I will return, however, is whether the semiotically inevitable undecidability and plurality of meanings is really so free. Derrida himself argues convincingly against the misunderstanding—often alleged by the opponents of deconstruction—that theoretical polysemy implies unaccountability. My endeavor here is not to use Vermeer's nail to discredit Derrida or his concept, but rather to reinsert Derrida's political potential within the theoretical discourse on art.[20]

But let me play the game first and return to Vermeer's light. Since the part of the woman's dress that is illuminated is also the part that covers her womb, it may, through metonymy, represent the slit that stands for that archaic opening of the womb—the navel.[21] If we focus on this element, we may come to associate the woman in this painting with the pregnant Madonna as represented in the Italian Renaissance—another case of inter-discursivity.[22] The woman's headdress and the blue color of her mantle may then be seen as emphasizing the visual similarity in the distribution of

surface space between her and God in *The Last Judgment*—a text whose embedded position underlines the intertextual status of the embedding work. An ordinary Dutch woman for some, an allegorical figure representing *Vanitas* for others, she may become Mary for those who pursue the interpretive game even further. The point is not to convince readers of its appropriateness or truth, but to offer the speculative possibility of demonstrating polysemy in principle. But the affirmative tone of proponents and opponents of the pregnancy theory demonstrates the Lacanian truth of the invisibility of the obvious: Poe's positivist prefect, so busy being systematic, was unable to *see* the hidden/exposed letter. Similarly, participants in this debate are unable to "see" their opponents' view, enclosed as they are within their own system of thinking.[23] This lesson against positivistic notions of visuality is of great importance for a disseminating perspective on painting that allows syntax to overtake semantics: whereas the pregnancy might otherwise have passed unnoticed, the light—and the color it generates—makes such a denial both futile and a necessary part of the meaning.

These examples confirm the (non-)logic of polysemy, but also demonstrate that the affirmation of a single meaning is profoundly motivated by socially relevant power positions. In keeping with Wittgenstein's concept of the language game, signs can be seen as *active,* and, of necessity, as both *public* and deployed *according to rules.*[24] A sign, then, is not a thing but an event that takes place in a historically and socially specific situation. Sign-events take place under specific circumstances and according to a finite number of culturally valid, conventional, yet not unalterable rules. The assumption of polysemy, including the radical version of it in dissemination, does not ignore power relations. On the contrary, it emphasizes them: since there are no definitive limitations on the meanings of signs, the responsibility for which meanings it is that win the game is entirely social and political. Interpretive behavior is socially framed and any interpretive practice has to deal with that framing *on the basis of* the fundamental polysemy of signs and the subsequent *possibility* of dissemination. In accordance with the concept of parergon, the frames, including the social and institutional forces involved, are *semiotically* part of the work. Thus, they limit the theoretically unlimited dissemination.[25] But, as we know from Derrida's *Truth in Painting*, the frame, like the parergon, is also inside. Therefore,

dissemination is ultimately limited from within. This is so because, deferred as it is, the production of meaning takes place not as an ulterior supplement but as something already inscribed, not in the work as a whole but in its semiotic status.

meaning

For me it was the nail and the hole illuminated by the light that instigated my burst of speculative fertility. When I saw the nail, the hole, the shadows, I was fascinated: I could not take my eyes off them. Roland Barthes would call these details *punctum,* which means "nail" or "pin." I don't like this word: it pierces, suggests violence against the work. It seems out of place in this Vermeer, where any potential "pricking" is countered by the quality of the light. I don't like the concept either: Barthes uses it to defy meaning.[26] The nail-and-hole, the shadow-and-light, fascinate, not because they prick the canvas but because they inscribe it with meaning, although which meaning is not clear. Why are they there? Are these merely meaningless details that Roland Barthes would chalk up to an "effect of the real?" Are these the signs that make a connotation of realism shift to the place of denotation because there is no denotative meaning available? Or do they point to a change in the significance of *The Last Judgment?* Do they suggest that that painting—which, according to Wheelock, is meant to balance the work, to foreground the similarity, the rhyme, between God and the woman—has been moved from an earlier, "original" position to a better position that visually offers a more convincing balance, leaving only a telltale trace of the nail's hole? As it is, the woman stands right below God, a position that emphasizes the similarity between judging and weighing. Also, the separation between the blessed and the doomed is obliterated by her position, suggesting, perhaps, that the line between good and evil is a fine one. But, in the midst of this speculative flourish, I am stopped short by the recollection that we are looking at a rendering of balancing, not at a real room. The painter surely did not have to *paint* the nail and the hole, even if, in arranging his own his studio, he may actually have moved *The Last Judgment.*

As Barthes rightfully points out, "naïve *realism*" cannot be easily dismissed; it is part of the effect. If the room were a real room, the hole and the

nail would recall traces of an effort to hang the painting in the right place; they would be an inscription of balancing and of the value attached to this act, indices of writing, *grammata*. As such, they would stand for the materiality of the difficulty and delicacy of balancing. Hanging a painting in exactly the right place is a delicate and crucial business, since the result is of the utmost visual importance. As a representation of this statement on visual balance, the nail alone would not do the trick; the failure of the first attempt to correctly balance the represented painting must be shown through an even earlier attempt. The hole is the trace of this prior attempt. The suggestion that *The Last Judgment,* which has balancing as its very subject matter, was "initially" if not "originally" unbalanced, threatens to unbalance the painting as a whole. While the metaphoric link between the idea of judgment and the woman's activity is further emphasized by the final result, the difficulty of balancing and judging is also foregrounded. That difficulty, in turn, is related to the similarity between the woman, whose womb is illuminated by the light, and the difficulty of the act of balancing, which is illuminated as well.

I have used the first-person pronoun more often in this section than in the preceding one. This is because I have been speaking about meaning. At the moment when I became really excited about the painting, "I" became a factor in its game. What does this imply about the location of meaning? As Culler has so eloquently demonstrated,[27] attempts to locate meaning either in the text or in the viewer end up flipping over to their opposites. In reader-response criticism, for example, although meaning is located in the critic, the critic "at work" protects herself by claiming that the meanings she puts forward are more "plausible" than those put forward by others, because the text "lends itself" to her particular meanings. But the opposite is also true: textual critics, when defending their views, ultimately need to claim that their meanings are the most "adequate" ones because the text "suggests" them to the reader, who then actualizes them.

This is convincing, yet it fails to account for the responsibility of meaning production. According to Ernst van Alphen, the theoretical problem here is the untenable, monolithic character of such concepts of meaning that leave accountability evasive. His attempt to solve the problem is relevant to my argument. He begins by stating that both text and reader *perform* something.

The danger of speech-act theory, however, is that it returns to intentional criticism and confining categories.[28] Therefore, van Alphen extends performativity to include the act of reading without positing a symmetry between text and reader. It is in the collaboration, the conflicting struggle for coherence between text and readerly response, that social reality is affected. *Effect* becomes the key notion, but no coincidence, no symmetry, no equality between text and reader can be achieved.

Van Alphen thus proposes distinguishing two "moments of meaning production." The first involves the author, but is no more "original" or primary" than the second, whose subject is the reader. The text as produced by the author responds to and brings order into the collection of possible meanings couched in the pre-text, the set of previous discourses that impel the new text while at the same time being an excuse to do something different with it. This sheds new light on Vermeer's struggle with order. The difficulty of balancing, commenting on the act of the judging God, now also becomes a metaphor for the creative performance of the painter. Between the woman and the deity, balanced on the vertical axis of the painting, a third person, the subject of the act of painting, enters to share the polished surface of the painting on the horizontal axis. The pre-text is the historical, biographical, and ideological reality from which the text emerges. The reader can try to adopt the modest attitude of "listening" or "just looking at what is there," but the text is the result of an act of listening or looking. Performativity, then, is cut off from any "original intention" and becomes a response.

The second moment of meaning production occurs when the reader articulates an ordering and reworking of the collection of possible meanings offered by the text and of additional possibilities brought in by herself. At this moment, the text is an occasion for, not the cause of, meaning: a lateral signifier rather than a signified. The central notion now becomes *reflection*. The author reflects upon the pre-text, and the reader reflects upon the text which is her pre-text. Both subjects are directed by the reading conventions of their time and social group. In order to grasp the process of meaning production, it is crucial to analyze the conventions underlying the acts of reflection inherent in reading at the time. These conventions are by no means limited to the documents left by contemporary art critics.

So, the event of meaning production between Vermeer and me—partly a clash and partly a dialogue—illuminates how a non-documented reading can form a part of, and must be taken seriously by, a genuinely historical art history. To recapitulate: Vermeer's painting brings in light, and I bring in Derrida's parergon, thus setting the light in motion and allowing it to take over. In the painting, the narrativity that is so blatantly absent on first—and second—glance turns out to have been introduced through a sign that makes a statement on visuality. The visual experience that encodes the iconic association between woman and God is not displaced but rather underlined by this narrative aspect. We imagine someone trying to hang the painting in exactly the right place. We are suddenly aware of the woman's artificial pose: instead of changing the painting, the artist, in arranging his studio, might simply have changed the position of the woman or his own angle of vision. All of a sudden something is happening, the still scene begins to move, and the spell of stillness is broken.

The nail and the hole, both visual elements to which no iconographic meaning is attached, unsettle the poetic description and the passively admiring gaze that it triggered, thus activating the viewer. Whereas before the discovery of these details the viewer might have gazed at the work in wonder, she is now aware of her imaginative contribution through the very act of looking. The work no longer stands alone: the viewer must now acknowledge that she makes it work; the surface is no longer still but tells a story of its and her making. This is what narrativity does to a work of art, be it visual or literary. In attracting attention to the actual work that representing involves as well as to the work of reading or viewing, the nail and the hole are traces of the *work* of art, in all senses of that word.

This, then, raises questions about the place of narrative in visual art. Whereas narrativity is generally considered to be an aspect of verbal art, it is thought that it can only be mobilized in visual art under great representational pressure.[29] Something comparable is alleged with regard to visual imagery: literature strives to achieve it, but can never completely do so. I propose to alter the terms of these questions and to reconsider the characteristically medium-bound terms of interpretive scholarship—such as spectatorship, storytelling, rhetoric, reading, discursivity, and visuality—so that they will refer to aspects rather than essences, and, with respect to each art's

strategies to deal with these aspects, to modes rather than systems. The above interaction, in which meaning is produced, turns the painting into a statement about meaning as work, and work as meaning. Dissemination has now even affected the classic distinction between the visual and the discursive, the very basis of the disciplinary boundary between art history and the other humanities. Or did the light do that? It is the light that decentered the image by making my glance move back and forth between the orange patch on the woman's belly and the hole and the nail higher up. High and low: where have I heard that dichotomy before?

woman

God is high up, and the artist's masterstroke of light—the hole and the nail—are at the same level; the woman's womb is low, down below. But if Vermeer is closer to God, "she" is closer to "us." As I have argued, the object of a reader-oriented analysis of art is *our relationship to the image*. The "our" in this statement needs further analysis. While this phrase is meant to suggest how deeply entrenched we are in any act of interpretation, in images stemming from other times and places, "we" is emphatically not a monolithic subject. Within a psychoanalytical framework, this collective subject can be further differentiated. With "us" I mean a subject traversed and fraught by the unconscious, including the superego and its social implications, narcissism and its defensiveness against affect, desire, and the fantasy-character of response. The way we perceive and interpret images is based on fantasy, and fantasy is socially based. Thus, there is a dissymmetry between men and women when they look at male and female figures. This dissymmetry is also unstable, varying according to which aspects of the unconscious are more or less strongly implicated in the act of looking. For example, the response to Rembrandt's *Danaë* is more likely to differ according to gender, while the response to his *Blinding of Samson* might differ less strongly or at least in a different way, because this painting appeals to a pre-oedipal fantasy.[30] The differentiation, here, occurs not so much directly along gender lines, as primarily according to other divisions, such as narcissistic fulfillment and the relative solidity of the ego.

In thinking about the uneasy fit between psychoanalysis—a basically verbal discourse—and visual art, and the equally uneasy fit between psycho-

analysis—an overwhelmingly masculine discourse—and feminism, the strategics and concepts of deconstruction are indispensable. This becomes obvious when we look at a traditionally narrative as well as gendered painting, such as Rembrandt's *Danaë* (fig. 2). This painting shows the defects of the traditional concept of narrative, with its fixed relationship between sign and meaning, its hierarchical structure, its suppression of detail, of the marginal, the "noise." It was in order to counteract such an oppressive notion of next that Derrida proposed the concept of dissemination. This concept enhances the slippery, destabilizing mobility of signs in interaction with the sign-users or viewers.

But dissemination, like every other concept of contemporary theory, is inevitably bound up with the Freudian legacy and its pervasive set of body metaphors. The *Danaë* is also traditionally gendered. Derrida replaces the masculinist metaphor of the phallus as the ultimate meaning with that of

Figure 2. *Danaë*, Rembrandt, 1636. Courtesy of Kunsthistorisch Instituut, University of Amsterdam.

the hymen which, through speculations around all kinds of figures of pen-
etration and articulation, also stands for the sheet—or canvas—on which
meaning circulates without fixity. Fully dressed as she may be, Vermeer's
woman, whose female body is syntactically foregrounded, is inevitably
caught up in a viewing tradition that has the female nude as its favored
subject, voyeurism as its dominant semiotic mode, and the body as the
sheet on which writing on art is done. As the debate around the woman's
role, meaning, and womb demonstrates, this is emphatically the case; the
body fixes. These speculations remind one of another Derridean phrase:
"Spelunking in the Antre."[31] The female body, not only as having the
(protective) hymen but as being the disseminating hymen? There might be
more coherence to this Derridean network than appears—and more,
perhaps, than the author would like. Rembrandt's *Danaë*, for example, is
more than a narrative in the traditional sense of re-production, more
than an illustration of a preexisting, narrative text. How does it turn the
woman into a hymen? The pre-text has it that this woman, forever barred
from love by her frightened father, is, at the moment the picture presents,
visited by Zeus, who has managed, thanks to his disguise as a shower of
gold, to break the taboo that the woman's father had imposed on his
daughter.

Looking at the picture as an image, we see a female body, nude, at first
displayed for the lust of the viewer, who is allowed to peep into the intimacy
of the closed bedroom. This is a visual story, the story of vision in Western
culture. It is the story of the male voyeur and the female object—of the
eroticization of vision. It is the story of the central syntagm—subject-
function-object—in which positions are fixed along gender lines, and
through which gender itself is constructed. It is the scheme that is invariably
nearly-dominating, nearly-exclusive, but never absolutely so, because the
dynamic of narrative precludes its foreclosure. It is worth undermining this
verbal/visual opposition if only in order to break the monopoly of the visual
construction of gender. Again, the light illuminates, this time against
it/himself.

Between the text (the story of the welcomed arrival of Zeus rendered as a
sheen) and the images (the exhibition of a female body for voyeuristic con-
sumption), the painting produces its own narrative, reducible neither to the

work's visual nor narrative textuality. The pre-text is literally a pretext: its anteriority underlies the painting's appeal to the general understanding of the story as a frame for its reversal. The story's centrality, as the theme of the work, allows everything that is decentered to slip in—it allows, that is, for the dissemination of meaning.

This can also be phrased differently. The work's genesis in a preexistent narrative helps sever the tie between the two and produce another narrative, irreducibly alien to it, void of the deceptive meaning that the pre-text brought with it. With genesis, the severing of the tie, a central void, and the dissemination of what *matters,* an alternative to the hymen as the central bodily metaphor creeps in. That alternative is the navel—the very site struck by light in the Vermeer.

Here, too, light comes in, but rather than illuminating the woman's navel, it sidesteps it. The divine lover, who is supposedly welcome, is visible only as a sheen. But the sheen, the border of light, so crucially "Rembrandtish," dissolves into futility. For, in spite of deceptive appearances, Zeus's gold does not illuminate the woman. Rather, the sheen delineates the space in which the woman is enclosed; it demarcates her private space, emphasizing the form of the opening in which the woman's feet disappear—her opening. The sheen emphasizes the opening but does not produce it; so, in this way, the sheen does not *count,* and the pre-textual story—as well as the inter-discursive story on gender—is undermined.

Looking at the image from a different angle, we must take our own position into account. The viewer is *also* supposed to come in and be welcomed—as a voyeur, allowed to see the female body on display. But, at the same time, the viewer is deprived of his identity, when his eyes come into contact with his mirror image in the form of the two onlookers. According to a formal analysis, these two onlookers, the putto and the servant, form an insistent triangle, with the female body as its base, which parallels and reverses the triangle of the exit curtain. The putto refers iconographically to the pre-text, his tied hands the "symbol" of forbidden sexuality. While also offering a way of viewing the woman, it is an immature, childlike way. For though he wrings his hands in despair, he is not looking at the woman's body. Perhaps he despairs over this lack, a lack imposed by the bonds on his hands that, in fact, prohibit both touching *and* looking. Exasperated by the

interdiction, the putto is visually self-enclosed. The servant does not look at the woman at all.

These two stories—the textual, verbal pre-text and the story of the visual present—collude and collide in the work's textuality. They produce a new story, the text of *Danaë* as an interaction between the canvas and the viewer who processes it. In this text, Zeus, invisible as he/it is, thus becomes the pre-text the woman uses to get rid of the indiscreet viewer: narratively stretching out her hand to welcome him, she visually dismisses the viewer, urging him to exit in the direction of the sheen. The woman, who at first sight seemed to be on display, *as spectacle*, in a static, visual reading, takes over and dominates both viewer and lover. Her genitals, symbolized by the slippers and magnified by the opening of the curtain at the other end of the sight line, are central in the framed text. They are turned toward the viewer, but they can be seen by neither viewer nor lover because the viewer is sent away while the lover comes toward her from the other side. In this way, her sexuality, despite its centrality, is a trace of the pre-text, for the conflicting lines of sight cut it off; it is also the locus of the metaphor that crept into the vocabulary of my analysis: it is the navel of the text. But between sex and the navel lies a difference: it is the difference between voyeurism and its deconstruction.

The metaphor of the navel could replace—supplement—that of the hymen with that of the deconstructed image. Diluted into multiple textuality, it is a false center, a hole that is not a hole, attracting attention to its void of semes—to its dis-semination. Following Derridean practice, the metaphor of the navel as a Derridean *trace* pushes Derrida's concept of dis-semination to its limits, and beyond them. Although he undermines the phallic view of the sign and meaning inscribed in Saussure's semiotic, Derrida is also implicated in it. This is because his dissemination, intended to dissolve the penetrating power of the dualistic sign, sometimes looks like an overwhelming dispersion of semen; coming all over the text, it spreads out so pervasively, so biblically, that it becomes like the stars in heaven or sand at the seashore: a promise to global fatherhood—precisely what the futility of Zeus's sheen in the *Danaë* undermines.

A word of caution though: Derrida writes the following when he specifies the status of his own moves in the interpretation of Soller's *Mimique:*

> What counts here is not the lexical richness, the semantic infiniteness of a word
> or concept. … What counts here is the formal or syntactical *praxis* that com-
> poses and decomposes it. … If we replaced "hymen" by "marriage" or "crime,"
> "identity" or "difference," etc., the effect would be the same. (1981, 220)

When trying to abandon semantics and allow syntax to take over through
praxis, the alternatives to "hymen" become semantically strongly overdeter-
mined and bound up with gender.

The concept of dissemination is itself bound up with the concept of
hymen, the veil that protects from penetration as an alternative for the
phallic privileging of the invisible signified. It is this connection with the
hymen that genders dissemination, and ruthlessly so. For, by invoking
Hymen, it also embraces the moment when the virgin bride is torn open
and filled with semen. Invoking Hymen invokes marriage. And marriage
imperialistically prevails, threatening to become the metaphor for semiosis.

In deconstructing this metaphor with the help of visual images as texts,
the navel can supplement it: not by getting rid of the hymen or of gender,
but by pushing the hymen aside and shifting gender to an altogether differ-
ent plane. The navel—both *grammé* or trace of the mother and token of
autonomy of the subject, male and female alike. This alternative concept
reminds us of its own deceptive pervasiveness in Western thinking, where it
has served to foreground origin and center (*omphalos*) as well as subjective
autonomy (contemplation of the self as navel staring) at the expenses of the
obviousness of the tie with the mother. Putting the metaphor of the navel to
this new use deconstructs the mythologies to which it is attached. Although
a center without meaning, it is a meaningful pointer that allows plurality
and mobility, that allows the viewer to propose new readings to meet his or
her needs but without letting those readings fall into the arbitrariness that
leads to isolation and irrelevance.

The navel leaves room for the specificity of the visual that it also beto-
kens; indeed, it builds the reading it suggests on the image's visuality. In
addition, the navel has the same quality as Poe's hidden/exposed letter had:
it is too obvious for words. Thus, it demonstrates that the metaphoric
network related to the phallus is all but obvious. On the other hand, the
"navel" metaphor enhances the irreducible textuality: its play between story
and static image, its visual mobility, and the indispensable collaboration

between the work and its socially and historically positioned viewers. The navel, then, is a metaphor for an element, often a tiny detail, that hits the viewer, is processed by her or him, and textualizes the image on its own terms. Such details need not be bodily, but calling them "textual navels" keeps us aware of the bodiliness of looking.

In *Danaë*, the "textual navel" is not the woman's "real" navel but her genital area. In Rembrandt's *The Toilet of Bathshebah* (The Louvre), another nude with an ostentiously represented navel, it is the left-hand corner of the letter the naked woman is holding. In Vermeer's *Woman*, it is the nail and hole, which, significantly, are pointed at, or pointed out, by the woman's hidden-and-illuminated navel. Elsewhere, I have argued that the navel of Rembrandt's *Susanna* in Berlin is the fist of one of the Elders.[32] In the latter work, as in many others, the textualizing navel is an emptiness, a small surface that the work leaves unfilled.

navel

The navel is particularly useful for a deconstruction of voyeurism as the dominant mode in the Western tradition of visual art. When movement itself is endorsed and decentering assumed, innumerable images start to move away from unproblematically gendered visual pleasure toward a self-reflective return to the navel: Toulouse-Lautrec's *Two Ladies in the Moulin-Rouge*, or his *Englishman in the Moulin-Rouge*, both popular postcards, might find fewer eager buyers once the convention of voyeurism, their pre-text, is both endorsed and questioned, and we see the fear beneath the ridicule. Looking at the image instead of filling it in with what one already knows, the viewer of Pieter Coecke van Aelst's *Joseph and Potiphar's Wife* (fig. 3) (Catharijneconvent, Utrecht) will think twice before engaging in voyeurism, because the revenge of the furious former "object of the gaze" will be to return the compliment.

This playing with metaphors should not be seen as a meaningless linguistic game. Using bodily metaphors is one way of acknowledging the impossibility of disentangling oneself from the discourse into which one is, so to speak, born. Here, the navel is the symbol of a body part, as is the phallus, and it, too, is loaded with connotations of gender. Yet these connotations are

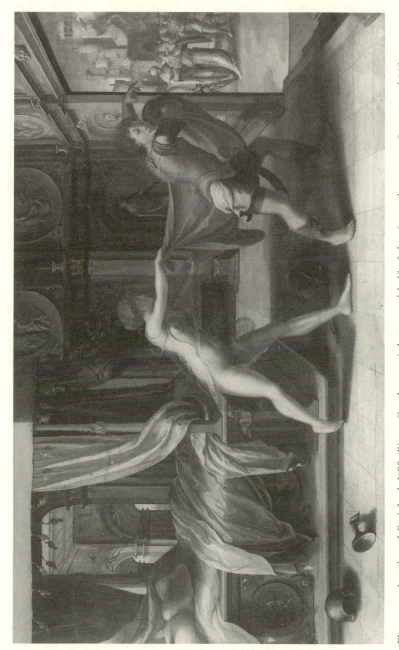

Figure 3. *Joseph and Potiphar's Wife*, Pieter Coecke van Aelst, second half of the sixteenth century. Courtesy of Rijksmuseum Catharijneconvent, Utrecht.

radically different in status. The phallus refers to gender in terms of "haves" and "have nots," or "to have it" versus "to be it." So, too, I am afraid, does the hymen. By contrast, the navel, although fundamentally gender-specific—it is the scar of dependence on the mother—is also democratic in that both men and women have it. And, unlike the phallus and its iconic representations disseminated throughout post-Freudian culture, the navel is starkly indexical, both being and pointing away from itself.

The metaphor of the navel as the detail that triggers textual diffusion, variation, and mobility of reading while countering the repression of the mother is therefore not a device for justifying that "anything goes." It ensures that the body and its genderedness are continually implicated in the act of looking. It is a tribute not only to an antiphallic semiotic but also to an antiphallic genderedness that does not assign women to a second-rate position. This attitude toward gender, then, is comparable to the attitude toward "high art" implied in Vermeer's balancing of high and low illumination and ordering. In both cases, hierarchy is not denied—it cannot be because it is a cultural reality—but shifted and thereby undermined. The woman, a mediator between the ordering creators up there and the ordering viewers down here, becomes the center of meaning production. No wonder that the light illuminates the place of her navel more than anything else.

In an important article on Freud's *Beyond the Pleasure Principle*, Elisabeth Bronfen (1989) suggests that we focus on the navel as an image of primary castration. To support her suggestion, she argues in favor of the psychoanalytical importance of the experience of primary narcissism. She makes her case through a close analysis of Freud's repression in his essay on the place of the woman—his daughter, who is also the mother of the child out of whose game the theory emerges. Bronfen shows that Freud identifies with his daughter's child and thereby assumes a position between father and son. This identification is based on the conflation of mother and daughter, and demonstrates the genderedness of the very formation of this theory and, by analogy, of theory in general. But when Freud, the day after the death of his favorite daughter, shifts attention from *her* death to *his* woundedness, calling her death an incurable assault on his narcissism, another identification—that between father and daughter/mother—is at stake. Only when the father/son is wounded are gender boundaries crossed.

Using Derrida's critical mode to challenge his concept—not to eliminate it but to push it off center—I wish to propose readings in the "navel" mode, readings that acknowledge visuality but do not shy away from discursive elements, which recognize where cultural commonplaces are mobilized yet leave room for the marginal "other," which endorse the "density" of visual signs and let that density spill over into literature while not fearing to point out specific, discrete signs in visual works and the loci of density in literature. Such readings cannot be full, comprehensive descriptions of what we see in paintings, any more than traditional art historical readings can be; nor are they narratives reconstructing the pre-texts that give the works meaning. Instead, such interpretations start at the navel, with the fine detail that doesn't fit into the "official" interpretation: the view of the work put forward by the terms of agreement among the readers before me.[33] For invariably, official readings leave a rest, a lack. They speak of something that isn't there and should be, or something that is there and shouldn't be, thus triggering an alternative reading. Where classical narrative readings cannot accommodate it (the "rest") unproblematically, another narrative is set in motion—via the suspenseful encounter between the narrative and the visual. In this way, the concept of the "navel of the text" is programmatic: it proclaims an interaction, not an opposition, between discourse and image.

Vermeer's light directs our gaze to the place of the navel by way of the textual navel: the nail and the hole. Despite the prominence of the invisible navel, the thought of pregnancy is not interesting in itself. Rather, it is significant because of what it does to the visible but displaced navel—the hole illuminated by the light, if we let the light do its parergonic work. Procreation, "low" creation, is thus elevated to the same level as the judging God and the balancing artist. In fact, woman's role in creation is what this painting illuminates. The role is not, as the cliché says, a natural, material process that men subsequently need to take in hand, but a creation that orders, balances, and judges, all in equal measure. Unexpectedly, such a reading is not incompatible with art-historical interpretations of painting.[34] It is, however, polemically pitted against art-historical dogma insofar as such dogmas deny intertextuality, polysemy, and the dynamic location of meaning, as well as, of course, a certain importance for women. Only a disseminated art history can give light and women their due.[35]

notes

1 C.S. Peirce, "The Scientific Attitude," quoted by Culler (1988), xvi.

2 Jacques Derrida (1987). In this chapter, I will concentrate mainly on the concept of dissemination and the theory of signs it is engaged with. But it needs to be clear that most other Derridean concepts are embedded within the same opposition to classical semiotics; in the end, concepts like *supplément, différance,* par-ergon, and, indeed, deconstruction itself, tend to converge in the one major project or undermining from within the status of meaning in traditional Saussurian semiotics.

3 Arthur J. Wheelock Jr. (1981), 1067–7.

4 For an overview of current interpretations of this painting as well as a new one, see Salomon, "Vermeer." X-raying and microscopically examining these painted pans seems a compulsory action for art historians; see Salomon (1983) and the literature mentioned there. This particular X-raying has come to stand for "serious research," "empirical methodology," or "original." I wonder, however, what conclusion might have been drawn if the result of that inquiry had been different. What exactly would the status of any hidden content of the pans have been? Invisible riches, erased by the artist or his followers, or accumulated varnish, could hardly match up to the careful balancing of the surface of this painting, articulated by the light. Salomon is quick to draw this conclusion from the emptiness of the scales: there is as yet nothing to weigh, the state of expectation is one of perfect balance.

5 See Nelson Goodman (1976).

6 The tone for such a sense of crisis is set by books like Belting, *The End of the History of Art?* (1988) (don't believe him: he adds a question mark), and Preziosi, *Rethinking Art History* (1989). I have discussed the state of art history within the humanities in Bal (1989) and (1991a).

7 See H. Perry Chapman (1990). Other, more pervasive "sources" for these self-portraits are, according to an argument such as Chapman's, cases of interdis-cursivity, like the discourse on melancholia of the sixteenth and seventeenth centuries in medicine, philosophy and art, with Dürer's famous woodcut as the prime example. No direct quotation but a use of standardized discourse is at stake here.

8 Michael Baxandall (1985), 58–62.

9 Svetlana Alpers (1983, 1988), among others, resists the attribution of meaning to visual art, although I think it cannot be avoided.

10 Mary Garrard (1982, 1988).

11 This argument is more extensively developed, and the example analyzed, by Bal and Bryson (1991).

12 Gary Schwartz (1985) suggests this and other similar iconographic precedents in Rembrandt.

13 Emile Benveniste (1966).

14 This is not to say that Vermeer's painting is unique in this respect. In fact, the opposition between realists (Alpers 1983; Hecht 1989) and allegorists (e.g., de Jongh 1976) among students of seventeenth-century Dutch art in general is no more than a typical case of binary thinking that is entirely alien to the paintings. The principle of "either-or" denies the most central feature of the painting as a whole, which is precisely an integration of the exclusive pair. To take sides in this conflict is also, I think, to deny the painterly status of the works as visual texts. Paintings either mean something other than what they "say" (allegorists) so that their visual presence is denied, or mean nothing at all, are just "descriptive" (realists) so that meaning is denied, thus denying the works' status as semiotic object. For a discussion of this debate, see Bryson (1989).

15 This is how Barbara Johnson, in her introduction to the English translation of the book, describes Derrida's moves in "The Double Session," the essay from *Dissemination* which is most central to my argument. See Derrida (1981), xxix.

16 Much ink has been spilled over the Zeuxis anecdote, among others by Stephen Bann (1989). For more on this anecdote and on realism in Dutch still-life painting, see Bryson (1989).

17 The syntactical insistence on the woman's womb has been remarked upon by Salomon (1983): "It [the light] particularly strikes her stomach, which, like an annunciate Mary's, glows almost as if from an internal light source" (217). How so, "almost," "as if"? This is precisely how the syntactical light is parergonic: its falling on the womb where it becomes internal is a *mise en abyme* of this parergonic status.

18 The former inversion is performed by Herbert Rudolph (1938), 409, the latter by Lawrence Gowing (1970), 135, by Arthur Wheelock (1981), 106, and by others.

19 For different views of allegory, see Paul de Man (1979), Joel Fineman (1980), Craig Owens (1984). For a more elaborate critique of allegory, see Bal (1991a), ch. 3.

20 His most percutant text on this is the afterword to the paperwork edition of *Limited Inc.* (1988).

21 The obvious synecdochical meaning of the vagina will be left unmentioned for the moment—obviousness hampers rather than helps theory.

22 See Mary Jacobus's fascinating discussion of Raphael's *Sistine Madonna*, with reference to the Arezzo *Pregnant Madonna* by Piero della Francesca. Jacobus discusses the Raphael as it is read by Freud's patient Dora. See "*Dora* and the Pregnant Madonna" in (1986).

23 The different threads of the debate around this central Lacanian-Derridean text have been brought together by Muller and Richardson (1988). The point of the Poe story is not that there is a truth which is hidden by exposure, but that for the eye of the beholder exposure can hide, hence, subjectivity is inside the visibility and "truth" is beside the point.

24 In the *Tractatus Logico-Philosophicus* (1921), Wittgenstein gives a visual dimension to verbal propositions and regrets language's cloudiness, thus suggesting that density is by definition visual, which it is not. In his later *Philosophical Investigations* (1953), he rejects the nostalgia for purity in his earlier work and argues that language is no less dense than pictures are. Here, he endorses language's ambiguity as one of its most basic features. For the transition and break between modernism and postmodernism in literature, see Allen Thiher's account of Wittgenstein's views of language (1984). The assumed visuality of language plays a key role in that change.

25 For a wonderfully clear argument in favor of this view, see Culler (1988), author's preface.

26 Barthes (1981). The *punctum* is the locus of fascination and is alleged to resist meaning.

27 Culler (1983), "Stories of Reading."

28 The argument is developed by Van Alphen in a book in Dutch (1988). A shorter version exists in English (1989). I have discussed this problem in more detail elsewhere (1989). Derrida's well-known critique of speech-act theory is most concisely articulated in *Limited Inc.* (1988).

29 A recent version of this view is presented by Varga (1989). See also Steiner (1988). For a critique of these views, which go back to Lessing and Romanticism, see Mitchell (1985).

30 I argue for such an interpretation in detail in *Reading "Rembrandt"* (1991a).

31 The phrase is used by Johnson in her introduction to Derrida (1981), xxvii, when speaking about Derrida's discussion of Plato's second mimetic paradigm, the cave. Needless to say how strongly gendered both Plato's mimetic paradigms are: the always inferior bed and the obscure cave.

32 *Reading "Rembrandt"* (1991a), ch. 4.

33 Naomi Schor's wonderful book *Reading in Detail* (1987) should be seen as having played an important part in my interest in the navel.

34 Despite all the difficulties of translation pointed out by both Derrida and his translator Johnson, my reading of the Vermeer painting could, semantically speaking, be translated into Salomonian terms. In the process, though, it would lose its syntax, which, as this paper is meant to argue, would mean the loss of meaning seen as production.

35 Fortunately, disseminating analyses of art history are beginning to appear. The most effective of these question the discourse of art history as informed by an authoritative position for the image. Such a disseminating move is *not* based on positivistic truth-claims but on the idea that images too are discursive. A good deconstruction of art history in terms of the relationships between discourse and image is Holly (1996).

calling to witness: lucretia 3

If the object becomes allegorical under the gaze of melancholy, if melancholy causes life to flow out of it and it remains dead, but eternally secure, then it is exposed to the allegorist, it is unconditionally in his power. That is to say it is now quite incapable of emanating any meaning or significance of its own; such significance as it has, it acquires from the allegorist. He places it within it, and stands behind it; not in a psychological but in an ontological sense.
—Walter Benjamin, *The Origin of German Drama 183–84*

The very notion of a "rhetoric of violence" ... presupposes that some order of language, some kind of discursive representation is at work not only in the concept "violence" but in the social practices of violence as well.
—Teresa de Lauretis, *Technologies of Gender 32*

introduction

ALLEGORY IS AN HISTORICAL ATTITUDE, yet allegory can never replace the "literally" real.[1] Rather, allegory is an extended metaphor; it is a reading based on the continuous *similarity* or *contiguity* between its vehicle—say, here, the myth of Lucretia—and its tenor—political tyranny.

The subject of the chaste Roman Lucretia, who stabbed herself in the presence of her husband and father after she had been raped by her

{93}

husband's fellow soldier, was familiar in Rembrandt's time; it was, so to speak, part of the culture,[2] receiving, of course, political and religious allegorical interpretations. But such cultural currency is never sufficient to explain an oeuvre's interest when the subject both offers a persistently powerful image, a cultural emblem, even a cliché, and addresses a real and serious problem such as rape.

In keeping with the assumptions set out in the introduction, I propose to examine here not a particular work of art but a "case." That case will expose a cultural problem related to the representation of a topic that is at once popular in the culture, difficult to represent, yet often represented, and real. My analysis will aim at understanding the margins of that case, the seams where art is attached to reality: I will foreground the artificiality of the artistic utterance as well as its anchorage in, and effect upon, the real. For this first exploration, the case is rape; the subject, the myth of Lucretia; the tool, rhetoric.

Lucretia is a good subject to begin our discussion with: first, because it is a story, a verbally propagated theme; second, because it has been and still is popular; third, because it was often painted, represented visually. In fact, even in the corpus of "Rembrandt" paintings, Lucretia figures twice. Hence, this subject invites key questions: what are the relations between cultural fascination, verbal representation, and visual representation? And how does rhetoric, a mode of analysis traditionally applied to verbal art, serve to connect these?

In order to avoid special pleading and hence the construction of a social relevance for humanistic analysis on a circular argument, neither literary theory nor "Rembrandt" will be privileged a priori in this chapter. Both will be brought to bear on the real-life issue: the case of rape will be rigorously foregrounded and seen as a semiotic event.[3] The semiotic aspects of rape will be considered on two levels. One level is the semiotic behavior surrounding rape, such as the difficulty survivors have recounting the experience, the refusal of others to listen to survivors, and the semiotic use of the rape for other purposes. Another level is the semiotics of rape itself, its status as, among other things, body language, as a speech act of aggression, as an attempt at destroying the victim's subjectivity, which equates rape with murder. I will examine the difficulties of getting access to the semiotic of

rape on both levels, because of the nature of the act, as well as the cultural attitude toward the act, through a detailed analysis of the two "Rembrandt" paintings of the suicide of Lucretia and through a comparison of these works with both the textual pre-texts in Livy and Ovid and with another Renaissance representation in Shakespeare's *Rape of Lucrece*. Thus a manner of reading will develop that is particularly suited to grasping the artificial construction of rape, as well as to recovering the unspeakable aspects of the experience of rape.

Since the case of rape is doubtlessly the one that touches reality most closely, I will make separating art from reality even more difficult by choosing rhetoric as my major tool of analysis. Rhetoric has traditionally been divided untenably between argumentation and decoration.[4] My claim in this chapter will be based on the intricate connection between "beautiful"—that is, decorative—speech and real, effective persuasion. I will try to show the limits to, if not the lack of, any distinction between modes of expression and rhetorical, that is, real, effect.[5]

A rhetorical perspective on a classical "rapish" situation on the one hand, and brief remarks on textual versions of the same story along with another ancient rape tale on the other, will help generate a view of rape that will then, even more briefly, be confronted by a few women's rape stories. But since the share of a visual rhetoric in the reading of rape will prove indispensable, the analysis of the "Rembrandt" Lucretias will show the point of visual poetics as cultural critique.

the rape of lucretia

The "heroine of rape" celebrated throughout Western culture is Lucretia. She killed herself, calling for revenge, because she was raped; her death initiated the revolution that led to the Roman Republic. As a mythical story, we may assume that the Lucretia legend speaks to the culture that brought it forth, as well as to the cultures that maintain and repeatedly reproduce it. Its popularity is demonstrated in Renaissance and in Northern Renaissance painting in particular, and this popularity in fact continues. In order to arrive at a satisfactory explanation, let us first try out what a "hysterical" poetics can do to construct Lucretia's experience in the representations of a story which

deploys all its strategies to ignore and erase that experience; I shall discuss two visual representations of it. For now, I shall use the two "Rembrandt" Lucretias to develop an understanding of the continuing mythic significance of rape.

"Rembrandt's" two Lucretias are both late works, dating from 1664 (Washington; fig. 1) and 1666 (Minneapolis; fig. 2).[6] It is striking that these paintings are late works. For although "Rembrandt" painted scenes that in

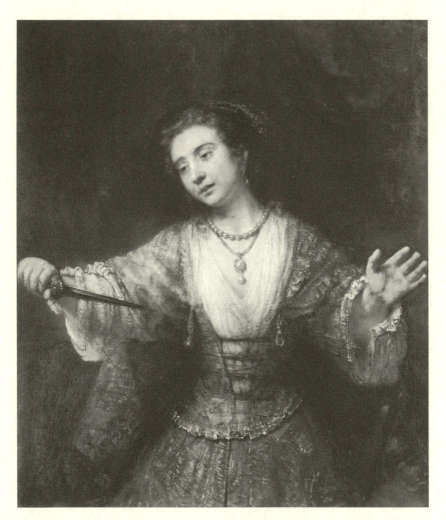

Figure 1. *Lucretia*, Rembrandt, 1664. Courtesy of the National Gallery of Art, Washington, D.C.

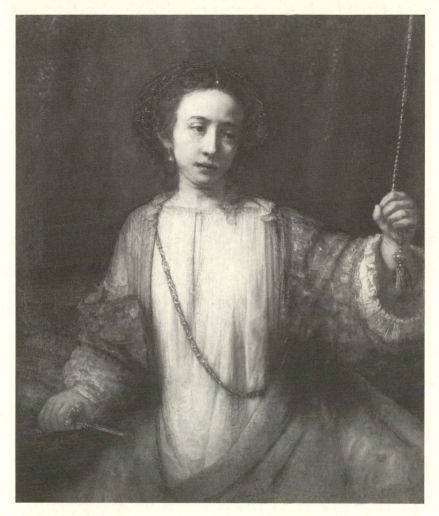

Figure 2. *Lucretia*, Rembrandt, 1666. Courtesy of The Minneapolis Institute of Arts.

English are referred to as rapes more than twenty years earlier (the *Rape of Proserpine* and the *Rape of Europa*, both probably painted in 1632), the differences between these works and the Lucretias in both style and content are enormous. Thus it is significant that in *Proserpine* and *Europa* "Rembrandt" depicts the events that *precede* any actual, sexual rape (which neither the stories nor the paintings represent), whereas in the Lucretias he depicts what *follows*. And ultimately, the latter works thematize the effect of rape whereas the former works do not. If, as I shall argue, the Lucretias can be seen as

metaphoric/metonymic representations of real rape, the abduction scenes do not necessarily lead to an insight into rape.[7]

Lucretia faces more than one man in three respects. First, according to the myth, Lucretia killed herself in the presence of her father, her husband, and the latter's friend. Second, Rembrandt, a man, and probably his students, also men, represented Lucretia cooperatively.[8] Third, the men who observe Lucretia's suicide are outsiders: ignoring her experience, they go forward to take revenge against the tyrant of Rome, the father of Lucretia's rapist.

My very first impressions of the 1664 painting (fig. 1) were Lucretia's movement away from my voyeuristic gaze and the deathly color of her face. But despite her deathly pallor, as the curator of the department in Washington rightly remarked, the cleaning had actually brought her back to life. Her hands had come forward, emphasizing the force and the surprise of her act of suicide—literally, self-killing. Immediately I was struck by two tiny details. First, the earring on Lucretia's left ear does not hang straight. This suggests movement of her head, as well as of her hands. Second, the point of the dagger seemed doubled, thus suggesting a shadow which, in turn, suggests strong emphasis on frontal lighting.[9]

Like the first *Lucretia*, the later one (fig. 2) also represents the suicide rather than the rape. In that work the frontal presentation is even stronger, the white undergown larger. The necklace, which in the Washington piece enhances the frontal pose by its symmetry, is here replaced by a diagonal sash. Lucretia's face is turned in the other direction here, to her left instead of to her right. And the movement, notable in the earlier picture, is replaced in the later one with a frozen pose. The left hand, open in the Washington *Lucretia* as if to persuade or implore, now holds a cord—curtain or bell cord? The red gown, which hangs down normally in the Washington painting, here bulges, thus suggesting either Lucretia's sitting posture or, more likely, the beginning of her collapse, her body beginning to sink into a red mass. Her tears are gone, her earring hangs straight, her dagger points in a different direction, and there is blood on her undergown.

Reading the earlier painting "for the plot," we would interpret Lucretia's movement as a consequence of the presence of the men. Father and husband are trying to comfort her when suddenly she kills herself. For she has to act

swiftly before they can restrain her. Such a reading is realistic in its argument. It is an explanation of the detail in terms of the "real" story,[10] taking the motivations from the story, rather than from the scene as it is depicted. It is also verbal in the traditional sense, since it superimposes on the painting an "underlying" verbal story which the painting is then supposed to "illustrate." The appeal to such a realistic reading demonstrates how much even traditional art interpretation owes to the relations between visual and verbal texts, without, however, examining its own foundations.

But I shall argue that the discursivity of the painting is much more intricately connected with its visuality. In other words, in reading the Lucretias I shall try to make a case for a concept of "visual verbality" in which rhetoric, a representational strategy traditionally associated with verbal communication, is analyzed in visual terms. As a consequence, the relationship between the paintings and the verbal sources must be conceived of in a radically different manner, not as offering two layers of meaning but as providing an intricate interaction.

What would the meaning of the signs of speed be in such a framework? Starting with the details of the 1664 *Lucretia*—the earring and the doubling of the dagger's point—the emphasis on the act itself becomes the primary sign. This emphasis recapitulates an aspect of the ideology of rape, in which the victim is conceived of as having committed the crime against herself. This is a crucial displacement, betraying its own project of censorship: thus, rape is identified with suicide, not with murder as it should be. I contend that Lucretia has become the heroine of rape not only because she is posited as a model of chastity, but even more so because of this identification between rape and suicide. This identification, made most explicit in Livy's story, the oldest source (Foster), is also represented in the "Rembrandt" Lucretias, where suicide is the outcome of a rape story; thus these "Rembrandts" partake of the ideology that makes the social disease of rape so hard to cure. Shortly, I will go on to argue that the painting does, however, not merely do that.

What, then, are the semiotics of rape that we can infer from this displaced and misplaced, yet inevitable, suicide? *Suicide*—or, translated into its Anglo-Saxon synonym, "self-killing" (or, as the Dutch and German have it, "self-murder")—replaces the rape in this and other representations because rape

itself cannot be visualized. It cannot be visualized, not because a "decent" culture would not tolerate such representations of the act, but because rape makes the victim invisible.[11] It does that literally—first the perpetrator covers her—and figuratively—then the rape destroys her self-image, her subjectivity, which is temporarily narcotized, definitively changed, and often destroyed. Finally, rape cannot be visualized because the experience is, physically as well as psychologically, *inner*. Rape takes place inside. In this sense, rape is by definition imagined; it can only exist as experience and as memory, as *image* translated into signs, never adequately objectifiable. As a consequence, the signs are all we have. We must turn the "logical" consequence—if rape is an imaginary crime, it must therefore be dismissed before the bar—upside down and take rape as an inherently semiotic case that derives its strength from that status. The need to listen to survivors, then, becomes doubly urgent, as the only way to reach a solution to the juridical dilemma rape represents.[12]

Because of this difficulty in representing rape, its depiction is often displaced; it is then depicted as self-murder, as in Lucretia's case where self-murder stands for rape, the suicide becoming its metaphor.[13] But replacing the experience, the metaphor displaces the rape itself. Thus its very occurrence conveys the idea that the victim is responsible for her own destruction. As far as the subject of action is concerned, the act of killing herself shifts attention from the rapist to the victim.[14] But as a consequence of the non-representability of rape, spectators/readers reinterpret the self-murder rhetorically as metaphor. This consequence, then, shows that the notion of rhetoric can be extended, as was the notion of semiotic, to signify the real.[15] By this I do not mean that rhetoric is exactly identical with "literal" language, but that rhetoric is important because of the very difficulty it presents in deciding which reading is literal and which is figural. But before such an extention of rhetorical concepts can be useful in analyzing the "Rembrandt" Lucretias, we must consider whether we can really use rhetorical concepts for the analysis of visual works.

Using rhetoric for the analysis of visual works assumes two things: first, that figures of style, or rather, figurations of meaning, are used not only in language but in other media as well. That is to say, concepts from one field, literature, are not merely being metaphorically transposed to the other,

visual arts; rather, both already use the same devices to shape meaning. In the following pages, I shall try to substantiate the claim that rhetoric is as visual as it is verbal, and that the two can be separated only on the basis of an artificial *a priori* distinction.

The second claim, equally basic to this study, is that rhetoric, by shaping meaning, constructs reality through the construction of the meanings it offers reality to work with. That is to say, the rhetorical analysis does not stand in opposition to the real issue of rape. Rather, it partakes of it, the rhetorical figurations helping to construct the views of rape dominant in the culture in which the rhetorical discourse or image functions, and condition the responses to real rape (Estrich). Like the first claim, the second posits the inextricable intertwining of verbal and visual representation. Real rape is already, according to this claim, a representational act. If the first claim is one of method, the second is both concerned with method, based on semiotic principles as it is, and directly related to the concern of feminist scholars about their work's ability to contribute to changing reality.

The importance of seriously attending to rhetoric becomes obvious as soon as we look again at the metaphor of suicide in the "Rembrandts." The use of metaphor raises the question of motivation: why compare this tenor—the content of the metaphor—with this vehicle—the metaphoric image? This motivation is more often than not metonymical: a sign represents the rape not by similitude but by temporal contiguity, just as a consequence can represent its cause, or a later event its predecessor (Genette, "Metonymie"). Read metonymically, then, we would interpret the scene depicted in the Lucretia paintings as follows: rape *is like* self-murder (metaphor) because rape *leads to* self-murder (metonymy). In other words, the choice of a rhetorical term is itself already an ideological decision. By limiting ourselves to metaphor, we displace responsibility onto the victim— emphasizing "self" rather than "murder." In contrast, if we use metonymy as well, responsibility is returned to where it belongs: to the rapist and the rape as destruction—to murder, rather than "self."

But if rhetorical terms are so important, then we need not stop at a metonymic reading. Synecdoche—that is, taking the detail to stand for the whole, *pars pro toto*—can become another important tool in reading the painting. By using that rhetorical strategy, self-murder becomes the "detail"

representing the entire process. Lucretia's raped body part comes to stand for her whole person, just as her suicide, *her* act that stands for herself, comes to stand for the entire story, the rape and its consequence. Not only is the rape itself thus brought back into sight, but the rape also recovers its place as the act that brings about the *murder* of the *self*.

Reading synecdochically, then, emphasizes the fact that rape *has* consequences, that it alters the victim definitively. In this sense, Lucretia's suicide does not suggest her own culpability, but emphasizes instead her position as victim, and the perpetrator's responsibility for both the rape and Lucretia's death—for the rape *as* her death. Reading synecdochically includes the rapist in the representation. He becomes again a part of the represented whole, despite the fact that—or even because—he is invisible in the painting. And as he is synecdochically reinstated in the scene, his vacant place needs to be filled. The urge to fill that place involves the viewer.

In order to avoid the social clichés associated with rape, we must complicate our rhetoric even further. We can do so by returning briefly to the details of the earring and the dagger in the 1664 *Lucretia* to see how another trope is also at work here. The movement of the earring and the doubling of the dagger's point, which produce a tension between the static composition and the dynamic effect, might allow us to ask to what extent Lucretia is subject of the act and object of the representation.

The frontal light becomes significant in answering this question by helping to produce the tension between these two contradictory positions. If we can see the figure of Lucretia as a body on display, other details become meaningful. The woman—the subject, or rather, object of the representation—stands right in the middle of the canvas, her body turned directly toward the spectators. So does her upper gown which, closed beneath the bosom, has an opened "lock." This opened closure refers rhetorically to the violent opening of Lucretia, to her rape and to her display at the same time, with the latter coming to stand for the former as we have seen. The chaste Lucretia, thus, has become public property by her rape; she has been opened to the public. The visual representation of the woman at the moment of her self-killing partakes of this "publication." Lucretia is put on display for the eyes of the indiscreet onlooker.

Once we are reading in this mode, there is little to stop us. In the face of this display, Lucretia has her arms spread as one crucified. Within the Christian culture in which this painting of a secular subject functions, the connection with Christ's martyrdom can readily be established, initiating another metaphor, one that operates to pernicious ideological effect. For in the crucifixion the victim is doubly complicitous: he accepts his own death, and as a human being he is complicitous in the human sinfulness that supposedly makes his death deserved. Hence, for those viewers who establish this metaphorical connection, there is yet another reason to concentrate guilt on the victim. The crucifixion seems a valorization of the same process of displacement of guilt, of accepting guilt as necessarily redounding upon the victim of violence. In this process the acceptance of guilt is a means of asserting identity between victim and assailant.

But again, using metaphor by itself obscures another set of meanings that using the other rhetorical concepts brings about. Although the pose is in iconographic concordance with Christ, Lucretia turns her face away with just a little more insistence—as the earring's movement shows. This movement appeals to the spectator, makes present the painting's external spectator through a direct address, as an *apostrophe* (Culler, "Apostrophe," in *Pursuit*; Johnson, *A World*). This device, so common in lyric poetry, makes the semiosis personal and makes the reader/spectator aware of her or his own position. The movement is the equivalent of a powerful speech act. This speech act establishes a continuity between the subject of address and the addressee. Thus Lucretia's pose can be activated as a metonymy that writes the spectator into the painting.

But if Lucretia's turning away is a sign of such an apostrophe, who is being addressed? Within the story and within this scene, the father and husband are present, hence addressable. But the part-of-the-whole reading of synecdoche which would conflate the gesture as an appeal to father and husband—legal owners—with repulsion of the rapist—illegal appropriator—would make those two an inappropriate choice. Outside of the story the spectators become potential addressees. But as they are metaphorically identified with the witnesses inside, because they too are witnesses, looking at somebody who does not want to be looked at, the spectators become

"rhetorically" contaminated by the similarity between their positions and those of father and husband, and through the positions of husband and father, by that of the rapist.

But the addressee of apostrophe, traditionally out of reach, might merely signify the speaker's isolation and emphasize the rhetorical status of her hopeless address. Lucretia turns her head away in order to break contact with the spectators, preferring isolation to remaining an object of their voyeuristic gaze.[16] Her upraised left hand, then, comes to signify resistance to that gaze, a request to the viewer to turn away. Denying contact with others in this final moment of death by her own hand, she seems to say that she alone can perform it. Even the pitying, sympathizing onlookers are, at this moment, indiscreet and superfluous.

The duplication of the dagger's point is the second detail that now becomes a major sign. It points to the rape victim, who is so much destroyed as a subject that her personality disappears behind that of the rapist. The rapist dictates her self-image to her. *His* murder of her subjectivity becomes *her* self-murder. This is often expressed in the self-blame rape victims express: "I must have deserved it." The idea that the rape was a punishment stems from the feeling of worthlessness, of being nothing, which in turn comes from the experience of having been taken possession of. Only by *becoming* the rapist is the woman able to perform an act which, however negative and destructive it may be, is the only illusion of self-determination she has left.

The replication of the one—the rapist—by the other—the woman—is signified in the duplicated shadow of the dagger. Dagger and penis, the weapon of the victim and the weapon of the rapist, become each other's metaphor. The violent penetration of the alien and hard, destructive object into her body occurs *twice*. The dagger thus represents the feeling of guilt, which seems to be part of the experience of rape and which rests on a causal reversal: the thought of being nothing and *therefore* of having deserved, caused, the rape. This reversal is an ultimately desperate means of fighting the destructiveness of rape at least partially, for one who is guilty must exist. This reversal of cause and effect, a reversed metonymy, continues to be a cultural commonplace. The person who has been raped cannot live any longer, and she is the first to agree; she has to be raped again, by the dagger,

by the public conception of rape, by others—police, court officials, the rapist's lawyer—and by herself.

The direction of the dagger in the 1664 *Lucretia* emphasizes this point even more. Lucretia directs it to the bottom of her bosom, to its vertical middle and the composition's center. This composition makes us aware of the display of Lucretia's body. Just as the rapist's penis was directed toward her vagina—that part of her body which, in the eyes of the rapist, defines her synecdochically as a woman and makes her "rapable"—just so the dagger aims at this figuration of it, this part so similarly shaped but decently displaced to higher regions, representable and visual: her bosom. The bosom, close to her heart, is thus metonymically related to the heart, an organ which, according to the commonplace, is the site of or metaphor for feeling, for self-experience.[17] There, at the heart of the body, of Lucretia's selfhood, the dagger will perform its destructive penetration. This figure, the displacement of the "literal" wound to the metaphorical one, reminds us again of the wandering womb, emblem of Freudian displacement and of this reading that attempts to recover what has been repressed.

lucretia's last moment

The second *Lucretia* is not only a later product; it also represents a later phase in the story. Lucretia has already struck; she is bleeding. She still clutches the dagger she has already removed from the wound, an act that is done by Brutus, one of the onlookers, in Livy's story. In that tale Brutus uses the bloody dagger as a sign to instigate the revolution that will end the tyranny of the kings and inaugurate the Republic. But by removing it herself, Lucretia robs Brutus of this opportunity to use her drama semiotically for political purposes.

By keeping the dagger in her own hand, it not only serves to remind the viewer, then, of the rapist's weapon; it also draws a parallel between rape and this use made of it to further political ends. We might even suggest that in a sense Lucretia is also using the bloody dagger semiotically for political purposes; but Lucretia's politics hold that the political is personal, while Brutus makes this personal experience highly political.

In the image of her hand holding the bloody dagger, we can clearly see the two levels of meaning that run through the painting. On the one hand, Lucretia can be thought of as wielding the dagger against herself in her guise as a substitute for the rapist; in this reading she continues to conform to the image of the rape victim who exists only as the mirror of her assailant. On the other hand, in a rhetorical reading she can be seen as wielding it for herself, as one excluded from the rather limited democracy about to be initiated.

The dagger in the second *Lucretia,* pointed towards her vagina, emphasizes the idea that the victim compulsorily repeats her rape. The oblong wound denoted by the bloodstain on the white gown becomes now a more iconic representation of the wounded vagina;[18] displaced upward, and to the left of her body (to the right for the viewer), it is nevertheless metaphorically identifiable by its shape, color, and location as an analogue of the *locus* of Lucretia's destruction.[19]

The gown, by virtue of the more emphatic exploitation of the three-quarter format, seems magnified, compared to the one in the Washington painting, where it was only a small part of her clothing. Thus it suggests an indiscreet display of the belly and represents much more explicitly that the woman's body has been raped: wounded, destroyed, and made public.

Bell cord and curtain cord join the double sense of the dramatic which is at stake in the case of rape. The cord Lucretia holds has been interpreted in various ways. Held (54) interprets it as belonging to a stage where it would control the curtain. Alpers (*Enterprise,* 146), within her discussion of the studio, sees it rather as a model's sling, a studio device. I do not find this either/or argument useful ; rather, the collusion—or maybe even collision—of the two meanings is what interests me, as both together would enhance the work's complexity in challenging ways. To be sure, Lucretia does seem to be holding the cord as if for support. Within the present perspective, the cord thus becomes a metonymical representation of the two central events in the aftermath of the rape. As a bell cord, it can indicate an appeal to the men—father and husband—called upon to avenge her. As a curtain cord, it can indicate the opening of the curtain of the stage, Lucretia's "publication," her display. Lucretia has become drama, both inside and outside the story. That the model's sling, which the cord doubtlessly also is, would be used in

this manner may be typical of Rembrandt the studio master, as Alpers would suggest; it is also typical of the viewer's interpretive impulse that we let it have these meanings. Inside, the drama already performed by the rapist unfolds itself again for the men whose property she is. Outside, the dramatic relation between the painting and the public, the spectators to whose gaze she is subjected, is manifest.[20]

In Livy's story Lucretia kills herself for two reasons: she fears for her reputation, and she wants to set an example for other women. In Livy's text, the rape equals destruction, not because it denies the woman's subjectivity, but because it is an assault on her chastity, her exclusive possession by some other man. Livy makes her say that her suicide must prove her innocence. A culture that makes women believe they have either caused or imagined their rapes pushes victims toward self-destruction; and that *self* destruction, which completes the destruction initiated by the rapist, is supposed to show their victimization.

If we read in complicity with the Livy story, then, the red stain on the white gown, the sign of the suicide that proves her chastity, can be seen as an allusion to a very old tradition of visual positivism: the widespread practice of showing the bloodstained sheets after the wedding night as evidence of the bride's virginity. The large stain on Lucretia's body "proves," by a metonymical allusion to that tradition, that Lucretia's chastity has been violated, even if "technically" she is not a virgin. Again, then, we see a duplication, not of the weapon but of the raped organ.

This duplication helps us see the representation as a story, but not exactly the traditional one told since Livy. Recognizing the 1666 *Lucretia* as another story changes the relationship between Livy's text and the "Rembrandt." No longer are the two texts related hierarchically with Livy's as "primary" and "Rembrandt"'s as "secondary," or with Livy's as story and "Rembrandt"'s as illustration. Rather, the painting re-presents the culturally available story, the doxa, and proposes its own story as a response to it. This response partially reaffirms, partially denies, or revises the tradition, counters it polemically and undermines it. To the extent that no re-production of a story can completely duplicate its "sources," the cultural life of the legend is always active, always transforming the cultural view of the fictitious "source" to which each work contributes.

Thus a painting can contribute to the transformation of a view held by the culture in which it functions; this painting does so by representing its own interpretation of rape. By conveying a suggestion of a succession of two moments, the moment before the rape and the moment after, the 1666 *Lucretia* emphasizes rape's deadliness. Read rhetorically, the slit in the top of the gown depicts the intact nightgown-hymen of the innocently sleeping Lucretia, and the lower, bloody slit depicts her wound, her femininity chaste before and violated after the rape. The two moments are related to each other in several ways, which form the links constituting the structure of visual narrative.[21] From a narrative perspective they succeed each other. Metonymically they are causally related, and metaphorically they represent each other. Together all three of these relationships figure the displacement of hysterics. The diagonal cord or chain relates these two moments of innocence and safety to wounding and mortal terror by leading our gaze from the first moment to the second. By thus making us aware of the movement of our gaze, the cord has a critical potential: by following it with our eyes, we can break the painting's stillness and the abstraction of our own gaze.[22] As a result, we become participants in Lucretia's story, but the role we are to occupy remains a disturbing question.

conclusion

As pointed out by Winifred Woodhull in the collection *Feminism and Foucault,* the problem of how to view rape and how to act upon that view is far from being solved. The 1970s gave rise to a lively debate in France that centered on Foucault's proposal to separate rape and sexuality, and instead to treat rape as an ordinary civil offense. This view was based on Foucault's relational concept of power, which would "shift the emphasis from power's repressive function … to its productive function."[23] Woodhull goes on to argue that

> instead of sidestepping the problem of sex's relation to power by divorcing one from the other in our minds, we need to analyze the social mechanisms, *including language and conceptual structures,* that bind the two together in our culture. (171; emphasis added)

One can see how the foregoing analyses fit into this program.

The conclusions that can be drawn from these analyses are threefold: they relate to the domain of the social, to the domain of the semiotic in general, and to the specific relations between the verbal and the visual. Rape, as I have tried to argue, is encouraged by cultural attitudes that are hostile not to the phenomenon of rape but to its victims. These attitudes can remain in force because of the frequently held misconceptions about meaning which allow the rapist's usurpation of the authority over meaning to pass unnoticed. The radical separation of seeing and speaking, not only in academic disciplines but also in gender relations, fosters these misconceptions.[24] Reversing these cultural attitudes is crucial.

The semiotics of rape, available through a rhetorical-visual reading, can help us to redefine rape in a way that will change cultural attitudes toward it and allows those changes to be translated into measures—juridical, medical, therapeutic—that will make rape not only intolerable but untolerated. To that end, it is crucial that we recognize that besides being violent and aggressive, rape also has the following characteristics: first, rape is a language, a body language. It speaks hatred caused by fear and rivalry. As a speech act, it is the "publication," the public appropriation, of a subject. It turns the victim into a sign, intersubjectively available. The speech act of rape signifies the arbitrary relationship of sign to meaning, of men to offspring through the indispensable mediation of the woman whose children his children really are. Therefore, the primary meaning of rape for the perpetrator is revenge, a crime of property; the victim becomes anybody's property because she is no longer one man's. Second, it is important to remember that the goal of rape is the destruction of the victim's subjectivity, a destruction necessitated by the problematic self-image of the rapist. This destruction is accomplished by the alienation from self that ensues as a result of the experience of hatred being spoken in one's body by means of another's, by forced contiguity. As a consequence of the semiotic nature of rape, the victim, a member of the semiotic community in which the rape takes place, understands and internalizes the message of annihilation absolutely. She is destroyed, hence unable to participate in semiosis anymore. Just as her body has been appropriated, so too her semiotic competence has been usurped and her semiosis becomes the other's. As a consequence, the most characteristic result of rape is the victim's agreement with the rapist's hatred of her. The victim is not only

blamed by others, she also blames herself, because she is not addressed, not spoken to, but *spoken.*

Any change in the culture that aims at putting an end to the proliferation of rape should start at this last point, should help survivors undo their assimilation to the rapist by emphatically refusing their guilt. The cleaning of the Washington *Lucretia* shows us how this transition can take place, for it brought the dying woman back to life by granting the movement of her arms the attention it called for. But rather than turning violently against herself, as Lucretia did, the raped woman should be helped to listen to the other story of her own movement. As the emblematic cultural story of rape, Lucretia's case must be replaced by stories such as the one of Ayoko in Buchi Emecheta's novel *The Rape of Shavi,*[25] because it is both allegorical and real; and because it describes both the woman's experience and its meaning for the culture as a whole in which that experience takes place. It is here that semiotic analysis, as an interdisciplinary endeavor that suspends the specifics of different media, becomes relevant. Through semiotic analysis it becomes possible to understand a social phenomenon like rape in terms of representation, which is an important dimension of the problem of rape that has remained otherwise unexplored.

But what is the point of discussing rape through paintings and novels? For one thing it is important because these works are public, intersubjectively available for scrutiny; but is it really possible to move back and forth between the real issue of real rape and the representations of fictional rapes in "high" art? The crux of this problem is the relationship between meaning and experience. Analyzing such a relationship might shed light on my ongoing appeal to empathy with the victim of rape. Therefore I would like to return briefly to an issue raised earlier, that of the location, the status, and the nature of meaning.

Teresa de Lauretis is one of the few semioticians willing to explore the tenability of the apparent watershed between a materialist-historical semiotics such as that developed by Umberto Eco, which locates meaning rigorously in the social domain, and a subject-oriented semiotics such as that developed by (Lacanian) psychoanalysis. In her centrally important paper "Semiotics and Experience" (*Alice*), de Lauretis rereads Peirce's famous definition of the sign:

> A sign, or representamen, is something which stands to somebody for some-
> thing in some respect or capacity. It addresses somebody, that is, it creates in
> the mind of that person an equivalent sign, or perhaps a more developed sign
> [the interpretant]. (Peirce 2:228)

In spite of the problems of mentalism in some of Peirce's formulations, this
widely endorsed definition stages the interaction between the social and the
subjective. De Lauretis rightly argues that this definition provides ample
support for the notion, quite insistently argued away by Eco (*Theory*), that
meaning is produced by the users of signs, not solely by the sender:

> [T]he interpreter, the "user" of the sign(s), is also the producer of the meaning
> (interpretant) because that interpreter is the place in which, the body in
> whom, the significant effect of the sign takes hold. That is the subject in and
> for whom semiosis takes effect. (179)

De Lauretis makes the decisive move to theorize the concept of experience in
these Peircean terms by placing experience within the realm of Peirce's enig-
matic concept of the habit. This concept is Peirce's bridge between the indi-
vidual and the social. De Lauretis writes: "The individual's habit as a
semiotic production is both the result and the condition of the social pro-
duction of meaning" (179). The habit is shaped by experience. Experience,
then, is not predicated upon some innate femininity that qualifies every-
thing that subsequently occurs for the female subject, but is a product and
producer of meanings in which the subject is implicated and through which
the subject is produced and reconfirmed as gendered.

Within such a view of experience as the producer and product of
meaning, it is not only possible but necessary that we posit experience as
centrally operating in interpretation. Rape, a cultural phenomenon that par-
takes of the production of meaning, is then inextricably intertwined with
the representations circulating about it. For rape itself is immersed in mean-
ings, again, not transhistorical or universal; it is immersed in meanings
through fluctuations of its embeddedness in doxic representations and
interpretations of those doxic representations that condone rape because it
duplicates the enforcement of the violent, alien meaning inside a body; it
duplicates the dislodging of the subject that occurs in myriad forms in the
process of acculturation.

The place of visuality in the semiotics of rape has turned out to be crucial. But this dimension became apparent only once I had integrated rhetoric with vision. As long as we keep respecting the arbitrary and mystifying dichotomy between "literal" and "figural," the positivistic ideal of objectivity will always be a hindrance, rather than a help, to understanding experience. We have seen that a visual reading with the help of rhetorical concepts can mediate between what the culture, in the name of the rapists, tries to suggest and what the experiences really is. The counter-action I propose is radically readerly: works of art that offer public texts for reading propose images whose ambiguity allows for this resistance.

But this visual rhetoric has a second effect, equally crucial. The movement of Lucretia's earring, the movement typically denied to painting by the cliché views on the sister arts, introduces the idea of a narrative that ends in Lucretia's death. Like that narrative, rape is not a single event; instead, with a cause and a consequence that narrative shares, rape is the cause of the end of a story. That is why it equals murder: it leads to the ideal end—to death. The realization of this murderous quality of rape is the first step toward an adequate treatment of it in our culture, a treatment that looks into the space between verbal and visual expression.

This is why I chose to discuss, in a book on "Rembrandt," the case of rape. The problem of rape is too urgent to be dismissed as irrelevant. Art forms repeatedly choose it as their privileged theme; rape must be taken as emblematic for our culture. Too pregnant with relevant and problematic meanings for all members of our culture to be dismissed merely as "high" culture, as elitist, these representations of rape are central in any definition of culture one can come up with. Fully realistic yet fully rhetorical, utterly readable yet totally ambiguous, the works discussed here can bring us closer to the experience of an art that is not only part of social life but constitutive of it. As I hope to have shown, arbitrary or ideological delimitations of the domains of the visual and the verbal can only serve to obscure the urgency with which these works confront us. In a certain manner a raped woman can stand for every interpreter who can opt to identify with her. For in a sickly acute and definitive way, every interpreter is what the rape victim is: to repeat de Lauretis's phrase, "the body in whom semiosis takes effect."

notes

1 On the ambivalent attitudes toward allegory in contemporary scholarship, see Owens (1984). For an excellent understanding of the allegorical impulse, see Fineman (1980). The basic text is, of course, Benjamin's *The Origin of German Drama.*

2 In a very broad sense, we can speak of Dutch culture in the seventeenth century as a *textual community* in Stock's terms (*Implications,* 90–91). The best description to date of this community is Simon Schama's wonderful *The Embarrassment of Riches.* The *visual* culture of that community as analyzed by Alpers (*Describing*) can best be imagined as partly overlapping with Schama's description. Hence the visual culture of that community forms that part of the *textual* community that is concerned with visuality. In order to confront my analyses in this book with historical evidence, a similar analysis of the culture's textual base would be needed: what did people read, and about which texts did they talk, not only the burgher elite but the larger community? Sermons held in churches are a powerful source for such an inquiry. Although this is, for the time being, only an idea for a project, its relevance could be demonstrated by the sheer number of scholars who base their claims on unexamined assumptions about this textual community. Several examples can be found in Schwartz (*Rembrandt*); for example, his assumptions about the Samson myth.

3 I am well aware of the difficulty of analyzing rape in terms of semiotics only. The all-too-real horror of rape thus seems to be left out of the discussion. However, my claim is not that semiotics exhausts the subject, but that it should be included.

4 No further argument is needed for this untenability since the appearance of Hayden White's *Metahistory* and *Tropics.* The classic on argumentative rhetoric is Chaim Perelman's *Rhetoric;* on rhetoric as *l'art de bien dire,* as ornamental language, and the tropes and other figures of style, J. Dubois *et al.* (1981).

5 Let me emphasize once more that claiming that rhetoric touches, has an effect on, reality is not the same as claiming that reality is only rhetorical.

6 Gary Schwartz confesses his lack of data to reconstruct the circumstances under which the late history paintings were made. About the Lucretias he provides no clue. About the subject of Lucretia he writes nevertheless confidently: "The story of Lucretia, appearances aside, was pure political allegory in the circles of Rembrandt's patrons" (*Rembrandt,* 330). The notion that allegory explains away an entire subject is alien to my enterprise in this study. I have argued at greater length for a literal understanding of the rape scene in Judges 19, equally subject to being explained away as mere allegory, in *Death and Dissymmetry.* Svetlana Alpers's recent book on Rembrandt makes a powerful use of a detail of the

second *Lucretia* on its cover. Alpers focuses on Rembrandt's handling of paint. Her remarks on the second *Lucretia* (*Enterprise*, 80) will be discussed later.

7 In Dutch, the two earlier rape scenes would not be referred to as rapes, but "simply" as abductions. And abduction is not, in the legends of antiquity, systematically represented as against the will of the abducted woman, whereas actual rape is against her will by definition.

8 As I suggested earlier, the way I deal with the paintings allows me to dispense with inquiring into the difficult problem of their authenticity. Moreover, the whole discussion seems highly problematic to me and cannot be seen outside the situation of power and the economy, and the investments art historians have therein. Semiotically speaking, the endeavor to tell a "real" from a "false" Rembrandt falls flat when confronted with its own premises. If the production of art in the seventeenth century was as much based on studio work, teaching, and collaboration as the researchers claim, then the whole notion of authenticity loses at least part of its meaning. In the face of this frustrating research, Svetlana Alpers provides answers to the authenticity problem by displacing the question, turning the very deceptivity of Rembrant's hand into a feature of his art.

9 Regrettably, both details are hardly visible on the copies printed here. They do come out quite strongly on the canvas, although they are definitely details—of the "clitoral" kind, as Schor would say. A comparable detail is the blurred sleeve of the arm holding the dagger. This blurring emphasizes both movement and foregrounding. The frontal lighting is functional in bringing out the sense of display and the ambivalent address of the viewer.

10 This meaning of realism is not to be confused with considerations of the historical reality of either the event or the production of the painting. The best source for the latter aspect of "Rembrandt" is Alpers's (*Enterprise*) account, which is more analytical than Schwartz's (*Rembrandt*) anecdotal one. Alpers proposes an interpretation of the second *Lucretia* that is entirely different from, but not in the least incompatible with, mine.

11 There are, in fact, visual representations of the act, as for example in Titian's *Rape of Lucretia*. In instances where the act itself is represented, the ambiguity lies either in the grotesque quality of the representation as a whole, as in a painting by Christiaen van Connenbergh (Vandenbroeck), or in the theatricality of the representation of resistance. Again, there, the rape tends to be represented as the victim's own doing. But I will argue that the metaphoric representation of rape as suicide is even more pernicious than that.

12 "Under conditions of sex inequality, with perspective bound up with situation, whether a contested interaction is rape comes down to whose meaning wins" (MacKinnon 652). There are reasons enough to prefigure whose meaning has a chance of winning, by inserting focalization as the figuration of the woman's

experience within the evidence. Tania Modleski analyzes how unself-evident this is apropos Hitchcock's *Blackmail* and its critics:

> Patriarchal law can hardly consider her innocent, nor can it possibly offer her real justice, since its categories precisely exclude her experience—an exclusion to which the critics we have quoted amply bear witness as they strain the limits of patriarchal discourse in order to subdue the truth of this experience. (28)

13 There is an enormous literature on metaphor. A powerful introduction is provided by Lakoff and Johnson, *Metaphors.* Their later *Women, Fire, and Dangerous Things* is also important, as is Lakoff's later book, *More Than Cool Reason,* co-authored by Mark Turner. Perhaps the best-known theory is Ricoeur's *The Rule of Metaphor.* Particularly relevant for this chapter is Sweetser, *From Etymology to Pragmatics.* Mark Turner offers an unorthodox account in *Death is the Mother of Beauty,* whose title alone is pertinent to this chapter.

14 The question "Who acts?" is one of the three key questions of narratology as I see it. See especially my *Death and Dissymmetry,* ch. 1, for an overview with a justification of the relevance of these questions.

15 This possibility is implied in Peirce's distinction between dynamic object and immediate object. For a discussion of Peirce's view of the object, see Umberto Eco, "Peirce and the Semiotic Foundation of Openness"; for a discussion of Eco's paper, see de Lauretis, *Technologies,* 38–42. See also de Lauretis's seminal "Semiotics and Experience" in *Alice Doesn't,* to which I will return in the conclusion of the present chapter.

16 The concept of *gaze* as opposed to *glance* has been revitalized by Norman Bryson in his *Vision and Painting* (1983). The abstraction from the spatio-temporal position on the onlooker that is implied in the gaze is precisely what makes it voyeuristic. Feminist film theorists have criticized the assumption that the gaze is by definition male. See Kaja Silverman's seminal "Fassbinder and Lacan" for a brilliant revision of the Lacanian concept of the gaze.

17 In the seventeenth century the bowels were often considered the seat of feeling. For an audience holding that view, there would not have been metonymy here; for contemporary viewers, there is. Since I am mostly addressing issues of work-viewer interaction, this historical change only limits the validity of the metonymical interpretations, but it does not undermine it.

18 Note that the term "iconic" is meant here in a specifically Peircean sense as referring to signs that relate to their meanings on the basis of a formal analogy. As I wrote before, I do not want to suggest that the visual is by definition the domain of the iconic. On the contrary, in this chapter I am making the case that Peirce's three modes of signification, the iconic by analogy, the indexical by contiguity, and the symbolic by convention, are unevenly and unpredictably distributed both in visual and in verbal works. For example, the interpretation of the wound as an iconic representation of the vagina does not appeal to visuality, any more

than taking the wound "literally" does. Both interpretations are starting from the visual sign and giving it verbal meaning, complex and plural in the first case, singular in the second.

In spite of its sharp insights into the process of semiosis, I find Eco's rejection of Peirce's three concepts not altogether convincing; nor do I find his alternatives, useful in themselves, sufficient to replace them (*Theory*). I prefer to define and relativize them carefully.

19 This interpretation receives support from Alpers's remark on the thickness of the paint as representing the artist's physical engagement with the violence. The use of red paint in thick layers for the representation of already thickening blood makes of the painter a *sculpteur manqué* (*Enterprise*, 31). In a later chapter on performance in the studio, Alpers relates the question of impasto with that of theatricality and the work in the studio. Comparing a sketch of the dead body of an executed woman with the *Lucretia,* she draws attention to the pragmatic dimension of the work. She writes: "But for the blood which stains the pleated cloth over her breast red, the three-quarter format and the figural authority are characteristics of Rembrandt's later works." And: "In his studio, death becomes an event: description (of Elsje) is replaced by enactment (on the part of Lucretia)" (80).

20 Painterly canvas or theatrical curtain, in Dutch the word (*doek*) is the same. Hence, even the appeal to history and authorial intention cannot decide here. For a historical study of the relationship between painting and the theater in Italian Renaissance art, see Damisch (*Nuage*).

21 The idea of visual narrative must be sharply distinguished from that of the visual rendering of a verbal narrative. One of the major arguments of this study is for the importance of a specifically visual, yet decisively narrative, mode of signification.

22 This is a good example of the critical potential of Bryson's theory of the logic of the gaze. In his terms, the gaze would here be broken and the glance would take over, thus engaging the viewer's own bodily presence and, I would add, instating visual narrative.

23 Winifred Woodhull (1988), 168. This article provides a good brief introduction to the current state of the debate on rape. Woodhull is critical of Foucault's position, while using his theory of power to get away from essentialist accounts of rape such as Brownmiller's, and from an overemphasis on socialization which often verges on the brick of essentialism. Foucault's statement appeared in the Change Collective publication *La Folie encerclée* (1977), Monique Plaza's response in *m/f* (1980).

24 Mitchell (*Iconology*) demonstrates that the distinction between verbal and visual inevitably brings with it a hierarchy, in which either one or the other sense is superior, and a chain of related dichotomies, like time and space, intellect and sense, and, of course, male and female.

25 The original chapter of *Reading "Rembrandt"* contained an analysis of this novel (96–98).

on show: inside the ethnographic museum[1]

<div style="text-align:right">4</div>

for "A," in loving memory

setting as image, nature as sign

NEW YORK CITY, IN MANY WAYS THE heart and icon of American culture, allows the casual stroller to be struck by the semiotic charge of the environment. Its very layout, with its central axis centripetally drawing toward its green heart that is reminiscent of the indispensable nature it has replaced, and its monumental avenues running alongside the park, conveys the importance of a balanced intercourse between background and figure, overall plan and detailed specifics, and organization and spontaneity.

The tourist entering Manhattan from downtown might not even be struck by the neat symmetry in the heart of the city: Central Park, the token of an indispensable, domesticated preserve of nature-within-culture, with two major museums, preserves of culture and nature, one on each side. The symmetry is taken for granted; so is the rationale that sustains it. The city plan itself points to aspects of the city's life.

To the right, on the more elegant East Side stands the Metropolitan Museum of Art, the MMA or "Met": the treasury of culture. The world's

great art is stored and exhibited here, with a quantitative as well as an expos-
itory emphasis on Western European art, as if to propose an aesthetic basis
for the social structures that reign in this society. It makes the world around
the park look almost normal.[2]

The museum fits all the priorities of its own social environment: Western
European art dominates; American art is represented as a good second
cousin, evolving as Europe declines, while the parallel treatment of "archaic"
and "foreign" art, from Mesopotamian to Indian—it is literally kept in the
dark—contrasts with the importance accorded to the "ancient" predeces-
sors—the Greeks and Romans. The overall impression is one of complete
control, possession, storage: the Met has the world's art within its walls; its
visitors have it in their pockets.

The West Side is, today at least, less "classy." On the left-hand side of the
park stands the American Museum of Natural History. At around 10 A. M.,
yellow dominates the surroundings as endless numbers of school buses dis-
charge noisy groups of children who have come to the museum to learn
about life. A booklet for sale in the museum, first published in 1984 and reis-
sued in 1990, and somewhat pompously entitled *Official Guide to the
American Museum of Natural History,* makes sure that the public does not
underestimate the institution's importance on the city map. It begins as
follows:

> The American Museum of Natural History, a complex of large granite build-
> ings topped by towers overlooking the west side of Central Park, has spread
> its marvels before an appreciative audience for over a century. Its stored trea-
> sures work their magic on millions of visitors every year and are studied by
> resident and visiting scientists and scholars from all over the world. A mon-
> ument to humanity and nature, the museum instructs, it inspires, and it pro-
> vides a solid basis for the understanding of our planet and its diverse
> inhabitants.[3]

The *Guide* is nothing like a guide: it provides no floor plans or lists of
exhibits, nor does it suggest an itinerary or feature a catalog of the museum's
collection. Instead, it is emphatically a self-presentation representing the
main thrust of the institution's ambition. If taken as a symptom of the
museum's sense of self, it strikes one in its insistence.[4] The grandiose image
of the museum is clearly not taken for granted. The emphatic and repeated

representation of the institution's ambition signals an unease about itself, a lack of self-evidence that harbors the conflicts out of which it emerged and within which it stands: an un-settlement.

There is nothing surprising about this unease: we are confronted with a product of colonialism in a postcolonial era. The past clashes with the present of which it is also a part, and from which it cannot be excised even though it keeps nagging from within the present, like a misfit. By way of exploring the issues pertaining to display, the unsettlement at the heart of this monument to settlement and the ways it is dealt with form the subject of inquiry of this chapter.

This monumental institution houses the "other" of the Met in three senses, all of them paradoxical. First, it is devoted to nature not to culture. But here nature is equipped with that fundamental, defining feature of culture: history. Second, in this museum animals predominate, presented in their "natural" setting, whose representations are crafted with great artistic skill. The natural setting is the backdrop of the animal kingdom. But then, several rooms are devoted to peoples: Asian, African, Oceanic, Native American. These rooms represent the Met's "other" in the third sense. In the Met it is precisely these peoples whose artistic products are represented in remote and dark galleries. They are the "exotic" peoples, those who pro-duced works that we, unsure of our judgment, only reluctantly classify as art. Their works of art are exhibited here as artifacts, rigorously remaining on the other side of James Clifford's Art-Culture System.[5]

The juxtaposition of these peoples' cultures with the animals reflects the conflict that lies at the heart of this museum and that distinguishes it from its unproblematically elitist colleague on the other side of the park. In fact, through this division of the city map, the universal concept of "humanity" becomes filled with specific meaning. The division of "culture" and "nature" between East Side and West Side Manhattan relegates a large majority of the world's population to the status of "static being," assigning the higher status of "art producers in history" to only a small portion. Whereas "nature" is a backdrop in the dioramas, transfixed in stasis, "art" presented in the Met is ineluctable in evolution, is endowed with a story. But the American Museum of Natural History presents its own story too: that of fixation, of the denial of time.[6]

Yet artistic production is an important part of the display in the represen-
tation of those foreign peoples. The artifacts function as indices of these cul-
tures, whose structures and ways of life have been elaborately crafted by the
museum's staff, past and present (mainly past). Yet their works of art are
indices not of the art of the peoples but of the realism of their representa-
tion. They serve an "effect of the real," an effect in which the meaning "real-
ness" overrules the specific meanings.[7] Instead of artifacts processed into
aesthetic objects as they would be on the east side of the park, they are
indices interpreted as nature.[8] The American Museum of Natural History
houses the Met's "other" in this sense too: it displays art *as* nature, for when
"nature" turns out to be difficult to isolate, "art" will assist, but as nature's
handmaiden. Whereas the Met displays art for art's sake, as the climax of
human achievement, the American Museum of Natural History displays it as
instrumental cognitive tool: anonymous, necessary, natural.

An exposition, both in the broad, general sense of "exposing an idea" and
in the specific sense of "exhibition," points at objects, and in doing so makes
a statement. The constative speech act conveys a "text," consisting of the
combined proposition of "these artifacts are natural (as opposed to artis-
tic)" and "this (conception) is real." I hope to analyze this text further,
decomposing it into its constitutive "sentences," as I read them during my
visit to the museum in 1991.

who is speaking?

A first element that needs to be brought out in the open is the invisible "I,"
the subject of the text, that slippery deictic element that has no meaning
outside the discursive situation of which it is a part. Let me be emphatic,
first, about the wrong answer that might slip in here: the expository agent is
not the present curators and other museum staff. The people currently
working in museums are only a tiny connection in a long chain of subjects.

Who, then, is this "I" who is "speaking" in the American Museum of
Natural History, what is this expository agent's semantic makeup, and which
discourse does it speak? For any museum with a past of this dimension, the
agent is both historically double and "monumental," serving collective
memory. The American Museum of Natural History's historical two-sided-

ness—its inherited status and material condition coupled with its agency within New York society in the 1990s—emanates from every pore of the building as you approach, then enter it.

The American Museum of Natural History is monumental not only in architecture and design but also in size, scope, and content. This monumentality suggests the primary meaning of the museum inherited from *its* history: comprehensive collecting as an activity within colonialism.[9] In this respect, museums belong to an era of scientific and colonial ambition stretching from the Renaissance through the early twentieth century, with its climactic moment in the second half of the nineteenth century. They belong in the category of contemporary endeavors, such as experimental medicine (Claude Bernard), evolutionary biology (Charles Darwin), and the naturalistic novel (Emile Zola), which claim to present a comprehensive social study. Such projects have been definitively compromised by postromantic critique, postcolonial protest, and postmodern disillusionment.[10]

But that troubling prefix "post-" doesn't make things easier. Any museum of this size and ambition is today saddled with a double status: it is necessarily also a museum of the museum, a reservation, not for endangered natural species but for an endangered cultural self, a meta-museum.[11] Willy-nilly, such a museum solicits reflections on and of its own ideological position and history. It points to its own complicity in practices of domination, while continuing to pursue an educational project that, born of those practices, has been adjusted to accommodate new concepts and pedagogical needs. Indeed, the museum's use of research and education is insisted upon in its self-representations, including the *Guide*. The "I" thus begins to point to itself.

The critique of nineteenth-century collectionism easily misses its purpose if it fails to confront the safely distant past—the Victorian era as the bad conscience of the late twentieth century—with the present, whose ties to what it critiques also need assessment. That is the trouble with "post-," as with the disciplines that pursue an archeology of meaning. On the one hand, the prefix suggests a detachment, a severing of the umbilical cord that binds our time to history; on the other, it reminds us of what it leaves behind, insisting that we settle accounts with the "post-" within ourselves.[12]

For the purpose of this essay, therefore, I will look at the meta-museum status of the displays in the American Museum of Natural History as I found them. I will examine how the gesture of display accords with the content of the proposition and how the museum as an expository agent shows its hand at showing others. This analysis engages the museum discourse *now*, and probes its effectivity today. The focus is not on the nineteenth-century colonial project but on the twentieth-century educational one. While Donna Haraway described and criticized the way in which the collection was compiled in the past, I will consider the rhetoric of the museum in justifying or passing off the legacy of that past ambition, its forms of address in the present: where "I" says to "you" what "they" are like.

The space of a museum presupposes a walking tour, an order in which the dioramas, exhibits, and panels are viewed and read. Thus it addresses an implied focalizer, whose tour produces the story of knowledge taken in and taken home. I will focus on the display as a sign system that works in the realm between the visual and the verbal, between information and persuasion, as it "produces" the walking learner. My analysis will concentrate on a small portion of the second floor, as it was when I visited it in the fall of 1991.

Entering the imposing hall at the main entrance on Central Park West, and already prepared by the monument outside, the words of Theodore Roosevelt fall upon the visitor. His statements are engraved on all four walls. The personification of the historical expository agent speaks of the values that this institution—at the time it was built—was meant to bring home to the nation. On the left, facing the visitor as s/he enters, is the statement "Youth," on the right, "Manhood." Turning around to see the writing on the other two walls, you read, on the left, "The State," and on the right, "Nature." To be very clear about what I mean by the need to pay attention to the meta-museum status of the museum, let me quote a line or two from each of the accompanying texts. Remember, we are reading what was written at the beginning of the twentieth century.

Youth
… Courage and hard work self mastery and intelligent effort are all essential to a successful life.

Manhood
… All daring and courage all iron endurance of misfortune make for a finer
nobler type of manhood.

The State
… Aggressive fighting for the right is the noblest sport the world affords.

Nature
… There is a delight in the hardy life of the open.
 There are no words that can tell the hidden spirit of the wilderness that can
reveal its mystery its melancholy and its charm.

The museum's installations come for the most part from a time when,
clearly, youth was defined through the virtues of masculinity and the goal of
life in terms of success. Masculinity in turn was defined by aggression and
sublimation. Nationhood promoted war, and women were not spoken
about. Nature was mystified in terms that both express and hide it ("hidden
spirit"), the qualities of femininity that put both nature and women up for
grabs.

 It is good, therefore, that these texts remain on the walls. All it would take
to make them work toward a better understanding of the historical embed-
dedness of what otherwise would seem to be a half-heartedness inside the
museum is an indication of that historicality. The agency of these state-
ments, which in the first decades of the century were intended to have ever-
lasting, universal value, could be inscribed within the chain of history by
pointing out how they demonstrate what history most prominently is—
change. The imposing, monumentally inscribed walls could be made the
first object of display instead of a display of unquestioned, naked authority.

 The most obvious problem of the American Museum of Natural History
is the collocation, in its expository discourse, of animals and foreign peoples
as the two "others" of dominant culture. The visual displays speak to the
visitor in more than just informational terms; they also present a surplus
discourse. It is on this surplus discourse that I will concentrate here.
Similarly, "collocation" is more than just visual juxtaposition; by speaking
together about animals and foreign peoples, the displays communicate an
ideology of distinction, which has this conflation as its sign system.[13] I
contend that the double function of the museum as a display of its own

status and history (its meta-function), as well as of its enduring cognitive educational vocation (its object-function), requires an absorption, *in the display*, of that critical and historical consciousness.

This double mission entails a specific exchange between the verbal and visual discourses. One could expect that whereas the visual displays, the dioramas which form the bulk of the museum's "treasures," must be preserved as objects of the museum's meta-function, the *Official Guide* and the panels containing verbal explanation and information, which are more easily adjustable and have, in fact, clearly been adjusted, would present the displays critically. The sign system of the verbal panels constitutes precisely the museum's luck: it provides the latitude to change.

Putting forward the "I," the expository agent who is "speaking" this text, means transforming the interaction between visual and verbal representation so as to allow the one to have commentary on the other. The displays can then point at their own discourse as not natural, as a sign system put forward by a subject. The written panels do demonstrate an awareness of the burning issues of today's society. However, it is not only the successes but also the absence of a more acute and explicit self-criticism and the presence of an apologetic discourse that I wish to focus on in this analysis. "Reading an exposition" willfully brackets such important but, from a semiotic perspective, contingent aspects as personnel, material, and financial constraints, requirements made by regents and sponsors, and the conditions of the building. The question of "Who is speaking?" will not lead to a name, a scapegoat, or a moral judgment; it will, hopefully, lead to insight into cultural processes.

asian mammals: the politics of transition

Turning left after going up the stairs near the Roosevelt Memorial at the Central Park West side of the museum, the visitor enters the Hall of Asian Mammals (fig. 1).[14] S/he is surrounded by dioramas of animals whose strangeness has long been effaced by that even more "natural" museum, the zoo. The animals are placed against painted backdrops familiar from postcards and geography books. The dioramas are impressively realistic. This

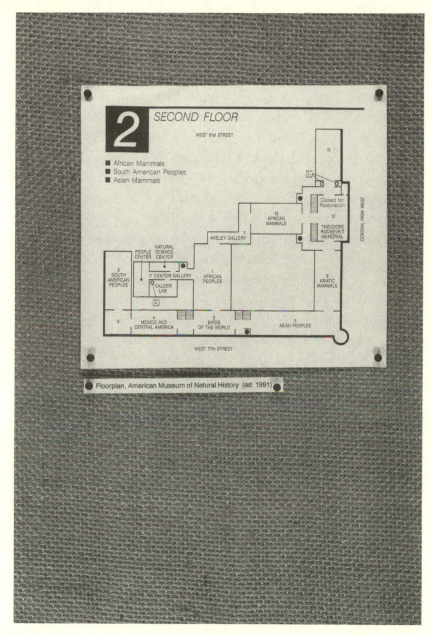

Figure 1. Floor plan of the American Museum of Natural History, New York (information leaflet, ed. 1991). Detail from *Das Gesicht an der Wand* (*The Face/Stain on the Wall*), Edwin Janssen, 1995.

realistic rhetoric is helped by the relative obscurity in the hall, which makes visitors invisible to each other and to themselves, while the dioramas are illuminated from within. The obscurity is obviously necessary from the point of view of preservation; *at the same time*, it sustains the effect of "third-person" narrative that, literally, highlights the object while obscuring the subject. There is a tension here, perhaps a paradox, inherent in the museum as a whole, between common and strange. The displays hover between the attempt to represent reality as natural through an aesthetics of realism and the attempt to demonstrate the wonders of nature through an aesthetics of exoticism.[15]

As in other halls, the double edge of the American Museum of Natural History's discourse of exposition is acutely felt: the imitation of nature, striving for perfection ("Look! That's how it is"), foregrounds itself by that very *telos* ("I am showing you this"). Other, less conspicuous elements, potential speech acts, clash with this major one. The skillful but ruthlessly artificial painting, the protective glass, the neat separation of species, the limited size of the settings compared to the animals, make one constantly aware of the representational status of this "nature."

But the effect of the real reconciles the two discourses. This is one form of "truth-speak," of the discourse that claims the truth to which the viewer is asked to submit, endorsing the willing suspension of disbelief that rules fiction. For the visitor entering through this hall, the discourse of realism sets the terms for the contract between viewer or reader and museum or storyteller.

At the far end of this hall, the door opens to the Hall of Asian Peoples. Within the framework of the mimetic success of the realism in the Hall of Asian Mammals, the transition from this cultured "nature" to culture *as* nature—from mammals to peoples—is inherently problematic. The most obvious problem is the juxtaposition of animals and human foreign cultures. The doorway between the two halls is semiotically charged as a threshold. At this threshold the difference between the colonial past and the postcolonial present lends itself to different meaning productions.

In the case of these two Asian departments, there are indications of an awareness of the need for a transition, but they remain on the level of symptom, not signal. The transition is monitored by a small display within

the Hall of Asian Mammals, at the far end to the right, between the Indian rhinoceros on the left and the water buffalo on the right. In contrast to the dioramas, this small display contains only one simple exhibit, black against an undecorated orange background: a nineteenth-century statue from Nepal. It bears the title "*Queen Maya giving birth to the Buddha from her side*" (fig. 2). It represents an elegantly shaped female surrounded by decorative ornaments. It is at odds with the other displays in this hall.

The panel underneath it contains key phrases which elaborate the transitional status of this statue's display:

> *Queen Maya giving birth to the Buddha from her side,* Nepalese bronze, 19th century.
>
> According to popular tradition, Gautama, the historical Buddha, was born to Queen Maya of Kapilavastu as the result of a visit by a white elephant with golden tusks who ran around her bed three times and then returned to the Heavenly Mountains. Buddhism, one of the principal religions of Asia, has many stories of the previous lives of the Buddha as a compassionate soul in the bodies of animals. As a consequence, many Buddhist sects are vegetarian.

The verbal presentation is consistently anthropological. Keeping its purpose and status distinct from those of the museum of high art on the other side of the park, this display includes an artifact from a "low" moment in the history of Buddhist art, low because the moment of making coincides with the moment of acquisition: the nineteenth century. This temporal coincidence deprives the artifact of historical patina and scarcity, a requirement for "high art" status. Typically, nothing is noted about its style, as it would be in the Met. It is, moreover, thoughtfully presented as being anchored in "popular tradition," that nameless "other" of individual elite art. Instead of art it thus becomes anthropological evidence of a timeless culture.[16]

The verbal text accompanying the statue frames it thoroughly in its specific transitional function. A close reading makes that clear. The mention of the white elephant introduces the animal element which justifies the curious collocation of this artifact with "nature" and with the animals in their settings in the hall. Looking back, the visitor notices that the statue is facing the centerpiece of the hall, two life-size elephants, gray with white tusks. The historical information concerning Buddhist mythology, empha-

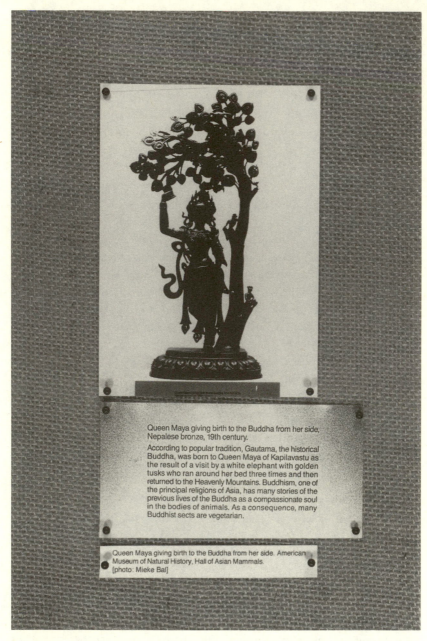

The following text appears within the image on the museum label:

Queen Maya giving birth to the Buddha from her side,
Nepalese bronze, 19th century.

According to popular tradition, Gautama, the historical
Buddha, was born to Queen Maya of Kapilavastu as
the result of a visit by a white elephant with golden
tusks who ran around her bed three times and then
returned to the Heavenly Mountains. Buddhism, one of
the principal religions of Asia, has many stories of the
previous lives of the Buddha as a compassionate soul
in the bodies of animals. As a consequence, many
Buddhist sects are vegetarian.

Queen Maya giving birth to the Buddha from her side. American
Museum of Natural History, Hall of Asian Mammals.
[photo: Mieke Bal]

Figure 2. Queen Maya giving birth to the Buddha from her side, Nepalese bronze, 19th century, Hall of Asian Mammals, American Museum of Natural History. Photo Mieke Bal. Detail from *Das Gesicht an der Wand* (*The Face/Stain on the Wall*), Edwin Janssen, 1995.

sizing Buddhism's distinctness from Christianity in its metempsychosis's polytheistic tendency ("many stories"), serves the explanatory function that is such an important part of the museum's scientific-educational mandate. But language's density requires that more be provided than just explanation. Polytheism is a loaded concept in the West. Buddhism may be "one of the principal religions in Asia," but the word "sects" in the following sentence is pejorative in a culture whose dominant ideology is monotheistic. This pejorative connotation is enhanced by its plural form. Both the colorful story and the word "sects" estrange Buddhist culture from the Western viewer. But the official *explanandum* of this statement is Buddhist vegetarianism, and one may well wonder what the relevance of that anthropological feature is in connection to the Hall of Asian Mammals.

As it turns out, it is highly relevant, not for Asian mammals but for American educators and the function of anthropology. Anthropology is pervasively present in the American Museum of Natural History as the unquestioned supplement of biology; the Hall of Pacific Peoples is named for Margaret Mead.[17] The discipline of anthropology has speculated extensively on the origins and meanings of alimentary taboos (Douglas). One explanation that has gained wide popularity is educational (Oosten and Moyer). Taboos on food, along with sexual taboos, serve the purpose of teaching distinction. By forbidding certain connections or incorporations—in the context of this analysis, one might also say, collocations and metonymies—people learn to respect the difference between self and other. Tabooizing cannibalism, for example, teaches "savages" that they are humans, not animals. This learning is necessary for the survival of the species.

In the Hall of Asian Mammals, the reference to vegetarianism can suggest a prior form of savagery. The taboo on the consumption of meat affirms the distinction, between humans and animals but between animals, including humans, and plants. In other words, for these Buddhist sects the difference between people and other creatures is defined in relation to the vegetal domain, which can be eaten, rather than in relation to the animal domain, whose members these people are too congenial to use as food. The history of the Buddha as told in this panel is supposed to prove it: he was fathered by an elephant. And the elephants down in the center of the hall suddenly stand as witnesses to their mythological brother.

Thus the panel accompanying the display of the statue does not question and criticize as outdated the collocation of man-made with "real" animals but, on the contrary, sustains it. Self-reflection is relinquished in favor of naturalization; "I" disappears behind "them" who cannot speak back, although "they" are alive and kicking as a culture. The words read as an explanation of the relevance of human presence in the animal realm, but they do so by qualifying the humans in question as being close to animals, closer than "we" are. This human presence is only emphasized as the object of representation; the obvious human performance in the dioramas of the hall, especially in the painted scenery, remains relegated to the unnoticeability of realism. Realism is the truth-speak that obliterated the human hand that wrote it, and the specifically Western human vision that informed it. In contrast, the statue represents humanity, specifically in a conception of its essence; birth, that is. And it is an index of the humanity that is represented in the next room: foreign and exotic. The question arises: what is the more specific meaning of the visual display, that it needs to be sustained so emphatically by words?

The statue represents a woman, "naturally" as close to animals as humans can come, and it represents her in the most "natural" of poses, in birth-giving. But this is not an ordinary birth whose representation would strain the tolerance of educational prudishness; it is a mythical birth from the woman's side. There is an instance here of cultural similarity rather than difference. In the Hebrew Bible, Genesis 2 represents the first woman's emergence out of the side of the first, androgynous creature, a birth that resulted from an equally unorthodox conception. To point this out would be to "anthropologize" Western traditions as an effective strategy for showing the problematic of the anthropological representation of others. But instead, the strangeness of this nature-woman is emphasized.

By selecting a representation of femininity which reaffirms woman's closeness to nature through a thoroughly unnatural fiction presented as a foreign "other," the subject of the mixed-media speech act of exposition has accomplished a semiotic feat. The expository agent has managed to mitigate in this local transition the major ideological oddity of the museum as a whole. The metaphorical equating of "woman" with "nature," so familiar in the culture betokened by and surrounding this museum, mediates between

mammals and foreign peoples, emphasizing the otherness that justifies the relegation of these peoples to this side of Central Park.

Gender politics are thus intricately enmeshed with ethnic stereotyping. For there is more to this visual ideologeme than meets the eye: the Buddha himself, in spite of his masculinity, is aligned with the archfemininity of giving birth. Associated with this double naturalness of birthgiving femininity and mythical remoteness, he is authenticated as the proper authority to prescribe vegetarianism as a feature of animality. It is this surplus of ideological information that the panel with the verbal representation is conjured up to "explain." The visitor is now prepared for the acceptance of the ambivalent display in the next hall: the showing of peoples as nature. And what extends before the learner is culture frozen in a clever double structure that, according to the panel at the entrance, can be read alternatively as unfolded in space or developed in time.

the contest between time and space: evolutionism and taxonomy

The Hall of Asian Peoples proposes a double representation, offering a choice of two frames: through time and through space (fig. 3, top). The spatial presentation divides Asia into regions, moving "from Japan westward to the shores of the Mediterranean Sea." Taking the spatial route entails the likelihood of missing the temporal one, which is tucked away in the corner, while the temporal option does inevitably lead into the spatial section. Turning left, then, is the most obvious things to do.

After electing this route through time, the leading phrase that guides the visit is stated on the introductory panel and then again as the headline for all sections: "Man's Rise to Civilization." The question as well as the program it entails are posed clearly:

> How did man achieve civilization? We have no final answers but we have *archeological traces* and *anthropological parallels* by which to create possible models. (emphasis added)

The conflation of time and space is made possible through the unstated notion of the primitive, so dear to the forefathers of the museum. The

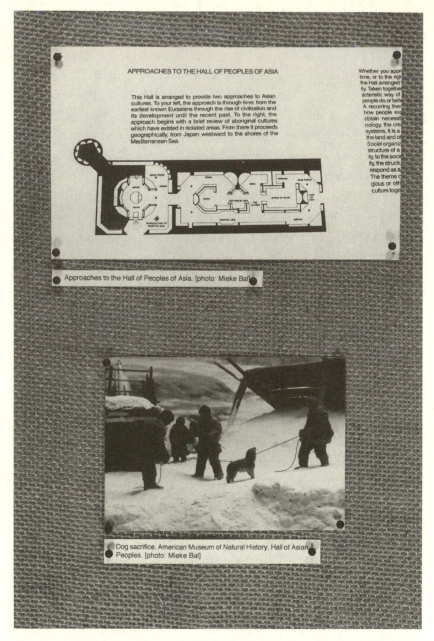

Figure 3. (top) Approaches to the Hall of Asian Peoples, American Museum of Natural History. (bottom) Dog sacrifice, Hall of Asian Peoples, American Museum of Natural History. Both photos Mieke Bal. Detail from *Das Gesicht an der Wand* (*The Face/Stain on the Wall*), Edwin Janssen, 1995.

collocation of trace and parallel is the speculative tool that proposes answers to unanswerable questions whose very statement implies, literally, too much for words. "Man's rise to civilization" encompasses the universal concept of "man," the evolutionism of "rise," and the transhistorical generic use of "civilization." These are the three presuppositions that inform this museum's other, the Met. As Douglas Crimp phrased it apropos of Malraux's *Museum Without Walls*: the Met displays "art as ontology, created not by men and women in their historical contingencies but by Man in his very being" (*Ruins* 56). The three concepts functioning as running head throughout this hall frame the hall's contents as "not-art." For the study of cultural difference which this hall could be assumed to be, these concepts insert the awareness that the double access to this hall is based on an untenable distinction. "Time" will become a question and "space" will be the metaphoric coverup of its unanswerability.

Tucked away in a corner that extends into a rotund space is the section devoted to "Man's rise to civilization in the Near East." To the left of the entrance are the Greeks, singled out with panels that sing their praises in unambiguous terms: panel 10 headlines "Troy and Western Civilization," while panel 11 bears the title "The Ionian Achievement." The ancient Greeks are represented by Homer, and are selected to establish the connection to "our own" culture. This is not a surprising choice, and it may be partially informed by the irresistible attraction of iconic thinking: we are looking at a culture where excellence was an ideological core, hence excellence is selected as its synecdochic representative.[18] The Greeks are praised for their investigation of "nature to the limits of human intellect," suggesting the happy outcome of an evolution that has just been traced before us. The panel on Ionian culture offers a neat example of the way time overtakes space in this section:

> Asian ideas and innovations were integrated with local genius. A century earlier, Ionian thinkers had laid the basis of the philosophies of Socrates, Plato and Aristotle. Seeking answers to the nature of the world, the Ionians looked to their own experience rather than myth to discover first principles.

Suddenly, as we approach "our own," that is, European, culture, anonymity yields to great names, and the characteristic of the represented culture

selected for representation is the very definition of the scientific pursuit that this museum represents. The voyage ends with a conflation of the two temporal moments between which stretches the period to which the "rise to civilization" has led.

The Greeks, then, are not just an episode or stopping place on a voyage through time but the emblem of the highest level of civilization. Representing the Greeks at the transition between the timebound and the geographically ordered exhibits on the Asian peoples is a gesture that qualifies the concept of Asia, giving meaning to the presentation "from Japan westward to the shores of the Mediterranean Sea": from utterly foreign to cozily familiar. But, more importantly, this placement qualifies the concept of the museum as a whole. It functions, again, as a transition, this time not between animals and foreign peoples but between the latter and "us." It installs the taxonomy of "us" and "them" by proposing the Greeks as the mediators, just as the woman in the Buddhist statue functioned as a mediator. The Greeks, closer to Western culture than any of the peoples represented in the museum, stand for the highest form of civilization, both starting point of "our" culture and endpoint of Asian cultures.

The time frame initiated, then, is not that of a casual voyage through time. Transforming temporal tourism into knowledge production, the time frame is that of an evolutionism colluding with taxonomy, dividing human cultures into higher and lower, the ones closest to "ours" being the highest. It would be feasible, although not easy, to walk backwards, to undo the telling of this Eurocentric story, but the museum has not provided panels that make such a reversed story readable. Indeed, between the spatially developed presentation and this climax of time, the most marginal items mitigate the transition: "The approach begins with a brief review of aboriginal cultures that have existed in isolated areas," in order to begin seriously with Japan. After entering the hall via the Greeks, all peoples represented later in it can only be less developed, more foreign.

Semiotically speaking, this transition from time to space functions as a shifter. The full implications of Benveniste's distinction between the personal language situation of I-you exchange and the impersonal representation of "him," "her, "or "them" are relevant here. The two axes are not symmetrical: in a normal conversation the I-you positions are reversible, while the "third

person" is powerless, excluded. But in the case of exposition, the "you" cannot take the position of the "I." While the I-you positions preside over the "third person," the "I" performs the representation, the gesture of showing, in conjunction with a "you" who may be real, but who is also imaginary, anticipated, and partly molded by that construction. The peoples represented in the American Museum of Natural History, just like the animals, belong irreducibly to "them": the other, constructed in representation by an "I," the expository agent. The "you" for whose benefit the "third person," here the Asian peoples, is represented, is constructed by implication. "You" are suitable readers of the show. That construction is foregrounded in the opening display on the Greeks: by emphasizing the Greeks' influence on the culture in which the museum functions, the addressee is marked as belonging to the Western white hegemonic culture. The alterity of the represented and the displayed other is thereby increased: made absolute and irreducible.

The degree to which that "I," the subject of representation, is readable in the representation of the display itself opens up the possibility of a critical dimension. For any self-representation of the subject implies a statement concerning the subjectivity of the representation as potentially fictional. But instead of stating and foregrounding the "I," this display proposes to identify with the Greeks, an apparent "third person." This privileging of the Greeks appeals to ideological allegiance, without exposing the subjectivity of the agent making the appeal. The construction of such a radical division between self and other works to deny the divisiveness in contemporary society where cultural diversity is present—so much so that the construction of an unified category of "them" is no longer possible.

Hence, the need to obscure the I-you axis through the metaphorization of the Greeks as "our" stand-ins. But the very act of foregrounding that is readable in the gesture of obscuring this I-you interaction—in other words, the construction of subjectivity within the representation—remains invisible. It obscures itself in the ambiguous evocation of the people that stands between Asia and Europe, between archaic and modern, between "them" and "us." Evolutionism serves to blur the boundaries built up by taxonomy.

What is really on display for the addressee who insists on "speaking back" is this rhetorical strategy, in which words are used to provide images with meanings they would not otherwise have. Instead of the panels, on which

words give meaning to the order of things, large mirrors might be a more effective ploy. Strategically placed mirrors would not only allow the simultaneous viewing of the colonial museum and its postcolonial self-critique, but also embody self-reflection in the double sense of the word. They could lead the visitor astray, confuse and confound the walker who would lose her way through evolution and instructively wander around, perhaps panicking a bit, in diversity.[19]

circular epistemology

The museum's current expository agent has made effective use of the possibilities of visual and verbal channels of information to convey very different positions and mitigate tensions. What matters here is the effort to reconcile instead of enhance tensions by shedding verbal light on visual objects, and by imposing a particular, semiotically loaded order onto what would better have remained chaos. This use of expository discourse is foregrounded in the double presentation of the Hall of Asian Peoples through time—storytelling as well as historywriting—and through space—taxonomy as well as geography. Within each of these presentations, the specific semiotic potentials of each medium are also reflected upon. In the presentation through time, there is one panel enigmatically and possibly ironically called "Pre-historic storytelling," which presents a perfect example of the conflation of "archeological traces" and "anthropological parallels" to "create possible models" of "man's rise to civilization."

Grammatically speaking, the phrase refers to a narrative self-reflection: "prehistoric" qualifies storytelling, so we can expect a theory of storytelling specific to prehistory. The explanation demonstrates the kind of epistemological usage visual storytelling allows:

> The panels displayed here, made by 19th-century Siberians, tell stories of daily life. Dominated by tales of hunting both sea and land mammals, they also include scenes of the settlement that show the kind of houses, sleds and other items commonly used by those people. The panels at the upper left and upper right even depict the dog sacrifice shown in the Koryak exhibit to the right. For the Siberian viewer, each panel is a complete account and clearly reflects the well-known exigencies of daily life.

> For thousands of years, peoples have told such stories both orally and graphically. The painting at the back shows a hunting scene from the site of Catal Huyuk, in Turkey, about 6500 B.C.

This text is a good example of the kind of knowledge production—and consequently, of the kind of epistemological seduction—going on in this museum. First of all, it foregrounds visuality as the crucial form of reception. It describes the ideal viewer as the model addressee. But surely there is no such person as a Siberian *viewer* of these panels, at least not if, by that denomination, a prehistoric Siberian is meant, and not an occasional visitor from eastern Russia. The nineteenth-century Siberian maker of these images cannot be asked, nor does he or she have any direct relation to the prehistoric peoples who present this episode in the history of "man's rise to civilization." The panels this viewer is supposed to understand so readily are irreducibly of a different time and place and, as the presence of the text panels suggests, they address a literate viewer, while prehistory is (problematically) defined by illiteracy.

But that may be precisely the point. The text proposes to read this information in the mode of the prehistoric humans: visually. Why is that so important? The second striking element of the panel suggests an answer to this question. The model addressee reads the panels as *complete* and as *accounts*. The combination of these two features describes the aesthetics at stake: realism, the description of a world so lifelike that omissions are unnoticed, elisions sustained, and repressions invisible. The direction given by this verbal rhetoric is to read the panels realistically in this double sense: as complete accounts for a contemporary member of the represented culture. This mode of reading is further strengthened by an incredible density of metarepresentational signs, all symptomatic of a desire to make representation coincide with its object: "clearly" leaves no room for doubt; "reflects" borrows the very terminology of realism; "well-known" disqualifies as ignorant the surprised viewer who hesitates to willingly suspend disbelief; "daily" emphasizes the ordinary, the anonymous, the opposite of individual excellence or noticeable events, again with an effect of the real. Who would dare to doubt the truth of the representation after such pedagogy? The "I" has made the irreversibility of the I-you axis foolproof.

Following this insistence on realism, the trace is wed to the parallel. The second paragraph of the panel brings up the epistemology at stake. The nineteenth-century Siberian is conflated with thousands of years of similar men. The peoples in question do not have a history, any more than does the "nature" depicted in the dioramas. They are prehistoric in this sense, and therefore they qualify for this museum of *natural* nonhistory. The background painting, although different in style and medium, is placed so as to form a literal-visual background to the modern panels (fig. 4, top). Representing hunting scenes, it provides the idiom with which to read the panels in the foreground.

The issue is epistemology not addressed explicitly; but the conflict it hints at is present in the epistemology for which these panels are made to work. Within this utterly realistic display, the images are said to be symbolic. For the use of symbols is what characterizes civilization, as is stated in the neighboring panel, where reliance on archeological traces and anthropological parallels is proposed as an epistemology. It reads:

> The beginning of modern man may go back almost 500,000 years. But only in the last 5,000 years has man achieved civilization, which is characterized by the dominant rule of symbols.

This appeal to symbolism is already a problem in view of the crystal-clear realism claimed in the introductory panel. But the argument leading to this conclusion is circular, and deserves a closer analysis.

The explanatory panel is not alone in preparing the viewing of the visual objects. Immediately *preceding* this exhibit on prehistoric storytelling is an exhibit that presents a model of the Koryak group. In addition to "the well-known exigencies of daily life," it includes a rudimentary representation of the sacrifice of a dog. Or so it seems, visually (fig. 3, bottom). In imitation— realistic representation—of one small section of one of the nineteenth-century artifacts (fig. 4), the display represents a "real" dog sacrifice, showing little mannequins spearing a dog tied with ropes. "What are they doing to that poor dog?" exclaimed one of the numerous children who walked by. "I don't know," said the teacher lamely. "It's mean!" replied the child.

The epistemological connection between this exhibit and the Siberian panels is based on the trace-parallel conflation. Clearly, the exhibit imitates

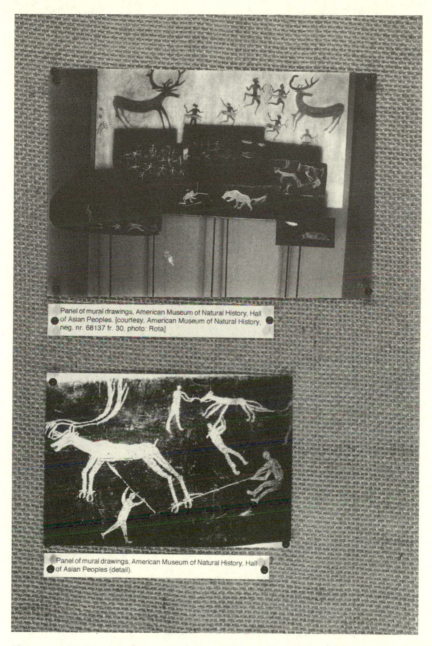

Figure 4. (top) Panel of mural drawings, Hall of Asian Peoples, American Museum of Natural History, Courtesy, American Museum of Natural History. (bottom) Panel of mural drawings (detail). Detail from *Das Gesicht an der Wand* (*The Face/Stain on the Wall*), Edwin Janssen, 1995.

the artifact, but the artifact has been interpreted realistically in the first place. The dog sacrifice, symbolically represented on the artifact, is taken to be "symbolic" of the "real life" it points to. (Hence the appropriateness of the child's exclamation "It's mean.") In the narrative of the walking tour, however, the realistic model *precedes* the historical object it imitates, thus enhancing belief in the anthropological truth of both the modern display and the ancient image. This visual argument is comparable to the idea of an anthropological representation of Western culture through the crucifixion of men with headdresses made of thorns, or tied-up bodies pierced by arrows, and other varieties of martyrdom. "It's mean!", foreigners would cry out. Our children don't. Civilized as they are, they know a symbol when they see one.

The connection between the nineteenth-century artifact and the twentieth-century exhibit is based on a powerful rhetorical figure: metonymy. The twentieth-century exhibit comes first, the Siberian panel follows. This sequence allows for a reversal of "model" and "copy," of two different levels of (representations of) the real. Visually, it seems as if the Koryak exhibit reveals the truth of the Siberian panel. The reference to the copy of a "really old" painting—the Turkish find from about 6500 B.C.—provides the authentication of this conflation of time into space. But the trouble is, the painting, representing hunting scenes, does not have a trace of a dog sacrifice.

As usual, the verbal panel mediating this epistemology of juxtaposition makes the slippage in this epistemology explicit. It is a slippage from space to time, and from present to past:

> The Koryak *live* in Northeastern Siberia, a place of extreme cold ... Our knowledge of shelter and clothing during the Ice Age is limited, but we can be *certain* that prehistoric man adapted to the climate much as have the Koryak ... As *shown* to the left, the people ritually sacrific*ed* dogs as offerings to the spirits of the hunt and the settlement itself. (emphasis added)

The link between contemporary but geographically remote cultures and the prehistoric past is presented as a *certain* connection, and the dog sacrifice represented in the twentieth-century exhibit *shows* how the people in the past actually did things. The discourse of display is practically irresistible. The realistic representation of a fictional leftover of a culture long gone is

taken as the source for an older artifact that will now have to be read realistically through this rhetoric. Realism, here in a visual form, is one of the primary forms of "truth-speak" used by the museum.

This display, I assume, predates current awareness of the problems of knowledge production it entails. How does the mixed-media nature of museum discourse help this rhetoric along even today? To be sure, this circular argument would never go so massively unnoticed in a verbal historical analysis. My point is this: the visual panels get away with it because the order in which they are displayed constitutes the syntax that gives the well-shaped "sentence" its meaning. But the combination of exhibits can only pull this off because the verbal direction, the rhetorical setup of the addressee's semiotic attitude, sustains the circle. This specific collaboration between visual and verbal sign systems partakes of an epistemology that is very much part of our present-day culture. All the effort is put into emphasizing the realism of this particular section in order to establish and sustain that circular epistemology. "Prehistoric storytelling" thus gains an unintended connotation: it becomes a prescientific, mythical way of telling the story of cultures we cannot know, prehistoric historiography practiced in the 1990s.

in the beginning was the word

After the Hall of Asian Peoples, our journey through the semiotics of display takes us through the "Birds of the World" to the Hall of African Peoples on the right. The panels here demonstrate a serious attempt to cope with the contradictions of a contemporary race-conscious society. They are evidently quite recent and could provide the critical note which is indispensable if a museum such as this one is to be effective in the 1990s. And to a considerable extent they do.

The entrance panel on the left wall states the contemporary educational ambition of the hall:[20]

> With the swift transition from tribe to nation, much of Africa's past is disappearing. The heritage remains, however, to influence the character of the new nations and, in the New World, to give to Afro-Americans an individuality of their own. Although this hall deals largely with the past, it can perhaps help to gain a better understanding of the present.

This panel, stating the educational purpose of the hall, hangs on the hall outside the hall proper, its position spatially signifying the distance today's museum curators take from the way the hall was conceived of some fifty years ago. Thus, it begins to semanticize the deictic, slippery "I" by means of spatial distancing; spacing writes difference.[21] But the meaning of spacing depends on museum syntax. In itself, the panel suggests a critical project: to explain the problems of contemporary multiracial society through its roots in colonialism. This self-critique could work if it were sustained throughout the exhibits. If not pursued inside the hall, however, it remains a preface, whose spatial position outside the hall reflects its ideological position of framing what happens inside with an apology. The problem can be compared to that of quotation, indirect discourse within a narrative. Here, the narrator, who is the expository agent's present incarnation, "quotes" the descriptive discourse inside the hall—the dioramas. Quotation in narrative is introduced, or moderated, by what is termed "attributive discourse" (Prince, *Narratology*). Attributive discourse has a double function: it attributes the quotation to a speaker, and it qualifies the quotation's content. The distancing of this panel from the hall would work to neutralize that attribution if it were the only introduction. But this panel is only the first step in an elaborate set of frames. Framing here is so emphatic and elaborate that the subject's dilemma shows through. The entrance is further framed by two bright window cases whose rhetoric adopts the second form of truth-speak used by the museum: scientific discourse. In the distance in the dark hall, we can already glimpse one of the displays in the realistic mode. The contrast is striking (fig. 5, top, for an example).[22] The introductory exhibits at the entrance, "family" on the left and "society" on the right, present three-dimensional graphic models of that essence of Africa which only scientific analysis is able to provide. The connotation of these models is "scientificity," with reliability as its primary feature, thus visually proposing that what we are about to see is the truth of Africa, not the historically produced mixture of "science" and "fiction" which constitutes the basis of contemporary vision, and whose critical analysis I had been expecting on the basis of the verbal introductory panel. Thus the critical project announced by the panel as the outer frame is overwritten by the scientific one of the second-level frame (fig 5, bottom).

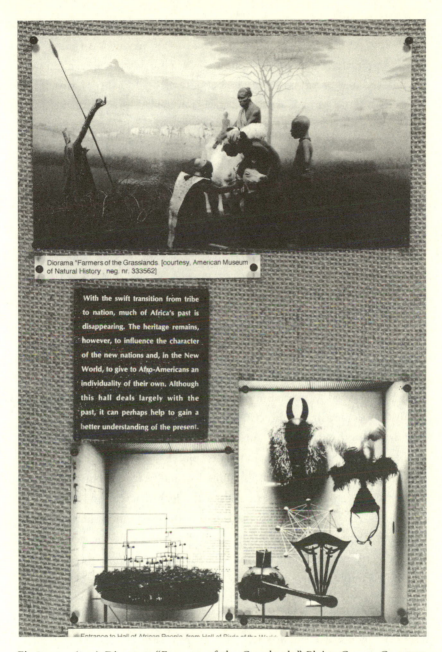

Diorama "Farmers of the Grasslands. [courtesy, American Museum of Natural History , neg. nr. 333562]

With the swift transition from tribe to nation, much of Africa's past is disappearing. The heritage remains, however, to influence the character of the new nations and, in the New World, to give to Afro-Americans an individuality of their own. Although this hall deals largely with the past, it can perhaps help to gain a better understanding of the present.

Entrance to Hall of African People from Hall of Birds of the World

Figure 5. (top) Diorama, "Farmers of the Grasslands," Plains Group. Courtesy, American Museum of Natural History. (bottom) Entrance to the Hall of African Peoples, American Museum of Natural History. From the Hall of Birds of the World: text panel and two displays. Photo Mieke Bal. Detail from *Das Gesicht an der Wand* (*The Face/Stain on the Wall*), Edwin Janssen, 1995.

After this double, conflicting introduction, the first displays within the hall—although not yet within its main body—are devoted, on the left, to "foreign influences" and, on the right, to "Africa today."[23] In agreement with the introductory panel, both are more about what colonialism has made of Africa than about Africa's "natural history." But the latter will nevertheless be the object of the subsequent displays. Hence these two displays function as a third level of introductory framing: following the critical and scientific ones, these displays now present the double voice of the museum's contemporary vision of Africa through Africa itself.

"Foreign influences" is divided into economic, political, and religious influences. The political situation is represented thus:

> The imposition of foreign rule created political entities much wider than existed before, *and this might have been advantageous,* but the same powers that set up these unities failed, usually, to consolidate them. They existed largely on paper alone; the common sentiment that must underlie any truly unified nation was lacking, and with the removal of foreign military force the imposed unity tended to crumble. (emphasis added)

This presentation is quite critical: foreign rule—colonialism—imposed an order that it failed to maintain. Indeed, the repeated use of the concept of imposition demonstrates the critical project; so do words like "failed." In contrast, the criticism hardly conceals reconfirmations of the values that produced the colonial situation in the first place.

Thus the idea that wider political unities would be better than small-scale organizations remains unargued, as does the legitimacy of any imposition whatsoever. The desire for a large-scale nation is the common sentiment that Africans failed to muster. Its indispensable nature is stated in generalizing phrases like "any *truly* unified nation." Finally, the sorry consequences of the removal of military force demonstrate the conflicting message: critique in the word "imposed" that qualifies unity, but uncritical in the presentation of "tended to crumble" as the inherent weakness of the Africans unable to sustain the goods. Hence, there remains room for the suggestion that colonialism was bad for Africa because it was not radical and lasting enough: if only the foreign rule had managed to impose its alien system more durably, all would be well today.[24] Not a word on the social systems dislodged by the imposition of large-scale nations.

This verbal message is conflicting in its double view of what happened to Africa. The visual exhibits illustrating this double view are all critical of what became of Africa's political organization. But instead of representing the violence done to Africa, the exhibits are mostly caricatures and presented as such. The visual displays illustrate the verbally expressed view; the "third person" itself here sustains the constative statement. The image of Africa has been replaced by the image of its protests against alienation, but these protests are not directed against the foreign colonizers; they are ambiguously presented as self-criticism. Hence, the combination of words and images turns the tables on the critical project: Africa is ridiculous and it says so itself (fig. 6, top).

The relation between verbal and visual messages becomes one of blatant contradiction in the section of this display devoted to religion. The verbal text states that Islam was far more successful than Christianity in its attempt to impose itself because Christianity, being "far less unified and much more in conflict with traditional African values,"

> had a largely disruptive influence, socially and politically. The African countered by making of these new religions something of his own, and this genius for selective adaptation is now bringing forth distinctive, new and vital beliefs in Africa.

Again, this text is critical of colonialism, denouncing Christianity's destructive influence and projecting a positive image of Africans ("genius"). Visually, however, these words are overruled: with an unrecognizable rosary as the token item referring to Islam, my overall impression of this exhibit is its emphasis on Christianity (fig. 6, bottom).[25] The display is unified by a Virgin Mary in the center, accompanied by a wise man holding a ritual bowl topped by an African symbol of a bird. The former element will be recognized by Westerners as Christian, the latter is African, although it could easily be mistaken for one of the Three Wise Men at the Christian Nativity scene. Standing slightly behind the Virgin, and placed so as to suggest submissive offering, the visual syntax does not suggest African religious genius.

This is an affect of visual syntax. The message is one of a submission to Christianity rather than a genius of appropriation. The Madonna is central and the ensemble is the largest visual element in this window. Moreover, it is

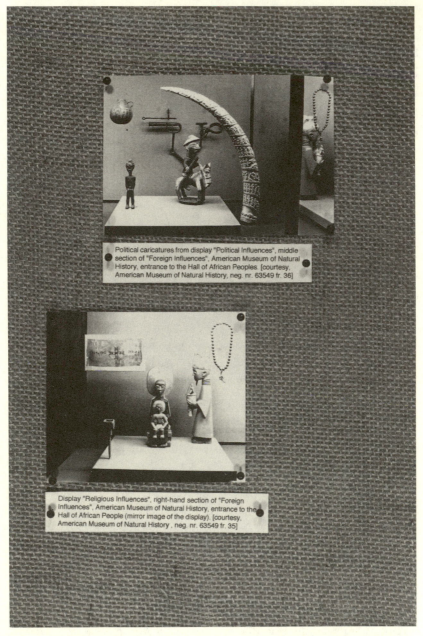

Figure 6. (top) Political caricatures from display "Political Influences," middle section of "Foreign Influences." (bottom) Display "Religious Influences," right-hand section of "Foreign Influences" (mirror image of the display). Both at the Entrance to the Hall of African Peoples, American Museum of Natural History. Both photos Courtesy American Museum of Natural History. Detail from *Das Gesicht an der Wand* (*The Face/Stain on the Wall*), Edwin Janssen, 1995.

the only one that is immediately figurative, and, hence, the only recognizable visual element. Its unambiguous message is, therefore, Christian primacy. The African element, although on display, is syntactically made invisible.

In the most negative reading of this sequence—but by no means the only possible one—the visitor is set up to feel a solidarity with the moral rightness and righteousness expressed in the outer framing panel, only to become caught up in a narcissistic reflection on Africa as "we" have made it—on Western expansion more than on what was sacrificed by it. By failing to enforce awareness of that mirroring, by failing, for example, to install mirrors so as to visually insert the viewer and thus enable "you" to become, momentarily, an "I," the content of the constative speech act entirely negates the critical message.

This triple introduction frames the main part of the hall, where the various peoples are represented in the traditional manner of early anthropology. The combination of authentic artifacts presented as realistic details and life-size puppets representing otherness in a frozen posture obviously belong to what the museum, in its meta-museum function, must preserve. The panels here matter-of-factly add no new dimension, no criticism, no self-awareness. The visitor's semiotic attitude thus remains uncertain. Of course, the "you," here more than anywhere, is differentiated according to cultural and racial allegiance. Reassured and self-centered by the opening, the white Western viewer is prepared to take in visual and verbal information in wonder at otherness. What happens to the visitor of African descent, I cannot tell; supposedly, the reassuring effect of the introduction will not be lost on her either. The frame fails to provide the visitor of either background with the lasting mirror s/he needs in order to see the African peoples within history.

So far, I have discussed the negotiation of transition according to the former itinerary, which leads up to the most emphatically elaborated entrance. The monitoring of the effect described above is confirmed by even a casual look at the other entrance to this hall. While the entrance just described thematized the relation between representation of the past and understanding of the present, this one is firmly positioned in a search for beginnings.

From this other entrance, the hall bears the title "Man in Africa," proposing a universalism that cancels out the specificity of African peoples to which the hall is devoted. History is effaced in favor of prehistory, in favor of the archeology of human society of which African Man is the primary index. On the left is a panel called "Early Humans in Africa," and on the right an exhibit called "The Beginnings of Society."

The display on the left shows a photograph of, supposedly, the earliest human footsteps, those indices par excellence of real human existence and location. The exhibit on the right shows the earliest economic activities of herding, cultivation, hunting and gathering, and toolmaking. This entrance honors the continent as the cradle of humanity, indeed, of civilization. But whereas at the other entrance the influence of "us" on "them" frames the information on Africa, here, "African Man" becomes "Man" in general, not a forerunner to the same extent as the Greeks. Thus, it does not challenge the standard conception of history as bound up with writing, the state, and the military. Instead, the very longevity of African societies blurs their historical position. "The beginnings of society" speaks of a universal humanity whose *primitive* stage is associated with Africa. The scientific fact of Africa's long history here sustains the signification of a primitivism that stands outside of history, and of which the displays inside present the frozen images.[26]

Again, the frame is more sophisticated than that. Approaching the main body of the hall from this direction, the visitor goes through a narrow doorway into "Africa" proper, with Ethiopia on this side of the geographical division into "lands": river valley, grasslands, desert, forest. The reason why Ethiopia occupies this exceptional position is readable in the exhibits. It may be because it is in Ethiopia that the oldest signs of human life were found. But there may be another reason, too, at least on the connotative level.

The first two exhibits are devoted to "Christianity" (on the right), and "warfare" (on the left). The "Christianity" display begins with the fourth century B.C.E. and the Solomonid dynasty of the third century B.C.E., with claims to Solomon and Sheba. The word "Christianity" in the display's title centers the entire presentation, so as to make us view the oldest exhibit as a prehistory of later Christianity.[27] The notion of Jewish culture does not appear; yet Solomon can hardly be considered a Christian personage. The major visual exhibits in this window are a visual narration of the story of

Solomon and Sheba, painted on canvas, and a written one, with an illustration.[28]

May we construe a stretch of the suggested walking tour in the museum as a text, as a narrative with a story to tell? The consequence of such a view seems inescapable. Whichever entrance one chooses, the Hall of African Peoples can only be approached through Christianity. This could be imagined as a relevant way of introducing Africa's history, but it is not an appropriate introduction to "Africa" as the ethnographic self-identical frozen continent that the hall presents. Instead, the entrances through the concept of Christianity function as an address to the viewer to go through a rite of passage: through a reversal of priorities and a suspension of logic (the conflicting messages), the visitor is prepared for a viewing of African peoples through the lens of Western Christianity. The various exhibits that could potentially present Africa with all its variety and internal differences are thus neutralized by the a priori identification of the targeted visitor as belonging to the culture which produced this museum.

For others—most notably, the visitor of African descent—the entrance presumably poses a problem of alienation. Either armed or saddled with a Christian identity, the visitor is confronted with an "Africa" that is already a fiction: a story focalized in a particular way, in which bias supplements knowledge and metaphoric translation neutralizes foreignness—hence, a vision. The overall concept of this hall as well as of the other anthropological halls freezes cultures in a static representation based on the concept of typicality. It represents human bodies as samples of ethnic unity and it shows cultures outside of history.

Let me end this analysis by citing an extreme case of what it is that the elaborate framing actually frames: a "specimen" of what you get to see inside this dark representation of the African continent. To be sure, the diorama on Mbuti Pygmies in the dark center of the Hall of African Peoples is obviously dated. I wish it were dated explicitly as well. It wouldn't take much, it seems to me, to use this datedness to emphasize the representational status of the exhibit. If it were up to me, I would foreground the kind of anthropological knowledge put forward in the past as well as its historical genres. This diorama is so strikingly disturbing that I can only show it in this book in a modified form, by including at least one representation of the expository agent (fig. 7).

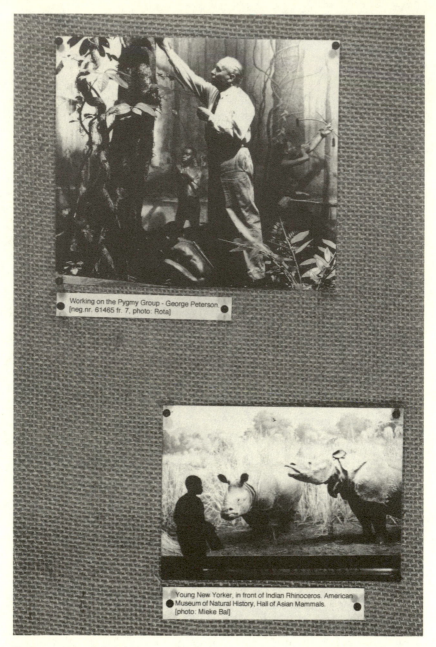

Figure 7. (top) Working on the Pygmy Group—George Peterson. American Museum of Natural History. Photo Rota. (bottom) Young New Yorker in front of Indian rhinoceros, Hall of Asian Manmals, American Museum of Natural History. Photo Mieke Bal. Detail from *Das Gesicht an der Wand* (*The Face/Stain on the Wall*), Edwin Janssen, 1995.

The diorama is as beautifully crafted as it is seductively realistic. The emphasis is on small people with naked, shiny skins. Most striking is its accompanying text panel. This, too, I will quote only in modified form, with emphasis on the words upon which, I think, even a minimal meta-museum panel ought to reflect. For a textual analysis, the panel is easily broken up into three parts, which I number:

> 1. The Mbuti Pygmies of the Ituri forest *typify* both physical and sociological *adaptation*. Their small stature (4′6″ maximum) and *light skin color* helps them to *move about easily and unnoticed,* their economy requires few tools, with no animal or plant raising. Gathering mushrooms, roots, fruits and honey provides the bulk of the diet, but the hunt shapes Mbuti society. No *band* can number beyond what local food sources can support, and to avoid hunting out any area, each band must move monthly.

> 2. The family is the basic unit, but though families may start out together on a hunt, they soon split into age groups. The men set up the nets and stand guard with their spears. Youths stand *further back* to shoot with bows and arrows. Women and children drive the game into the nets, also *gathering* plant foods on the way. Before the hunt a fire is lit as an act of propitiation to the forest God. *One youth practices with his bow, while another signals the hunters to hurry.*

> 3. The central Ituri forest, Northeast Congo, on the north bank of the river Lelo. The foliage and trees were *collected* in the Budongo forest, an extension of the Ituri, in Uganda. (emphasis and paragraph numbering added)

The first part of the panel in particular provides the kind of information you also find in the Halls of Animals. Clearly, early anthropology focused heavily on being a science like biology, and had learned a lot from Linnaean classification and Darwinism. The word "typify" indicates the former discourse, the word "adaptation" the latter. The insistence on "third-person" discourse demonstrates how easily the repeated third-person pronouns ("they" and "them") construe an us-them discourse in which the "us" part remains invisible yet predominant as a speaker.

The second part, while equally faithful to the discourse of early anthropology, displays two additional features: gender stereotyping and a shift from generalizing anthropological discourse to descriptive discourse. The reference accordingly shifts from the Mbuti Pygmy people to this representation of it,

the diorama. The first shifter is "further back," a deictic element that, linguistically speaking, has no referent outside the speech situation. It is a sign of expository agency. This deictic element facilitates the shift to the final sentence of this part, which describes the display. Such shifts partake of the truth-speak of realism; they transfer the plausibility from the description of the "real people" allegedly based on anthropological knowledge to the representation of them in this fictional work of art.

The third part of the text is the credit line. It functions like a footnote in a scholarly publication, identifying sources so as to make the presentation verifiable and hence trustworthy. The formal resemblance to the crediting footnote turns it into a third form of truth-speak, that of "scholarly seriousness." This is largely rhetorical. Although it makes sense for a museum to keep track, in its archives, of the places where material objects were gathered, the information is not going to do anything to help the visitor track down the source for verification. Hence, the line is a piece of truth-speak in the precise sense: in its very stating of the truth—specifying that not all the material came from the same place—it is lying, suggesting that the representation is truthful. It fleshes out the authority of the expository agent, who must be able to get away with the shift noted above and still be believed.

A second remark concerns the "symptom," the small detail that betokens this problematic semiosis around truth. It is the choice of the word "collected." This word reflects back on a synonym used earlier in the panel, "gathering." The Mbuti women are said to be gathering; the museum, in contrast, collects. Both gather or collect vegetation. Why use a different verb? Each word has a different frame, pointing to a different subject. Collecting is what scholars, pioneers, art lovers, colonialists, and museums do; gathering is what primitive folk do. "I" collect, "they" gather. Now, it seems extremely useful, educational, to take advantage of the need both to preserve this outdated presentation and to show not just the Mbuti but also the way "we" got to know "them."

In Western cultural history, images have been assigned the functions of showing, and words those of telling. These two strategies of representation are in competition even within their respective mediums, visual and verbal art.[29] Plato and Aristotle, while figuring as individual heroes of Man's Rise to Civilization for their appeal to experience rather than myth to seek answers

to the nature of the world, also set the tone for an endless discussion on the respective semiotic merits of "telling" versus "showing" in literature. A parallel discussion on the representational capacities of visual art insistently sheds doubt on the ontological possibility of visual telling. The Hall of African Peoples provides a glimpse into the ideological motivations for such a hierarchization of the arts and its intimate connection to the scientific appeal to "*their own*" experience. To deny the image's capacity to tell stories is one way of claiming narrative innocence for visual display. The story that the museum could tell, and whose telling would make its present function so much more powerful, is the story of the representational practice exercised in this museum and, indeed, in most museums of this kind. This is the story of the changing but still vital collusion between privilege and knowledge, possession and display, stereotyping and realism, exhibition and the repression of history. There are indications that the expository agent is interested in pursuing this difficult project.

The fact remains that the representation of the peoples of Africa as visually graspable actively deprives them of their history, in a manner that does not break radically with the colonial imposition of "foreign influences." The representation outside of history goes hand in hand with the representation of typicality. And typicality ignores the very individuality which forms the basis of the concept of high art on which the Met is founded. There, artifacts have a name attached to them, and a date, but no social context. Here, in the very attempt to *show* foreign cultures, the displays *tell* a story. But it is not the story of the peoples represented, nor of nature, but of knowledge, power, and colonization—of power/knowledge.[30] Yet that story does not show its hand as much as it could; it does not tell "in the first person." If only that act of storytelling and its subject were foregrounded more, the museum would be better equipped to respond to the expectations of a postmodern critique. It is ironic that natural history excludes history, and that through that exclusion it excludes nature itself.

picking up crumbs

This interpretation of several of the problems in the American Museum of Natural History demonstrates the *tension* inherent to such educational

institutions and, by extension, to display as an act of constative demonstration or exposition, even when a well-intentioned and expert staff is in charge of the expository agency. I have focused on problems, leaving it to the standard presentations such as the *Official Guide* to propose a different view, not because there is nothing to be content with or in order to blame anyone in particular, but because the problems appear both ineluctable and serious.

The two major forms of truth-speak—realism and scientific discourse—together with the scholarly truth-speak like the citation of sources, as they compete for the conquest of constative authority and demonstrative persuasiveness, are embodied in the "chapters" constituted by the displays in natural settings and articulated systems: the dioramas and diagrams. Each entertains a different dynamic between visual and verbal signs. They seem divergent in their manners, yet convergent in their effects. This convergence suggests that realism, where the hand of the maker obscures itself and the words informing the visual image make their speakers invisible, is as strongly discursive as the scientific foregrounding of discursivity is in the diagrams, figures, and explanations.

Clearly the expository agent has put considerable effort into inserting a critical edge onto its old treasures. To emphasize that agency does not coincide with intention, I want to end this chapter by focusing on them. Attempts to alert the visitor to ideological problems assume three forms. The first makes explicit and repeated comparisons between the cultures on display and "Western culture." This could help to remedy the excessive "othering," although the absence of "our" culture as part of the display remains an oddity that threatens to neutralize the effect of the comparisons.

One example of this effort is the presentation of African masks. The display of various masks bears the title "Masks and Social Control" and the verbal panel accompanying it explains their function. The person wearing the mask does not speak as an individual but in the name of society. The panel compares masks with the wigs and robes that judges in the West wear to denote society as the speaking subject. The visual display remains a collection of exotic items, but what makes this case noteworthy is the fact that the text does show the critical intent in its very offering of understanding.

The second well-represented strategy for critical presentation is the insistence on the continuity of tradition. This is particularly emphatic in a

minor, third entrance to the Hall of African Peoples, coming from the Center Gallery, which is devoted to African tradition in African-American culture. The display makes clear that slaves saved the African traditions in the guise of selective adaptation. The notion that African-American culture is African as much as it is American is an important one that still needs to be driven home to segments of the American public, and thus this entrance's display is true to the intention expressed on the outer frame panel at the entrance through the Birds section.

The third strategy is explicit self-reflection. Nowhere are the panels and the exhibits ironic—ironic, that is, toward the museum and its own background. As I suggested earlier, an astute use of mirrors might have helped to encourage a reversal of the trajectory in the Hall of Asian Peoples, and might insert the viewer at crucial moments into the foreign world represented. Thus, alterity would be mixed with acknowledgment that the world that grew out of this colonial endeavor is the one that each visitor today participates in. Some representation of colonial violence at key moments, such as at the entrance to the Hall of African Peoples, is, I think, indispensable. But visual and verbal detypifying measures can help to get away from holistic representation, from the synecdochic trope which underlies these halls.

Other displays are more successful than those discussed above in suggesting a different approach to the meta-museum, one that integrates the conveyance of knowledge of the object with an understanding of the construction of it by subjects. There are, indeed, displays where the verbal panels do not contradict the visual exhibits. There are exhibits that are so strong in their visual persuasion that no panel can counter their rhetoric. And there are displays in which the exhibits do benefit from the critical edge brought in by the verbal accompaniments.

One example of the latter may serve to show a way of opening up to an integration of a nonconflicting representation and the kind of self-critique that the museum might develop further. At the same time, it constitutes an instance of the third strategy that the museum uses to draw attention to problems: the emphasis on burning issues in the West, so as to avoid an exoticist setting off of the other as absolutely different. I quote this example because, in its ambivalence, it contains both the liabilities and the assets of a museum such as the Ameican Museum of Natural History.

Somewhere in the middle of the Hall of African Peoples there is a small display related to Pokot women. The accompanying text reads as follows:

> When women work together at their chores in company, or drink beer together, they also formulate a body of opinion that by its very unity influences the behavior of men.

The implications of this text are that the division of labor in Pokot society is gender-based; that women have the leisure, the means, and the desire to spend time together; that they discuss matters concerning their lives during those periods. All this is obvious enough, yet the following conclusion is not. The shape of social life produces a discourse, the text says, which is unified enough to have an impact. It influences the men. The implications are important: here lies the power of women even if they don't have it any other way.

But, just like the other texts, this one has a meta-discursive implication. It also says that in general, discourse, even unofficial discourse, does shape social reality. This particular discourse derives its shaping effect from its unity. But this is not a feature of the Pokot women's discourse in particular. Any discourse that is socially unified will be stronger in its reality-shaping effect than one that is not. This holds for the particularly powerful educational discourse of the museum as well as for all expository discourse. If the visual and verbal interaction between exhibits and panels collaborate to sustain the repression of the conflicts that characterizes the museum's endeavor, then it will convey a sense of unity that contributes to the shaping of social reality. In fact, that is the stated ambition of such educational institutions.

The fractures within this mixed discourse of images, words, and spatial distribution that I have attempted to show are representative of similar fractures within the social reality of New York City, the center of a world having difficulty coping with its colonialist inheritance. And this similarity is tricky: it may naturalize what should in fact be enhanced as historically specific and, hence, changeable. The peoples inhabiting New York City are members of a world that cannot too easily endorse the prefix "post-" of "postcoloniality." As such, the conflicts in the museum point to problems and breaks in the unity of an overall discourse of domination. But as I have also tried to demonstrate, there is a predominance of one particular element, the convergence of an attraction that is already very powerful: the tendency to believe in the truth of the knowledge represented through fiction.

Different museums speak different fictions, but what these fictions have in common is that they show their objects, not their own hand or voice. "Showing" natural history uses a rhetoric of persuasion that almost inevitably convinces the viewer of the superiority of the Anglo-Saxon, largely Christian culture. At the end of the evolutionary ladder, a pervasive speaking "I" is itself absent from the content of the shows, from the "monstrations" that the museum's displays are. Showing, if it refrains from telling its own story, becomes showing off.

notes

1 I am grateful to Michael Ann Holly for her very pertinent remarks on an earlier version of this chapter. This seems the place to explain the dedication of this chapter. When I first published a version of it, I had dedicated the paper to Alexander Holly. Alexander had told me to go to the American Museum of Natural History to see the whale, instead of always going to the Metropolitan. In his child's wisdom, he persuaded me that showing animals is just like showing art. I got stuck at the Buddhist statue and never got to see his favorite. Alexander died the week the paper appeared, and he never knew the surprise I had been preparing for him. He gave me the first idea for the connections I am trying to establish. For that reason, and because he will always be the fourteen-year-old boy he was then, I dedicate this chapter now to his memory. He could have said "That's mean!" to the representation of the dog sacrifice I will mention later. He could also have become—was on his way to becoming—one of the finest critics of just such epistemological and pedagogical tricks.

2 For an illuminating discussion of naturalization in literature, see Jonathan Culler, *Structuralist Poetics* (1975). Hamon uses the term "motivation" to refer to a similar phenomenon: rhetorical devices that allow description in order to pass themselves off as "naturally" belonging in the narrative which, in fact, they interrupt. See Philippe Hamon, *Introduction à l'analyse du discours descriptif* (1981). My use of the term "naturalization" here is meant to enhance the rhetorical nature of the experience of the city layout.

3 Zappler, *Official Guide*, 3.

4 The term "symptom" is meant in its specific, Peircean sense of "inadvertently emitted sign." Whether one wishes to connote the term with medical or Freudian connotations of signifying disease or dis-ease is up to the reader. See Sebeok, *Signs*, 24–28.

5 James Clifford presents an illuminating and witty version of Greimas's semiotic square according to Jameson. Like Jameson, Clifford uses the semiotic analysis to map out the structures of ideology, not to suggest—as Greimas would—that

{158} MIEKE BAL

meaning production must be limited in this way. See James Clifford, *The Predicament of Culture*, 224; A. J. Greimas and François Rastier, "The Interaction of Semiotic Constraints"; and Fredric Jameson, *The Political Unconscious*.

6 See Fabian's classic critique of the evasion of time in ethnography. Johannes Fabian, *Time and the Other* (1983).

7 The term "effect of the real" (*effet de réel*) was successfully introduced by Roland Barthes in 1968. See "L'Effet de réel." The term is problematic as well as attractive; see my critique in *On Story-Telling*, 109–45. Briefly, the term refers to literary phenomena such as description, whose connotation of a second meaning, "this is reality," becomes more important than the primary meaning of what is specifically described.

8 For the distinction between artifact and aesthetic object, see Wolfgang Ingarden, *Das Literarische Kunstwerk*; the distinction has been taken up again by Wolfgang Iser in his version of reception aesthetics, *The Act of Reading*. The terms "icon," "index," and "symbol" are used in the Peircean sense; a short text that has all the important terms was published in Robert E. Innis, *Semiotics*, 1–23. For an introduction, see Sebeok, *Signs*, and the introduction to my *On Meaning-Making*.

9 The relation between domination (in the field) and collecting (for the museum) has been argued by Donna Haraway, *Primate Visions*. On the problematic of collecting, see Susan Stewart, *On Longing*; Phyllis Mauch Messenger, ed., *The Ethics of Collecting Cultural Property*; and Michael Ames, *Museums, the Public, and Anthropology*. A more general volume on the subject of collecting is John Elsner and Roger Cardinal, eds., *The Cultures of Collecting*.

10 For the latter critique, see Michael Fischer, "Ethnicity and the Postmodern Art of Memory."

11 The meta-museal function of a museum like the American Museum of Natural History has been analyzed by Ames.

12 Or with the "wild man within." See Hayden White on the logic of the "ostentive self-definition by negation" at stake here: "The Forms of Wildness: Archeology of an Idea," in *Tropics of Discourse*. For a critique of the (neo)colonialism within postcoloniality, see Gayatri Chakravorty Spivak, *Outside*.

13 The word "distinction" is meant here in the specific sense given to it in Pierre Bourdieu's study *Distinction*.

14 The illustrations in this chapter are "details" of a work that was made by Dutch artist Edwin Janssen for my book *Double Exposures*. The burlap represents a bulletin board, the pinned-up images, my collection of snapshots. The idea is to emphasize the subjective input in collecting and displaying. The far-from-perfect quality of the images is part of the message. It represents the erasure of the "original" meaning and use of the object. The numbers refer to Janssen's plates, not to the individual objects. Where the pinned-up caption is missing, Janssen added his own picture, as a visual commentary.

15 In other rooms of the museum, a third representational strategy is deployed: the aesthetics of scientificity, which projects aesthetically pleasing and cognitively convincing three-dimensional diagrams. This strategy is more emphatically present in the Halls of Animals, which I will not analyze.

16 For the semiotic status of evidence, see Umberto Eco and Thomas Sebeok, eds., *The Sign of Three*. On "tribal art" as cultural evidence, see Clifford, *Predicament*, 187–252. I am largely in agreement with Clifford's reading of the museum, but I am not convinced that his distinction, borrowed from Ames, between "formalist" and "contextualist" protocols fully accounts for the semiotic strategies used in the Met and the American Museum of Natural History respectively. "Aesthetics" is also a context, which is why "formalism" necessarily fails. In both cases, the works are used as indices, specifically as synecdoches, but the "whole" for which, as a "part" of it, they stand, is different for each. *Time* is the crucial factor, the ground whose absence (in the American Museum of Natural History) or presence (in the Met) produces the meaning of the representative object.

17 I cannot resist referring to Clifford's quotation (*Predicament*, 230) from a letter written by Mead, which I wish he had analyzed in more linguistic detail. Let me just quote a few telling phrases: "We are just completing a culture"; "They have no name and we haven't decided what to call them yet"; "They are … revealing … providing a final basic concept"; "and having articulated the attitude toward incest which Reo [Fortune] outlined as fundamental in his Encyclopaedia article"; "they are annoying" [for not fitting the categories]"; "A picture of a local native reading the index to the *Golden Bough* just to see if they had missed anything"; "we are going to do a coastal people next." Fabian's subtitle (*Time*) is ironically illustrated here: how anthropology makes its object. See Margaret Mead, "Note from New Guinea," *American Anthropologist* 34 (1932), 740. The discourse is structurally identical to that used by biologists, in particular in the classification of animals. See the end of the section on the Hall of African Peoples in this chapter.

18 See Nagy's study, *The Best of the Achaeans* (1979).

19 This remark should not be taken to advocate a general and uncritical use of mirrors. The new installation of the National Museum of the American Indian, opened in 1994, has a mirror placed at the end of the route. That mirror, next to the exit door, shows the exiting visitor, but nothing of the installation. As a result, its effect is the opposite of what I am proposing here. It isolates the visitors from the objects from First Peoples' cultures they have just seen, and if any feeling is elicited, it seems to be one of relief rather than of solidarity or hybridic identity. See Hill and Hill, eds., *Creation's Journey*. In contrast, see Edwin Janssen, *Narcissus*.

20 After going back for a final check in December 1994, I noticed that this particular panel had been removed to make way for a temporary installation, "The First 125 Years."

21 If this spatial distancing is read as the writing of moral distancing from a position remote in time, it becomes an emblem of Derrida's theory of *différance*. See *Writing and Difference* (1978).

22 This is not the diorama you first glimpse, which is on a desert people, but a comparable one. No photograph was available of the first one, nor did the darkness allow me to make one.

23 The hall itself is dark, protecting the fragile dioramas; the entrance, with these displays on either side, is like a short corridor. "Africa" decidely takes the shape of a female body.

24 This idea becomes even more painful because it points out, by way of similarity, that this is precisely how the nation in which this museum stands succeeded in leaving its lasting "benefits" in the space *it* conquered. Could this possible similarity-in-opposition have appealed to the expository agent's "political unconscious" (Jameson)?

25 As a Western European with a (remote) Catholic background, I supposed I read this installation differently from someone who knows African religious culture. But that is precisely the point: this museum claims to inform "us" about "others"; its main purpose is epistemic-pedagogical.

26 On primitivism in literature, see Marianna Torgovnick, *Gone Primitive*; in art, Susan Hiller, ed., *The Myth* (1991).

27 The construction of chronology as an ideological tool is a well-known problem in scholarship. I have discussed it at some length in *Death* (1988). David Carrier (1987, 16–17) reminds us of Gombrich's double structure of chronology in *Art and Illusion*. Carrier distinguishes between an annal (a simple listing of events in the order of their occurrence) and a narrative. I find Carrier naïve in assuming that a list like Gombrich's Egyptian prenaturalism, Greek naturalism and Byzantine antinaturalism, the Renaissance revival of naturalism, the development of naturalism, the end of naturalism in the nineteenth century, is a "simple listing of events" and not a (focalized) narrative. Gombrich's insistence on naturalism as the ordering principle for the history of art is as biased as the American Museum of Natural History's insistence on Christianity as the "beginning" of the Hall of African Peoples. A most incisive critique of Gombrich's naturalism is Bryson's *Vision* (1983).

28 No photographs of the displays described here are available.

29 In *Reading "Rembrandt"*, I argued that the difference between the visual and the discursive is one of modes, not of media, and that each medium is by definition mixed.

30 For a reconsideration of this Foucaultian concept, see Spivak's brilliant critique of dogmatic philosophy in "More on Power/Knowledge," 25–52 in *Outside*.

on grouping: the caravaggio corner

5

WHAT HAPPENS—IN THE STRONGEST possible sense of that verb—when one painting, in a particular museum room, ends up next to another, so that you see the one out of the corner of your eye while looking at the other? This essay analyzes and describes such a happening and the narrative that unfolds in it. The analysis is part of a larger study (1996a), in which I take as my starting point the verb "to expose" and its multiple meanings.

Of its various meanings, the most directly relevant one is that of "exposing," showing, as in a "museum exhibition." This meaning is taken as a paradigm for the analysis of the broader range of meanings implied in the verb. The second nuance I am interested in is that of alleging examples in argumentation for their epistemic authority. By citing an example, one assumes that the "case," often a narrative, can be a substitute for a step in the argumentation. In art historical writing, when images are reproduced as visual "evidence," these examples become even more ungraspable. The third nuance is the one expressed in the social or juridical sense of "exposure." To

show is also "to turn inside out," "to lay bare." The classical genre of the nude is the most obvious case. In all three senses, the verb has effects that may be of a pleasurable, often libidinal engagement.

In trying to disentangle and make explicit the many implications of these three cultural acts—showing, alleging illustration, and laying bare—I have tried, in my larger study, to connect "display" in museums (showing and using bodies as in the nude) with "exposing" arguments in academic discourse. In doing so, I act as a cultural analyst, not an art historian. I do not ignore history but take contemporary culture as my object of analysis. I work on the question of what happens with the classical canon of art in today's society. The "new narrator" that I focused on is the exhibition maker, or, to put it more modestly, the team of museum professionals who decide, for various reasons relating to contingency, material conditions, and aesthetic judgment, where paintings will be hung.

"Reading exhibitions" is a new academic subject of study that floats around in the interdisciplinarity of what is commonly called "cultural studies," but which I would like to reconceptualize as "cultural analysis."[1] One of the reasons for its popularity has to do with the interest, on the part of artists, in "installation" as a medium for narrative expression: combining objects in a specific way to make a "story" out of loose "words." The Dutch artist Edwin Janssen, for example, put together such an installation in Museum Boijmans Van Beuningen in Rotterdam. Entitled *Narcissus and the Pool of Corruption* (fig. 1), it consisted of a bulletin board with pictures from his own collection of items from visual culture, combined with a series of sculptures, all facing a wall of mirrors. Whereas each item in the installation can be considered a "word," an element with a significance of its own, displayed together in this way they tell the story of Western humanity's obsession with a kind of self-definition called "ostentatious self-definition by negation."[2] By pointing to the alterity of others—ranging from animals to foreign peoples to women—Western man has displayed an outspoken tendency to define himself by pointing out how he is not "like them."

Janssen tells this story using various means, which can be called "syntax" to the extent that they are based on meaningful juxtaposition. One such syntactic relation is the juxtaposition of a monkey, who is busy reading a copy of the *National Geographic* (a magazine that exemplifies the tendency of

Figure 1. *Narcissus and the Pool of Corruption*, Edwin Janssen, 1994 installation, Museum Boijmans Van Beuningen, Rotterdam. Courtesy of the author.

emphasizing alterity), and a skeleton with Rodin's idealized male, associated, through Rodin's *Thinker,* with the supremacy of Western thought. The viewer cannot look these anthropomorphic sculptures in the face without seeing him- or herself. Thus, through this self-reflexive dimension, Janssen's museal discourse is able to tell the story of Western civilization in that narrative mode usually called "first-person narrative." This, in turn, is a polemical response to the powerful tradition of "third-person" narrative, which includes nineteenth-century realism, universal exhibitions, and the institution of the museum itself.

The reasons for the popularity of museums as an object of study are quite different from this interest in the narrative aspect. If museums are suitable for this new kind of analysis, it is clearly because they are multimedial. Hence, they appeal to those interested in challenging the artificial boundaries between media-based disciplines. But intermediality goes deeper than that. Curious about what could happen if the mixed-media nature of museums were to be a paradigm of cultural practice in general, I have decided to displace the emphasis and to pursue a critical analysis not of museums as objects but of the "discourse" that is deployed in and through them.

I do not take "discourse" to mean yet another invasion by language. On the contrary, the use of such a term for the analysis of museums necessitates a "multimedialization" of the concept of discourse itself. Discourse is the set of semiotic and epistemological habits that enables and prescribes ways of communicating and thinking that may be of use to others participating in the discourse.[3] Discourse provides a basis for intersubjectivity and understanding. It entails ways of knowing and of going about pursuing knowledge: epistemological attitudes. It also includes hitherto unexamined assumptions about meaning and the world. Language can be a part of the media used in discourse, but not the other way around.

I am particularly interested in one aspect of what I will call the "museal discourse," that aspect which allows for extending from the specific, literalized sense of the role of the museum to a broader, partly metaphorical sense, in which the museum postures or exposes. For the discourse around which museums evolve, and which defines their primary function, is *exposition.* Using an interdisciplinary encounter between literary theory and the "new

museology," I want to examine what is involved in gestures of exposing, in gestures that point to things and seem to say "Look!" while often implying "That's how it is." The "Look!" aspect involves the visual availability of the exposed object, which is thus potentially objectified. The "That's how it is" aspect involves epistemic authority. The gesture of exposing connects these two aspects. It is the ambiguity that results from the possible discrepancy between the object that is presented and the statement that is made about it that I probe in this essay.

In trying to get away from discussions about how important, invasive, or pervasive language as a medium in relation to images is, I have chosen, as a guideline or searchlight, the notion that such gestures should be considered discursive acts, like (or analogous to) speech acts of a specific kind. These acts are not necessarily linguistic in terms of the medium in which they are performed, but rather are based on the communicative possibilities offered by language.[4]

Here is how I provisionally see "exposing" as a "speech art," implying an utterance like "Look!" An agent or subject puts "things" on display. A subject/object dichotomy results. The dichotomy enables the subject to make a statement about the object. The object is there to substantiate the statement. There is an addressee for the statement—the visitor, the viewer, or the reader. The discourse surrounding the exposition, or, more precisely, the discourse that exposition *is*, consists of "constantive" discourse. Constative speech acts are informative and affirmative. They have truth value: the proposition they convey is either true or false. In expositions, as in all discourse consisting mainly of such speech acts, a "first person," the exposer or the expository agent, tells a "second person," the visitor, about a "third," who does not participate in the conversation. But unlike in many other constative speech acts, in expository speech acts the object is present.

The distribution of roles in expositions is typically the following. The "first person" remains invisible. The "second person," implicitly, has a potential "first person" position as a respondent; his or her responding to the exposing is the primary and decisive condition for exposing to happen at all. The "third person," although silenced by the discursive situation, is, at the same time, its most important element, the only one *visible* in the discourse. This visibility, this presence, paradoxically makes it possible to make

statements about the object that do not "fit" it; the discrepancy between "thing" and "sign" is precisely what makes signs necessary and useful. But the discrepancy in the case of exposition is blatant and emphatic, because the presence of a "thing" that recedes in the face of the statement about it brings the discrepancy to the fore.

Of the numerous semantic additions, or "fillers," that occupy the space between the thing and the statement, narrative is the most pervasive, the most inevitable. The very act of exposing the object—presenting it while informing about it—impels the subject to connect the presence of the object to the past of its making, functioning, and meaning. This is one level on which the expository speech act is narrative. Another level is the necessarily sequential nature of the visit. The "walking tour" links the elements of the exposition on behalf of the "second person" and thus constructs a narrative. The two narratives overlap but are not identical. Again, there is a fundamental discrepancy between the two which potentially produces an anxiety that all subjects alleviate by filling in the gaps. The narrative of "the museum wall," of the installation, produced as it is by an agent, its narrator, is what I will look at here. The expository agent, then, is the *new narrator*.[5]

In this essay I will present a small sample of the kind of analysis that such conceptualization allows me to carry out. I will turn to the wall of an art museum, specifically to a classical one, full of canonical art. As I have said above, connections between things are syntactical. I will analyze such connections with the help of the fundamental notion that exposition as display is a specific integration of constative speech acts that employ rhetorical figures to build up a narrative discourse and an implicit description of an invisible but authoritative "first person" narrator. I will try to see how this "first person" "speaks," so as to understand the implications of such diverse acts of exposition as showing and showing off, pointing out and pointing at, praising, trashing and taking for granted, explaining and persuading. I am not interested in the agency of the exposer as a means of understanding his or her intention. Rather I am interested in the effect that agency has on the viewer, in the production of meaning. Whenever I refer to the "expository agent," I am speaking of the agency that structures the display, like the narrator in a literary text. What I would like to propose here is not a way of judging a particular museum, but rather a way of reading museum walls.

Some museum people prefer to include only minimal factual information in their captions. The director of the new art museum in Grenoble, France, believing that art should be for pleasure only, not for education, limits the captions to the artist's name, the painting's title, and the date. This is obviously not a way of avoiding the expository speech act; it is simply saying something else. It is *saying* what art is for, and also, through the choice of exposed objects and the order in which they appear, what art is. By reducing interfering verbal "noise" to a minimum, this restraint acts out, and thereby asserts, a confidence in the primacy and sole power of visual images. What eludes the viewer, however, is not the imposing subject (the subject's power only increases as it becomes harder to contradict), but the "voice" itself as one speaker with whom the addressee can argue.

The Gemäldegalerie in Berlin-Dahlem is not so reticent—I am tempted to say, not so naïve. Here, captions give various bits of information. Some bits not only *support* but *explain* the sequence in which the works are presented. The museum is on my top ten list of favorites when it comes to preferred holdings and installation. Carefully hung at eye level, where appropriate, the art is so accessible that you feel really addressed by the expository agent. Well-written and beautifully produced information sheets are also available, a mini-guide for each department and a detailed sheet for each room (often all taken by eager visitors). And whenever you look a little at a loss, a friendly guard comes and offers his help.

I would like to examine the power of words by looking more closely at two clusters of interactions between words, images, and their installation, in the form of two exhibits at the Gemäldegalerie in Berlin-Dahlem. The first is a small exhibit of two paintings by Lucas Cranach the Elder, which I ran into quite by chance; the second is the Caravaggio exhibit, which I found just as I was about to give up my search for it. The first of these two exhibits demonstrates that the verbal aspect is part of the display, and therefore should be taken seriously. Subordinate to the image, it is always on the verge of overruling it, something that cannot be helped. In the context of the museum, there is no "innocent," "immediate," "direct" visual experience that can be un-framed. The second exhibit demonstrates that the juxtaposition already provides a syntax of its own, which shapes the "text" of the combination.

The two Cranachs, of identical format, are housed in a small glass case. One is *David and Bathsheba,* from 1526, and the other, *Lucretia,* from 1533. Both represent mythical subjects in which a woman is the main character (fig. 2). The text accompanying the *Bathsheba* reads:

> According to the biblical story, King David looks down upon Bathsheba, the wife of the soldier Uriah, while she is taking a bath. His desire for her is kindled, he commits adultery with her, and arranges Uriah's death on the battlefield. This entanglement of a powerful man in guilt through the seduction of a woman counts as one of "women's guiles." They show that even powerful men, heroes and wise men, are subject to the power of women.[6]

I happen to know this biblical story quite well,[7] and it doesn't run exactly as described here. The first half of the caption is reasonably accurate, but the second half is not. What matters here, though, is that the second half is an interpretation, not of the text or of the painting it is supposed to illuminate but of the myth or doxa to which both loosely refer. It is like a moral at the end of a fable, or an explanation that spells out the meaning of an allegory. The new element here is "seduction." In the biblical story, set in the ancient Middle East where baths were taken in courtyards, not a word is said about seduction by a woman, and when there is a mention of guilt, it is David's,

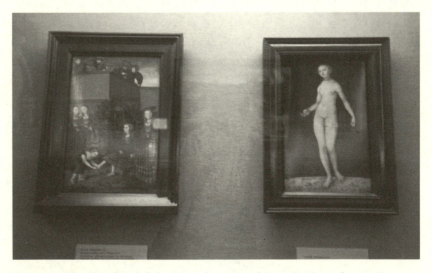

Figure 2. *David and Bathsheba,* Cranach, 1526, and *Lucretia,* Cranach, 1533. Courtesy of the author.

who is guilty of the murder of a good soldier and the theft of his wife. In fact, his guilt is emphasized when he is admonished by Nathan the Wise in the next chapter of 2 Samuel 12.

Perhaps—in fact, more than likely—in Cranach's time the story was read as an example of "women's guiles." This is an interesting case of how readings can change. An historicizing specification would seem to be called for if the caption is to be art-historically relevant. But the caption does not comment on the question if, and how, this particular work ties in with that earlier interpretation. Most unsettlingly, the (German) verb *gilt*, meaning "is held," is in the present tense. Thus the text not only suggests a political and ideological interpretation that one may want to question, but it universalizes it as the sole possible, eternally valid one, based on the self-evidence of "women's guiles." Limiting itself to a summary of the story with an historical interpretation, then, the caption falls to historicize the painting, to analyze its representational and painterly aspects. Instead, it pulls it in a particular direction. This direction, the misogynistic interpretation, would not be acceptable today if the discourse of art history had not trained its users to consider "contemporary" clichés as relevant. It all but suggests that *gilt* is "naturally" (almost) a past form of the verb (*galt*), which only a slip of the pen has mistakenly put in the present because "we" still read the story that way.

But, given the constraints to which museum captions are subject—number of words, accessibility, attractiveness—how could the caption have been otherwise? That this was not the museum's normal way of presenting—exposing—paintings on this subject became clear when, later in my visit, I came upon another *Bathsheba*, this one by Sebastiano Ricci, from 1725. Here, the caption read:

> At the edge of a spring of a Renaissance villa sits Bathsheba, the wife of Uriah, at her toilet. A woman (on the left) holds the letter from King David, who has observed Bathsheba from the top of his palace, brought in by a black messenger. David invites her to his house and makes her his lover. He sends her husband to the battlefield, where he dies (2 Sam. 11).[8]

This caption also tells the story. But it in no way imposes a politically loaded interpretation—neither a sexist nor a "politically correct" one. Although the

final sentence all but excuses or obscures David's murder of Uriah—it suggests that Uriah's death is accidental—this caption seems much more helpful to me in terms of exposing than the previous one. It provides much more visual detail, pointing ("at the left") and describing (the "edge of the spring," the "Renaissance villa," the "black messenger") while telling the tale, not coincidentally, with more specific detail. It is remarkable, in the face of a long history of effacement, that the black messenger is even mentioned.[9]

The effect of this mixed discourse is powerful. Through the simple use of a pointer (the caption), one is led to look at the picture. In reading the descriptive words, one is enticed to check their referential adequacy in the image. One is also made aware of the anachronistic setting, which in turn both provides art-historical information and emphasizes the representational, hence fictional, status of what you see. In contrast—and this is my main point here—the caption accompanying the Cranach *Bathsheba* leads away from the specific, visual image, back into age-old fables that universalize particular ideologies. Thus, through the very act of reiterating misogynistic platitudes, it makes the painting—its history, its meanings, its work—invisible. Politics and aesthetics are not distinct, let alone opposed, categories. If this case is any indication, they are mutually reinforcing.

This Cranach painting, however, is not only semanticized by its caption; it also becomes a "sentence" in conjunction with its neighbor, the *Lucretia*. Here, the caption reads:

> A figure from the early history of Rome. Lucretia was raped by the son of King Tarquinius Superbus and in order to save her honor she killed herself. This heroic act is held to exemplify higher female virtue.[10]

Here, too, the present tense of the last sentence universalizes the moral interpretation of the act. This universalizing is remarkable in light of the long and well-known history of controversy surrounding the interpretation that has persisted through Christian time, from the Church fathers to the Renaissance artists and writers, up to the present. The act has alternately been seen as either wise and virtuous, or rash and sinful.[11] The confusion of readings is not surprising: if on the one hand, the suicide extols the virtue of chastity, it is also considered a sin, mostly of excessive self-determination.[12] But again, this is not my major point. My point here is that while in both

cases the captions lead away from the paintings and thus perhaps separate them, they bring them together again in their mutual appeal to the misogynistic cliché. The two paintings seem to make a plausible pair: vice and virtue, two opposite types of women. In both cases, the issue is adultery and its corollary, chastity.

One tends to believe the discourse that brings these two works together, especially its Renaissance interpretation. And again, the present tense reads like an accidental slip, and may even go unnoticed. The two subjects do have themes in common, including the unspoken element of the husband, murdered in the one story and widowed in the other, and the intermale competition and power inequality, in which each story features a royal man and a commoner. But none of this is mentioned; only the judgment on women is repeated. In the similarities there are also differences, and these are not pointed out. Yet the most striking absence of all is that there is no reference to the visual image. Or to genres in painting.

One of the most obvious facts that the caption does not even touch upon, let alone address, is the one that *Lucretia* is a nude. Earlier museum visits begin to resonate in me as soon as I see a nude and a caption that ignores or denies this generic allegiance. Like Cranach's larger *Lucretia,* his smaller one exposes a woman's body. By covering it with a veil that is totally transparent, the visual effect of nakedness is heightened. The dagger that, according to the literary source, kills her, does not penetrate her flesh; rather than wounding, it points like an effective index. As a pointer it collaborates with the veil to highlight the perfect form of female beauty. A nude—that is all there is to it. It is hardly a history painting; it does not represent a story, it only hints at one, but that hint is overruled by the pointer indexing the nude. Is it a coincidence that the story hinted at is another story of male rivalry over a woman's beauty and possession? Here, I will simply suggest that the *Lucretia,* although of the same format as the *Bathsheba* and historically paired with it, can also be alleged to form a clumsy pair with it. But the exhibit in the Gemäldegalerie that juxtaposes the two, and, helped along by the commentary, joins the two in meaning, also *produces* a set of two affiliated paintings, based on the implicit views of women.

This display not only does not historicize the paintings and their possible morals, or the collocation; it also does not expose its own framing agency in

any way. I therefore came to appreciate another caption that I saw elsewhere in the museum (in room 242) all the more. It was the small painting by Terborch, entitled *"The Fatherly Admonition"*, including the quotation marks. Here, the caption did all the necessary jobs at once:

> *"The Fatherly Admonition"* (ca. 1655)
> On the right, a cavalier, who flashes a coin (hardly visible now) to the young woman. A morally dubious offer is represented here. Seen from the back, the "delicious figure in her rich white dress" (Goethe) saddles the viewer with a suspenseful lack of clarity about the decision.
> The unfitting title "Fatherly Admonition" goes back to a tradition of the 18th century.[13]

The title is both acknowledged as part of the historical text and historicized. It recalls that the eighteenth century was the age of moralism, much more so than the supposedly stern seventeenth century. The invocation of Goethe's comments reminds me of how much art-speak has been instilled in us by earlier writers, in particular the Romantic ones. But in addition to briefly telling us the story of the reception of this painting, the text also subtly contradicts that interpretation through references to the visual image. The pointer "on the right" encourages reference to the visual through references to the visual image. The pointer "on the right" encourages reference to the visual object. The parenthesis about the hardly visible coin makes me aware of the changes that images themselves undergo through time. The tension between the lurid and the moral subject, maintained by the undecidedness of the dénouement, makes the woman a subject in the full sense. She will decide which story will prevail; she will decide to which genre the work belongs. And, as an additional bonus, for which I am exceedingly grateful, despite all this information the caption is in no way moralistic.[14]

Appropriately, it imposes neither a sexist nor a feminist interpretation; it does better than that. By showing how uncertain the interpretation of images is, and how interpretations change over time and according to interests, it also suggests that the painting itself thematizes that uncertainty. Thus, ultimately, it yields semiotic power to the visual image, without naïvely assuming that the image has such power in and of itself. Retrospectively, then, the major problem of the Cranach display is the imposition of a verbal

discursive mode that overrules the images while making the expository agent invisible and invulnerable.

Hence, neither restraint, as in Grenoble's beautiful museum, nor pseudo-simple storytelling, as in the Cranach display, are satisfactory ways of dealing with the inevitable fact that exposing in itself already "speaks." I like the idea that the Terborch caption does not need more space, does not take more time to read, than the Cranach captions. With comparable succinctness, it manages to address the most relevant issues concerning exposition. Thus, it partakes of the endeavor of "double exposure" that my book on the subject proposes.

But I was on my way to that other exhibit, the Caravaggios. I found them tucked away between two larger rooms. In one corner, two Caravaggios were combined with a contemporary painting by Giovanni Baglione that had the same subject as one of the Caravaggios. From left to right, this is what I saw (fig. 3):

1. Caravaggio, *Amor Vincit Omnia,* ca. 1602
2. Caravaggio, *Doubting Thomas,* ca. 1600–1601
3. Giovanni Baglione, *Heavenly Amor Defeats Earthly Love,* ca. 1602–1603.

Caravaggio's *Amor* has obvious thematic (as well as stylistic and historical) links with Baglione's, and *Thomas*'s presence on the same wall makes sense in terms of authorship: both *Thomas* and *Amor* are by the same artist and were made in almost the same year. But if my notion of reading walls makes sense, there must be more to the combination than these two divergent motivations. Put differently, the combination *does* more than just mix theme and authorship. What does the collocation of two twosomes do for viewers who come here, not as art historians but as respondents to images?

What other viewers do, I do not know. But for me, the attraction of Caravaggio, who was already part of my own baggage, overruled the thematic link, so that on entering the room I first kept going back and forth between *Amor* and *Thomas.* This privileging was further helped along by the placement of the Baglione on the other wall of the corner. And yet the thematic link kept announcing itself in the corner of my eye, stimulated as well by the proximity of the works hung so low. As a subliminal effect of the placements, while looking at the *Thomas* I felt enclosed on both sides by the *Amor* subject. Caravaggio's *Amor,* the link to the two "others," although

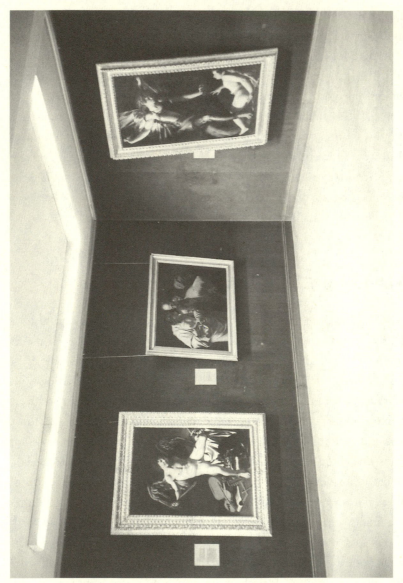

Figure 3. Caravaggio Room, Berlin-Dahlem, Gemäldegalerie. Photo by Monique Moser-Verrey.

initially on different grounds, became the key or shifter between the two sets.

Caravaggio's *Amor* (fig. 4) is a very provocative painting, a nude—this time male—erotic, and, for reasons that will be spelled out below, obviously

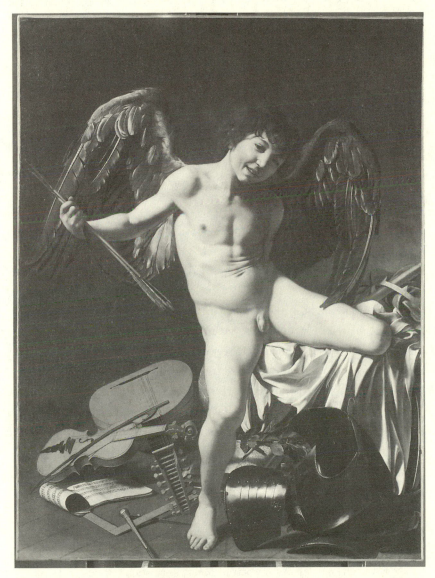

Figure 4. *Amor Vincit Omnia*, Caravaggio, ca. 1602. Staatliche Museen zu Berlin-Preußischer Kulturbesitz Gemäldegalerie. Photo by Jörg P. Anders.

homoerotic. What I became fascinated by was what that painting did to promote a coherence in the wall. A parenthetical remark is in order here: I find the homoerotic charge of many Caravaggio paintings blatant, and I acknowledge and underwrite the importance of recognizing gay art when you see it. But I am not interested in the gay, straight, or, more likely here, bisexual life that the painter may have led. The images I was looking at on the wall were homoerotic in an obvious way, and I am analyzing both that way and how I connected to it while participating in the signification.

In his widely read book on the painter, Howard Hibbard notes, slightly defensively:

> Although we do not need to presume that Caravaggio's pictures with homo-erotic content are necessarily more confessional than others, there is a notable absence of the traditional erotic females—no Venuses, Danaës, or Europas. In his entire career he did not paint a single female nude, which was wholly unlike the great Venetians.[15]

Together with others who have written about the artist in such terms (like Donald Posner, Nanette Salomon, Andreas Sternweiler),[16] I take the homo-eroticism in Caravaggio's work for granted. The question is, though, how does that aspect "come" to me? I will explain.

Thomas was caught in the middle, and, moving back and forth between the two *Amors*, it somehow became "natural" to look at this work more closely first (fig. 5). It immediately seemed to me to be a "navel" painting, according to the way I developed that notion in my book *Reading "Rembrandt"*: one whose subject is overruled by an odd detail, which in turn takes over the representation and abducts it in different directions, resisting coherence and thereby provoking resistance. A defining feature of such "navel" signs is that most commentators notice them, and fight them off. Howard Hibbard, for example, writes:

> The surgical detail of the picture is unbearable—or would be, were it not for the counterbalancing composition. Caravaggio placed four heads in a concen-trated diamond in the center of a canvas that is artfully planned and plotted, which is to say that it is unnatural. Thus the shockingly realistic *Doubting Thomas* could even be called classicizing in its composition.[17]

I quote this to frame the way I saw the picture. The passage renders closely both what I saw and why I would need a second look to really see. "Surgical

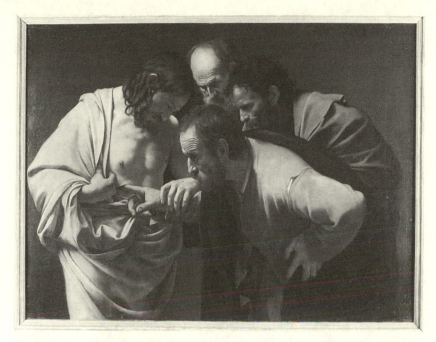

Figure 5. *Doubting Thomas*, Caravaggio, ca. 1600–1601. Staatliche Museen zu Berlin-Preußischer Kulturbesitz Gemäldegalerie. Photo by: Jörg P. Anders.

detail" is connected to realism and makes that mode "shocking." The classicizing composition is mobilized to counterbalance that effect. Hence, there appears to be a problem with the realism qualified by "surgical."

But, although addressing the "navel," the word "detail" also works as a shifter to get away from *the* detail, the work's navel, in this case the most surgical detail of all: the wound. If it is that wound that the critics need to get away from, it is because it is eye-catching; it is literally fascinating, holds you riveted at the same time as frightening you away. It looks shockingly "surgical," not only because of the precision of its representation—in particular, the spelling out of the loose skin that opens the flesh—but also because the "surgeon" is still there busy with it. Thomas's poking finger *points,* in more senses than one, at the surgical quality of the wound, thus enacting a penetration of the flesh.

An index of realism, an index of which direction to look, an index of penetration, this finger is part of the surgical detail that it represents, cutting the image's effect into three distinct areas, which it also unsettlingly integrates. It makes the flight into considerations of composition almost

compelling. But the composition of the "concentrated diamond" does not counterbalance the centripetal pointer; it emphasizes it. Where four men are so concentrated on a visual detail, we should look too. This is where I got sucked in.

Another who got sucked in is the Norwegian artist Jeannette Christensen, one of the "new narrators." Like the Dutch artist Edwin Janssen, she too uses installation as a medium. The work she made using Caravaggio's *Thomas, Ostentatio Vulnerum* (1995), was part of an installation in which polaroids after Vermeer, laser copies of Rembrandt's *Lucretia,* and other such works were combined with gelatine-filled frames. She tells her story of the surgical detail in a single work, albeit with a dual structure (fig. 6). Irreverentially, she made a laser copy of a coffee-table book reproduction of the painting, cutting out, surgically, the detail, thus cutting off the diamond of the reassuring composition. All that remains of the group of four men is the utterly eager look of one of them. The rest of the image is filled with hands, Jesus's one hand that guides Thomas's, and his other that mimes the gesture of penetration with its finger. Christensen put the copy into a plain wooden frame.

The second part of *Ostentatio Vulnerum* is an identical frame attached below it. In this frame she poured a layer of the outrageously contemporary and most transient of American desserts, Jell-O. The installation included several Jell-O frames, combined with other copies of old master paintings. Because of gelatine's ephemeral and transient quality, its painterly aspect and materiality, its luminosity that evokes Vermeer's fragile lighting, Rembrandt's golden displacements, and Caravaggio's chiaroscuro harshness that so effectively underscores subtleties, the Jell-O frames were absolutely crucial to the installation as a whole. The thickness of the works that exist as substance responds to the thinness and superficiality of bold and disrespectful laser copies of unique masterpieces; blown up, blown to pieces. What remains across that process is the bond between gender and suffering. It strikes even more forcefully as it survives the violence Christensen did to the "work of art." The bond remains distinct from the substance of paint, from the "original."

Subject to change in time, the Jell-O works inscribe time and thus inscribe the installation itself in time, as an intervention in the present, in a culture whose lengthy past makes the present appear frightfully hasty and

Figure 6. *Ostentatio Vulnerum*, Jeannette Christensen, 1995. Laser copy and Jell-O in wood. Photo courtesy of the artist.

time-ridden. This temporal dimension also narrativizes the work. The frame below the *Thomas* detail is blood red, filled as it is with strawberry-flavored Jell-O. Over time, the gelantine dried up; other such frames started to mold and smell. The gelatine dried unevenly, left marks that could be seen as aggrandized blood cells, as well as shiny areas, cracks, and tiny spots that convey a powerful sense of being inside: inside the wound. This view of the inner body makes Christensen's work a commentary on the "abject" or grotesque side of Caravaggio's work: precisely the one that Hibbard apparently could not deal with.[18] Thus Christensen uses the medium of installation to tell a different story with and about this painting, as well as about the relation of the present to the past (of art). Confrontationally, she blows the painting's navel up for the viewers, the "second person" of her narrative, who are now no longer able to escape into realism and classicism.

In fact, both the beginning and the end of Hibbard's paragraph contain a textual detail that betrays, like a symptom, that the navel of the painting has worked on him too. In the beginning he writes that the surgical detail *is* unbearable, even if he then sets out to resist it; he does not write "would." And in the end he acknowledges shock. I can understand his shock: the extreme realism of the skin surrounding the wound foregrounds the fact that the finger goes inside, very, very deeply.

To the left of the *Thomas*, the *Amor* keeps tugging at you. The young boy, laughing engagingly, provocatively, encouragingly, is very, very sexual. His half-open mouth and smile are as pointedly offered for your delight as is his frontally represented penis. The arrows are elegantly held, showing muscular, strong shoulder flesh, but pointing, as arrows tend to do, at the genitals. Well, perhaps not quite. The muscular shoulders are displayed thanks to the fact that the body holds the arrows slightly behind the torso. Thus they become even more ambiguous. Reading the surface of the image, they point to the genitals. Reading with the depth of linear perspective, they point to the boy's behind. They evoke a double sexual promise, depending on which mode the image is read in; this suggests that it might be rewarding to allow the two readings to collaborate. This double visual reading—"superficial" and "realistic" with perspective—is something I have learned from the great painters of the past: Rembrandt, Vermeer, Caravaggio, Velázquez. It is a strat-

egy that wonderfully sustains both the notion of reading images and the specificity of the visual.

Iconographically speaking, the boy's awkward pose can be read as a nod to Michelangelo, whose sculpture *Victory* of 1527–30 (?) and *Saint Bartholomew* in the Sistine Chapel of 1534–41 not only have the same pose but also show the effect of that pose on the flesh of the inner thigh. The Michelangelo image is reproduced in Hibbard (159). Hibbard comments on it with his characteristic ambivalence: "There may well have been more than rivalry or rebellion moiling in Caravaggio's mind when he created these Michelangelesque images. We also seem to see a profound identification (even if it is momentary and perverse) with a great artist of the past whom Caravaggio must have believed to have been homosexual." As we will see shortly, here as well as in the captions there is a striking insistence on homosocial rivalry whenever the subject of homosexual desire comes up. But if we believe Hibbard's account of Michelangelo's images (1983, 159), and in particular his older, bearded and bold martyr, little else links the "quasi-Platonic metaphor of the aspiration of the soul to God" with this angelical yet naughty boy, whose pose seems designed to show as much flesh as possible and to be suggestive of the rest. You get to see all the roundings of the boy's right thigh (on your left), including his buttock and then the left inner thigh. A feather caresses the thigh, and also subtly points in the "right direction." Because the left leg is raised on the drapery, you can even see, beneath the penis, which almost seems to point it out for you, a hint of the dark cavity that leads right up to the boy's anus.

The armor, the instrument of protection, lies defeated on the floor, with the stem of a rose between the boy's feet; on the other side of him are the musical instruments. Together they make up the still life that is so often inserted into this artist's history paintings. The still-life element is more than a nod to convention or a patron; it helps me to go beyond my initial limits in reading the painting. Its painstakingly realistic mode reads like a direction for use: it entices me to look at all the details in the image; they are meaningful and worthy of close attention. It cannot be helped that the "naval" here—pointed out by arrows and a caressing feather and then again by the curved line that runs from the encouragingly smiling face through the throat, breast, wrinkled stomach flesh, navel, belly to the penis and beyond—is the

just barely, yet clearly suggested access to the hole behind/underneath the penis.

The move from this hole to the surgical hole in the other painting: the juxtaposition of the holes makes it hard to avoid. Through the installation, the realistically represented cavity, that index leading up to the anus, points to the metaphorical but iconically represented hole. The wound thus *becomes* a metaphor, or at least more insistently so, through this incidental metonymic motivation.[19]

Is Baglione's *Amor* only there to foreground Caravaggio's superiority as a painter or his more daring eroticism (fig. 7)? The shapes in this work, in the right corner of my eye, have been present all along. In Baglione's *Amor* the figure is fully armored. The heavenly Amor descends from above as if to interrupt the earthly couple. The one figure with his bare buttocks lies ready for action. According to "official" iconography—the one that translates images into meanings that are outside of what is seen—the pointed ears turn the figure into a demon. But if you don't translate, if you don't leave the visual image to prior meanings, you see the earthly lover as simply an older man. The heavenly Amor is not so much a "purer," spiritual lover, but a more attractive, younger, more handsome other man. Less overt, this painting metaphorizes the eroticism even more; instead of a penis on offer, toes stand erect in response to the angel.

I haven't said anything about the captions yet. The one accompanying the Baglione mentions the competitive relationship between the two painters, and presents this work as a direct act of rivalry. Baglione painted it for Cardinal Benedetto Giustiniani, while Caravaggio did his *Amor* for the Cardinal's brother, the Marchese Vincenzo Giustiniani. The rivalry between the two has been well documented; there are records of a libel suit by Baglione against Caravaggio in 1603. Here, in the gallery, there is definitely a competition as well, and not just between a better painter and his lesser colleague. Baglione puts the issue of rivalry between men in his image. The descending victor's younger appearance ties in, at least for me and through this installation, with ideas and images of homosocial power relations in which older men dominate younger men and of homoeroticism's revenge: the culture which gives ruthless priority to youth. This is a much-debated issue in cultural studies, under the influence of the conjunction of feminism and "men studies."[20]

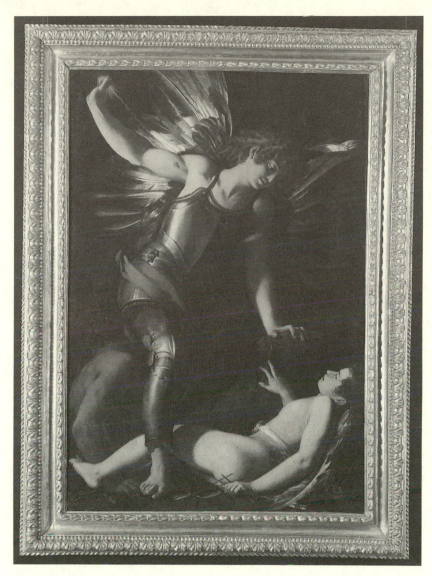

Figure 7. *Heavenly Amor Defeats Earthly Love*, Giovanni Baglione, ca. 1602–1603. Staatliche Museen zu Berlin-Preußischer Kulturbesitz Gemäldegalerie. Photo by Jörg P. Anders.

Whether Baglione had an opinion about Caravaggio's attractive young boy or not, whether his hatred for his rival had anything to do with it, whether he knew the *Thomas* and considered it: none of this is relevant for a reading of the collocation of these three images in this particular corner of this Berlin museum. But in situ, on this wall and "read" in 1994 by someone

interested in relations between men, the Baglione and its caption contribute as much to a rereading of the *Thomas* as does Caravaggio's *Amor*. For now, to return to the *Thomas,* the homoerotic thematic imported from the adjacent *Amor* becomes invested with rivalry because of the caption, and it becomes a rivalry qualified around age because of the image. Caravaggio's boy is alone; although he is not really alone, in the sense that he is emphatically "talking to" the viewer, he is the rival of no one else. Baglione's representation has three men, two of them rivaling, the younger one winning. Now, *Thomas* has not simply a "counterbalancing composition" of four heads, but three men, all three with wrinkled foreheads where concentration and age meet, all vying for access to the fourth whose forehead has no wrinkles.

Now, and only now, for that one fleeting moment when I look back again from the Baglione, which I read as a transformation of the other *Amor,* the painting with the religious subject becomes not just secular—I had read it secularly from the very beginning, surrounded as it was by the two "others"—but emphatically, even thematically erotic, "about" the cutting edge between homosocial power relations and homoeroticism, where the line between "being a men's man" and "being interested in men" is about to disintegrate.[21] It indicates that in spite of the gap between homosocial and homosexual relations, the former is predicated upon the denial of the latter. The "navel" completely takes over, becoming a *mise en abyme* that multiplies itself.

Indeed, now that Jesus, squeezed in between two works of eroticized rivalry, becomes the younger man for whose favors—access to the hole in his body—the three other men vie, the painting becomes full of holes, folds, and creases. Jesus's barely visible leg at the lower left becomes slightly coquettish, recalling Amor's open (dis)play of legs. The finger of the lucky Thomas, already inside the wound, is thrice repeated in Jesus's thumb, index, and little finger, going into other folds, other creases of his own body. Openings are suggested all over the place, beginning with Jesus's half-open mouth, which recalls Amor's lustful one.

While Thomas's finger is (already) poking inside the hole, the issue of rivalry is not only one of physical but of *visual* access to it. Like the indexically indicated anus of Amor, difficult visual access is stimulating: it

enhances desire and visual attention. The representation not only stages the three men waiting for their turn in a supreme reversal of power relations between older and younger men when desire comes to threaten erotic power. It also stages the intricate connection between desire and vision. The interplay between the two forms of power, sociopolitical and erotic, the one not canceling but counterbalancing the other, also writes in the viewer as participant, addressee, one who is not silenced but involved.

The wall, for me and at that moment, completes the telling of its story. Let's read that story once more. Baglione, in the now-established fabula, comes first, and the caption's indication of rivalry, at first sight irrelevant and only serving Caravaggio's hypostasis, only enhances what the painting itself adequately "tells": men may rival, but eroticism and power relations rival too, and mess up the rivalries. From there on, the *Thomas* enhances the need to bow down to erotic power, a need the three older men act out in a strong, literalized metaphor. Firstly, they bow their heads, literalizing "bowing down" as a metaphor for abdicating power. Simultaneously—and secondly— they involve viewing as substantially invested in eroticism. But—thirdly—the desired body is not displayed, ready for the colonizing gaze, but made difficult to have visual access to. Meanwhile—fourthly—its bodiliness is signified quite emphatically: Jesus has no aura, but a bare chest; his human quality overrules his divine status in all respects, especially by the moving detail of the ear that sticks out through his hair like a Barthian punctum.[22] His look, directed at his own hole, coordinates with his hand that gently guides Thomas's hand inside the hole. I am aware that this painting was made as a religious representation, and I am not trying to provocatively overdo the iconoclasm of the erotic reading. But the work is so strongly framed by the two others that this reading, as "immanent" as it is and therefore limited to the situation, made all the sense in the world to me, as an example, precisely, of how reading walls is different from reading paintings. The wall, the museum installation, thus becomes a new narrator, embedding, colonizing, if not overruling the narrator within the image and his predecessor, the biblical narrator. In this case, the resulting story is most exciting.

With this realization, my imaginary narratee is ready for the final episode. Visual attention is rewarded here. You get it all. The best painting; the most

beautiful boy; erotic power, which has at least temporarily disposed of homosocial power. His most desired body part is visually accessible—almost. Looking and/as longing has accomplished its goal. Desire is fulfilled, the story is over.

But instead of displaying this body part, the very showing of it, including the three pointers that tell you where it is, also serves to hide it. For eroticism is also rather intimate. The viewer is allowed to be alone with the body. Thus this story, fully erotic as it is, is not only subversive of social power relations. It also offers a systematically opposed alternative to the abuse of eroticism that is prevalent in so many other representations of bodies. Read within this installation and in this narrative mode, the work becomes the opposite of the nude as we have so often seen it, for example, framed as the object of competition between ambitious upcoming impressionists in the Metropolitan Museum of Art, as in the placement of Courbet's semiporno-graphic *Woman with a Parrot* and the subordination of Manet's counter-painting to it. (Manet's work bears the same title and was painted in the same year as Courbet's, but is such a systematic opposite of it that the pre-sentation seems hilariously "wrong.")[23] This does not make the Caravaggio installation porn for gays; it is not porn, for it does not encourage abuse and appropriation, nor do I feel that as a woman I am excluded by the gay aspect of its erotic plot.

The boy is beautiful in my eyes too, but that is hardly the issue. It seems important, from the perspective of cultural criticism, to fully acknowledge the homoeroticism of the story instead of paying lip service to it and then "counterbalancing" it away. The way the installation's narrator enables me intimately and intensely to see the homoeroticism already gives me pleasure; it provides the thrilling realization that the installation speaks. But most rel-evantly, the intricate relations this story tells me about while staging the story before and for me—connections between social and "private" pleasures and pains, power and submission, and, above all, the fragility of these posi-tions, and the place of vision in all that—leave me breathless. Thanks to this installation, I have not been confronted with a nude and invited to gauge the beauty of art through the beauty of a displayed body. Instead, I have been allowed access to a wonderful story, a twentieth-century art fiction that chal-

lenges and overcomes the bond between sexuality and abuse, stereotyping and power.

No expository agent can foresee, program, or totally preclude such visual experiences. Some of this must simply be left to luck, intuition, and to the art itself. The installation's marveling effect, however, is facilitated by the narratorial decision to keep these three images together, for better or for worse, because somehow they "work" together; and to hang them so low, so close together, and so well illuminated that they invite viewer participation as much as Amor's smile does. The utterance of exposing seen as a discourse is no longer confined to the authoritative, constative, "third-person" narrative here. Caravaggio's *Amor* alone would overrule such discourse. But the effect of the display—of the new museal narrator's story—is much more than the accumulation of the effects of the three works. Its cultural-political story could not have been told by any of the three works individually. Nor could its story have touched me, allowing the constative to become highly performative and the "second person" to participate beyond the expository agent's program. This strong appeal to viewer participation in the construction of the narrative makes this narrator new, postmodern, in spite of the deceptive classical status of the art he/she uses to construct the episodes.

What I derived from this experience is something I am tempted to call "Allegorical Museology." Thus, I end by proposing to take this event of meaning-making as an allegory of the power of display. If there is anything that would differentiate the "new" museology from the "old" or plain museology, it is the serious follow-up to the idea that a museum installation is a discourse, and that an exhibition is an utterance within that discourse. The utterance consists not of words or images alone, nor of the frame or frame-up of the installation, but of the productive tension between images, caption (words), and installation (sequence, height, light, combinations).

Such a perspective deprives the museal practice of its innocence, and provides it with the accountability to which it and its users are entitled. The direction I see at this point for the collective endeavor of museum studies within—and as a leading paradigm of—cultural analysis is threefold.

First, the most obvious thing to be done is to systematically analyze the narrative-rhetorical structure of a number of specific museums, in order to

refine the categories and deepen our insight into their effects. Such studies have been undertaken from the perspective of the history of epistemology, and could be supplemented from a more analytical, narratological perspective.

Second, establishing the connection between museal discourse and the institution's foundation and history can help us to understand what can be improved and what is inherent in the museal institution. Studies in this area are being published, but tend to be fairly general, focusing on the institution rather than on the specifics of what happens inside it, and on the historical more than the current situation.

But there is an escapist aspect to the all-pervasive call for history. It is as if the past can teach us about the present, which is of course true. But, on the sly, the idea is also implied that the present *has* indeed learned from the past. Progress is an idea that is difficult to get rid of. If I am proposing rigorously, perhaps provocatively *contemporary* readings, it is not out of indifference to history, but because of a need to counterbalance that escapism and the evo-lutionism it implies—the old story of the nineteenth-century narrator. Through detailed attention to specific cases, I have tried to make a case for such willful anachronism. My project advocates taking the position of the viewer into account without appealing to empiricist fallacies or falling back into relativist subjectivism. This only seems possible and acceptable if close attention to the object as well as to the sociopolitical aspects of the interac-tion between the reader and the expository agent is part of the reading.

Third, an indispensable consequence of the confining nature of discourse is the need for self-critical analysis. For there is a serious problem, of logic and of politics, with the self-righteousness of many so-called critical studies of ethnocentric practices. If discourse confines us all, the critic is confined too. Therefore, I also analyze the way "new museologists" use the discursive perspective itself.

It is obvious that in a museum the "order of things" matters. To conceive of museological agency as a new narrator requires a profound understand-ing of the nature of material narration. But the rhetorical and narratological reflections suggest that there is some method to that madness. Understanding that method—the discursive system that underlies appar-ently incidental acts—would seem to represent a contribution on the part of

humanists to a museology that wishes to be worthy of its title of honor, "new." Conversely, the new museology can also become an emblem for a concept of inquiry in the traditional humanities that will help the "turn to cultural studies" to become a convincing innovative principle.

It was also important to me to make clear that the things that happen in cultural practices cannot be fully mastered, predicted, or programmed. The erotic story on which I have ended this essay, allegorical as it is of the importance of visual imagery in social and erotic relations, can be taken as an allegory of the kind of museology I like to think of as a paradigm for the humanities. Its narrator—multimedial, primarily visual—whose primary tool is framing, can only be called *new* if his or her agency as such is openly declared, reflected upon, and engaged in dialogue with the second person or narratee of the story: the viewer, that postmodern fellow narrator.

notes

1 This is the program, for example, of the institute for research and doctoral study at the University of Amsterdam, the Amsterdam School for Cultural Analysis (ASCA), of which I was the director for five years.

2 See Hayden White, "The Forms of Wildness," in *Tropics* (1978).

3 See Michel Foucault (1972).

4 For a presentation of speech act theory, see Austin (1975). A brilliant discussion is Shoshana Felman (1987).

5 This was the theme of a lecture series held at the Musée Georges Pompidou in Paris and the Centro Galego de arte contemporáneo in Santiago de Compostela, for which I wrote this text.

6 "Nach dem Bericht der Bibel erblickt König David bathseba, die Frau des Söldners Urias, beim Bad. Er entbrennt in Liebe zu ihr, bricht mit ihr die Ehe und richtet es ein, dass Uria im Kampf unkommt. Diese Verstirckung eines Mächtigen in Schuld durch die Verführung einer Frau gilt als eine der "Weiberlisten." Sie zeigen, auch Mächtige, Helden und Weise, erliegen der Macht der Frauen." Cat. No. 567.

7 See Bal (1987), ch. 1 and (1991a), ch. 6. I have also written on various versions of the Lucretia story (e.g. chapter 3 here), so I cannot claim to know what the word-image interaction would mean to one who is not as familiar with these stories as I am. Usually, one knows of them, vaguely; they are part of the *doxa* or stock of cultural commonplaces. This status makes them ideal as "ideo-stories," ready to be semantically filled. And this is precisely what the captions do.

8 "Am Brunenrand einer Renaissance villa sitzt Batheseba, die Frau des Urias, bei
der Toilette. Einer Frau (links) hält dem vom Negerboten überbrachten Brief
König Davids, der Bathseba von den Zinnen seines Palastes beobachtet hat. Er
lädt sie zur sich und macht sie zur Geliebten. Ihren Mann schickt er in den
Kampf, wo er fällt (2 Sam. 11)."

9 See Fred Wilson's marvelous installation for The Contemporary in 1995. Lisa G.
Corrin, ed., *Mining the Museum: An Installation by Fred Wilson*. New York: The
New Press, 1995.

10 "Eine Gestalt aus der Frühgeschichte Roms. Lucretia wurde vom Sohn des
Königs Tarquinius Superbus vergewaltigt und gab sich, um ihre Ehre zu retten,
den Tot. Diese heroische Tat gilt als Beispiel hoher weiblicher Tugend." Cat.
No. 1832.

11 See Ian Donaldson (1982) for the Lucretia tradition.

12 See chapter 3 of this volume.

13 "Rechts ein Kavalier, der einer jungen Dame ein Geldstück (kaum noch sichtbar)
entgegenhält. Ein sittlich zweifelhaftes Angebot is dargestellt. Als rückenfigure
belässt die 'herrliche Gestalt im faltenreichen weissen Altaskleid' (Goethe) den
Betrachter in spannungsvoller Unklarheit über ihre Entscheidung. Der unzutref-
fende Titel 'Die Väterliche Ermahnung' geht auf eine U[..]berlieferung des 18.
Jhs zurück."

14 For a fine feminist interpretation of this genre, often referred to as "proposition
scenes," see Frima Fox Hofrichter (1982).

15 Howard Hibbard (1983), 87.

16 Donald Posner (1971); Nanette Salomon (1991); Andreas Sternweiler (1993).

17 Hibbard (1983), 167–68.

18 For the grotesque as an inside-out, a display of the inner body, see Ernst van
Alphen (1995). Van Alphen's analysis is influenced by Susan Stewart's book
(1984).

19 For this notion that metaphors are metonymically motivated, I refer to Gérard
Genette's seminal article "Metonymy in Proust" in *Narrative Discourse* (1972).

20 One can think of Norman Bryson's analysis of Géricault's paintings in this light
(1994); or of Ernst van Alphen's analysis of Ian McEwan's novel *The Comfort of
Strangers* (1996) and Paul Schrader's film based upon it, "The Homosocial Gaze,"
in which he provides the theoretical background and bibliography, or Van
Alphen's ch. 5 of *Francis Bacon* (1992), with an analysis of Bacon's visual decon-
struction of this social scheme.

21 This phrase is recurrently used by Eve Sedgwick as one of her illuminating catch-
phrases in *The Epistemology of the Closet* (1990).

22 Roland Barthes (1981).

23 See Bal (1996a), 87–134.

vision in fiction: 6 proust and photography

introduction

MUCH HAS BEEN WRITTEN ABOUT THE confining, colonizing nature, or at least effect, of the gaze as a social force. This essay presents a literary case of a different use of the gaze. Rather than being a psychoanalytic or social concept, the gaze is seen here as a mode of producing and communicating meaning. In other words, the gaze I am discussing is a gaze that produces meaningful signals; it is a semiotic mode. Active but secretive, masking understanding with visuality, pursuing a knowledge that is more profound and new for being unacknowledged: such is the particular form of vision I want to put forward. What I mean here is that vision is an act of connecting, yet potentially unacknowledged, silent, one that others may not notice; a gaze that enables subjects to communicate without giving themselves away. The "gaze in the closet" is a homosexual gaze, desiring, establishing contact with the object, hence communicative, yet *at the same time* remaining silent about itself, silencing the homosexual connection.

This semiotic gaze has a double orientation: it is erotic and epistemological. Taking closeted homosexuality not as a negative, defensive attitude but as a model for a specific manner of "speaking" that cannot be spoken, I will map the features and possibilities of the closeted gaze as an epistemological trick. The case I will discuss for its use of the closeted gaze is Marcel Proust's modernist masterpiece *Remembrance of Things Past.*

outsider's snapshots

There are two or three paths that can take us to the notion of the closeted gaze. One is through locating what I call the focalizer's position. This is a position on the outside, and, in its precision, it produces the kind of photographic effect that characterizes many of the visual descriptions in Marcel Proust's *Remembrance of Things Past.* Some of these descriptions will be the object of the present analysis. The passages concerned refer to, or take their model from, particular kinds of photographs: snapshots, instantaneous arrests, random stills. They are narrative paradoxes: turning narrative into pictures, they subsequently turn a photo album back into a record of "life" while simultaneously emphasizing the immobility caused by the medium rather than by the object. This paradoxical character is necessary, I contend, in order to produce the specific epistemological mode of vision which, on the basis of the examples analyzed in this essay, I call "the closeted gaze."

The snapshot effect often gets lost in the English translation. Thus, the following description, "taken" during dinner at the Verdurins', renders the strangeness, the position of he who "sees" as outsider, in narratological terms, the focalizer to whose visual mediation we owe this glance inside a milieu. But it is precisely these features that the translation obscures.

> Et la [sa pipe] gardant toujours au coin de sa bouche, il prolongeait indéfiniment le simulacre de suffocation et d'hilarité. Ainsi lui et Mme Verdurin qui, en face, écoutant le peintre qui lui racontait une histoire, fermait les yeux avant de précipiter son visage dans ses mains, avaient l'air de deux masques de théâtre qui figuraient différemment la gaîté. (1:262)

is translated as:

> And by keeping the pipe firmly in his mouth he could prolong indefinitely the dumbshow of suffocation and hilarity. Thus he and Mme Verdurin (who, at

the other side of the room, where the painter was telling her a story, was shut-
ting her eyes preparatory to flinging her face into her hands) resembled two
masks in a theatre each representing Comedy in a different way. (1:286)

The translation, although narratively adequate, emphasizes narrativity at the
expense of visuality: the durative verb "il prolongeait" becomes "he could
prolong," and the still visual description of the mimes is replaced by a paren-
thetical remark. In contrast, my visual reading requires emphasis on the still-
ness, the suspended quality of the actions. The scene as a whole, theatrical
like so many of Proust's *salon* scenes, presents that well-known combination
of mercilessly ridiculed conversations and characterizing gestures. But the
two images represented in the passage, the two masks, isolate the two faces
through framing. They also freeze the movement through the imaginary
clicking of the camera, which turns this one description into a set of two
snapshots: a contact sheet of serial photography.

Of course, Proust's work is literary, not visual in the material sense. My
analysis of vision in it is predicated upon a distinction between (material)
medium and (semiotic) mode. The language of narrative can produce
vision. Where there is visuality, there is a viewer. The viewer within narrative
may or may not be identifiable as the narrator. This subject of vision, the
focalizer, is often used to stage the position of the outsider as photographer.
This position is a precondition for the production of the snapshot. In the
above case, the focalizer is Swann, who is new to, and already about to be
cast out of, the "clan" of insiders. This position matters; it is crucial to our
understanding of the mode of vision at stake. The discrepancy between the
focalizer and the object makes for the gap, the slight mismatch, that allows
for the representation of strangeness. What the "photographer"-focalizer
captures is what cannot be seen when one surrounds the gaze with affective
routine.

Proust described this estranging effect as photographic, in a meditation
on the estrangement he felt at seeing his ailing grandmother (who doesn't
know she is being watched). There, the outsider's position bears the mark of
deadly difference: the grandmother is beyond visual recognition because she
is dying; he is not. The seriousness of the divide between insider and out-
sider casts its shadow over other visual encounters as well. In particular, the
position of the outsider bears an obvious relation to the issue of the closet.

writing movement

In preparation for the revelations of *Sodome et Gomorrhe,* a vision is set up to serve as the door of access to the closet. While waiting for an excessively long time for the return of the Duke and Duchess of Guermantes, from whom he intends to ask a favor, Marcel has occupied a position from which he feels he can effectively watch for the intended return of the couple. From his "innocent" position he will, "by chance," be able to watch the revealing encounter between Charlus and Jupien, who, unawares, come out of the closet for Marcel. Thus far, the narrative situation.

From his station, the narrator, here also acting as the focalizer, produces two twin descriptions. The first yields a series of successive "art" photographs that, together, form an imaginary museum of Dutch genre paintings. It consists of the focalizer's act of framing, the cutting out of a portion of the spectacle of the world.[1] The view is related to painting, and the verbal "framing" indicates that the semiotic of photography is at stake: "... framing silent gestures in a series of rectangles placed under glass by the closing of the windows, with an exhibition of a hundred Dutch paintings hung in a row" (2:595). And the kitchen maid is daydreaming, the girl is having her hair done by an old woman with a face like a witch, so as to effectively evoke the atmosphere of such paintings.

But there are moments when, rather than providing a balanced exhibition, the different views suggest a random collection of snapshots, and not very successful ones at that: "... nothing but blocks of buildings of low elevation, facing in every conceivable direction, which, without blocking the view, prolonged the distance with their oblique planes" (2:595). When, in the afternoon, the hero resumes his watch, the description of views taken from a distance alternate with those—detailed as if through a telephoto lens—of the orchid and the hummingbird. In between, at medium range, are the snapshots of Charlus and Jupien, whose gestures occur in rapid succession. These descriptions recall the serial shots made by the American photographer Eadweard Muybridge or by the French scientist Etienne-Jules Marey that were designed to "write" movement (fig. 1).

There are great differences in Proust's visual effects. For our purposes it is important to notice the difference between the "museum effect" on the one

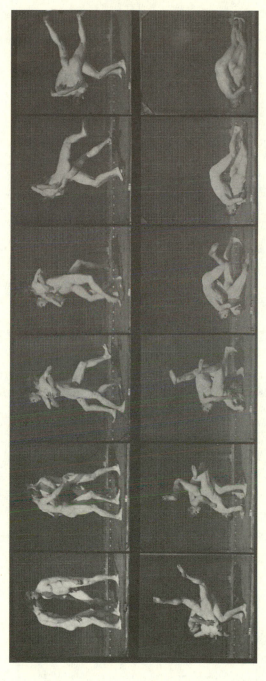

Figure 1. *Wrestlers* (details), part of the series Human and Animal Locomotion, Eadweard Muybridge, 1887. Private collection. Photo courtesy of Kunsthistorisch Instituut, University of Amsterdam.

hand—the juxtaposition of pictorially pretty images which entertain an obvious interdiscursive relation to a specific genre in painting, one based on the voyeurism of domestic intimacy[2]—and the "snapshot effect" of the emphatically random and vulgar kind on the other. This difference is explicitly theorized by the narrator. The Duchess of Guermantes, spokesperson of "bêtise," displays a blindness to this difference which enables the narrator to highlight it:

> "What! You've been to Holland, and you never visited Haarlem!" cried the Duchess. "Why, even if you had only a quarter of an hour to spend in the place, they're an extraordinary thing to have seen, those Halses. I don't mind saying that a person who only caught a passing glimpse of them from the top of a tram without stopping, supposing they were hung out to view in the street, would open his eyes pretty wide."
> This remark shocked me as indicating a misconception of the way in which artistic impressions are formed in our minds, and because it seemed to imply that our eye is in that case simply a recording machine which takes snapshots. (2:544)

The difference between the two visual domains, art and photography, is exacerbated here by the Duchess's denying it in one of her characteristic exaggerations. The imagined situation—a tram ride as the worker's museum visit—also implies a change in social class, which in turn brings in the banality, the vulgarity, that the photographic snapshot also stands for, the record of everyday life, as opposed to the paintings which varnish that life with aura. The misappreciation of artistic impression is simultaneously a misconception of the different visual domains. The word "snapshot" itself appears to summarize this philosophy of vision bound up with a class-specific aesthetic, indicating in its wake a notion that movement can be visually recorded. This visual recording mechanism produces serial snapshots as a form of writing.

libidinal epistemology

At the center of the novel's experiments with photography, in particular its exploration of the epistemology of the snapshot, stands the narrator's best friend, his ego model, closeted homosexual and closeted love object Robert

de Saint-Loup. His ontological status is like Albertine's: surface instead of depth, albeit a surface not characterized by photographic fixation but by fugitive mobility. Visions of him yield not a picture album but a contact sheet of rapidly taken photos of movement.

Photography, in its specific guise of the serial snapshot, provides the narrator with a uniquely suitable and efficient mode of representing this important character, of revealing the secrets he is invested with but also meant to keep. Saint-Loup is the most "photographic" character in *Remembrance* in three distinct ways. First, he is the most photogenic one, of a luminous beauty, and thus the ideal object of "art" photography. Descriptions of his beauty are plentiful, and they challenge the narrator's need to keep both his and Robert's homosexuality a secret. Second, he is also the "official" photographer: he is the one who takes the famous photograph of the dying grandmother, who wished to leave her grandson a visual memory of herself. That "photo session,"[3] with its great number of narrative and poetic functions, narratively enables the revelation of Robert's homosexuality: as gossip has it, that developing the photo in the darkroom was a pretext for him to make love to the liftboy in the Balbec hotel. But, third, and most importantly, he is constantly being "photographed" in his movement. One such photo session constitutes the *mise en abyme*[4] of the poetics and politics of the snapshot in *Remembrance*.

Robert is a Muybridge character, a seagull in flight of the kind Marey was constantly recording in his epistemic endeavor to understand movement. The attempt to fix movement *qua* movement is, naturally, as old as the attempt to visually represent is, and studies by late-nineteenth-century photographers, while leading up to cinema, stand in the tradition of Greek vase paintings. Speed characterizes this Proustian character, speed is his sign, as it is the sign that signals the difference between snapshot and cinematic writing. This rapidly moving character is a fleeting being, but not in the same way as Albertine. The difference between them is gendered.

The latter is characterized by a certain passivity, and is so systematically adapted to the narrator's wishes that she entirely loses her consistency as a character. The reader will recall the repeated change of plans to which the narrator subjects her on the day she intended to go to the gathering at the Verdurins', where, the narrator discovers to his dismay, Mlle. Vinteuil—

the feared evil spirit, since she is overtly gay—was expected to appear. He sends Albertine elsewhere, only to discover that another "dangerous" woman, Léa, was supposed to go to that same place, so that he sends his maid Françoise to fetch her and bring her back home. All this is madness, but Albertine, lacking any autonomy as a character, like a puppet who submits to the needs of the narrative, complies and does exactly as she is told. Faced with the narrator's desperate attempts to know her through fixing her, stenciling her on paper, Albertine lets him try. The resulting snapshots only reveal all the more painfully the essential impossibility of "fixing" her.[5]

Robert, on the other hand, escapes being fixed in a different, more active, and fundamentally more visual way. From the beginning of their friendship, the narrator has characterized Robert through speed of movement, a trait that will pursue him throughout the novel, as his determining, identifying sign.[6] This trait, however, develops into much more than a simple label, arrow, index of identity. It is replete with narrative meaning, psychological characterization, physical features, providing the narrator with a kind of support onto which he can build his plot.

As is well known, this long novel is punctuated by a series of scenes of voyeurism, emphasizing, through that rhythmic return of the "primal scene," the crucial importance of this particular visual libidinal epistemology. The series begins with the spying on an infantile "sadistic" scene between Mlle. Vinteuil and her female lover, typically centered on a photograph, then moves on to the literalization of the closet at the Hôtel de Guermantes, and finally ends with the "adult" sadomasochistic scene during the war. As an introduction to the last scene of the series, Robert's rapidity serves to identify him, but it also fulfills a number of other functions. Here is the very Muybridgean description of this scene:

> when, at a distance of fifteen yards, ... I saw an officer come out and walk rapidly away.
>
> Something, however, struck me: not his face, which I did not see ... but the extraordinary disproportion between the number of different points which his body successively occupied and the very small number of seconds within which he made good this departure which had almost the air of a sortie from a besieged town ... This military man with the ability to occupy so many different positions in space in such a short time disappeared (3:838)

quand je vis sortir rapidement … trop loin pour que dans l'obscurité pro-
fonde je pusse le distinguer, un officier.

Quelque chose pourtant me frappa qui n'était pas sa figure, que je ne voyais
pas … mais la disproportion extraordinaire entre le nombre de points dif-
férents par où passa son corps et le petit nombre de secondes pendant
lesquelles cette sortie, qui avait l'air de la sortie tentée par un assiégé, s'exécuta
… le militaire capable d'occuper en si peu de temps tant de positions dif-
férentes dans l'espace avait disparu …. (3:810)

Again, the French is closer to not just representing but also iconically signi-
fying the effect of speed than the English; the pace is established though the
initial positioning of what is ultimately at stake: "quand je vis sortir rapide-
ment": all is said. The relationship between subject ("je"), vision ("vis"),
movement ("sortir") and speed ("rapidement"), consolidated in the French,
is dispersed and stretched out in the English, in a rhythmically slow, albeit
narratively adequate sentence. That hopelessly sense-based "je vis" is what
Muybridge and Marey, each with different goals, tried to fix *in* the image
itself: the passage of time in a subjective perception whose center is void,
without the unreliable help of the senses.[7] The denial of recognition on the
basis of the face foregrounds the epistemological value of the snapshot *as
such,* as movement, conceived of as the occupation of points in space, and
determines the individual uniqueness of the character. This strange, and
estranging, description significantly binds this passage to an earlier one that
I will discuss at some length below.

The above description identifies Robert as a "regular" of the rather louche
place, Jupien's hotel, where the hero-ethnographer finishes his travels of dis-
covery and runs into himself. Robert "is one of them" (il *en est*) as well,
although at the moment this "contact sheet" is made, the narrator does not
yet know "of what" he is a member—a spy novel, a horror story? But he is
soon to find out: Robert is not only a member of the cursed and elected
"race" of "inverts," but also, and more specifically, of the masochists whose
ultimate joy it is, according to the narrator's description, to allow themselves
to be bound to flat surfaces and ironed out by beatings.

The psychological explanation for this characteristic rapidity was sug-
gested much earlier. It is, in fact, quite "logical": "… the fear of being seen,
the wish to conceal that fear, the feverishness which is generated by self-

dissatisfaction and boredom" (3:717); "la crainte d'être vu, le désir de ne pas sembler avoir cette crainte, la fébrilité qui narît du mécontentement de soi et de l'ennui" (3:698). Later on, another reason is added, a narrative-metaphysical one: the brevity of Saint-Loup's life. The above revelation is the last Marcel will see of him, as if it makes him redundant. Like Albertine, he can be killed off once the epistemology has been worked out. In fact, this adds a dimension to the fugitive nature of the character; paradoxically, in terms of the normative narratology of the Anglo-Saxon tradition, where "round" characters are the superior others of "flat" characters, it "thickens" him.

As usual in this deceptive novel, in this passage the description has a clear diegetic function, deceiving the reader with a psychological realism that is as flat as a snapshot. It allows the narrative to suggest the participation of this handsome and distinguished aristocrat in the homosexual sadomasochism of which Jupien's hotel is the theater, while at the same time confirming the obscurity of this curfewed night, which, by contrast, will shed definitive light on the sexuality that is being "ethnographed." In addition, the darkness enables the inscription of complex intertextual relations between this episode and several literary genres, of which it constitutes a catalog: the realistic novel (the darkness is the result of the curfew due to the war situation), the spy novel, the mystery novel, the coming-of-age novel, and even, at the extreme, the "strange" novel, between realistic and fantastic, of which Maupassant's *Horla* is the paradigm.

Much more elaborate in its preparation than the earlier voyeurism scenes, this scene definitely calls into question the subject of the gaze: its attempt to "cover" the object will be virtually successful here, so that the act of looking, of taking the inhabitants of the closet out into the open, will lock itself in. The description of the officer is part of that preparation, and the detailing of the snapshot in almost geometric terms underlines its importance. To put it simply, this scene from the final volume of *Remembrance* constitutes an important stage in the process toward the Writing of Time, which is the end, in both senses of the term, of this work.

That this end, in the double sense, is staged in a closet and, importantly, does not have the hero come out, is of course relevant to the nature of the knowledge and the mode of knowledge production that the scene demonstrates. In this respect, the nature of the gaze involved and the function of

the serial snapshot in representing that gaze deserve closer attention. I contend that the novel's most basic exploration is this erotico-epistemological experiment: the serial snapshot, producing a contact sheet that allows the inside of the closet to become a knowable spectacle conveyed by a closeted gaze, accessible only for whoever is able and willing to handle such knowledge. In the tradition of the metaphor of the camera obscura, the instrument, after all, of inversed vision, of ideological distortion and of exteriorization, the closet occupies the same paradoxical position of allowing vision without having anything "inside" to show. This image suits the text perfectly: behind the surface of photographic light-writing there is neither depth, as Albertine's case demonstrates, nor inside, as Robert's case shows.

violent revelations

This brings me to the scene I want to focus on in this essay and which I like to describe as a "contact sheet" of a series of snapshots made at a distance, through a telephoto lens, and extremely quickly. In this case, photography comes closer and closer to cinematography yet remains crucially distinct from it. The description represents a much earlier stage of the slow discovery that the hero is about to make in Paris on that dark night. Occurring earlier in the narrative, the scene reveals even more in terms of the poetics of photography. It sets up the apparatus of vision that allows the later revelation. Here he is in full daylight and also in Paris. The scene contains all the elements of the photographic poetics Proust deploys, and it enumerates all its different contributions to the particular visual epistemology that underlies Proust's text. It is the scene of the passionate loiterer, "le promeneur passionné."

The event, in all its simplicity, can only be reconstructed retrospectively: Robert is accosted in the street by a man who propositions him; Robert responds by beating him up. The event happens just after an outing the narrator has just taken with Robert and the latter's woman lover, the actress Rachel. The narrator meditates on the illusionary nature of Saint-Loup's love for Rachel. The reflection is based on a visual support, the flowering pear trees he had been contemplating that morning (2:163/2:161). In the diegesis, this reflection justifies that Marcel has lingered and stayed behind a

bit; a delay that, in turn, motivates the vision at a distance. In other words, the chain—Rachel/flowering pear trees/illusions in love—motivates the specific discrepancy caused by the telephoto lens, the "objectivity" of the object-glass. Here is the description that follows the meditation, which, I take it, essentially describes this contact sheet:

> I saw that a somewhat shabbily attired gentleman appeared to be talking to him confidentially. I concluded that this was a personal friend of Robert; meanwhile they seemed to be drawing even closer to one another; suddenly, as an astral phenomenon flashes through the sky, I saw a number of ovoid bodies assume with a dizzy swiftness all the positions necessary for them to compose a flickering constellation in front of Saint-Loup. Flung out like stones from a catapult, they seemed to me to be at the very least seven in number. They were merely, however, Saint-Loup's two fists, multiplied by the speed with which they were changing place in this—to all appearance ideal and decorative— arrangement. (2:186)

> je vis qu'un monsieur assez mal habillé avait l'air de lui parler d'assez près. J'en conclus que c'était un ami personnel de Robert; cependant ils semblaient se rapprocher encore l'un de l'autre; tout à coup, comme apparaît au ciel un phénomène astral, je vis des corps ovoïdes prendre avec une rapidité vertig- ineuse toutes les positions qui leur permettaient de composer, devant Saint- Loup, une instable constellation. Lancés comme par une fronde ils me semblèrent être au moins au nombre de sept. Ce n'étaient pourtant que les deux poings de Saint-Loup, multipliés par leur vitesse à changer de place dans cet ensemble en apparence idéal et décoratif. (2:182)

The theme of speed, which almost but not quite equates the description to cinematography, is again, as in the passage analyzed above, represented by a drawing of movement that is reduced to a series of fixed points. The English "flickering" suggests cinematic vision; "unstable constellation," in contrast, invokes the wavering hand of the camera, hard pressed to take so many shots in succession. The important point here is to realize that time is being transformed into space; the fixation. The "rapidité" allows the inscrip- tion of the constellation *in front of,* hence, detached from, Saint-Loup. The subject is detached from himself by the sense of sight, like the Lacanian baby in the imaginary stage, who is unable to coordinate and proprioceptively recognize as his the little hands and feet that fly by.

One sees several "copies" of the same body successively. Seven in number, the "ovoid bodies" give Robert many arms, of which the number seven is also an allusion to the sacred number, necessarily uneven, of the pairs of arms that dancing Hindu divinities have in Indian iconography. The combination of rapidity and the distinctive position of each element in the description turns this passage into the description of a contact sheet rather than of a film. This, I contend, is not a coincidental side effect but a crucial poetic aspect.

For Proust objects to cinematic writing. In one of the passages from the "essayistic part" of the work,[8] toward the end of *Le temps retrouvé*, in which the Proustian narrator reflects on literature, he presents the following objection to cinematographic writing:

> Some critics now liked to regard the novel as a sort of procession of things upon the screen of a cinematograph. This comparison was absurd. Nothing is further from what we have really perceived than the vision that the cinematograph presents. (3:917)

> Quelques-uns voulaient que la littérature fût une sorte de défilé cinématographique des choses. Cette conception était absurde. Rien ne s'éloigne plus de ce que nous avons perçu en réalité qu'une telle vue cinématographique. (3:882–83)

Indeed, on the condition that we place the accents correctly, this statement fits perfectly with the poetics of the contact sheet. What the narrator rejects is the procession, and most particularly the procession of *things,* a word which receives more emphasis through its grammatical final position in the French. For such a presentation would be situated beyond the realm of perception, whereas perception is the real and only object of representation. There may be a procession, but there are no things. The difference between the contact sheet of rapidly made serial snapshots and cinema is illusion: the greater the success at "writing movement," the more invisible the perception of that movement and its writing.

If the poetics of the contact sheet suggest a cinematographic potential, they point to avant-garde and self-reflexive cinema, in which a succession of images spread out in space, each one held still, and take over and cancel out the illusion of "true" movement produced by the even more rapid succession

of images that constitutes cinema's realistic triumph. In other words, the descriptive device at stake here must produce not just visual writing that is a trace of movement, but also a movement that is a trace of writing. Pre-post-modern as the text sometimes is, it is also pre-poststructuralist, prefiguring Derrida's conceptualization of writing and the trace in *Grammatology* (1976).

The setting up of this photographic scheme in the introduction to the scene of the "promeneur passionné" warns the reader of the importance of things to come. The discrepancy of the telephoto lens motivates the distance, the framing, the reduction of all perception to sight alone, as well as the incomprehension involved in this vision. As is often the case in this work, the incomprehension facilitates comprehension, for it helps to *see* better: that alone is a lesson in visual epistemology, and specifically in photographic epistemology: the senses lose their power over perception, the subject's center is evacuated, and the notation—the writing proper—is the trace of the movement, of which it captures the essence. What we see here, in an absolutely pure way, is the profound link between rapidity spatialized like writing time, on the one hand, and perception of desire in all its purity because it is purely visual, on the other.

For it is indeed a question of desire in this system of vision that is pre-sented as an aesthetic. The revelation—exposure, in the photographic sense—of this desire is patiently mapped out in progressive stages, the first of which operates the transition from distant to close-up vision, as if through a zoom lens:

> But this elaborate display was nothing more than a pummelling which Saint-Loup was administering, the aggressive rather than aesthetic character of which was first revealed to me by the aspect of the shabbily dressed gentleman who appeared to be losing at once his self-possession, his lower jaw and a quantity of blood. (2:186)

> Mais cette pièce n'était qu'une roulée qu'administrait Saint-Loup et dont le caractère agressif au lieu d'esthètique me fut d'abord révélé par l'aspect du monsieur médiocrement habillé, lequel parut perdre à la fois toute conte-nance, une mâchoire, et beaucoup de sang. (2:182)

The triple loss: the man seems to accept it like a fact of nature, since "seeing that Saint-Loup had made off and was hastening to rejoin me, [he] stood

gazing after him with an offended, crushed, but by no means furious expression on his face" (2:186) ("voyant que Saint-Loup s'éloignait définitivement pour me rejoindre, resta à le regarder d'un air de rancune et d'accablement, mais nullement furieux," 182–83). The man thus acts as visually as does the narrator; the one removes himself, the other comes nearer in this silent dance, representing the figuration of an entire "unstable constellation" whose meaning will be engraved into the monument that is this work.

The shift from visual epistemology to ontology and back recurs throughout the scene, most explicitly in the words "dont le caractère agressif au lieu d'esthétique," which evokes the aggressivity underlying the aesthetic interest of another Robert, the one in Ian McEwan's *The Comfort of Strangers*,[9] who ends up killing the man he desires. Upon closer inspection, however, the aggressivity, which in *The Comfort of Strangers* is lethal and due to homosocial desire, is here a cover-up and acting out of homosexual desire.

The revelation of meaning is limited first of all to the level of the anecdote. This kind of reporting has a narratological relevance. The interpretation is reported by the narrator. But he does not present this revelation as free indirect discourse, which it might, or even realistically, should be, but rather as a rendering of his own focalization. He has good reason for this omission: "It was an impassioned loiterer who, seeing the handsome young soldier that Saint-Loup was, had made a proposition to him"; "C'était un promeneur passionné qui, voyant le beau militaire qu'était Saint-Loup, lui avait fait des propositions." Although, according to the logic established by the teleobjectivity of the presentation, this explanation should be coming from Saint-Loup, since the narrator had volunteered to take up a position of distant visuality only, it is he himself who, equally "logically," endorses the evaluation of his friend as a handsome, military—virile—man. The shift occurs midsentence: from "seeing" to "being," "*voyant* le beau militaire qu'é*tait* Saint-Loup"; vision is truth; image overrules thing. As a result, and third "logic," we must conclude that the narrator shares, at least visually, the photographed desire.

Indeed, the explanation for the event is immediately followed by a further explanation that is inspired by a sort of unfettered psychology, which is quite difficult to understand if one fails to take seriously the photographic epistemology that underlies the scene:

And yet the recipient of his blows was excusable in one respect, for the trend of the downward slope brings desire so rapidly to the point of enjoyment that beauty in itself appears to imply consent. (2:187)

Pourtant le monsieur battu était excusable en ceci qu'un plan incliné rapproche assez vite le désir de la jouissance pour que la seule beauté apparaisse déjà comme un consentement. (2:183)

In order to grasp what is at stake here, it seems important to me to acknowledge that this sentence is strictly incomprehensible. The inclining plane, one can *see,* was already visible on the contact sheet ("they seemed to be drawing even closer to one another") but nevertheless it is also a metaphor of the essential flatness/platitude of this sense, which only reinscribes the importance of this particular manner of becoming acquainted with desire.

writing desire

Three aspects of this scene both make it central to the work and transform it into a *mise en abyme.* First, the pure desire is a figuration, in writing, of time, which is visually accessible if one takes the indispensable distance to see it and at the cost of giving up on ever satisfying it. "The closet" stands for the irreducible incompatibility of knowing and acting. The reader will recall the mythical "kissing organ" that the narrator invented to enable him to integrate vision with the other senses. But this organ described precisely a fundamental lack.[10] Second, the desire fixes itself visually onto Saint-Loup as the military figure: the "military" category of males whose virility has already been staged very early on, by way of the military parade at Combray, which also demonstrated its insurmountable visual-epistemic difficulties. The presence of the military in the final voyeurism scene, which will complete the hero's ethnographic knowledge through the revelation of inversion's "flatness," is therefore essential because it extends beyond the anecdote and beyond the distribution of roles among the characters.

Third, and this aspect brings us to the crucial point about photography, this work in which desire occupies such a central and structuring place reveals here that desire is in turn subordinated to the possibility of writing. As a sample of a writing, magically situated between space that makes flat and time that spreads out, the contact sheet of seven ovoid bodies figures the

work which, abandoning linear sequentiality in favor of an architecture of "unstable constellation," is just now parading before us. But like photography, the contact on the sheet is only the "positive," the print between fugitive light and the sheet of paper, whose negative, called "form and solidity" in the madeleine episode, is here defined as loss. Loss, then, is located here in the unknown man, a shabbily dressed fugitive figure and *figurant,* who is nevertheless indispensable as a screen.

The triple loss—of his self-possession, a jaw, and a lot of blood; in other words, his triple loss of face—is what I have elsewhere called a *dis-figure,* a figure of rhetoric, a detail that is overformed and overinvested with meaning.[11] On the contact sheet, filled with Saint-Loup's astral and quick movement, one imagines that only one tiny image of the bleeding figurant would be visible. In the narrative, Robert pretends to be outraged by the man's proposition; he complains about the lack of sexual safety in the streets of Paris, and dismisses Marcel; end of episode. The outraged reaction Saint-Loup displays provides the necessary transition to the moralism needed for the epistemological adventure to continue, and for the passage to end.

That tiny snapshot of the bleeding man is, within the contact sheet and the episode, a detail, but one that is greatly disfiguring and disfigured. It figures a Lacanian responsiveness to the self-division of visuality as well as of desire. It also marks the profound need for visuality that this narrative demonstrates; literature without art translates into: no textual, linguistic intelligibility without vision.

The loss of self-possession can be situated on the "realistic" level, of psychological explanation, where Proustian characters seem to have a traditional literary existence. But the loss of the jaw is hardly plausible. The jaw can be distorted, ruined, but not lost, by a "roulée." The loss inscribes the disfiguring of the character's face into the series. *Mise en abyme en abyme,* this loss disfigures the very figure of the man. The loss of blood, which adds an obscene, violent, and "colorful" detail, discolors him. It also triggers a rereading of the final scene of *The Comfort of Strangers* and *its* coloring, painting, with lost blood.[12] As the subject of this triple loss, the marginal object of serial photography is nonetheless the exemplary subject of desire, the only one visible in its pure state; a subject of desire who, on a "downward

slope," approaches while remaining visible, thus accomplishing—almost—the epistemic ideal pursued throughout the novel.

The triple loss, however, is disfiguring in yet another sense—the sense that makes it a "logical" consequence of the closeted gaze. This loss figures, gives visible shape to the loss of knowledge incurred by all subjects involved—the narrator, focalizer-"photographer," and character. A loss which is, in addition, incurred by those critics who, eager to psychoanalyze the event, "forget" its specifically gay nature, thus maintaining the closet.[13]

What is not stated by any of the above subjects is something that is so banal that only the term *platitude*, with all its ambiguity, is appropriate to describe it. Saint-Loup, a short time later, takes unexpected leave from Marcel, alleging the need to be by himself for a while, and shows up many hours later at the afternoon party they were to attend together. What remains unseen, then, is what this strange photographic setup has *revealed* and hidden at the same time, a knowledge that is both a revelation and a concealment, and also about a revelation and a concealment. Thus in this crucial passage the narrator is able to see and know what cannot be acknowledged as being known.

Maintaining the proper distance for this particular kind of focusing, Marcel refuses to hear the proposition made by the loiterer and, thus, to participate in the "impassioned" encounter, of which he only sees the downward slope. Saint-Loup, in turn, refuses to say it. After the beating, however, he sends Marcel away, promising to join him later, whereby the possibility of a meeting with the loiterer is both inscribed and left uncertain, unknowable. Here homosexuality becomes unspeakable. The reader or the critic who theorizes the downward slope in general terms in turn participates in this tabooizing of homosexuality, its being closeted, that is, of its taking place at this very moment of revelation, "in the (literary) act." Platitude—covering the homosexual event in a generalizing theory of desire—thus contributes to—in fact, repeats and endorses—the refusal to gain access to an "intimate" knowledge, a participating ethnography, access to the act. That, too, is a loss of self(-possession).[14]

The banal question of whether or not Robert will, after all, have an encounter with the loiterer is, narratively speaking, totally irrelevant. Epistemologically speaking, however, the unanswerability of such an indis-

creet and naïvely realistic question is absolutely crucial; the major flaw in Proustian criticism is that it fails to take banality seriously. Like Albertine, Robert is unknowable; the closest the narrator can come to knowing (him) is by exercising this closeted tele-gaze.

Elsewhere in Proust's novel the most successful erotic-epistemic pose, or act, is emphatically not penetration but "covering": instead of penetrating unknowable Albertine, the narrator's most pleasurable experience is to lie against her, covering as much of her skin as possible with his own. For those of us trained in a literary discipline, coverage as the epistemological ideal is not as strange as it might seem. In the vision of the impassionate loiterer, the epistemological feat of "covering" has almost, but not quite, succeeded. The trace left of the attempt is the contact sheet itself, on which is inscribed, hardly legibly, the very movement of approach, a writing pad where an infinitely tiny moment of time is spread out in space.

eroto-graphy

The reader no doubt remembers the opening of Barthes's *Camera Lucida*: "One day, quite some time ago, I happened on a photograph of Napoleon's youngest brother, Jerome, taken in 1852. And I realized then … 'I am looking at the eyes that looked at the Emperor'" (3). The concept of photography that Barthes develops further in the book is already present: it is a vision, by definition in the present, of an irretrievably past vision. There is no exchange of eye contact, but nonetheless two gazes confront each other, the one dead, the other alive. Between these two gazes the gulf of past time has carved itself out.

Barthes developed this wonderful essay on photography out of this initial "snapshot"—quick, incidental vision—of a photo. From instrument of visual, spatial fixation, photography becomes the instrument of the definitive loss of time and death. Between one eye and another, things happen: Barthes uses the word "punctum" to sum up all the tiny events that he describes, modifies, criticizes, circumscribes, specifies all through his essay,[15] until the word no longer designates anything but his experience faced with his mother's death. Along the way he mentions the photograph taken by Saint-Loup of Marcel's grandmother. Yet it is not to this photo-

graph but to the involuntary memory that he compares the *Tuché,* the photograph of the Winter Garden that was his encounter with the real "that was." Strangely, while writing about photography he missed the photographic specificity of Proust's writing.

But we are not finished with being astounded by photography, that glass eye that slides in front of the eye of the "operator" (Barthes's term) that is Saint-Loup in the anecdote about the photograph. But the narrator is the real photographer throughout *Remembrance.* What photography allows the Proustian narrator to inscribe, to fix like writing, is an essentially fugitive vision, which is both purely subjective and totally objective. As Ann Banfield (1990) has shown in her in-depth analysis of Russell's epistemology read through the optic of Barthes's essay, the photograph is centered but its center remains empty. It is a flat image that is infinitely reproducible and allows endless alteration, thus offering an objectified image that is nonetheless circumscribed by a total subjectivity. This paradox of photography enables the seizure of the punctum, which is constituted not by form but by intensity. The punctum is an effect generated by an irredeemably flat image, in all senses of the term. Banality adds to the wonder.

"Ce *quelque chose* a fait *tilt,* il a provoqué en moi un petit ébranlement, un *satori,* le passage d'un vide," writes Barthes (81) about a detail-punctum that ravished his entire reading. *Tilt:* the downward slope that turned the impassioned loiterer, on yet another level, into a *mise en abyme*/disfigure of the photographic stance that informs Proust's novel. The detail that blows up with meaning (Schor), that invades the text by its status as "instruction for use" which makes it into a self-reflection, overdetermined the disfiguring, the "downward slope" that caused the triple loss that disfigured the figurant but that, it must be added, continues to resist logical sense.

The downward slope is the ultimate attempt to enforce Proust's narrator's epistemological desire, to stick, cover, map himself fully, like light on a sheet of paper, upon the object that, therefore, must be flat. If Barthes has succeeded so well in rendering the effect of photography—of the one photograph that mattered—it is first because he was wise enough not to show it. Thus, it remains as fictional as *Remembrance* is. This restraint is also a way of maintaining photography's flatness. But the photo of Barthes's mother

rewrites, perhaps, the one of Marcel's grandmother; it is totally different from the photo session with the disfigured *promeneur*.

For there is one element in Proust that is crucially specific. For the objective eye, the impassioned loiterer must retreat. The slope is dangerously sliding, but the touch-*tuché* remains forbidden. But the flatness/banality of generalized knowledge remains impossible. There is one narrative reason for this, the one that defines this work as modernist. In order for desire to continue to work throughout this immense work, it must remain unfulfilled— the gaze must remain closeted. There is, however, also an erotic-epistemological reason for the restraint: this is the identification of erotic with ethnographic epistemology. If Albertine has to stay unknowable, and her unknowability has to be represented through her gay femininity, Robert has to stay away from the subject who desires him, in order to prevent desire from losing face.

notes

1 "Découper son tableau dans le spectacle du monde," Vincent Descombes (1987), 237.

2 See Norman Bryson (1989).

3 Bal and Boer (1994).

4 *Mise en abyme,* a term from narratology originally borrowed from André Gide, refers to passages or elements that represent in a nutshell the entire work of which they are a part, or at least a relevant aspect of it. The term has been extensively theorized by Lucien Dällenbach, *The Mirror in the Text.*

5 This inaccessibility of Albertine is *represented as,* not a representation of, lesbianism. In Proust there is no lesbian gaze, no "lesbian as visionary."

6 See the chapter on characterization in Bal (1997a), 114–32; also, Shlomith Rimmon-Kenan.

7 See Ann Banfield (1990).

8 The distinction between "essay" and "novel" refers to the one between overt and explicit philosophical reflections in the novel, and, on the other hand, philosophically relevant representations whose philosophical tenets the author may not have been aware of. See Vincent Descombes, *Proust: Philosophie du roman.* The distinction may not always be helpful, as Malcolm Bowie so brilliantly demonstrates, but it is a useful rule of thumb in most analyses (1987). With the exception of the passage on cinematic writing, this essay is limited to the "novel" side of the work.

9 For an extensive analysis of this aspect of McEwan's novel, see Van Alphen (1996).

10 2:377–78. See Kaja Silverman's brilliant analysis of this description in terms of the particular form of homosexuality that it figures (1992, 373–88).

11 See Bal (1997b), ch. 1. The argument is part of a reconsideration of the detail and especially of the opposition which has been proposed by Georges Didi-Hubermann in a response to Schor, between *détail* and *pan*. Georges Didi-Hubermann, "Appendice: Question de détail, question de pan" (1990, 271–318); Naomi Schor (1980) (Didi-Hubermann's source), later also published in (1987).

12 See Van Alphen's analysis (1996). The different route taken in McEwan's novel only underscores the pluralization of vision.

13 Thus Charles Bouazis, characteristically imitating the incomprehensible discourse he is supposed to clarify: "… la jouissance qui est 'rapprochée' ne l'est qu'en vertu d'un 'plan incliné' qui l'irréalise en la promettant (non en la 'consommant')" (1992).

14 For a relevant account of loss of self as represented in the visual images painted by Francis Bacon, see Van Alphen (1992).

15 See in particular *La chambre claire*, 49, 69, 74, 77, 81, 84, 88, 89, 148, 149.

7

second-person narrative: david reed[1]

And the moment the story is elaborated, the boredom sets in; the story talks louder than the paint.

—Francis Bacon

non-figurative narrative

DAVID REED'S PAINTING *#275* (fig. 1) is a horizontal strip of 26 by 102 inches, divided horizontally in a thin strip at the top, and two more or less equal halves, the lower one being distinguished by an additional layer of color; the whole is covered with waves, folds, perhaps representing brushstrokes. It is quite characteristic of Reed's work. It "agrees" with Francis Bacon's suspicion of narrative in painting as

Figure 1. *#275*, David Reed, 1989. Oil and alkyd on linen. Courtesy of Max Protetch Gallery, New York.

quoted in the epigraph to this paper, and explores a narrative that whispers instead of talking too loud; one that is the paint, instead of its rival.

Usually, Reed's work is called "abstract," and if that term is opposed to figurative, then it certainly is. If abstract is used in the sense given to the term in other contexts, namely, the opposite of concrete or tangible, then, I would argue, it is emphatically not. It is neither disembodied nor rationalistic; and it is sensuous beyond belief. Nor is it expressionist; quite to the contrary, Reed appears to oppose the idea of abstract expressionism, most emphatically in the work of two of its major representatives, Pollock and de Kooning. Reed's work has nothing of the tangible layering of brushstrokes that is a certain brand of abstract expressionism's most distinctive mark. There is nowhere a mark of the artist's hand.

The main reason why the label "abstract" sits uneasily with Reed's work is the sense that it is somehow, multivalently and innovatively, *narrative*. I mean this quite specifically and literally. In this paper I would like to propose a category or "genre" of nonfigurative narrative painting, and I see Reed's painting *#275* as a prototypical example of that genre, if not a "theoretical" elaboration and creative invention of it.

A narrative can be defined, as I have proposed in chapter 1 of this book, as an account—in whatever medium—of a fabula presented in a certain manner (Bal 1977). The medium can be film, language, painting. The fabula is usually considered as a temporally and logically connected sequence of events. The manner in which the fabula is presented so as to come across as a *story* concerns issues of the semantization of characters, the concretization and subjectification of space into place, the thickening of a sense of time by a variety of devices, and, most important of all, *focalization*. This term indicates the connection between the events that make up the fabula and one or more subjects whose "perspective" or "point of view" on, whose subjective engagement with, the events is represented in the narrative. Although the difficulty of defining—constructing or "re"-constructing—the fabula in no way disqualifies a work as narrative, but rather qualifies the kind of narrative it is, ultimately at least two related events must be involved for a work to be called narrative in more than just metaphorical terms.

In literature, narratives as accounts have a "speaker," a voice who utters the account, called the narrator. This voice may be either "invisible," because

uttering only sentences "in the third person," or emphatically audible, as in "first-person" narrative. In painting, the abstract expressionism of artists like Pollock and de Kooning, by virtue of its emphatic inscription of the hand of the artist, comes close to "first-person" narrative. It tells the story of its making, and the various layers or splashes of paint "tell" about the temporally distinct phases of that making. In contrast, images that eliminate references to the painting process present their objects, or contents, in a "third-person" mode.

David Carrier described this distinction as that between "deictic" and "diegystic" painting. The first term is based on the linguistic category of deixis, those elements that have no reference but only make sense in relation to the person (in the grammatical sense), place, and the moment of its utterance—here, its making; the second draws all attention to its content; it is based on the Greek-derived term *diegesis,* given new currency by Gérard Genette. In both cases, if the content can be described in terms of a sequence of events, we can use the terminology of narrative.[2]

first person, second person, same person[3]

Carrier's distinction, although quite common, omits a third possibility, the one I want to focus on in this essay. My interpretation of Reed's #275 is based on a particular genre or mode of narrative, a rather rarely used one perceived as artificial or experimental, which is *narrative in the second person.* This is a particularly difficult mode of writing.

In literature, Michel Butor's novel *La modification* (1957) is one of the few examples of a novel consistently written in the second person. In the beginning, that grammatical form hampers the smooth narrative reading commonly associated with the genre. But fortunately for a compulsive reader of novels like myself, quite soon it is almost inevitable that the narrative takes over, and one can sit back and go along with the adventures of the protagonist on his train ride between Paris and Rome, between his wife and his lover.

The narrative nature of this novel seems to be dependent on the fact that the second person cannot be sustained; without much effort, the reader

"translates" it into first-person format, which enables her to read on and process the text into a story. The "you" cannot be subsumed by the reader's position, nor can it be construed as the addressee of apostrophe, as in lyrical poetry.[4] The "you" is simply an "I" in disguise, a "first-person" narrator talking to himself; the novel is a "first-person" narrative with a format twist to it that does not engage the entire narrative situation, as one would expect it should.[5]

Although the normalizing effect of narrative reading at the expense of second-personhood cannot be sensed in a short quotation, I submit that the following passage in all its breviety already fails to sustain the second-personhood which is its overt narrative mode:

> Si vous aviez peur de le manuer, ce train au mouvement et au bruit duquel vous êtes maintenant déjà réhabitué, ce n'est pas que vous vous soyez réveillé ce matin plus tard que vous l'aviez prévu, bien au contraire, votre premier mouvement, comme vous ouvriez les yeux, ç'a été d'étendre le bras pour empêcher que ne se déclenche la sonnerie, tandis que l'aube commençait à sculpter les draps en désordre de votre lit, les draps qui émergeaient de l'obscurité semblables à des fantômes vaincus, écrasés au ras de ce sol mou et chaud dont vous cherchiez à vous arracher. (16)[6]

> If you were afraid of missing the train to whose movement and sound you are now already acustomed again, it is not because you woke up later than you planned this morning, since, on the contrary, your first movement upon opening your eyes was to extend your arm to prevent the alarm from going off, while dawn was beginning to sculpt the disordered sheets of your bed, the sheets which emerged from the dark like defeated phantoms trampled on that soft and warm floor from which you tried to tear yourself away.

This passage has all the appearance of a so-called interior monologue, that equally artificial mode of narration in the first person that seeks to eliminate reference to the first-person voice in favor of a silent first-person focalizer.

There is a precise reason for this easing back into the traditional narrative, from which the author sought to estrange his readers. This relapse is a consequence of the "essence" of Butor's failure to take seriously what the second person is: to be, to act out, the essence of language. According to French linguist Emile Benveniste, who gave currency to the importance of deixis, the "essence" of language lies in deixis, not reference, because what

matters in language is not the world "about" which subjects communicate, but the constitution of the subjectivity required to communicate in the first place. The pronouns "I" and "you," as opposed to "she," "he," "they," and the like, are totally empty in themselves. They do not refer outside of the situation in which they are uttered. Each utterance is performed by an "I" and addressed to a "you." This second person is crucial, for it is that subject that confirms the "I" as a speaker. Conversely, the "you" becomes an "I" as soon as the perspective shifts. It is only as (potential) "I" that the "you" him- or herself has the subjectivity to act, hence, to confirm the subjectivity of the previous "I."

What is lacking, in *La modification,* is that very essential feature of deixis: the reversibility, the exchange, of the first and second person. Not only is the "you" a clearly distinct, even semantically dense individual doing certain things, but the other people in his life, hence, in the fabula, are consistently described in the third person. The "you" is cut off from the others, or cuts them off, so that, rather than mutually confirming one another's subjectivity, the figure of this "you" lapses into an autistic monologism. The pronoun "you" becomes a reminder of the alienation, that recession of subjectivity, rather than a fulfillment of it. As a consequence, the "you" can never be identified with the reader, nor is the reader the "you"'s symmetrical counterpart, the "I." There is simply no "you" here whose turn-taking will make the written "you" into an "I." I contend, therefore, that Butor has based his novel on a misconception of deixis.

Butor's novel is an exception that seems to prove the rule that narrative's most appropriate modes are first- and third-person narration. When we oppose, with Carrier, Cézanne and Morandi to Chardin, or abstract expressionism to neorealism, the distinction seems to fit.[7] But Reed's work demonstrates, in a way that none of these examples does, that a more adequate understanding of deixis as the essence of language or, broader, of communication, can inform a mode of painting that succeeds better than Butor's narrative in foregrounding the second person in its essential relation of exchange with the first. Conversely, I also want to demonstrate how narratology can inform our reading of painting, including nonfigurative painting. Thus, while Reed's work will be engaged here as "theoretically" rich, narratology will be offered as visually pertinent. The ontological question,

whether *#275*—or any second-person narrative—can be "properly" qualified as narrative will be argued to be an ill-fated one by definition.

two episodes, and more to come

As has often been noticed, most of Reed's work, including *#275*, emphatically counters the expressionism of his abstract predecessors, so much so that one can read a statement, a theoretical position there. Instead of marking the canvas with visible traces of paint and paint handling, he offers surfaces so smooth and shiny that the eye, as Hanne Loreck puts it, "bounces off it."[8] Thus the two events required to make up a minimal narrative are already in place even in so simple and primary a reading: the eye goes to the canvas, then bounces back. But the narrative is immediately complicated by the implied "discussion" with expressionism.

For this is not a matter of a simple opposition. Reed's relation to the history of art, his position within the texture of that history, is much more complex than that. The artist actually attaches much importance to this historical attitude. In an article he wrote with David Carrier, the point is made quite explicitly. When reflecting on influence, and the anxiety over it, the authors state the importance of such self-reflection:

> Seeking the source for an image, some art historians conceive of it as a design that an artist borrows without considering the implications of the act of borrowing.

And they continue by stating the reason:

> … this generational struggle in which an individual finds his identity by struggling with his father figures is a patriarchal vision of history. We seek a history of art less concerned with struggle against the past than learning from it.[9]

This explicit anti-oedipal statement is confirmed by the complex and basically constructive, yet dialogic and relatively autonomous play with predecessors' art in Reed's *#275*.

Clearly, one "selfish" reason to shun oedipal antagonism is that it hampers one's own possibilities. One can only take a position against something else if one speaks at least partially the same language. The relation to

abstract expressionism of the "I"-oriented kind is part of a development in viewing time that helps the painting to become narrative. The eye bounces off but then returns right away, for there is something so emphatically "tugging" in the surface that after having been kicked off it because one came with the wrong—expressionist, tactile—assumption, one is drawn back into the surface on new terms. Then the second "episode" of looking takes place, one that engages the eye in a different kind of tactility. And this time the eye stays longer, thus subjectively modifying the quality of time.

The painting requires that the viewer at first "think" abstract expressionism, step back, then return; without the false start, the effect that replaces it would not so easily take hold. This is one of the reasons why the waves are made to "look like" brushstrokes, representing these, so as to emphasize that they only evoke them, without *being* them. It is only then that the new, alternative kind of tactility can be offered. For lack of a better word, we can call this tactility erotic.

Visual erotics, as distinct from expressionism, is not based on the inscription of the "I" in the work, but the inscription of the strongest possible dynamic between the "I" and the "you" on the basis of sense-based attraction. Instead of imagining a tactile roughness as a trace of the maker's hand, one wants to caress or lick these surfaces. But, while leaving self-expression behind, Reed's work holds on to the passionate abstraction that is characteristic of the previous generation. For a partial engagement with, and distantiation from, a narrative outside of figuration, he has to look elsewhere.

This erotic tactility joins, and then breaks away from, yet another predecessor: Francis Bacon. In his totally different—both figurative and pastose—mode, Bacon also locates narrativity not within the image but in the contact between painting and viewer. Ernst van Alphen develops a pragmatics of vision as a narratology of Bacon's painting:

> I have proposed a narrative reading in which Bacon's works represent a pragmatics of vision as the narrative of perception.

And he aptly describes it as follows:

> This narrative would then have a double status. On the one hand, it would be diegetic: the events acted out by the figures in the representations are events of perception. On the other hand this diegetic narrative *about* perception would

be doubled in relation to the viewer. The narrative could be called apostrophic and metonymic: it touches the viewer.[10]

Whereas Reed's *#275*, with its nonfigurative forms and nonpastose mode, has nothing visible in common with Bacon's work, the essence of Bacon's engagement with the viewer through a pragmatic narrativity is the most important feature of the work of both painters. There is even a comparable temporal shift at work in both painters' narrative: just as Reed's surface kicks the eye back, then attracts it again, Bacon insisted on having his paintings framed behind glass, which hampers the visibility of their impasto. As Van Alphen contends, this is Bacon's way of forcing viewers, who are bounced back by the glass's reflections, to come closer and *then* to see better.[11] Yet where Bacon's narrative, as Van Alphen explains, tells a story of eroticism as the loss of self, Reed's, in contrast, promotes an embrace of the self, not in self-absorption but in the exchange of "I" and "you."

This, then, is an altogether different story from the old one of one generation rivaling the preceding one, of fathers and sons. Reed's emphatic opposition against abstract expressionism needs not be seen as an oedipal distancing from great predecessors, as Harold Bloom would have it.[12] I see Reed's engagement with/against expressionism not as rivalry but rather as one element in an exploration of the possibilities of painting itself, of a specific integration of representation as visual engagement, intertextual allusion, and, most importantly, address. Instead of the focused if not obsessive attempt to overclass a fatherly rival, Reed borrows his visual language as well as his "philosophy" where he can; and if abstract expressionism has demonstrated the enriching possibilities of painting outside of figuration, Reed positions himself as "after" that movement so as to be able to further exploit those possibilities as a new frame to isolate specific meanings and effects. He evokes expressionism as a narrator "telling about" a possible first-person position followed by his rejection of it. But he is not obsessed, hence not oedipally entangled with it; if he is obsessed with anything, it is a much more positive, almost enamored obsession with something altogether different. For this exploration he is not so much engaging the immediate predecessor but a more distant past, and not rejecting but radicalizing what he finds there.

The means in which this erotic effect is made to happen is light, the least material of the painter's means, and again, most emphatically different from the heaviness of paint as substance; light, parading as substance. Reed is, as Lisa Corrin has demonstrated, a fundamentally *baroque* painter. This is, I would argue, where he finds the kind of "second-personhood" that enables him to narrate outside of the realm of figuration, but in a more intensely narrative way. This baroque narrativity comes about in an erotic engagement of the eye that, after intially bouncing away, now glues itself to the surface, like Marcel Proust's narrator to the cheek of his beloved grandmother.[13]

engaging caravaggio

One way to enter into Reed's baroque mode of painting and its specific eroticism is to read his waves as folds. In his translator's introduction to Gilles Deleuze's book on Leibniz and the baroque, felicitously titled *The Fold*, Tom Conley sums up what makes baroque forms so enticing:

> … an intense taste for life that grows and pullulates, and a fragility of infinitely varied patterns of movement … in the protracted fascination we experience in watching waves heave, tumble, and atomize when they crack along an unfolding line being traced along the expanse of a shoreline; in following the curls and wisps of color that move on the surface and in the infinite depths of a tile of marble. (x–xi)

The vocabulary here is mostly formal and aesthetic, describing the forms and their infinite expandability. But the aesthetic itself is based on terms that underscore the second person, as terms like "fascination" and phrases like "we experience" demonstrate. There is a suggestion of an intimate link between these forms that fascinate and the "intense taste of life that grows and pullulates." If that pullulating life is situated on the side of the canvas, the initial "first person," and the "experience" of forms on the side of the viewer, the initial "second person," then the deictic exchange that occurs when this aesthetic "happens" is itself what initiates and structures the aesthetic. The aesthetic of the baroque can thus absorb the paradox that it gave birth to the literary genre of the novel and that its painting is considered not narrative.

Seen through this formulation, in Reed's *#275* baroque aesthetics is present on various levels. The waves or folds "heave, tumble, and atomize when they crack along an unfolding line being traced along the expanse of a shoreline." The emphatically horizontal format of the work underscores precisely that. Like a film, it scrolls by with a live seascape. But the idea of a horizontal scroll, in addition to evoking film, and the narrative that is that medium's privileged mode, also suggests the traditional Japanese and Chinese scroll paintings that literally have to be unrolled before you; and these, too, are basically narrative.

Moreover, "life pullulates" in the waves, and, in a different way, if the waves are taken as folds. The folds are also "pullulating" into a third dimension—in a way that literally attracts the viewer to travel up and down the folds' hills, inside and out. And this represented three-dimensionality is to be specifically interpreted as the dance of eroticism.

Any number of Caravaggio paintings can further substantiate this pull and its converse, this address that is qualified as neither primarily intellectual nor lyrical, but sensual; or rather, that overcomes those artificial distinctions altogether.[14] But there is one particular painting in this baroque artist's oeuvre that resonates with Reed's *#275* in particularly illuminating ways. This work is not narrative, in the classical use of that term for painting, although it is, of course, figurative. I am thinking of one of the paintings of *St. John the Baptist* (fig. 2).[15] It is also quite emphatically erotic; perhaps less obviously sexual as, for example, the 1601–2 *Amor* in Berlin, but that makes the case for the erotic quality of the work even more compelling.[16] Here, too, there is a pullulating going on, by means of "a fragility of infinitely varied patterns of movement." And the attraction of the figure in the painting, erotic as it is, is accomplished by means of an effect of waves and folds and texture that totally lacks inscription of the artist's hand, whereas it comes forward to invite and accommodate the fantasmatic touch.

Both Reed's *#275* and Caravaggio's *St. John the Baptist* lose considerably in black-and-white reproduction. The green and orange-on-green areas in Reed's work, as well as the straight line that arbitrarily separates them, make a statement about the constitutive importance of color in painting. Caravaggio's work, similarly, sets the tones of the boy's flesh off against, on the one hand, an almost identical hue in a different texture, in the animal

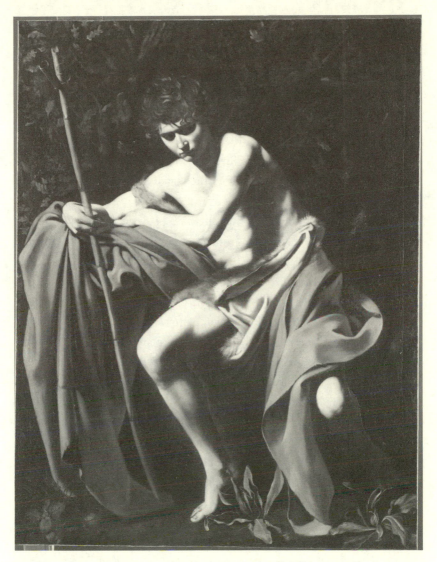

Figure 2. *St. John the Baptist*, Michelangelo Merisi, called Caravaggio, 1604–1605. Courtesy of the Nelson-Atkins Museum of Art, Kansas City, Missouri.

skin that traditionally identifies the Baptist, and on the other hand, an over-whelmingly rich, deep crimson cloth, an oversized mantle that takes more visual space than the body of the boy.

The more obvious areas where the eroticism of this work takes hold consist, of course, of the body and its appealingly young yet firm skin, the

muscles just defined enough to denote masculine vigor yet not overdone as in some contemporary male nudes. As always with Caravaggio, one is never prepared enough for the shock that total fantasy is so bound up with an almost excessive, illusionistic realist mode of painting, accentuated by subtle iconographic touches. Thus the veins near the elbow, the slightly rough elbow itself, and the dirty toenails tell us that this is a real boy, just as real as the plants at his feet; hence, that the erotic pull is emanating from an actually touchable body. Eroticism is further iconographed by the flesh of the inner thigh that comes forward due to the seated position of the figure, an almost classical "sign" of homoerotic realism.

The folds in the animal skin that alternate between fur and leather are cleverly disposed so as to suggest, just barely, an icon of the boy's penis parallel to the soft flesh of the inner thigh, which is thus tantalizingly signified but not shown. And whereas the boy's right leg displays its elegance so as to foreground the muscled calf stretched out to look longer due to the raised foot, the left knee, isolated from a leg left behind in the dark, when seen in a flash could almost be mistaken for an oversized penis. A flash, that is, of the kind that Lacan describes in *Four Fundamental Concepts,* as the glance that seizes death in the anamorphic skull in the foreground of Holbein's *Ambassadors.* The allusion to that case is meant here quite specifically. Both the aggrandizing vision of sexuality here, and the insight into mortality there, are solicited on a specific temporal mode that is set off against the main line of the story. This is one example of how painting is able to inscribe time otherwise then as artificially constructed diegetic chronology (1979).

But if this iconography *alludes* to a sexual attraction that may be especially homoerotic, the play with folds, substance, texture and light *performs* erotic work; a work that does not just inspire fantasy in the viewer, as in a third-person novel that strongly encourages identification, but that engages *with* the viewer in an erotic play. The boy is not the agent of this eroticism; he is one of its parties. The handsome face with the casual curls casting shadows on the forehead, the face into whose eyes, teasingly, we cannot look, may serve as a reminder that eroticism happens between people, and is based on teasing; but it is the combined, intricately commingled ensemble of surfaces that turn the look cast upon it into a caress. As tyrannical as love itself, the painted surface dictates how the "second person" must confirm the

first person; what kind of subjectivity it wishes to be produced; hence, also, how the viewer must be engaged: not as bare, abstract, theoretical, disembodied retina, but as full participant in a visual event in which the body takes effect. The second-personhood I am elaborating here is, then, qualified as erotic so as to insure this bodily participation. This bodily participation takes time, and the subject performing it changes through it. This is a definition of an event.

light-writing

The loss of color in reproduction, while regrettable in terms of visual pleasure, has the intellectual virtue of making clear to what extent this effect of surface as "second-personhood" is not bound up with material paint but with the lightest of materials: light. The firm yet tender skin, the fluffy animal fur and the smooth sheepskin, the soft, smooth crimson fabric, the soft curls, the finely articulated plants at John's feet, even the smooth bamboo staff he is holding as if it were an elegant wineglass, all these surfaces are produced by different shades of light. Light and shade together thus become the very substance of a painting that is neither "first-person," in that it does not inscribe the hand of the maker, nor "third-person," in that it does not eliminate deixis; instead, it becomes the very tool of deixis, the optical version of the exchange of touches in erotic contact.

Caravaggio's extreme illusionism is thus not simply a tool in the service of a banal, realistic ambition. Illusionism is part of the project of creating bodily contact with the means farthest removed from substance. This particular use of light, I contend, is what Reed endorses and adopts, and makes the most striking signal of his work's contemporariness. For Reed takes Caravaggio's light-writing to the letter, and turns it over to the late twentieth century by the inscription of photography.

The dialectic between presence and absence of light on the skin of painting replaces the pencil to create the design of the figure in the same mode, with the same substance, as the one that "gives body" to the figure. Light is used both for drawing and for substantiating the image. It is in this respect that the baroque folds in the crimson cloth become so much more than a theatrical ploy that emphasizes art as artificial and, in Caravaggio, the studio

as the deictic "here and now" of painting. The "fragility of infinity" of folds, due to the simultaneous appropriation of two-dimensional surface as well as three-dimensional fullness, envelop Caravaggio's attractive boy as a metonymically motivated metaphor of the connection between visual attraction and the infinitely touchable body whose skin is its largest and most intensely feeling sense organ. Light signifies the most tender and slight, yet most thrilling kind of touch.

That Caravaggio is a very erotic painter, and also a very plastic one, is easy to notice. That light is his primary instrument is also well known. In his superb analysis of Caravaggio's *Medusa,* Louis Marin made a case for the quintessential baroque painter as primarily deictic.[17] Yet neither his deictic quality nor his special deployment of light as paint and pencil are easily noticed outside the realm of the figuration that is the only visual language in Caravaggio's time. The innovations the painter introduced made him a forerunner, an avant-garde artist in his time. To be of your time, to make *con*-temporary work, is yet another way of signaling and enacting, "doing" deixis. Reed's profound, nonrivaling engagement with Caravaggio enabled him to understand this, so that his *#275,* similarly, reflects on what it takes to be a Caravaggio of this time, of the *hic-et-nunc* in the present; so that while proposing this presentness, he also illuminates Caravaggio's contemporariness for us.

This is where the reference to abstraction comes in. The elimination of figuration enables Reed to draw and paint with light in the same way as Caravaggio did, without recourse to the attractive body of a handsome youth. His light-writing is photographic. Photography, as Roland Barthes told us, is not iconic, as the capturing on which it is based deceptively suggests, but primarily indexical. Its power is the inscription of the presence of the object in the photograph, like a signature, even if that very presentness also fatally inscribes the pastness, the *ça-a-été* (1981).

Reed's *#275* makes its point about the photographic as a contemporary Caravaggist light-writing, by means of a double inscription. The surface displays an exceedingly realistic, illusionistic, mode of painting, just as distinct now as Caravaggio's illusionism was then, and foregrounds that mode, precisely, by its very nonfigurativeness. This, the surface proclaims, is realism: just a mode, without an object. There is no object, for the work is "abstract."

Yet there is, for the painting is realistic. Although there are no figures, there is an iconicity of forms. The waves become folds under the influence of this mode of painting. Folds—the quintessential figure of the baroque, hence, a theoretical figure—is the sole object of realism redefined as photography.

But this iconicity is, of course, only meaningful in polemical conjunction with the other, Barthian aspect of photography: indexicality. The past—Caravaggio, painting, baroque folds, and the erotics of surface—is *in* this work, as its *ça-a-été*. Thus Reed's painting *represents* not figures, as figurative painting including Caravaggio's does, but the theory of light-writing it enacts; it thematizes what, in it, *matters*.

On Reed's use of light, David Carrier wrote: "Reed is involved in using extreme darkness and bright piercing light which, now separated from any representational context, is thus disassociated from merely marking the edge of shapes" (32). There are no shapes to mark the edges of; the light now *is* the shape, makes it, and constitutes its climactic point. This is how the practice of *#275*, being based on an exploration of the essence of deixis, differs from Butor's more formalist adoption of the second person. Toward the end of the passage quoted above, Butor's narrator describes light-writing:

> … l'aube commençait à sculpter les draps en désordre de votre lit, les draps qui émergeaient de l'obscurité semblables à des fantômes vaincus, écrasés au ras de ce sol mou et chaud dont vous cherchiez à vous arracher. (16)

> … dawn was beginning to sculpt the disordered sheets of your bed, the sheets which emerged from the dark like defeated phantoms trampled on that soft and warm floor from which you tried to tear yourself away.

Light-writing is ascribed to nature, to the incipient daylight, as a force coming in from the outside that the figure of personification then turns into a life figure, but as a threat to the "you"'s otherwise unsustained subjectivity, that figure is necessarily an antagonist, focalized from the outsider that Butor's "you" is condemned to remain.

In *#275*, in contrast, the light does more than drawing and sculpting the shapes. Loreck wrote:

> … bright spots … arise, paradoxically, where color has been effaced with brush and scraper and the priming colors are laid bare. Here, the skin of paint has been peeled back, permitting a view of the "inward," which is revealed as

nothing more than an added, external form—particularly since individual priming colors also push to the surface, depending upon the means of over-painting. As if through a filter, one looks at the flow of color, that, like desire, circulates unfixably.[18]

The optical caressability of the surface attracts, after initially bouncing off the look that comes in with the wrong premise, and now we know what was wrong about it. Searching for the master's trace, leaving his or her own body behind, thus reconfirming a form of mastery that linear perspective and the figurative painting endorsing it has made so overwhelming: this makes the premise wrong, at least for this painting. In an intertextual reference to Caravaggio that is motivated neither by hostile rivalry nor by slavish submis-sion, Reed draws, paints, and sculpts *from within* the body, a body that is not there to *see* but is overwhelmingly there to *be*. The paint is not the skin but the blood pulsing underneath it; it is skin-deep. The light pushes up from within, like the pulsating blood at St. John's elbow—or the blood pul-sating in the sexual organ that is not represented but perhaps signified—to reach the surface, or in the waves of the blood-red fabric. Thus the light defines the surface as moving toward the outside world where the viewer is, begging the latter to confirm its subjectivity so that the viewer, saying "you" to the surface, can come into his or her status as a bodily engaged "I."

the sense of not-ending

There is one particular area in Reed's painting that emphasizes the sensual fullness of the light. That is the area in the upper half, the third portion on the right side, where the waves or folds are both broader and their edges closer to one another. The overall erotic effect of the painting is enhanced here by an increased level of sensuality that is almost "meta-sensuous," enfolding the eye and holding it a bit longer, so that the experience of time surfaces into consciousness. One of the signs that make this portion stand out is the small dot at the end of its lower curl, which bleeds over into the lower, orange-toned band of the work. This dot looks like a comma.

It seems significant that this dot-comma, ending the single largest and thickest set of folds in the painting, is the only place where any of the waves and folds seem to have an ending; yet this ending takes the shape of a sign

that, in writing, signifies not-ending, signals that there is more to come. And this linguistic nonending is visually represented by the crossing of the line. The line of colors, the line of the sentence, the line formed by the fold: the fragility of infinity is enacted here. In conjunction with the excessively horizontal format of the work, this larger as well as more plastic double curl, the dot that ends it, and the touching edges comment on the "theoretical" meaning of the division in artificially delimited bands. These bands cannot contain their distinct areas, it seems to say, no more than the surface of this painting can contain its work within two-dimensional flatness. Like the screen on which that other light-writing, film, rolls along, the end of the bands signify that the end of the frame, the size of the canvas, is arbitrary and artificial, because the work is performed beyond its limits. The lines that separate the bands, then, signify two-dimensionality as artificial, conventional, but deceptive. The *work* of art, not as object but as effect, is not to be confined to the surface or skin, nor to one person or hand, but instead initiates an interaction that comes to full deployment in this grander fold, where the work envelops the "you" that constitutes it. As the end that only underscores endlessness, the dot-comma embodies the Barthian punctum that pricks, so that the viewer bleeds. This comma inscribes, then, yet another event in the encounter with the work, signaling narrativity in its wake.

Hanne Loreck wrote about Reed's work:

> Doubts about the picture's flatness do arise, however, where something *optically feels* as if it has been injected under the surface. There, it is experienced as a "film," a layer that must be removed: in order to see better, to perceive the "true" surface and, particularly, to get closer to what lies underneath, to the "real thing."[19]

In the sentences following this quotation Loreck is quick to take this effect back into an expressionist reading, suggesting that the viewer wants to penetrate under the skin to uncover the operation of the making, to the irreducible origin and the past of the work. Instead, I suggest that the narrative that *takes place*, grounded as it is in deixis, must take place in the present. Reed's work on Caravaggio is retroactive: it draws Caravaggio into a present where the *hic-et-nunc* that gives deixis meaning is irreducibly different, yet equally intensely involved.

narrativity revisited

How is this interaction narrative, yet so exclusively visual that it uses light almost as its sole medium? To understand the narrative nature of this process, as well as the relevance of narrativity beyond its formalist limits, there are two directions in which to go, one psychoanalytical, one epistemological. First I will draw on Kaja Silverman's brilliant theory of love in *Threshold of the Visible World;* then, on Deleuze's account of the Leibnizian revolution in the baroque which will lead us back to narratology. Together, these two developments will further flesh out Reed's *#275*'s narrative "theory" as theoretically innovative, while also enabling us to read the story this work has to tell.

On the basis of the Lacanian model of looking anchored in the misrecognition of the mirror stage, the looking subject has the tendency to ascribe to itself what belongs to others and to project on others what belongs to the self but it wishes to cast out. In other words, the subject looks from within a constant misperception of the difference between self and other. If looking, then, according to the definition quoted above, consists of embedding or adapting that what is there to see outside of us within our stock of unconscious memories, then these are self-memories, and looking is self-looking; looking "through" or "with" self-images from the past that we carry with us, and which we have filled with illusory fulfillment.

Cultural images, such as films and paintings, can appeal to that tendency, by satisfying it somewhat and "un-settling" it somewhat, taking advantage of the "ecology of vision." Images come to the subject from the outside, but they arrive into an environment of memories: "When a new perception is brought into the vicinity of those memories which matter most to us at an unconscious level, it [this new image] too, is 'lighted up' or irradiated, regardless of its status within normative representation."[20] These metaphors of light and radiating remind us of the special status of a medium that practically consists of light alone, that creates representations consisting of bundles of rays, of sculptures made of luminous effects: film.

Reed's well-known fascination with film, visible in the extreme vertical or horizontal formats, is most clearly visible in his extreme, exaggerated version of Caravaggist light-sculpture. Light, the substance of film, fascinates Reed

most when it is itself thematized within film. In his favorite film, Hitchcock's 1958 *Vertigo*—all about illusionism, of course—there is an effect of light-writing that he describes in the following terms:

> … a huge neon sign [that] hung outside the window of Judy's hotel room and from inside one often saw its sharp turquoise light and a giant "P." This light is especially strong when Judy comes out of the bathroom dressed as "Madeleine." She is bathed in the lazy light which dissolves her form, turning her into a ghost.[21]

He goes on to connect the color turquoise with illusion and the repressed past. His essay on *Vertigo* is quite touching in its engagement with the sadness of illusions, even though it leads to Reed's ambition to become a "bedroom painter," not only because "then my paintings can be seen in reverie, where our most private narratives are created," but also because "all changes begin in the bedroom."[22]

But read through Silverman's analysis, the irresistible effect of Reed's light is also bound to its function of "lighting up," evoking, in itself as well as through the cultural unconscious as it is constantly fed by film, the images of our memories that have retained the capacity to thrill us. Reed's essay on his relation to *Vertigo* provides evidence of such a thrill, as well as of the source of it: the psychic effect of the *ça-a-été* of the cultural memory that light-writing, by way of indexicality, can make forever present.

Thus, these effects, now as theoretical metaphors, also connect the interaction between inner and outer image with the *ideal* that underlies Silverman's theorization of "the active gift of love." A third effect of the metaphors of light is the suggestion of a form in which the possibility of action on the inert unconscious can be explored. All this accumulates, "thickening" the narrative layers that design the intricate sequence of events that occurs between the painting and the viewer's involvement with it.

This links the affective quality of this light magic to the epistemological issues raised by Deleuze, and which constitute a third dimension of Reed's narrativity.[23] The most radical innovation of the baroque that Deleuze traces through the work of Leibniz, but whose visual aspect can be seen in Caravaggio, is a different conception of perspective. This new conception is so alien to linear perspective, yet so pervasively present in painting ever

since, that the persistence of the latter model in thinking about painting is actually quite astounding.

The baroque matter, as well as the objects consisting of it, has profoundly changed, become complicated, as "matter is folded twice, once under elastic forces, a second time under plastic forces, but one is not able to move from the first to the second."[24] One way to imagine this double folding is by way of the allegory of marble: marble's "natural" veins—the result of a long process over time—and the use of marble to represent folds in veils in sculpture.[25] But with that change in matter, the status of the subject has also changed. And thus, inevitably, has looking. What Deleuze writes in his second chapter, "The Folds in the Soul," is a far cry from the masterful and disembodied, retinal gaze of linear perspective:

> We move from inflection or from variable curvature to vectors of curvature that go in the direction of concavity. Moving from a branching of inflection, we distinguish a point that is no longer what runs along inflection, nor is it the point of inflection itself; it is the one in which the lines perpendicular to tangents meet in a state of variation.

Variation is the key word here. Variation, not only in what we can see, but also in where we are when we see it; how, therefore, we can see it as full participants in the event. Variation: the very notion inscribes more episodes, narrativizing as it deflates mastery. Deleuze continues:

> It [the state in which subject and object meet] is not exactly a point but a place, a position, a site, a "linear focus," a line emanating from lines. To the degree it represents variation or inflection, it can be called *point of view*. Such is the basis of perspectivism, which does not mean a dependence in respect to a pregiven or defined subject; to the contrary, *a subject will be what comes to the point of view*, or rather what remains in the point of view.[26]

Deleuze's description of point of view concerns epistemology; he is elaborating a view of knowledge that is neither Cartesian in its objectivism nor subjectivist as in relativism. But the entanglement of subject and object—an object itself entangled in its folds—embraces the reader within the narrative as a variable "you" who is fully dependent on, *and* constitutive of, its corollary, the "I." It is a view of knowledge that makes knowledge deictic, thereby involving it in the inexorable process of time. This mode of knowledge is so

much more productive for today's world, hence so in need of promotion over against the objectifying mode of mastery, that its attraction for the "you" must be made obvious. This, then, is the epistemological importance of the erotic pull of Reed's #275.[27]

Visual embodiments of this model of knowledge are plentiful. One can think of anamorphosis, as in Holbein's *Ambassadors*. If Lacan used this painting to theorize death and the gaze, it is because variation—and narrative—disrupt the illusion of stability embodied in linear perspective as well as in objectivism. One can think of the place of clouds in painting, disruptive as they often are in relation to the very linear perspective they refer to, then undermine. Most typical, the folds that attract the eye and the touch, then make it travel up and down their hills, enter and exit their caves, represent this view of point of view in which the subject is fully engaged in the knowledge that cannot be acquired but needs to be constructed.[28]

And then, the effect of light and shade in a visual regime—the baroque—comes to mind, that same regime that invented binary arithmetic. As Deleuze writes: "Things jump out of the background, colors spring from the common base that attests to their obscure nature, figures are defined by their covering more than their contour."[29] This remark fits squarely within Louis Marin's theorizing of color and relief in Caravaggio, which Marin considered enough of a reason for the painter's contemporaries to claim with outrage that he had destroyed painting. What he had to destroy, perhaps, is not linear perspective per se but that mode's confining monopoly to narrative; not narrative painting, but "third-person" narrative painting. The jumping Deleuze refers to is the unsettling mobility that is not referential, that is not the result or object of representation, but that is its effect. If painting, painted shapes, don't sit still, it becomes harder to pretend not to hear what they have to say, and to refrain from talking back.

nonfigurative second-person-hood, is that narrative?

Is Reed's #275, which is clearly nonfigurative, a narrative painting, or does it replace narrative with a more dialogic mode of communication? If narrative at all, it is the peculiar kind of narrative that Butor attempted to create, but

unsuccessfully, in *La modification,* namely "second-person" narrative. But perhaps Butor's failure was inevitable; perhaps such narrative is a contradiction *in terminis.* The *narrative* is dependent on the deictic parameters of the painting; second-personhood is contingent upon the way those parameters inflate the second, rather than the first person, so much so that it is no exaggeration to name the work and its genre after it. We have events that form a fabula; we have the subjective fleshing out of time, space, and focalization that makes the fabula a story. What seems to be lacking is, precisely, the *narrator,* the voice that offers the account of the story, for in the visual dialogue the voice is constantly exchanged. A final return to Silverman can further illuminate the possibility of such a wavering narrative voice.

Silverman discusses the bodily basis of the ego in terms of the proprioceptive sensations—coming from within the body—and exteroceptive images, sent to the ego from the outside. She casts her discussion in the following terms:

> ... one's apprehension of self is keyed both to a visual image or constellation of visual images, and to certain bodily feelings, whose determinant is less physiological than social.[30]

This statement explains how the relation between the individual subject and the culturally normative images is bodily without being "innate" or anatomically determined. In the quoted sentence the issue is feeling; the external images are "attached" to the subject's existence experienced as bodily, locked together; the subject is "locked up," or folded, in the external world of objects; also, in the musical sense of the word "key," subject and objects are adapted, harmonized together, the one is "set into" the tonality of the other.

But the words "to key to" can also be understood through the notion of code, the key to understanding, comprehending, communicating between individual subjects and a culture. Silverman writes shortly after the above quotation, still about the bodily basis of the ego, about proprioceptivity that it is the "egoic component to which concepts like 'here,' 'there,' and 'my' are keyed."[31] Strictly speaking, by placing deixis "within" or "on" or "at" the body, Silverman extends the meaning and importance of Benveniste's thought that deixis, not reference, is the "essence" of language.

Not only is language unthinkable, then, without bodily involvement, and, one can argue further, the idea that words can cause pain or harm and arouse sexual and other excitement is thus an integral part of linguistics. Conversely, this proprioceptive basis for deixis comprehends the muscular system as well as the space around the body, the space within which, to exploit yet another nuance of the verb to key, it "fits," like within a skin. Abstract space thus becomes concrete place within which the subject, delimited by its skin, is keyed in. The second person is keyed into the spaces he perceives and of which she is irrevocably a part, as a focalizer of the story of her own bodily involvement in the world it cheerfully engages in. Silverman indicates this place of the "keyed" subject with the felicitous term "postural function."

This interpretation of deixis makes room for a bodily and spatially grounded narratology of vision. Deixis can thus become a key term for a semiotic analysis of the visual domain, in the study of art and film, *without the reductive detour via language* which led so many art historians and film theorists to overreact and promote media-essentialism. This bodily-spatial form of deixis gives more specific insight in those forms of indexicality where the postural function of the subject—its shaping "from within"— sends back, so to speak, the images that enter it from without, but provided with "commentary."[32] This bodily posture of the viewer as second person is the visual-spatial equivalent of the narrator's voice.

This "sending back" in modified form—filled in with the second-person subject's "I"—makes the second person the primary narrator of the story of vision that, due to its bodily nature, unfolds in time, in episodes, in a fabula that the second person focalizes. Earlier on, Loreck described the gaze that Reed's work solicits: it bounces off the surface as off a mirror. The effect I have in mind here, although not quite adequately rendered by the metaphor of the unqualified mirror, looks a lot like that. But, as I wrote before, this initial bouncing back is but the first step in this story of vision. It is a false start, a necessary rekeying of the subject whose cultural baggage had limited his or her range of visual possibilities. The erotic attraction makes for the second episode, where the subject cannot help but return to the light reaching out and the welcoming folds that offer to envelop "you" in their caress. The narrator, then, has to be the second person, who works under the

solicitation of the first person. Instead of self-reference, this first person—the painting not the artist—orchestrates the acts of narration of the second person, who is moved by desire to say "yes, you are" to it.

But then, this eroticism, powerful and indispensable as it is, is also just one episode, followed by others. For it is the power of eroticism to teach us things that lie beyond itself. One such thing—one more episode that the second-person narrator further recounts—is the variation in the relation between what you are and what you see, a relation that is not stable but in process, keeping the narrative going. The urgency of that episode, or string of episodes, can be allegorically illuminated when we take not Butor's novel but the age-old *Arabian Nights* as the model of a more dangerous kind of second-person narrative.

There, the powerful husband who kills another wife each night after the erotic exchange is over can only be enticed to let her live—to let the process go on—as long as she, the second person whose subjectivity is threatened with destruction, keeps narrating. The moral of that narrative cycle is, then, that the most powerful subject's subjectivity is as much in need of confirmation as the weakest, most dependent subject's is. And that narrative as process has just that to offer. The inextricable bond between eroticism and knowledge, knowledge and power, power and vision, and vision and narrative, is thus demonstrated once again.

The narrator may be unstable, so much so that it might indeed be questionable for some readers whether this work can be labeled narrative. But while we hesitate and waver, producing more folds, the idea of narrative continues its epistemological work; and it has done more work than any "rightful" labeling can ever do. Thus, Reed's *#275* proposes a theory of theory: let it be neither master nor slave. Second-personhood is just that. Butor may have succeeded more convincingly in producing a narrative, but at the cost of second-personhood. Reed's work demonstrates that second-personhood can and must be sustained, albeit at the cost of ontological certainty about narrativity. I contend that theoretical concepts are more powerful, heuristically, theoretically, epistemologically, and philosophically, when their ontological propriety can be held at bay. At the very least, this theoretical fold enables the cultural objects and subjects we study to speak back, or just to speak.

David Reed's *#275,* and its little dot overflowing from its major fold into the realm of the other (color), can be seen as a visual embodiment of this, and as a theoretical statement that takes sides in the cultural debates and fights over epistemology, modes of vision, and ways of being.

notes

1 This is a slightly revised version of an essay with the same title published in *Paragraph* 19:3 (1996), 179–204, in a special issue on "Painting and Narrative," edited by Michael Worton.

2 Carrier (1986). On deixis, see Benveniste (1966, 1970). On diegesis, see Genette (1972).

3 Under this title, but followed by a question mark, I wrote an analysis of the play with second-personhood as an epistemological device in two contemporary works of scholarship. This use will become more directly relevant in the concluding section of this chapter (1996a).

4 On the poetics of apostrophe, see Jonathan Culler (1981), and on the political implications, see Barbara Johnson (1987).

5 Butor (1957). For a study on this novel, see Françoise Rossum-Guyon's *Critique du roman* (1970).

6 Butor, *La Modification* (my translation).

7 I would take issue with Chardin as a "diegystic" painter; whereas Carrier is right to claim that Chardin does not display self-reference, the tactility of his works as well as the instability of focus that force the eye to rove about their surfaces make it deictic in the sense of "second person" as well as narrative. See Norman Bryson (1989).

8 The sentence continues: "… as if off a mirror that produces an image by giving it back" (77). I will take issue with this interpretation later on. On abstract expressionism of the deictic kind, see Rosalind Krauss (1993).

9 Carrier and Reed (1991), 44.

10 Ernst van Alphen (1992), 56; emphasis in text. I suppose that Carrier's self-coined term "diegystic" is synonymous with the more established term "diegetic."

11 Ernst van Alphen, personal communication, July 27, 1995.

12 Harold Bloom (1973). Norman Bryson discussed Bloom's oedipal aesthetics in the context of French painting (1984).

13 Lisa G. Corrin mounted the spectacularly successful exhibition *Going for Baroque,* which featured contemporary art installed in dialogue with baroque art belonging to the permanent collection of the Walters Art Gallery in Baltimore. See Corrin (1995).

14 In my book *Double Exposures,* I have analyzed Caravaggio's *Amor* in Berlin in these terms (chapter 5 of this book). But that painting, I argue there, is both more specifically homoerotic than the *St. John* I will discuss here, while also, like this one, engaging viewers of any sexual orientation.

15 Caravaggio, *St. John the Baptist,* ca. 1605. Kansas City, Missouri, Nelson–Atkins Museum (Nelson Fund). A traditional study of Caravaggio is S.J. Freedberg (1983, 51–80). Louis Marin's brilliant *To Destroy Painting,* half of which is about Caravaggio, will be engaged with below.

16 Although Caravaggio is rightly claimed as a star in the gay canon, I feel compelled to use the more general word "erotic," rather than homoerotic. There is no general reason to qualify attractive depictions of bodies as either straight or gay, whether the bodies are feminine or masculine.

17 Louis Marin (1995).

18 Loreck (1995), 78.

19 Ibid., 78.

20 Kaja Silverman (1996), 4.

21 David Reed (1992), 4th, unnumbered, page.

22 Ibid., 6th page.

23 This epistemological aspect gives an additional urgency to the primacy of "real" second-personhood, instead of Butor's artificial and ultimately failed one, as contemporary attempts to *know* involve the tenuous existence of the objects of knowledge. See chapter 5 of my *Double Exposures* (1996a).

24 Deleuze (1993), 9.

25 On folds and veils in sculture as an epistemological questioning of boundaries, see Jacques Derrida (1987).

26 Deleuze (1993), 19, emphasis added.

27 For an extensive discussion of alternative models of knowledge better suited to be socially productive today, see Lorraine Code (1991).

28 See Hubert Damisch (1972).

29 Deleuze (1993), 31–32.

30 Silverman (1996), 14.

31 Ibid., 16.

32 This clarifies the theory of color—rather, of black and white or of three-dimensionality in the flat plane—which Louis Marin formulated through an analysis of black in Caravaggio, providing it with a subject-centered key (169).

the knee of narcissus

THE DIALECTIC RELATIONSHIP BETWEEN territorialism and desire is not always primarily a relationship between the subject and its others. Nor is it necessarily a relationship of painful tension. Prior to engaging in any relationship, the subject must first determine his or her position in the world. The process of this positioning, which Lacan called the mirror stage, has been rendered in a narrative by him, and by the ancient authors of mythical tales such as the story of Narcissus. But instead of repeating those tales by analyzing them, I would like to position them in relation to territorialism and desire.[1]

In this essay I will elaborate a perspective on the question of territorialism and desire by questioning the territorialism of semiotics itself, as it expresses itself in radical constructivism and the concomitant denial of anything "natural," "true," or "real." Briefly, the constructivist argument runs as follows. By making imperialistic claims, semiotics must offer a much-needed answer to traditional naturalism. First, nature, truth, reality, the body—all concepts traditionally seen as the opposite of culture, *vraisemblance*, realistic

strategies, or the mind—are part of the cultural baggage necessary to under-
stand those very concepts. Second, binary opposition itself, as a structure of
thought, is problematic, since it subjects its object—say, a particular seman-
tic field—to three successive logical steps that aggravate the damage: first, an
infinitely rich but also chaotic field is reduced to two centers; second, those
centers are articulated into polar opposites; and third, these two opposites
are hierarchicized into a positive and a negative term.

But here, logic catches up with this structure of thought. For the logic of
opposition has it that negativity is by definition vague, if not void. It cannot
be defined, hence articulated, and as a result it remains unmanageable,
indeed wild.[2] This vagueness of negativity is precisely the reason why, as
long as the two terms are used with a meaning attached to them, the avoid-
ance of binary opposition requires that we have an alternative semiotic view
on offer, one that would be able to articulate the relationship between nature
and culture without that fallacy. Linguistic-based semiotics has often been
criticized for its territorialism; its foundational logic in binarism seems a
good reason to step back from it and look elsewhere for an alternative. This
is not easy, for semiotics has thrived on the very logic it is now called upon
to defy. I will attempt to outline such a semiotics, a semiotics based on the
articulation of coevalness and spatial contiguity which allows the develop-
ment of a theory of subjectivity beyond the mind-body split, the nature-
culture opposition, and radical constructivism and naturalism. This theory
is in fact a theory of territorialism based on vision. For this theory, I take as
my starting point the myth of Narcissus, and discuss it in relation to Lacan's
account of the mirror stage.

According to the myth, Narcissus died because, unlike Lacan's child, he
did not recognize himself; nor did he see the mirror for what it really was: a
boundary between reality and fiction.[3] The erogenic effect of the image
worked on him, but not the formative one. When his mother, the river
Liriopa, consulted the seer Tiresias and asked whether her son would live to
an old age, the reply was: "If he does not know himself" (*Si se non nouerit*,
346). The self-knowledge that supposedly entails wisdom if it is spiritual,
kills when it is "carnal," erotic, or so it would seem.

Yet later, the opposite seems to be the case. Carnal knowledge, rather than
being situated on one side of the mind-body split, is presented by Ovid as

Narcissus's fatal failure: "He falls in love with an image without a body" (*spem sine corpore amat,* 417). Imputing bodily existence to what is only a visual image, he condemns himself (*corpus putat esse quod unda est,* 417). This story of "death and the image" is about the denial of the true, natural body.

Prefiguring his imminent demise, Ovid's Narcissus enacts the soon-to-occur rigor mortis:

> He remains immobile, his face impassive, like a statue sculpted in marble of Paros.

> Adstupet ipse sibi uultuque inmotus eodem haeret, ut e Pario formatum marmore signum. (418–19)

"Ut signum" he becomes like a sign, an iconic sign of a sign, as an enactment of radical constructivism.

Unlike common lore, Narcissus is not wrong in admiring himself;[4] his tragedy is not brought about by excessive self-love so much as by naïve realism: "What you are seeking does not exist" (*quod petit est nusquam,* 433). He does, in the end, recognize that he loves himself; and, destroyed by the sense of tragic hopelessness that he has inflicted so often upon others, he begins his slow descent into death.

Rather than blaming him—or the narcissism named after the mythical figure—for moral shortcoming or formative failure, Merleau-Ponty sees in it the visual *condition humaine:*

> It [my body] sees itself seeing; it touches itself touching; it is visible and sensitive for itself. It is not a self through transparence, like thought, which only thinks its object by assimilating it, by constituting it, by transforming it into thought. It is a self through confusion, *narcissism,* through *inherence* of the two who sees in that which he sees, and through inherence of sensing in the sensed—a self, therefore, that is caught up in things, that has a front and a back, a past and a future. (1964, 162–63)

A sense of self as a body extended in space—"that has a front and a back"—also entails a temporal existence. The temporal existence that is the motor of Ovid's narrative.

As the quintessential story of mirroring, Narcissus belongs to the baroque sensibility that so fascinates contemporary culture. As I have argued

elsewhere, mirroring is a process in which the subject of looking folds the past and the elsewhere of the other into the here and now of the mirror. Thus, it provides an indispensable complement to the historical disciplines, which take pride in placing the past and the other at a distance, leaving them untouched by the self. For Richard Rorty (1979) the mirror is the major flaw in Western philosophy. And while Rorty's critique of that tradition of the mirror was well taken, I submit that we are not done with the process of mirroring. What semiotics, as a theory of cultural coevalness, may be called upon to provide is an alternative to a cultural history that posits the non-problematic "reality" of historical otherness. It therefore seems worthwhile to reflect on a representation of the myth that dates from a time in history when Narcissus flourished pictorially as well as narratively and theatrically. This representation is Caravaggio's *Narcissus* (fig. 1).[5]

Caravaggio's painting surely has a precise historical position. It has been—uncertainly—dated 1600, the year in which Giordano Bruno was burnt at the stake for his ideas. One of Bruno's ideas related to a kind of materialism that endowed matter with potential form, beyond the ancient Aristotelian matter-form opposition. Applied to Caravaggio's painting, this pictorial "Brunism" might help us to develop a more concrete sense of the semiotic importance of the mirror.[6] According to Françoise Bardon (1978, 94), Caravaggio used his *Narcissus* to test, in practice, ideas about spatial "emergence" which were a synthesis of Bruno's materialism and Galileo's search for general laws. Bardon writes the following about Bruno's view of matter:

> Unity exists through and in matter, which is no longer negative but instead contains all forms; it is both form and unformed, it is potentiality of forms, it is, precisely, an act.[7]

What Bardon calls "form's latency within matter" manifests itself in Caravaggio's substantializing use of color, rather than geometrical perspective, to create depth.[8] In fact, "depth" may not be the right word here at all. For it is a "depth" that comes forward rather than receding, that is based on substance rather than line. It is more like a high relief, a sculpturality that demonstrates a rather compliant passage through the mirror stage.

As Louis Marin pointed out, Caravaggio used black in particular to produce a "thickness" from which white is pushed out to take sculptural

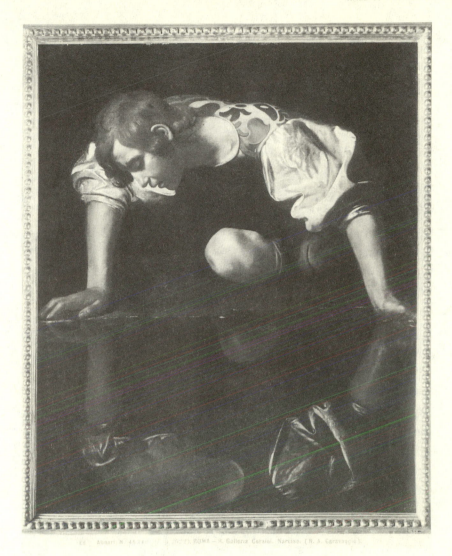

Figure 1. *Narcissus*, Caravaggio, ca. 1600. Galleria Doria Pamphili, Rome, Italy. Art Resource, New York.

depth, or relief (1995, 158–59). In terms of our discussion, Caravaggio's work is a case in which the "nature" or "reality" of space is indispensably "present" in the cultural self. The cultural adherence of visual, exterior wholeness to the "natural" but as yet "formless" body is the subject matter of his painting. Its primary feature is the "emergence," as "extension in space," of the body, to which the subject, through the act of mirroring, "inheres." In accordance

with Bruno, Caravaggio imputes to the image a function of active synthesis, but one that includes conceptual thought. No less than Sor Juana, whose act of writing is part and parcel of the viewer's self/other images, Caravaggio's painting "thinks" form into matter.[9]

All this is not to say that melancholia is absent from Caravaggio's work. This relatively small painting of *Narcissus* represents a youth, leaning forward, whose facial expression seems to embody melancholia. This leaning forward results from the technique of emergence; to use Marin's words: "... a 'black' painting is a represented space that *expels* the objects the painter wanted to include, forcing them outside of the painting and beyond its surface" (1995, 162; emphasis added). This emergence, realized through color not geometrical perspective, pushes the youth toward the picture plane, touching the viewer's space. The leaning forward into space doubles the narrative mirroring that is represented through the mirroring action upon the viewer.

If we look only at the figure's "real" body, the image is horizontal and the figure is shaped like a table. But if we ignore the water line—the surface of the represented mirror—and consider the double figure, the format becomes vertical, retaining the square and self-enclosed form. While the figure's arms seem to represent Ovid's simile in which Narcissus is equated to a sculpture (*ut e Pario formatum marmore signum*), a sign of the deadness to come, the stiffness of the rectangular shape is loosened up by the curved, almost decoratively baroque, wavering lines of the wisps of curly hair, the decorations on the sleeveless jacket, and the illuminated ear. The strongest curve in the upper plane is that of the neck.

The handsome face of illusionistically "real" flesh looks sad: just as the arms literalize the sign-status of the Ovidian sculpture (*signum*), the crease in the forehead is a culturally recognizable sign of distress; and while the half-open mouth denotes erotic engagement, the eroticism is represented as pain. Pain, wrote Judith Butler, defines the outline of the body (1993, 57–64). Here, the creased forehead does just that: it turns the light-fabricated matter into a body that knows itself. The crease that denotes pain is sculpted into a face whose carnality or "fleshness" gives sensational (proprioceptive) content to the mirror as surface. There certainly is pain, perhaps even melancholia: for the past, for what was lost, and for the future, where the empty space

needs to be filled through a potentially traumatic entrance into the symbolic order. But, unlike the resulting impulse to symbolically visualize the grief over and against repression, this painting fully endorses it.

But as Narcissus's body gets to know itself, it loses its boundary. Something along the way of this boy's mirror stage went wrong. At the four corners of the austere, self-enclosing rectangle, the sleeves, especially in their reflected form, seem icons of the water whose rippled surface makes Narcissus's image disappear. As Caravaggio represented him, Narcissus is suspended between the solidity that imprisons and the fluidity that dissolves.

As the story has it, Narcissus looks at his own reflection. But the act of seeing is not obvious here. The difficulties of seeing that Lacan evoked with the phrases "veiled faces" and "the penumbra of symbolic efficacy" are symbolized by the shadow that shades the eyes that see without recognizing; so much so that it is impossible to be sure that the eyes are open at all. The rectangular, or oval, frame constituted by the double body and arms leaves no way out. Lacan phrased it as follows:

> ... the *imagos*—whose **veiled faces** it is our privilege to see in outline in our daily experience and in the penumbra of symbolic efficacy—the mirror-image would seem to be the threshold of the visible world, if we go by the mirror disposition that the *imago of one's own body* presents in hallucinations or dreams, whether it concerns its individual features, or even its infirmities, or its object-projections; or if we observe the role of the mirror apparatus in the appearances of the *double,* in which psychical realities, however heterogeneous, are manifested.[10]

Shortly after this passage Lacan uses the term "spatial captation" to indicate what happens to the subject looking and seeing itself (seeing itself). This term, spatial captation, indicates the spatial element that complements the temporal aspect that the term cultural memory indicates: the here and now of meaning production. It also implies the other side of territorialism: the subject, far from occupying the space of the other, is occupied by it.

The mirror stage is crucial to the formation of the subject because it provides a sensational body of confused sense perceptions with an existence in space. Visually perceived, this existence connects back to the sensational body that is thereby enabled to take up a position in space and thus occupy

what has been called a "postural function": a function of something like "felt visibility," explained by Silverman as "the subject's sense of him or herself as a *body extended in space*."[11] The space in which the sense of self extends the subject's body is, I propose, nature as it is being "filled" with culture. This is what Henri Lefebvre means when he insists that space as social construct *is* nature (1991, 305).

The small format, the closed form, the self-obsession, all enhance a certain visual difficulty that can be summarized as: who is reflecting whom? In other words: in which *space* is this body located? The question raised is, what is real, and how is that reality worked upon by vision, exterior and fictional, so as to represent and further explicate the Lacanian mirror stage experience?[12]

The drama of the Narcissist who, Bardon writes, "in his failed desire for the other and his uncertainty of self, can only live in the sadness of this lack" is thus a spatial *manque-à-être*, a *knowing* impossibility to exist bodily in space, to occupy the outer space marked by absence.[13] The line that separates Narcissus from his reflection, the dotted line that barely indicates the surface of the mirror, is permeable, so that the failure to distinguish self from other is also a lack of sense of self. Consisting of marks, traits, hyphens, or dashes, this discontinuous line is Narcissus's act of writing.[14] The lack of limits signified by this act of writing is, again, doubled by the sculptural color perspective that pushes the body forward into the space of the viewer.

The most striking oddity in this painting is the naked knee. This knee embodies the spatial transgression most keenly. This piece of flesh, illuminated for emphasis, is not, as some critics have it, just another case of the eroticizing isolation of the knee found in other Caravaggio paintings.[15] Situated directly underneath the neck whose form it mirrors symmetrically, the knee is, besides the arms that signal deadness, the only part of the body that is actually reflected. Its representation is so illusionistic that it is more like a presentation, a making present.

What is it that it makes present? Through a double act of severing, it stipulates the fragmentation of the body. Read horizontally, the naked knee stands next to its other, the clothed knee, its symmetrical counterpart. That other knee is not reflected, or, rather, its reflection comes to naught. Read vertically, the knee looks like the reversed version of the neck: a neck without

a head on it. Thus, in two different ways that mutually reinforce each other, what the knee makes present is an absence.

The knee is wholly dependent on Caravaggio's construction of space out of blackness. But this space, invisible as it seems, is far from neutral. As Louis Marin has it:

> Black space is the space of a trunk, a coffin, or a cell. It is wholly bounded, like a tomb sealed forever ... How, then, is it possible to tell a story? (1995, 160)

The contrast between the dark front of the upper body and the emphatically illuminated knee makes the latter part come forward as if from nowhere. The knee looks as if it is detached from the body and floating in space, or in water. It destroys the body as it destroys narrative—or, if we must believe Marin as he paraphrases Caravaggio's detractors, it destroys painting.

The knee's detachment from the body signifies the "fantasy of the body in bits and pieces,"[16] attributed by Lacan to the child at the moment of "curing" itself from that fantasy by the construction of a "self-same body" by means of the mirror.

Many critics have remarked that Caravaggio is not a narrative painter. Marin explains this in conjunction with his sculptural mimesis:

> In a painting that presents itself as a narrative representation, the force of color has the effect of stupefying the action, of foreclosing the possibility of a story about human actions.[17]

The key word here is "about." Instead, from the tomb emerges a story that is performing human actions. For Marin, narrative is replaced by the performative imposition of scopophilia on the viewer.

But the desire to look has a more specific motivation here, one that pertains to the formation of subjectivity. If Caravaggio's tomblike black space and his excessively mimetic representation preclude the development of a narrative, the tension between the detached body part and its location locked within the frame of the body, the dead arms, and the reflection, replaces the diegetic narrative of the preestablished myth with a narrative that happens on the spur of the moment as a retrospective repetition of the mirror stage in all its narrativity. The knee remains as a synecdochic leftover

of the fantasy that is simultaneously presented and represented as in the past.

This is where I would like to locate the infringement of the mirror upon the space of semiotics; in other words, the relevance of a semiotic perspective on the mirror as the threshold where culture straddles nature, thereby decisively contaminating it as well as acknowledging its irreducible otherness. The sensational or proprioceptive body that can only begin to be the object of awareness when it is projected outside is the center of the semiotic activity that makes a connection between subject and world possible: deixis. It is only in relation to that body that cultural discourses and images make sense. But, equally fundamentally, it is only when the body has been projected outward, into the space that it occupies but *is* not, that the body can begin to *be* a body: both sensational and exteroceptive, visible for self as well as others. It is through this territorialization of exterior, "real" space that the proprioceptive body of sheer need is transformed into a subject of desire. That the boundary—skin and mirror surface—connects and thereby produces the body is indicated in this painting by the chiasmic structure that binds the eyes to the body.

Hardly visible, hence unverifiable in their "objective" act of looking but precisely thereby compelling the viewer to enter the image, the eyes of the youth are nevertheless shown to be oriented toward the knee. But they don't look at it directly. Within the representation, the "real" eyes look at the reflected knee, whereas the reflected eyes are directed to the "real" knee. This chiasmic structure binds the boy to his reflection while simultaneously underlining the latter's irremediable exteriority. The detachment of the knee enhances the formative importance of this act of looking: the only thing that, however tenuously, holds the body together is the visual continuity between the eyes and the knee by the detour of the reflection. The pain in the face is thus shifting back from erogenic to formative anxiety.

But this chiasmic interplay between eyes and body part, and between the subject and his reflection, is situated inside the frame constituted by the duplicated body. That the rectangular shape in the painting reiterates the shape of the painting itself, like an image-internal frame, is more than a simple compositional device. True to his program of making representation so perfect that it can no longer be representation because "the thing itself

appears before one's eyes,"[18] Caravaggio presents us with a scene of mirror-ing *as* a mirror. The knee which looks like a neck without a head is offered to us as a mirror image on which we can affix our own reflected face. Leaning forward, Narcissus extends his body into our space.

This painting, thus, confronts us with a reversed mirror stage; it mirrors that narrative. Whereas there the body extends itself from the position of the subject-to-be outward in order to culturally occupy natural space, here, from the black, tomblike outer space of the painting's background emerges the body that comes forward to touch us, unreflective "natural" viewers, with the magic stick of cultural embodiment. The sensational body is carved out for others to see, pushed forward. Thus the master of illusionism works the miracle of sculpting the proprioceptive body into visibility while retaining its sensational quality. The pain signifies that too: in an embodied act of mirroring, *we* feel Narcissus's pain. Touching our earlier, personal and cul-tural memory, it makes us nostalgic for what it proposes as a future.

This exteriority of the very interior of the body makes the work both nar-rative and self-reflective, but only tenuously in relation to Ovid's mythical narrative. It presents the fragmentation of the body with a remedy for or against the fragmentation that, according to the Lacanian narrative, follows. And it presents this remedy, the prosthetic illusion of wholeness that props the self up into existence, as a fiction, framed like a representation. The radical alterity and fictivity of the self-enclosed whole comprehends the detached knee, even while it is also iconic and indexical, resembling and spatially contiguous.

Strangely, then, this painting of Narcissus shows us—and contaminates us with—the collapse of narcissism. The narcissistic gratification based on ideal wholeness cannot be sustained. The frame fictionalizes. That, here, the frame consists of the body itself, only enhances the poignancy of the impos-sible conjunction of the two fantasies: of the body in bits and pieces, and the ideal wholeness of the narcissistically successful body. An impossibility which dialectically reinstates temporality in an image so adverse to it by its double endorsement of death.[19]

The more common use of the mirror in art is in representations of Venus. The mirror in the *vanitas* tradition, rarely without a skull and an hourglass

nearby, usually has as its iconic content—its reflection—simply the subject or the objects in the image. But it becomes filled with images of "beauty" when Venus is shown, gazing at her own image in a mirror held up by Cupid. Cupid narratively points forward to the inevitable consequence of beauty: desire. This indexical carry-over implies a temporal dimension. On the wings of time, beauty is thus carried over from the aesthetic to the erotic domain. To remain within the Baroque tradition, for example, we only need to think of Velázquez's *Venus* to see all the elements that turn the mirror into a reminder of specifically female *vanitas,* into one of the word's meanings: conceit. Conceit is symbolically imported as soon as the nude female body is supplemented by her face. But this face is represented at a different ontological level: in reflection. The point in paintings like Velázquez's *Venus* is not what the woman sees in the mirror; visually, her face is just a detail. The blurred quality of the reflected face signifies its existence on a different ontological level. The point is precisely that split between her body seen by the presumably male viewer, and her face seen by herself.

This different representation matters. The point is what men see in the painting: the nude. But the visibility of the nude includes the woman's collusion, which she acts out by showing the same interest in her appearance as men supposedly do. The separation of face from body in space and in ontology signifies this projected quality. In the words Marin used in the apparently different context of Caravaggio's *Medusa's Head,* "the mirror's effect *comes between the head and the body,* separating the site of the gaze and that of the gesture."[20] Therefore, reading the symbolic meaning *vanitas* in isolation, outside of the narrative dimension and the internal mirroring between male desire and female collusion as iconographic readers are wont to do— ignoring the split between the face and the body—ignores the production of meaning in a gesture that I would like to call a historicist fallacy, which is, in fact, antihistorical in its universalizing effect.

Caravaggio never painted a Venus. The closest he came to that tradition was when he painted the *Conversion of the Magdalena* (now in Detroit), around the same time he painted the *Narcissus.*[21] The mirror is there, a convex one, which Magdalena touches but does not look into. Nor is she reflected. Instead of a Cupid encouraging vanity, an older woman discourages it. But in spite of the iconographic presence of the mirror, this

Magdalena is less relevant for our discussion than the one at the Galleria Doria Pamphili in Rome, also contemporary with the *Narcissus* (fig. 2).[22]

In this painting there is no mirror for iconographic reading, but the rectangular shape so characteristic of the *Narcissus* is repeated. Yet, as opposed to the figure in the latter image, Magdalena is able to sustain the wholeness

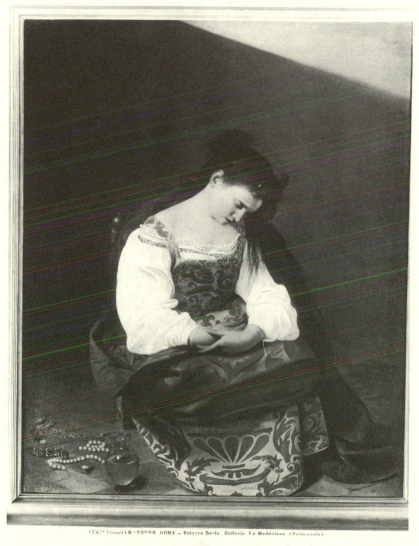

Figure 2. *Conversion of the Magdalena*, Caravaggio, ca. 1596. Galleria Doria Pamphili, Rome. Art Resource, New York.

that the primary narcissism of the mirror experience extends to the subject. Magdalena forms her own frame. She does this through her bent neck and folded hands. The wholeness of the frame is emphasized by the bright white sleeves on the two sides and the line formed by her hair and apron on the upper and lower sides. Unlike Narcissus, however, the woman is asleep.

The price to pay for the wholeness is the absence of consciousness. Magdalena suggests the illusion, often advanced by feminists, that somehow women are "closer" to their bodies than men.[23] According to Silverman, this illusion has two sides to it: on the one hand, women are assumed to have a less metaphorical relation to their bodies; on the other, they are alleged to be in danger of being psychically submerged by their "natural," literal bodies (1996: 31). Magdalena does not suffer, but then she does not "know herself" either.

Silverman goes on to conduct a devastating critique of this illusion through a discussion of Freud's vision of female narcissism, which depicts a woman "whose extravagant physical beauty miraculously erases all marks of castration." She shows that it is a male projection for whose lure women should not fall. For in this projection, woman

> must embody both lack and its opposite: lack, so that the male subject's phallic attributes can be oppositionally articulated; plenitude, so that she can become adequate to his desire. (33)

This sadistic, because impossible, model is culturally embodied by, on the one hand, Venus, and on the other, the Virgin-Mother, whose image and likeness religious women are required to live up to.

Caravaggio, then, although an avid painter of Madonnas, has not painted a Venus, or any other woman engrossed in her self-image. Instead, his sleeping Magdalena—a figure of transgression and conversion—represents the passive receptivity of the mirror as a gender-specific projection screen for the production of an illusory, exterior wholeness. In contrast, his Narcissus, now also gender-specific, demonstrates the breakdown of this illusion. If the sight in the fountain is human nature, this nature is either iconic but blind, or seeing but fragmented: exterior and fictional.

The myth, theory, or narrative of the mirror stage offers an account—or fiction—of how a subject can spatially and bodily emerge out of self-

enclosed autistic existence so as to learn not just to see, but to be in, the space of the world that is (also) "nature." This learning is difficult. Not because nature is empty and needs to be conquered, as it would be for an unreflected territorialist desire, but, on the contrary, because someone else was there before the subject. The mirror stage thus also represents a kind of colonizing. The question is whether the subject will *know* this—whether, as Tiresias warned, he would know himself. The repression of this colonizing of space, either in the hypostazing of the nature-culture opposition, or the denial of any difference between the two, as in radical constructivism, leads to the illusory acts of mapping that are so often complicitous with political and military colonizing. Against this repression, the effectivity of Caravaggio's *Narcissus* is bound up with the technique that the painter deployed to give embodiment to the fragmented body at the moment of its narratively fatal but visually formative-erotic mirroring.[24]

The vision Caravaggio's *Narcissus* embodies in its bodily mirror frame, then, comprehends an important insight into the implications of semiotic theories, specifically, theories of vision. In a psychoanalytic philosophy of nature, Karl Figlio recently asserted that the very project of visualization is built on repression; the necessary repression of an absence and the desire this absence inaugurates. He writes:

> The idea of place is charged with the search for love objects, in the form of an experience of absence. (1996, 75)

In particular, Figlio writes,

> Geometrical space is a representation of absence. It is that emotional notion of place that Bion says underlies the geometrical notion of space, which can then be located by coordinates. (1996, 75)

This is a description of one way in which "nature" is produced, a subjective, highly personal way, yet one which can be extended to encompass cultural habits as well, and which "happens" unknowingly. The term "repression," as Figlio uses it, marks the subject's pressure in natural space, its always-already exterior that is only now, at this moment, visible to the subject. The anxiety of the moment before this awareness will never quite leave the subject, and finds expression in the compulsion to such activities as mapping and

colonizing space. He cites the well-known woodcut by Dürer as an image of the anxiety of mapping that this felt absence entails. Thus he is able to explain the emotional investment in geometrical perspective.

Territorialism that knows itself, then, engages in the risky negotiation of becoming human, a subject of desire. In contrast, a territorialism that does not know that in becoming a subject of desire it fills exterior space, will also repress the presence of others in that space. Narcissus's pain, although hurtful if not traumatic,[25] expresses the price we all have to pay for gaining access to a natural world that can accommodate us, with our corporeal image but only in relation to others.[26] But at least, he, or it, does not hurt others by repressing that trauma at the cost of living on an insatiable desire for territory.

The theoretical allegory with which Caravaggio's painting thus presents us has implications for the place of semiotics as a "master" discipline in the cultural field. While binary opposition as a "master code" clearly produces more problems than it solves, the interaction between Narcissus and the space he must occupy also embodies the intricate and active relationship between "theory" and "object." Cultural analysis needs a semiotic perspective and semiotic concepts in order to articulate and explicate cultural processes that take place in and through cultural objects such as images and texts. But there can be no question of the mechanical "application" of a theory to an object condemned to muteness and only allowed to echo the semiotician's last word. Too often, such instrumentalist applications of semiotic theories and concepts have been deadly—more deadly than Narcissus's love of self (-image) that took him out of his self-enclosure of non-knowledge.

Spivak's analysis of Echo, Narcissus's unrequited lover, is a classic case of the dynamic interaction between theory and object that I am endorsing. In allowing Echo to speak for herself, the author practices what she calls a performative ethics: she reads Ovid's story as a narrative instantiation of an ethical problem. The problem she focuses her reading on is "the aporia between self-knowledge and knowledge for others" (19). Rare among Ovid critics, and faithful to her narratological ethics that posit that narratives "instantiate active ethical structures," she involves the narrative frame in her reading. Her loyalty to the discourse of her choice compelled me, in turn, to return to the opening sentence of Ovid's *Metamorphoses*, which so precisely

explicates Caravaggio's art as it conceptualizes and embodies his Narcissus's experience of ethical dilemma: "My mind is bent to tell of bodies changed into new forms."[27]

notes

1 This essay was first written for an ASCA workshop, held in 1996 within the framework of a conference on the semiotics of space, on the tensions between territorialism and desire.

2 Hayden White (1978) has exposed this logic in his analysis of the early modern fantasy of the "wild man," the inhabitants of wild nature outside the control of the city. More specifically, he called the logic of negativity underlying this fantasy "ostentatious self-definition by negation." White writes:

> They [the concepts] are treated neither as provisional designators, that is, hypotheses for directing further inquiry into specific areas of human experience, nor as fictions with limited heuristic utility for generating possible ways of conceiving the human world. They are, rather, complexes of symbols, the referents of which shift and change in response to the changing patterns of human behavior which they are meant to sustain. (154)

3 The oldest known source of the myth of Narcissus is Ovid's *Metamorphoses*, book 3 (1994, 80–86). Ovid exploits to the full the literary potential of the auditive mirroring through the figure of Echo, as a sonoric embodiment of the visual mirroring that, in literature, cannot be presented in such a concrete manner. See Frécaut (1972, esp. 57–58) for an analysis of Ovid's writing. On Narcissus, see Claire Nouvet (1991); also, with specific focus on Echo, Spivak (1994).

4 "He admires everything that makes him admirable" (cunctaque mirator quibus est mirabilis ipse, 424).

5 As an example of a positive representation of Narcissus in the theater, see Sor Juana Inés de la Cruz, *El Divino Narciso*. On Sor Juana, see Paz (1988) and Merrim (1991).

6 See Françoise Bardon's important study (1978). On *Narcissus* specifically, 94–95. On Bruno, 41–43.

7 "L'unité existe par et dans la matière, laquelle cesse d'être négative mais contient toutes les formes, elle est à la fois forme et non-forme … elle est potentialité de formes, elle est, proprement, *acte*. Ainsi la forme est dépossédée de son ancienne prépondérance, au profit de cette activité interne de la matière … D'où la théorie brunienne de la *latence des formes: la forme est en puissance dans la matière première en acte, elle n'est donc pas extérieure à la matière, mais elle y est impliquée*" (Bardon 1978, 42; emphasis in text).

8 The use of color to create depth was frequently practiced in the Renaissance, but never did color accomplish the same effect of substance as it did in Caravaggio.

9 "L'imagination est dynamique et créatrice d'unité, elle est ainsi au service de la pensée, en produisant un travail de 'contraction' imagée, préparatrice de concept, transformatrice" (Bardon, 1978, 43).

10 Lacan (1977), 3; italics in text; bold added. Silverman has borrowed the title and program of her book (1996) from this passage. See also my review of Silverman's book (1997c).

11 Silverman (1996), 13. The term "postural function" has been proposed by Silverman (12), who borrowed it from neurologist and psychiatrist Paul Schilder and developed it further.

12 Bardon (1978, 94) asks this question ("qui reflète qui?") but insists that this uncertainty exists only plastically. Iconographically, that is narratively, the face is full of pain.

13 "… drame du narcissique qui, dans son désir manqué de l'autre et son incertitude de soi, ne peut vivre que la tristesse de ce manque" (1978, 94).

14 See Hubert Damisch's *Traité du trait* for a remarkable study of traits in visual art (1995).

15 Mina Gregori (1985, 265) writes: "The figure and his reflection describe a circle at the center of which is the illuminated knee; a similar function is fulfilled by the highlighted knee of the angel in the *Stigmatization of Saint Francis* and by Saint John's knee in the Kansas City *Saint John the Baptist*." Gregori does not specify the function, but neither of these other knees is at the center of a circle, whereas both are quite erotic. See my analysis of the Kansas City *St. John the Baptist* (1996a).

16 Silverman (1996), 20–22.

17 Marin (1995, 106). The author contends that Caravaggio "destroys" painting because his excessive mimeticism precludes representation, as well as making narrative impossible. On his *Medusa's Head*, Marin wrote: "… this painting becomes improper or impure by virtue of an excessive degree of propriety. A characteristic feature of Caravaggio's paintings, then, is that they reveal and represent the excessive nature of representation, which grounds and authorizes them" (101).

18 Marin: "In his paintings Caravaggio irritatingly and sadomasochistically raises the question of truth in painting" (1995, 97).

19 Sculpturally through the tomb of black and narratively through the death of Narcissus.

20 Marin (1995), 132; emphasis added. On the Medusa painting, see Bal (1996a), 57–64 and 290–94.

21 See Gregori (1985), 250–55 for attribution, iconography, and dating.

22 For the meaning of Magdalena throughout art history, see Ernst van Alphen (1995).
23 See e.g., Montrelay, cited by Silverman (1996), 233, note 47.
24 For a critique of the overrated importance of geometrical perspective even today, imputed to the illusion of mastery it affords the spectator, see Damisch (1995), and my analysis of this work (1996a), 165–94. On the wider implications of Damisch's work, Van Alphen (1997).
25 On the possibility that the entrance into the symbolic order is intrinsically traumatic, see Janneke Lam's contribution (1997) to the special issue in which this essay first appeared.
26 See Jacqueline Rose (1986), 178–79.
27 Cited by Spivak (1994), 21.

afterword: looking back

IT IS WITH GREAT HAPPINESS AND A SENSE of opportunity and privilege that I accepted Norman Bryson's proposal—at the invitation of Saul Ostrow—to compile a volume based on a selection of my earlier work pertaining to visual culture and art. Preparing this book has helped me become aware of how I, as a literary scholar with a solid structuralist training, came to be perceived as close enough to being an art historian to warrant a volume in this series. The preparation allowed me to reflect on what I think most important to convey to readers interested in vision and visual culture and how to make the best possible use of this opportunity. In short, it became an occasion to look back, in a process whose outcome I can only refer to as an "intellectual autobiography."

Not long ago I began to reflect on what kept me going. I have worked in many different fields or disciplines—more or less "officially," in French, comparative literature, women's studies, biblical studies, and art history—and in my writing I have made use of philosophy, anthropology, and the

history of science. But all along, my interests, however much they have evolved, have been constant, to the point of obsession. What has been important to me in my work all along, whatever the "field of application," are concepts, intersubjectivity, and cultural processes. They initially determined my intuitive selection of *narrative* as my specialization. From early on, I have considered the theory of narrative—narratology—a relevant area of study precisely because narrative is a mode, not a genre; because it is alive and active as a cultural force, not just a kind of literature; because it constitutes a major reservoir of our cultural baggage that enables us to make meaning out of a chaotic world and the incomprehensible events taking place in it; and last but not least, because narrative can be used to manipulate. In short, it is cultural force to be reckoned with.[1]

Intersubjectivity is a concern that binds procedure with power and empowerment, with pedagogy and the transmittability of knowledge, with inclusiveness and exclusion. The notion came into currency in the academy in the context of the attempts during the 1960s to scientize the humanities, when Popper was Daddy Methodology.[2] Although I moved on, like the rest of us, I picked up the concept and cherished it for its insistence on the democratic distribution of knowledge. I was interested in developing concepts we could all agree upon and use, in order to make what has become labeled "theory" accessible to every participant in cultural analysis, both within and outside the academy.[3] Intersubjectivity is my standard for teaching and writing.

Concepts are the tools of intersubjectivity: they must be explicit, clear, defined in such a way that everyone can take them up and use them. Each concept is part of a framework, a systematic set of distinctions—*not* of oppositions—that can sometimes be ignored, but never transgressed or contradicted without serious damage to the analysis at hand. Throughout my professional life, I have been fussy about them. Concepts, or those words that outsiders consider jargon, can be tremendously productive. They help articulate an understanding, convey an interpretation, check an imagination run wild, enable discussion on the basis of common terms, perceive absences and exclusions. For me, a concept is not just a label that is easily replaced by a more common word.

Concepts that are (mis)used as labels lose their working force. They are subject to fashion and quickly become meaningless. A few years ago, "uncanny" was just such a label; today, it is "cultural memory" and, more disturbingly, "trauma," a concept with a precise, specific meaning, the understanding of which can actually be used to help people with serious grief, but not to meaningfully describe exposure to television news.[4] But concepts can become a third partner in the otherwise totally unverifiable interaction between critic and object, on condition that they are kept under scrutiny through confrontation with—not application to—the cultural objects one wishes to understand, are amenable to change, and are apt to illuminate historical and cultural differences. This is why I fuss about them, not because of an obsession with "proper" usage. The *gaze*, a key concept in visual studies, is one such concept that I find it important to fuss about. Norman Bryson's analysis of the life of this concept in feminist and gender studies, in the introduction to this book, amply demonstrates why it is worthwhile to fuss. He rightly insists that feminism has had a decisive impact on visual studies; film studies would be nowhere near where they are today without feminism. It would appear that to challenge concepts that seem either obviously right or too dubious to keep using as they are, in order to revise rather than reject them, is a most responsible activity for theorists. Interestingly, concepts that do not budge under the challenge may well be more problematical than those that do.

These three priorities—cultural processes, intersubjectivity, and concepts—come together in the practice of what I do. As a professional theorist, it is my belief that theory can be meaningful only when deployed in close interaction with the objects of study to which the theory pertains. Close, detailed analysis establishes a kind of intersubjectivity, not only between the analyst and the audience, but also between the analyst and the "object." The rule I have imposed on myself, and which has been the most exciting, productive constraint I have ever experienced, is never to just "theorize" but always to allow the object "to speak back." Making sweeping statements about objects, or citing them as examples, renders them dumb; detailed analysis—where no quotation can serve as an illustration but will always be scrutinized in depth and detail, with a suspension of certainties—resists

reduction. Even though, obviously, objects cannot speak, they can be treated with enough respect for their complexity and unyielding mystery to allow them to check the thrust of an interpretation, to divert it, complicate it. This holds for objects of culture in the broadest sense, not just for objects we call art. Thus the objects we analyze enrich both interpretation and theory. This is how theory can change from a rigid master discourse into a live cultural object in its own right. This is how I learn from my objects. And this is why I consider them subjects.[5]

The only way I can describe, however briefly, the various phases I have passed through—often related to places where I have stayed since the late 1970s, when I started publishing—is by using key concepts I have had to contend with along the way. Thanks to fruitful debates about these concepts, I have been able to put them to use in a critical analysis of culture, the endeavor that lies at the heart of my work. The concept probably most firmly associated with my name is *focalization*, explained here in the first chapter. This concept is the hub around which my work circulates, from which it receives its unity; it is the shifter, also, between my work on narrative in literary studies and my work on visual art.

Retrospectively, my interest in developing a more workable concept to replace what literary scholars call "perspective" or "point of view" has been rooted in a sense of the cultural importance of vision, even in the most language-based of arts. The linguistically inspired tools inherited from structuralism and based on the structure of the sentence failed to help me account for what happens between characters in narrative, figures in image, and the readers of both. The great emphasis on conveyable content hampered my interest in how such contents were conveyed, to what effects and ends. My linguistic inspiration came from a figure who was marginal to the structuralist movement. Bryson has rightly picked up Benveniste's fundamental influence on my work. Indeed, Benveniste is the least recognized of the French "masters of thought" who had such a lasting impact on the humanities. His work is crucial to understanding what Lacan did with Freud's legacy, Derrida's deconstruction of logocentrism—the content bias—and Foucault's definitions of episteme and power/knowledge,[6] but also developments in analytical philosophy as they have filtered through into the study of literature and the arts, through the concept of performance. For

him, reference—the linguistic term for "content," yet a word that is both a verb and a noun—is secondary to deixis, the "I"-"you" interaction that constitutes a referential merry-go-round. His writing is utterly clear and illuminating.[7] I have often been able to deploy his ideas to great benefit in my analyses as well as my theorizing.

In my concept of focalization, in which I deviated from the use Gérard Genette put it to in 1972, I found a tool to connect content and communication. It is a mistake to assume that this concept can be seen as an amalgam of Genette's use and mine, as is often done in literary studies; they are in fact utterly incompatible. It was when I was writing a critical assessment of their differences and their methodological and political frames that I understood for the first time the tremendous implications of what appears to be just fussing in the margins about a term, a piece of jargon:[8] the tiny differences related to such issues as the blind acceptance of ideological power structures versus a critical analysis of them; the possibility of overcoming the firm subject-object opposition; the obliteration versus the insertion of political issues such as class within a formal or structural analysis; and, perhaps most importantly, the possibility of analyzing rather than paraphrasing and broadly categorizing a text.

It became clear to me that analysis can never be the "application" of a theoretical apparatus. Theory is just as mobile, subject to change, and embedded in historically and culturally diverse contexts as the objects on which it can be brought to bear. Yet it is indispensable. But are theory and close analysis not incompatible in practice? A first, tenacious problem I had to contend with when practicing detailed analysis from a theoretical perspective, however, suggested to me why so many colleagues were interested in what I found to be reductive classification, rather than a close analysis informed but not overruled by theory. The problem is simply one of procedure: how do you do it? How do you get beyond endless microscopic scrutiny of a detail, whose relevance for the work as a whole, let alone for its genre or cultural context, is questionable at best? It is a question that invariably comes up when working with my doctoral students, just as it did when I was writing my own dissertation.[9]

The concept underlying this practical problem of reconciling theory and close reading is that of the status of the *detail* and all its implications: the

relation with the object as a whole; the impulse toward coherence that over-rules the detail, hence its power of resistance; the feminization of the detail;[10] its structuring force; its aesthetic impact. Once I gave the detail as such, in all its evasiveness, a bit more thought, I was able to develop a practice of cultural analysis in which both detail and whole, object and reading, text and context, and theory and practice could be carefully balanced, so as to yield insights into the finesse and complexity of the fragment—not as an exemplum or synecdoche of the whole but as an active force operating within it.

It was utterly gratifying to be able to elaborate this balancing act through a painting about balancing which happened to contain the minutest detail of theoretical relevance I had ever noticed: Vermeer's nail. Thus I had one of my moments of awe in the face of the intellectual brilliance of art. Chapter 2 of the present collection gives a sense of the way I work toward such a balance. The detail also plays an important part in chapter 3. But my thoughts on the detail in relation to coherence as a political force are most explicitly and extensively presented in the third volume of a series of three books that I wrote on the Hebrew Bible in the mid-1980s. This book, *Death and Dissymmetry: The Politics of Coherence in the Book of Judges,* explored the political underpinnings of the impulse to maintain coherence in interpretation, and the resistance which details can muster against such politics. It was the key text in the shift I made from an emphasis on structuralist and formalist concept-building, to a more philosophically oriented, poststructuralist intellectual style. But the series, sometimes half-jokingly referred to as my trilogy,[11] when read as a whole makes a point that I would like to foreground here as well.

Poststructuralism, as the term indicates, comes after structuralism, but also through it. I cherish and value my structuralist training, and often regret its absence in the cultural baggage of my students. It was structuralism—not in its objectionable guise as dogmatic, positivistic methodology, but as a search for an intersubjective method, a search involving clarity and systematicity—that pushed its best participants beyond it, into poststructuralism. Just as I wish to pay homage to Benveniste, in the full awareness that we also must move beyond his views—remember, theory is also historically specific!—I wish here to insist on the crucial, indeed, the utterly indis-

pensable insight I have gained from a hopelessly idealistic search that was doomed to failure from the start. It is the search that matters, yields insights, not the result, which can never be more than provisional. It was when struggling with the recalcitrant concepts of structuralist narratology that I came to the realization that changed my intellectual life.

Feminism is not a concept, but *gender* I find too general to express what motivated me more and more consciously and explicitly in my work. My feminist inclinations were pointed out to me by one reviewer of my first full-size book (1977); they had come "naturally" to me, and I wasn't aware of their academic importance. Again, it is only retrospectively that I realize how strongly my feminism had informed and propelled my attempt to radically revise Genette's concept of focalization. But the reverse is also true! At the time, I thought it was the difficulty of "applying" Genette's concept that urged me to develop it further. But the reason I could not work with it was the odd combination of the formal-theoretical recalcitrance of the object and a strong desire on my part to engage that object in a discussion rather than to subject it to classification and muteness. The stake of that discussion was invariably power-based—related to class, for example—and more often, gender-oriented.

Feminism, conceived as a critique of cultural exclusion and impositions of power, underlies my trilogy on the Bible. It also informs my book on "Rembrandt"—which is really less about the art of Rembrandt than about how to analyse visual images beyond a medium-essentialism that opposes images to language. This book, from which Norman Bryson selected the most emphatically feminist chapter for inclusion here, had a nicely messy start. I began looking at Rembrandt while writing *Death and Dissymmetry,* and throughout that year, Rembrandt was the object of my desire, necessary as a reward because I was reluctant to write what I saw as "another book on the Bible." I got hooked on the latter book at the moment that an obscure problem of philology—how to interpret an ancient, obsolete preposition— suddenly became fully understandable. This was the moment when I visualized the situation in the story. I'll never forget how excited I was each time I made a minor discovery of that sort. The excitement came from a strong sense of empowerment. I felt empowered by *visuality* and knew that, once *Death and Dissymmetry* was finished, I had to explore this concept further.

The "other book on the Bible" became a most fruitful search, a most reward-
ing and pleasurable writing experience. It permanently changed my writing,
my thinking, and my obsession.

Reading "Rembrandt" became the project for this further exploration.
But, instead of developing another set of tools for analysis, my focus shifted
a bit, and visuality became a concept not of an analytical but of a philosoph-
ical nature. Throughout the book, I studied visuality in discourse and dis-
cursivity in images, relations between the two, and the cultural impact of
events of encounter or struggle on vision and subjects. Instead of trying to
define visuality per se, I explored aspects and effects, forms and meanings
that visuality possesses or makes possible. In the course of that examination,
as it turned out, visuality gained the status of a discourse, not as subjected to
language but as a kind of language with its own capacity for meaning pro-
duction. Superficial readers of that work have blamed me for subordinating
images to language, but in my bold moments I think I did more for the
emancipation of the image from the tutorship of language than most art
historians. For, instead of framing the image as "purely" visual and thus
repressing its meaning-making effects,[12] I empowered it, by making it just as
strong, by giving it striking force, by giving it agency in today's culture,
instead of relegating it as a dead relic to the unreachable past. I made it just
as "impure" as language is in the narrow sense of the word.

The writing of Reading "Rembrandt" during the late 1980s was a definitive
step outside the field in which I was professionally locked up. In the pre-
interdisciplinarity days of the early and mid-1980s, I had had to justify that
studying the Hebrew Bible was a literary enough activity, and with
Rembrandt, I seemed to be pushing it. I wish to emphasize that I stayed on
in comparative literature as well. For I did not want to trade in one limita-
tion for another. Also, I knew that my work was going to be devoted to
undermining such limitations—in theory, in analytical practice, in teach-
ing—an endeavor I could only pursue from within the institution I wished
to loosen up, not to reject.

In addition to wonderfully exciting moments, during which I was hos-
pitably received both in biblical studies and art history, the 1990s began with
the realization that disciplinary limitations have a truly disciplining effect.
They turn tradition into laws and shut the doors to innovation and to others

who are not yet members of the club. Again, the crucial insight was that political exclusions go hand in hand with—indeed promote—intellectual weakness and closure. This insight has often helped me shrug off nasty attacks and discriminate between such attacks and intellectual debate. The former I tried to ignore, the latter enticed me to be passionately committed to bridging gaps and exchanging views, to bringing intersubjectivity to bear on academic practices. In short, as much as I loath trashing, I find polemics extremely fruitful, and I see serious criticism as the best way to overcome rigidity and limitations.

Since the opposition between language and vision could not be maintained, another limit that I had tried to overcome all along soon came up for further scrutiny: that of "the work"—the text or image or whatever object I chose to examine. Jonathan Culler, whose lucid and generous efforts to mediate between philosophy and literary studies have been a great help to me from the beginning, had made me aware of the concept of *framing* as an alternative to context and I have frequently quoted his formulations.[13] After *Reading "Rembrandt"*, it was time to run away with the concept.

In light of my clinging to close analysis as a first principle, and my awareness of the mobility of the object and its meanings in the face of the great power of framing, exhibition practices was an obvious area for me to examine. Chapters 4 and 5 of this book provide samples of that work. But, while engaged in the tricky business of turning articles and lectures into a book that was informed by a project, I realized that the very analysis of framing made me a bit "framo-phobic." Instead of bringing together all my papers on museums, I decided to resist that frame, which was already at risk of becoming just another proto-discipline. Instead, the principle of the book has become framing itself, that particular kind of framing which "shows"— things, ideas, people. This gesture of showing became my object. Hence, this book—to my own astonishment and for the first time in my work—had no object that can be placed within any disciplinary field. As a consequence, it may never be reviewed.

This book, I mused, was not to be a combination of art history and literary studies, however elaborate the interactions and exchanges between the two might be, but a true "other" of disciplinarity. Included in it are analyses of academic practices such as the use of illustrations and telling stories for

arguments, the rhetoric of showing deployed in a Shakespeare text but used as a theory of violent vision, and the showing that goes on within works of art and that offers a critique of the very show of which such works are a part. I was already busy articulating this antiframing framing of the book *on* framing when I became involved with the founding of the Amsterdam School for Cultural Analysis (ASCA), an interdisciplinary research institute in the humanities[14] whose conception was in turn influenced by my incipient *Double Exposures.* Like *Narratology* at the beginning of my career, *Double X,* as friends call it, is a book that could not have been written without the very activities that slowed down its writing: teaching in the former case, administrative activities in the latter. Here too, what many perceive as a hampering of the "real" work has always been for me an inspiration, another boundary—the one between research and the other work—whose penetrability has often greatly helped my writing.

Also in the early 1990s, while working on the pieces on showing, I found myself rereading Proust. A return to French, to literature, was the result. Advance copies of *The Mottled Screen* arrived just a few weeks before writing this afterword, and I am expecting the French edition any day. But just as a traveler who returns from a long voyage around the world is never the same again, I cannot see this book as "going back." It demonstrates, more radically and systematically, what I had already argued in *Death and Dissymmetry*: that the study of linguistic texts must take into account a *visual poetics.* This concept enabled me to integrate not only the obvious descriptions of paintings and other visual images to which Proust studies on vision tend to be confined, but also a photographic imagination and an obsessive play with optical instruments.

With visual poetics I tried to move beyond visual objects of representation to analyze a *visual mode of representation.* Within this large field, I distinguished a variety of visual modes, regardless of whether any direct allusion to images was present in the text. The photographic is no more identical to the painterly than photographs are to paintings; the snapshot is not the same as serial photography or, at the other end, a studio portrait. Surprisingly, it is precisely Proust's writing that endorses such distinctions, and I contend that this visual finesse is what results in the utterly distinct, rich, and ambiguous literature Proust wrote. Chapter 6 of this volume

(a previously published article) has been selected in place of a chapter from *The Mottled Screen* because it stands on its own. It gives an impression of what I mean by the concept of visual poetics: a stimulus to and strategy for writing, not a representation of painting or an attempt to imitate it.

After twenty years of increasing interdisciplinarity, it is almost as if I needed to write this book, to prove to my colleagues and myself that I am "still" a literary scholar. If anything, however, it proves that I have never been anything but that. Just as feminism is not a pair of glasses one can put on and off at will, I remain what I was before my forays into interdisciplinary work. I gained something, but didn't lose what I had acquired. If the book has any merit, it will prove how fruitful the contribution to literature is that comes from thinking about vision and practicing visual analysis.

This is perhaps the most important insight for academic policy. For if there have been an increasing number of literary scholars turning to visual art—perhaps due to a tedium experienced in their own field following the excitement of the "French" 1980s—I have seen little evidence of a move in the other direction. This I regret. My hope with *The Mottled Screen* is not to become visible and acceptable again in the field of literary studies but to convince readers how enriching the study of visual art is for the entire field of literary analysis.

Through all this, one concept remains tenaciously problematic. It is the concept of *history*. My self-descriptions have changed with time: I used to present myself as "not a biblical scholar" and "not an art historian," in order to avoid the misunderstanding that I was pursuing the same goals as those disciplines did. But as I kept trying this to no avail, I began to claim the opposite: that I was just that, but of a different kind; one who also had the right to make statements about the objects traditionally imprisoned within those disciplines.

As happens often, the critical reactions made me think harder. After *Double Exposures*, I decided to take on the issue of history. In the project I most recently completed, of which the last two chapters of this book offer a sample, I develop the concept of *preposterous history*.[15] The term indicates a reversal of perspective. The view of history I would like to propose, and which informs that project—the book of *Quoting Caravaggio* that just

appeared—is based emphatically and primarily on the historical position of the present.

With this I do not mean what Hubert Damisch proposes, although I agree with and endorse much of what he says. "History," as he has pointed out, is always "the history of." It is not an absolute notion, or, I would add, a self-sufficient argument in debates (see especially Damisch 1987). And that of which art history is a history is not the intentions of artists or patrons, nor of the circumstances in which works of art were made, although such data may have a modest place at the margin. Nor is it the history of isolated motifs or techniques. All these things are *not* art. What art is, Damisch claims, is a philosophical question, and hence the history of art is the history of that question.

I am exploring what history means to me by studying contemporary art that "quotes" Caravaggio, an old master whose work is invariably discussed on the basis of the marginalia of art history cited above. My contention is simple: "quoting" Caravaggio changes his work forever. Like any form of representation, art is inevitably engaged with what preceded it, and that engagement is an active reworking. It specifies what and how our gaze sees. Hence the work performed by later images obliterates the older ones as they were before that intervention and creates new versions of old images instead. This process is characterized by an engagement with the past through contemporary culture which has important implications for the ways we conceive of history and culture in the present.

Such re-visions of older art neither collapse past and present, as in an ill-conceived presentism, nor objectify the past and bring it within our grasp, as in a problematic positivist historicism. They do, however, demonstrate a possible way of dealing with "the past today." This reversal, which puts what chronologically came first ("pre") as an aftereffect ("post") behind its later recycling, is what I would like to call a preposterous history. In other words, a way of "doing history" which carries productive uncertainties and illuminating insights. A vision of how to re-(en)vision—in the case of my neo-Caravaggisti—the baroque.

The concept of *quotation* serves as the central theoretical focus or "hub" of these works, just as Caravaggio's work is the visual hub that helps me articulate, in a roundabout way, issues relevant for this exploration.

"Quotation" stands at the intersection of iconography and intertextuality and, hence, of the two disciplines with majority shares in this project. It refers to the readymade quality of signs which a writer or image-maker finds available in the earlier texts that a culture has produced.

Three features, and other crucial ones, characterize both intertextuality and iconography, even if in art-historical practice and literary source studies the consequences and possibilities offered by these features are not always followed through. In the first place, iconographic analysis and literary source studies tend to see the historical precedent as the source which virtually dictates to the later artist what forms can be used. By adopting forms from the work of a particular artist, a later artist proves to be under the spell of the predecessor's influence; he implicitly or explicitly declares his allegiance and debt to him. Michael Baxandall had already convincingly proposed reversing the passivity implied in that perspective and considering the work of the later artist as an active intervention in the material handed down to him or her.[16] This reversal, which also affects the relation between cause and effect, complicates the idea of precedent as origin, and thereby makes the claim of historical reconstruction problematic.

A second difference between the theory of intertextuality and source studies and iconography in practice is the place of meaning. Iconographic analysis frequently avoids interpreting the meaning of the borrowed motifs in their new contexts. But, because it is a sign, the adopted sign inevitably comes invested with a meaning. Not that the later artist necessarily endorses that meaning, but he or she will have to deal with it: to reject or reverse it, ironize it, or simply, often unawares, insert it into the new text. Instead of classifying and closing meaning as if to solve an enigma, this view of what Freud would call *Nachträglichkeit* attempts to trace the process of meaning production over time—in both directions, present/past and past/present— as an open, dynamic process, rather than as a mapping of the results of that process. It is in this sense that I claim that art "thinks."

A third difference between theory and practice resides in the *textual* character of intertextual allusion. Iconography tends to refer visual motifs back to written texts, such as the classical texts of mythology. I am trying to take the textual nature of precedents seriously as a *visual* textuality. By recycling forms taken from earlier works, an artist also takes along the text from

which the borrowed element has broken away, while at the same time constructing a new text with the debris.

Intertextuality—the specific quotation that is also the object of iconography—is, in this sense, a particular instance of the more general practice of interdiscursivity: the mixture of various different visual and discursive modes, which Mikhaïl Bakhtin called *heteroglossia*. Thus, the "textualizing" iconography will consider visual principles of form, such as chiaroscuro, color, folds, surface texture, and different conceptions of perspective, as "discursive positions" that entertain interdiscursive relations with other works. To make this clear, I discuss not only figurative but also nonfigurative art, as in the final chapter of the present book.

"Quotation," then, is a term that stands at the intersection of art history and literary analysis, a concept that makes preposterous history specific. Quotation can be understood in a number of distinct ways at the same time, each illuminating an aspect of the art of the present and of the past through their distinct theoretical consequences.

First, according to classical narrative theory, there is the direct discourse or "literal" quotation of the words of characters. As fragments of "real speech," they authenticate the fiction. In narrative, quotation of character speech is embedded in the primary discourse of the narrator. In visual art, such embedding structures are less conspicuous and are rarely studied. I try to foreground these structures and their effects.

Second, these fragments of reality are a product of manipulation. Rather than serving reality, they serve a reality *effect* (Barthes), which is something quite different, in a sense, the opposite: a fiction of realism. Thus they function like shifters, allowing the presence within a single image of multiple realities.

Third, quotations stand for the utter fragmentation of language itself. They point in the direction from which the words have come, thus thickening rather than undermining the work of mimesis. This conception of quotation turns the precise quotation of utterances into the borrowing of discursive habits, and as a result, intertextuality merges into interdiscursivity. This interdiscursivity accounts for pluralized meanings—typically, ambiguities—and stipulates that meaning cannot be reduced to the artist's intention.

Finally, deconstructionism paradoxically harks back to what this view might otherwise repress if it presented the polyphony of discursive mixtures a little too positively. Stipulating the impossibility of reaching the earlier speech claimed to underlie the quotation, this view emphasizes what the quoting subject does to its object. Whereas for Bakhtin the word never forgets where it has been before it was quoted, for Derrida it never returns there without the burden of the excursion through the quotation.

The first two meanings of the concept of quotation take the relation between image and reality beyond the question of reference. Their orientation leads from the image to the outside world in which it operates—the close environment of the work's own frames in the case of the first, and the world outside those frames in the case of the second. In contrast, the second two meanings of the concept focus on meaning coming from the outside in. Their simultaneous actualization thus also entails questioning the very boundary that separates outside from inside. This questioning, in turn, challenges the notion of intention.

In a very illuminating argument on constructivism and performativity, philosopher Judith Butler astutely exploits Derrida's conception of quotation, to rearticulate her theory of sexuality as a result not a cause of particular performative behavior.[17] She quotes Derrida's statement that performative utterances cannot succeed unless they repeat—hence quote—an already coded, iterable utterance. As a consequence, Derrida argues, "the category of intention will not disappear; it will have its place, but from that place it will no longer be able to govern the entire scene and system of utterance" (1988: 18). The subject whose "intention" is involved in the making of the image, or, in other words, in the uttering of the speech act, steps into the citational practice that is already whirling around it; the speech act is larger than the subject of utterance can possibly foresee and control.

In all four conceptions of quotation, the relation with what is quoted is established from the vantage point of the quoting text, which is situated in the present. Whether the quoted artifact is enshrined or abducted, dispersed or unreflectively absorbed, the resulting complex text is both a material object and an *effect*. Quotation, then, is situated, beyond individual intention, at the intersection between objecthood and semiotic weight.

These various meanings attached to the notion of quotation carry with them an epistemological view, a concept of representation, and an aesthetic. I intend to demonstrate the intricate connections among these domains. Indeed, their inseparability is perhaps the most important contribution of preposterous history. Therefore, the juxtaposition of these conceptions of quotation enables me to grasp issues of past art and present vision pertaining to the understanding, the history, and the activity of looking.

I contend that this view, and the concept of preposterous history, have very productive consequences, not only for art history but also for art practice and its cultural embedding in collections and museums.

Clearly, what we call "the past" is not a whole, not a smooth uniform development. In the case of museum collections, to give a concrete example, acquisition takes place in a specific moment, a particular cultural context that is overdetermined by synchronic connections to other events. Each moment in the past is a "present" when it happens. We know this all too well from the present; why suppose it was any different in the past? From today's vantage point, the past appears only as continuous, an appearance that is by definition reductive and simplifying .The two themes I have used as examples—the universalism and the nationalism of collections—are the "pretexts" of continuity that obscure discrepancies and contingencies. Therefore, I suggest developing collections on the basis of a productive suspicion of the notion of continuity.

But this is not doing away with history. In the case of museum collections, it is equally important that the history of a collection add to its identity and meaning. It is the conflation of *chronology* and *history*, and the compacting of the past as a whole, that I take exception to. History begins in the present but does not end there. The past is the present's other, both nostalgically idealized and rejected as different, a dead relic, a treasure, but always somehow a *whole*. Instead of deploring the impossibility of grasping the past in its heterogeneity and discontinuity, as active and *happening*, it is worth taking this logical consequence of time's elusiveness as a starting point.

One of the consequences of this decision is that more serious attention should be paid to *memory*.[18] Instead of "influence," bits of the past are present in the present in the form of traces. Memory does not allow the dis-

tinction between private and public; this makes it a helpful concept. Cultural memory is an alternative to traditional history on the one hand, to private subjectivism and uncontrollable self-indulgence on the other. Memory is a function of subjectivity. Cultural memory is collective, yet subjective by definition. This subjectivity does not lead to an individualist subjectivism; indeed, it actively counters the conflation of subjectivity and individualism.

The subjectivity implicated in cultural memories thus implies the activity of memory, and hence its situatedness in the present in an engagement with the past. The search for the past that is inherent in the present includes a sense of loss ("le temps perdu"). Time is thickened by subjectivity since subjectivity is thrown out into collectivity.

This is a contemporary view of history which can be meaningfully brought to bear on the study and practice of art, on collecting and display policy. It makes sense for today of what is there as a "result" of the past, but without illusory continuity, without presentist superiority and arrogance, and without underlying notions of "taste," "great art," styles or schools, nation or region.

Let me conclude with a concept that has been immensely useful to me for some time now, and which I want to foreground here—at the closure of this book that is its product. Underlying what I see as most important in my work is something that is rarely discussed. I am referring to a basis for "learning in *friendship*," an idea of which I was made aware through a book I read some years ago, by the Canadian philosopher Lorraine Code (1991). The concept of the series in which this book appears—one person with a certain reputation in art history is asked to select and introduce essays by another—is based on intellectual friendships: only someone who feels a close affinity with the work of another can make a selection that will be satisfying to both.

Intellectual friendship could be a model, in the first place, for academic relations among colleagues. Where these are friendly, imitation, intolerance for deviance, and exclusion of others are often the price that has to be paid. The department as a club is the worst result of such friendliness, which has little in common with what I call intellectual friendship. Where relationships are not friendly, the faculty members' work falls away like water in sand. At best, it is ignored; at worst, trashed.[19] Often, it is both plagiarized *and*

trashed. Energy is wasted in dumb, unspoken hostility. There is no hope for a field of study if the people working in that field are either closed-club members or hostile; in both cases a productive debate is impossible, and no one will ever learn anything that is not already known to him.

Discussion is best served by excitement and genuine interest. Because of the space it allows—indeed requires—for disagreement and criticism based on fundamental acceptance, intellectual friendship is productive and benefits the field or discipline(s) involved, even if many within the field disagree. I remember vividly how excited I was, before I ever met Norman, about his book *Vision and Painting* (1983). The most important idea at that time was the distinction between the gaze and the glance. I wanted to work with the ideas, "use" the book. When I did, I found that I did not quite agree on all of it, notably the part concerning that distinction. So in the end I revised it, helped by the work of another "intellectual friend."[20] But my point is that I could only do so because I had first accepted it, and *within* that acceptance, wanted to develop it. Neither rejecting it nor totally accepting it would have enabled me to make what I think is a small step forward.

For the same reasons, intellectual friendship is a model for friendship in general: for a friendship that stimulates change and growth, that inherently counters boredom and sleep-inducing self-satisfaction, that nurtures and is generously critical. Interestingly, narrative has an important role to play in such friendships. For Code, whose lead I followed in my understanding of friendship as an epistemological model, that relationship has features that clearly demonstrate why narrative is an important resource for it:

- such knowledge is not achieved at once, but rather develops;
- it is open to interpretation at different levels;
- it admits degrees;
- it changes;
- subject and object positions in the process of knowledge construction are reversible;
- it is a never-accomplished constant process;
- "the 'more-or-lessness' of this knowledge constantly affirms the need to reserve and revise judgement" (1991, 37–38).

But intellectual friendship can also be seen as a model for the teacher-student relationship. The mutuality and equality that saves such intellectual

friendships from the authoritarian one-sidedness that tends to spoil teacher-student relationships is often, at least potentially, also present in the practice of teaching. Any teaching worthy of its name is also—constantly—learning. Every group of students, every individual advisee, responds differently and thereby requires different teaching. The perspectives that students bring into the classroom or office make it impossible to lecture on the basis of a pre-pared set of ideas. The need to revise and give up, shift and turn, reformulate and present differently, makes teaching an intense form of learning, a learn-ing based on listening. The day I stop learning from my students—I have always thought—I'll retire.

My interest in the interaction with students has had a great influence on the way I write. The first chapter of this volume has a sample of my writing that was primarily and explicitly written for students. It is the first text that put me into the international scene, and for many students of literature it is the one by which they know me. What mattered most to me when writing that book was clarity. I had so loathed the unnecessary impenetrability of many of the books of theory I had attempted to use during my student days that my need to make clarity a first principle overruled everything. Clarity required being systematic, and writing short, affirmative sentences, or so I thought at the time.[21] Later, my style changed—my own writing is just as subject to historical change as anything—but Norman Bryson's insistence on bringing into this volume a sample from that early work seems right, espe-cially since the selected fragment, literary as it is, represents the early stage of my fascination with looking. His insistence made me aware of the connec-tion between style and content: communication without words is at the heart of my thought, and if I feel passionately committed to understanding vision, it is because I also want to see and facilitate others' desire to see. Sight and insight go hand in hand, and both friendship and pedagogy are based on a suspension of certainties. So, above all else, is an intellectual friendship.

I am today acutely aware of the immense importance of intellectual friend-ship for the acquisition of insight. Norman Bryson and I are intellectual friends: we eagerly read each other's work, discuss, use, and appropriate it, and without agreeing slavishly with all the other says, we feel we learn from each other. We are different, we have divergent opinions, we can disagree—

sometimes in important ways; friendship is not cloning. We lack both the envy and the impulse to imitate that often characterize academic relationships. Instead, the mutual respect and excitement we feel when talking about our work, or reading each other's texts—the sense that these are always inspiring, helpful, pointing us in new directions—give our intellectual relationship its capacity to enable learning. This capacity gives intellectual friendship the allure of a model for other relationships.[22] I know that the key moments in my professional life have been encounters, on paper or in the flesh, with kindred spirits whose work I could befriend. None of them worked in the same area of specialization as I did. I could cite many examples but will limit myself here to a few.

Michael Holly kept asking me how my detailed analyses of images differed from formalism, so that I became aware of the unstable meaning of that word and the connotations it had in different disciplines. Answering her question required an awareness of framing. Evelyn Fox Keller's precision and insistence on responsibility demonstrated that "feminism and science" need to turn to language but that this need does not reduce the relevance of hard reasoning.[23] She made me see the risks of a radicalism that looks only in one direction. Gayatri Spivak, whose uncompromising insistence that there is a lot of neocolonialism in postcoloniality, sharpened my (self-)critical edge.[24] Kaja Silverman's commitment to unite awkward bedfellows, her theoretical consistency in psychoanalytic thought, and her unfailing feminism often stimulated me to delve deeper into theories, instead of just extracting what I needed. Nanette Salomon, my favorite companion when visiting museums, shows me time and time again that seeing everything can be related to history.[25] And many, many others. My most constant intellectual friend is Ernst van Alphen, who has the keenest eye for oddities and invariably sees more than I do. He helped me understand contemporary art as a cultural practice.[26] His criticism keeps me committed to clarity and precision.

When Norman Bryson contacted me about the possibility of doing this book, I thought he was suggesting doing one for him. I was thrilled and happy to do it. It turned out he was suggesting the opposite. His introductory essay demonstrates the generosity of his close engagement with my work. It is the best demonstration of the productivity of an intellectual friendship. At a time when the institution at which I work is in difficulty,

and there is increasing pressure from conservative forces who are closing their ranks, this friendship and the evidence of it that this book constitutes gives me hope.

September 1997

postscript

Two years have passed since the writing of this Afterword. In the meantime, *Quoting Caravaggio: Contemporary Art, Preposterous History* has been completed and published. Among the many influential works by others which I have read since September 1997, Gayatri Chakravorty Spivak's *A Critique of Postcolonial Reason* (1999) is bound to have a significant impact on my further writings. Her analysis of the collusion between aesthetics and politics joins my current interest in different aesthetic passions. My next book will be continuing the reflections, occasioned by the afterword to this volume, on concepts as a methodological basis for an interdisciplinary study of culture.

November 1999 Mieke Bal

notes

1 In addition to my textbook *Narratology*, a collection of my essays citing various cases of narrative as a cultural process was published a few years ago (1991b).

2 Most famously, in his *Logic of Scientific Discovery* (1972, orig. 1959); unfortunately, most people didn't bother with his important *Postscript*, of which volume 2, "The Open University: An Argument for Indeterminism," is particularly relevant.

3 This concern was the driving force behind my writing of *Narratology*.

4 Trauma is not shock or grief, or even ordinary mourning; on the contrary, trauma precludes mourning. The holocaust—not the death of Lady Di—has been traumatic. For a good discussion of trauma, see Van der Kolk and Van der Hart (1995), and Van Alphen (1988), especially ch. 2.

5 As I have written many times—perhaps most explicitly in the introduction to *Reading "Rembrandt"*—the maker of an object cannot speak for it. The author's intentions, if accessible at all (since we know about the unconscious, even an alert, intellectual, and loquacious artist cannot fully know her own intentions) do not offer direct access to meaning.

6 For this concept, which underlies my interest in intersubjectivity beyond a formalist methodology à la Popper, see Spivak's chapter "More on Power/ Knowledge" in *Outside* (1993).

7 Kaja Silverman is one of the few scholars who have taken Benveniste's legacy seriously. See her *Subject of Semiotics* (1983) and my review of it, reprinted in *On Meaning-Making* (1994).

8 The assessment was published in English as "Narration and Focalization," chapter 4 in *On Story-Telling* (1991b).

9 In the first chapter of my dissertation (1977), which was later published in English (1983), I explicitly discuss this problem and come up with a handy solution, albeit without realizing the cause of the tension.

10 My major source for this line of thought is Naomi Schor's book (1987).

11 See for a review article, Jobling (1991).

12 Or, even worse, completely subordinating it to language as happens in traditional iconographic interpretations, and in the countless studies where the image is alleged to prove the art historian's point, is used as a mere illustration.

13 Jonathan Culler, the scholar whose work has empowered me in a crucial way and when I needed it most, was also the one who brought me to North America. I wish to thank him for his support and friendship.

14 And, we hoped, the social sciences. But what could be accomplished between departments has so far proved more difficult to accomplish between faculties.

15 The term was suggested to me by the term "preposterous events," developed in an article by Patricia Parker (1992).

16 Baxandall (1985), 58–62.

17 Butler is answering the critics of her earlier book (1990), who understood her notion of performance in a literalizing, theatrical sense. The misunderstanding could only occur within a voluntarist conception of intention, against which Butler's response argues emphatically.

18 Unfortunately, the "memory" boom has hit so hard that the concept is already on its way to becoming a superficial catchword, a vague and unspecific label.

19 In my view, trashing is a discursive genre that should be taken seriously (1992).

20 That friend was Kaja Silverman, whose work, including that on the gaze, has the rare quality of integrating Lacanian psychoanalysis with an uncompromising feminism.

21 I wrote this book, one of my very first, in 1978.

22 Bryson's trilogy from the early 1980s remains a document testifying to his stunning reading skill, as does his book on still-life painting.

23 Her books from 1984 and 1992 in particular had a lasting influence on me.

24 See especially Spivak (1987, 1993, 1999).

25 A recent sample of Salomon's way with images is a beautiful piece on Vermeer (1999), on whose work she is currently writing a book.

26 See in particular Van Alphen (1992, 1997).

figures

Chapter 1

Chapter 2

Chapter 3

Chapter 4

references

Alpers, Svetlana

1983 *The Art of Describing: Dutch Art in the Seventeenth Century.* Chicago: University of Chicago Press.

1988 *Rembrandt's Enterprise: The Studio and the Market.* Chicago: University of Chicago Press.

Alphen, Ernst van

1988 *Bij wijze van lezen: Verleiding en verzet van Willem Brakman's lezer.* Muiderberg: Coutinho.

1989 "The Complicity of the Reader." *VS/Versus* 52–53: 121–32.

1992 *Francis Bacon and the Loss of Self.* London: Reaktion Books/Cambridge, MA: Harvard University Press.

1995 "Facing Defacement: *Models* and Marlene Dumas' Intervention in Western Art." Marlene Dumas, *Models.* Frankfurt am Main: Portikus.

1996 "The Homosocial Gaze According to Ian McEwan's *The Comfort of Strangers.*" 169–86 in *Vision in Context: Historical and Contemporary Perspectives on Sight.* Edited by Teresa Brennan and Martin Jay. New York: Routledge.

1997 *Caught by History: Holocaust Effects in Contemporary Art, Literature and Theory.* Stanford: Stanford University Press.

1997 "Moves of Hubert Damisch: Thinking about Art in History." 97–124 in Hubert Damisch, *Moves: Playing Chess and Cards with the Museum.* Rotterdam: Museum Boijmans Van Beuningen.

Ames, Michael

1986 *Museums, the Public, and Anthropology: A Study in the Anthropology of Anthropology.* Vancouver: University of British Columbia Press.

Austin, J. L.

1975 *How to Do Things with Words.* Cambridge, MA: Harvard University Press.

Bal, Mieke

1977 *Narratologie: Essais sur la signification narrative dans quatre romans modernes.* Paris: Klincksieck (reprint Utrecht: Hes 1984).

1978 *De theorie van vertellen en verhalen.* Muiderberg: Coutinho.

1983 "The Narrating and the Focalizing: A Theory of the Agents in Narrative." *Style* 17, 2: 234–69.

1987 *Lethal Love: Feminist Literary Readings of Biblical Love Stories.* Bloomington: Indiana University Press.

1988 *Murder and Difference: Gender, Genre, and Scholarship on Sisera's Death.* Bloomington: Indiana University Press.

1988 *Death and Dissymmetry. The Politics of Coherence in the Book of Judges.* Chicago: University of Chicago Press.

1989 "Introduction." 11–24 in *Anti-Covenant: Counter-Reading Women's Lives in the Hebrew Bible.* Edited by Mieke Bal. Sheffield: Sheffield Academic Press.

1990 "De-Disciplining the Eye." *Critical Inquiry* 16: 506–31.

1991a *Reading "Rembrandt": Beyond the Word-Image Opposition.* New York: Cambridge University Press.

1991b *On Story-Telling: Essays in Narratology.* Edited by David Jobling. Sonoma, CA: Polebridge Press.

1992 "Rape: Problems of Intention." 367–71 in *Feminism and Psychoanalysis: A Critical Dictionary.* Edited by Elizabeth Wright. Oxford: Blackwell.

1992 "Narratology and the Rhetoric of Trashing." *Comparative Literature* 44, 3: 293–306.

1994 *On Meaning-Making: Essays in Semiotics.* Sonoma, Calif.: Polebridge Press.

1996a *Double Exposures: The Subject of Cultural Analysis.* New York: Routledge.

1996b "Semiotic Elements in Academic Practices." *Critical Inquiry* 22: 573–89.

1997a *Narratology: Introduction to the Theory of Narrative.* 2nd (revised & expanded) edition. Toronto: University of Toronto Press.

1997b *The Mottled Screen: Reading Proust Visually.* Translated by Anna-Louise Milne. Stanford: Stanford University Press.

1997c "Looking at Love: An Ethics of Vision." *Diacritics* (Spring): 59–72.

1999 *Quoting Caravaggio: Contemporary Art, Preposterous History.* Chicago: University of Chicago Press.

Bal, Mieke, and Inge E. Boer, eds.

1994 *The Point of Theory: Practices of Cultural Analysis.* Amsterdam/New York: Amsterdam University Press/Continuum.

Bal, Mieke, and Norman Bryson

1991 "Semiotics and Art History." *The Art Bulletin* 73, 2 (1991): 174–208.

Banfield, Ann

1990 "L'imparfait de l'objectif: The Imperfect of the Object Glass." *Camera Obscura* 24: 65–87.

Bann, Stephen

1989 *The True Vine: Visual Representation and Western Tradition.* New York: Cambridge University Press.

Bardon, Françoise

1978 *Caravage ou l'expérience de la matiére.* Paris: PUF.

Barthes, Roland

1968 "L'Effet de réel." *Communications* 84–89 (English: 141–54 in *The Rustle of Language.* Edited by Roland Barthes and translated by Richard Howard. New York: Hill and Wang, 1986).

1981 *Camera Lucida: Reflections on Photography*. Translated by Richard Howard. New York: Hill and Wang.

Baxandall, Michael

1985 *Patterns of Intention: On the Historical Explanation of Pictures*. New Haven: Yale University Press.

Belting, Hans

1988 *The End of the History of Art?* Translated by Christopher S. Wood. Chicago: University of Chicago Press.

Benjamin, Walter

1977 *The Origin of German Drama*. Translated by John Osborne. London: New Left Books.

Benveniste, Emile

1966 *Problémes de linguistique générale*. I. Paris: Gallimard.

1970 "L'appareil formelle de l'énonciation." *Langage* 17: 12–18 (English: *Problems in General Linguistics.* Translated by Mary Elizabeth Meek. Coral Gables: University of Miami Press, 1971).

Bloom, Harold

1973 *The Anxiety of Influence: A Theory of Poetry*. New York: Oxford University Press.

Bouazis, Charles

1992 *Ce que Proust savait du symptôme*. Paris: Méridiens Klincksieck.

Bourdieu, Pierre

1984 *Distinction: A Social Critique of the Judgement of Taste*. Translated by Richard Nice. Cambridge, MA: Harvard University Press/London: Routledge.

Bowie, Malcolm

1987 *Freud, Proust, and Lacan: Theory as Fiction*. Cambridge: Cambridge University Press.

Bronfen, Elisabeth

1989 "The Lady Vanishes: Sophie Freud and 'Beyond the Pleasure Principle.'" *South Atlantic Quarterly* (88) 4: 961–91.

Bryson, Norman

1981 *Word and Image: French Painting of the Ancient Regime*. New York: Cambridge University Press.

1983 *Vision and Painting: The Logic of the Gaze*. London: McMillan.

1984 *Tradition and Desire: From David to Delacroix*. New York: Cambridge University Press.

1989 *Looking at the Overlooked: Four Essays on Still-Life*. Cambridge: Harvard University Press.

1994 "Géricault and 'Masculinity'." 228–59 in *Visual Culture: Images and Interpretations*. Edited by Norman Bryson, Michael Holly, and Keith Moxey. Hanover and London: Wesleyan University Press.

Butler, Judith

 1990 *Gender Trouble: Feminism and the Subversion of Identity.* New York: Routledge.

 1993 *Bodies That Matter.* New York: Routledge.

Butor, Michel

 1957 *La Modification.* Paris: Les Editions de Minuit.

Carrier, David

 1986 "Artifice and Artificiality: David Reed's Recent Painting." *Arts* (January) 30–34.

 1987 *Artwriting.* Amherst: University of Massachusetts Press.

Carrier, David, and David Reed

 1991 "Tradition, Eclecticism, Self Consciousness: Baroque Art and Abstract Painting." *Arts Magazine* 65, 5: 44–49.

Change Collective

 1977 *La Follie encerclée.* Paris: October.

Chapman, H. Perry

 1990 *Rembrandt's Self-Portraits: A Study in Seventeenth-Century Identity.* Princeton: Princeton University Press.

Clifford, James

 1988 *The Predicament of Culture: Twentieth-Century Ethnography, Literature, and Art.* Cambridge, MA: Harvard University Press.

 1991 "Four Northwest Coast Museums" Travel Reflections." 212–54 in *Exhibiting Cultures: The Poetics and Politics of Museum Display.* Edited by Ivan Karp and Steven D. Lavine. Washington and London: Smithsonian Institution Press.

Code, Lorraine

 1991 *What Can She Know? Feminist Epistemology and the Construction of Knowledge.* Ithaca and London: Cornell University Press.

Corrin, Lisa G.

 1995 "Contemporary Artists Go for Baroque." 17–33 in *Going for Baroque: 18 Contemporary Artists Fascinated with the Baroque and Rococo.* Edited by Lisa G. Corrin and Joaneath Spicer. Baltimore, MD: The Contemporary and The Walters.

Crimp, Douglas

 1993 *On the Museum's Ruins.* With photographs by Louise Lawler. Cambridge, MA: MIT Press.

Culler, Jonathan

 1975 *Structuralist Poetics: Structuralism, Linguistics, and the Study of Literature.* Ithaca: Cornell University Press.

 1981 *The Pursuit of Signs: Semiotics, Literature, Deconstruction.* Ithaca: Cornell University Press.

 1983 *On Deconstruction: Theory and Criticism after Structuralism.* Ithaca: Cornell University Press.

1988 *Framing the Sign: Criticism and Its Institutions.* Norman and London: University of Oklahoma Press.

Dällenbach, Lucien

1977 *Le récit spéculaire. Essai sur la mise en abyme.* Paris: Editions du Seuil (English: *The Mirror in the Text.* Translated by Jeremy Whiteley with Emma Hughes. Chicago: University of Chicago Press, 1989).

Damisch, Hubert

1972 *Théorie du nuage: pour une histoire de la peinture.* Paris: Editions du Seuil.

1987 *L'origine de la perspective.* Paris: Flammarion (English: *The Origin of Perspective.* Translated by John Goodman. Cambridge, MA: MIT Press, 1994).

1995 *Traité du Trait.* Paris: Musée du Louvre.

Deleuze, Gilles

1993 *The Fold: Leibniz and the Baroque.* Foreword and translation by Tom Conley. Minneapolis: University of Minnesota Press.

Derrida, Jacques

1976 *Of Grammatology.* Translated and with an introduction by Gayatri Chakravorty Spivak. Baltimore: Johns Hopkins University Press.

1978 *Writing and Difference.* Chicago: University of Chicago Press.

1981 *Dissemination.* Translated and with an introduction and additional notes by Barbara Johnson. Chicago: University of Chicago Press.

1987 *Truth in Painting.* Translated by Geoff Bennington and Ian McLeod. Chicago: University of Chicago Press.

1988 *Limited Inc.* Translated by Samuel Weber. Evanston, Ill.: Northwestern University Press.

Descombes, Vincent

1987 *Proust: Philosophie du roman.* Paris: Editions de Minuit.

Didi-Hubermann, Georges

1990 *Devant l'image: question posée aux fins d'une historie de l'art.* Paris: Editions de Minuit.

Donaldson, Ian

1982 *The Rapes of Lucretia: A Myth and its Transformations.* Oxford: Oxford University Press.

Douglas, Mary

1966 *Purity and Danger.* London: Routledge and Kegan Paul.

Douglass, Frederick

1968 *Narrative of the Life of Frederick Douglass.* New York: Signet.

Dubois, J., *et al.*

1981 *A General Rhetoric.* Translated by Paul B. Burrel and Edgar M. Slotkin. Baltimore: Johns Hopkins University Press.

Eco, Umberto

1976 *A Theory of Semiotics*. Bloomington: Indiana University Press.

1979 "Peirce and the Semiotic Foundation of Openness: Signs as Texts and Texts as Signs." 175–99 in *The Role of the Reader: Explorations in the Semiotics of Texts*. Bloomington: Indiana University Press.

1984 *Semiotics and the Philosophy of Language*. Bloomington: Indiana University Press.

Eco, Umberto, and Thomas A. Sebeok

1983 *The Sign of Three: Dupin, Holmes, Peirce*. Bloomington: Indiana University Press.

Elsner, John, and Roger Cardinal, eds.

1994 *The Cultures of Collecting*. London: Reaktion Books.

Estrich, Susan

1987 *Real Rape: How the Legal System Victimizes Women Who Say No*. Cambridge, MA: Harvard University Press.

Fabian, Johannes

1983 *Time and the Other: How Anthropology Makes Its Object*. New York: Columbia University Press.

Felman, Shoshana

1987 *Literary Speech Acts*. Ithaca: Cornell University Press.

Figlio, Karl

1996 "Knowing, Loving and Hating Nature: A Psychoanalytic View." 72–85 in *FutureNatural*. Edited by George Robertson, Melinda Mash, Lisa Tickner, John Bird, Barry Curtis, and Tim Putnam. London and New York: Routledge.

Fineman, Joel

1980 "The Structure of Allegorical Desire." *October* 12: 47–66.

Fischer, Michael

1986 "Ethnicity and the Postmodern Art of Memory." 194–233 in *Writing Culture: The Poetics and Politics of Ethnography*. Edited by James Clifford and George Marcus. Berkeley: University of California Press.

Foucault, Michel

1972 *The Archeology of Knowledge and the Discourse on Language*. Translated by A. M. Sheridan Smith. New York: Pantheon Books.

Frécaut, Jean-Marc

1972 *L'esprit et l'humour chez Ovide*. Grenoble: Presses Universitaires de Grenoble.

Freedberg, S. J.

1983 *Circa 1600: A Revolution of Style in Italian Painting*. Cambridge, MA: Harvard University Press.

Garrard, Mary D.

1982 "Artemesia and Susanna." 147–71 in *Feminism and Art History: Questioning the Litany*. Edited by Norma Broude and Mary D. Garrard. New York: Harper and Row.

1988 *Artemisia Gentileschi: The Image of the Female Hero in Italian Baroque Art*. Princeton: Princeton University Press.

Genette, Gérard

1972 "Metonymie chez Proust." *Figures III*, 41–66. Paris: Editions du Seuil. (English: *Narrative Discourse: An Essay in Method*. Translated by Jane E. Lewin. Ithaca and London: Cornell University Press, 1980).

Glissant, Edouard

1981 *Le discours antillais*. Paris: Editions du Seuil.

Gombrich, E. M.

1968 [1960] *Art and Illusion: a Study in the Psychology of Pictorial Representation*. London: Phaidon Press.

Goodman, Nelson

1976 *Languages of Art: An Approach to a Theory of Symbols*. Indianapolis: Hackett.

Gowing, Lawrence

1970 *Vermeer*. London: Faber and Faber (original edition 1952).

Gregori, Mina

1985 "Narcissus." 265–68 in *The Age of Caravaggio*. New York: The Metropolitan Museum of Art and Electa/Rizzoli.

Greimas, A. J., and François Rastier

1968 "The Interaction of Semiotic Constraints." *Yale French Studies* 41: 86–105.

Hamon, Philippe

1981 *Introduction à l'analyse du discours descriptif*. Paris: Hachette.

Haraway, Donna

1989 *Primate Visions: Gender, Race, and Nature in the World of Modern Science*. New York: Routledge.

Hecht, Peter

1989 *De Hollandse fijnschilders: van Gerard Dou tot Adriaen van der Werff*. Amsterdam: Rijksmuseum/Gary Schwartz/SDU.

Held, Julius S.

1969 *Rembrandt's Aristotle and Other Rembrandt Studies*. Princeton: Princeton University Press.

Hibbard, Howard

1983 *Caravaggio*. New York: Harper & Row.

Hill, Tom, and Richard W. Hill Sr., eds.

1994 *Creation's Journey: Native American Identity and Belief*. Washington and London: Smithsonian Institution Press in association with the National Museum of the American Indian Smithsonian Institution.

Hiller, Susan, ed.

1991 *The Myth of Primitivism: Perspectives on Art.* New York: Routledge.

Hofrichter, Frima Fox

1982 "Judith Leyster's *Proposition:* Between Virtue and Vice." 173–82 in *Feminism and Art History: Questioning the Litany.* Edited by Norma Broude and Mary D. Garrard. New York: Harper & Row.

Holly, Michael Ann

1996 *Past Looking: Historical Imagination and the Rhetoric of the Image.* Ithaca and London: Cornell University Press.

Ingarden, Wolfgang

1965 *Das Literarische Kunstwerk.* Tubingen: Niemeier.

Innis, R. E., ed.

1984 *Semiotics: An Introductory Anthology.* Bloomington: Indiana University Press.

Iser, Wolfgang

1978 *The Act of Reading: A Theory of Aesthetic Response.* Baltimore: Johns Hopkins University Press.

Jacobus, Mary

1986 *Reading Woman: Essays in Feminist Criticism.* New York: Columbia University Press.

Jameson, Fredric

1981 *The Political Unconscious: Narrative as a Socially Symbolic Act.* Ithaca: Cornell University Press.

Janssen, Edwin

1994 *Narcissus en de poel des verderfs (Narcissus and the Pool of Corruption).* Rotterdam: Museum Boijmans Van Beuningen.

Jobling, David

1991 "Mieke Bal on Biblical Narrative." *Religious Studies Review* 17, 1: 1–11.

Johnson, Barbara

1987 *A World of Difference.* Baltimore: Johns Hopkins University Press.

Jongh, E. de

1976 *Tot lering en vermaak.* Exhibition catalog. Amsterdam: Rijksmuseum.

Keller, Evelyn Fox

1984 *Reflections on Gender and Science.* New Haven: Yale University Press.

1992 *Secrets of Life, Secrets of Death.* New York: Routledge.

Kolk, Bessel van der, and Onno van der Hart

1995 "The Intrusive Past: The Flexibility of Memory and the Engraving of Trauma." 158–83 in *Trauma: Explorations in Memory.* Edited and with introductions by Cathy Caruth. Baltimore: Johns Hopkins University Press.

Krauss, Rosalind

1993 *The Optical Unconscious.* Cambridge, MA: MIT Press.

Lacan, Jacques

1966 "Le stade du miroir comme formateur de la fonction du Je." 89–100 in *Ecrits*, vol. 1. Paris: Editions du Seuil. (English: *Ecrits: A Selection*. Edited and translated by A. Sheridan. New York: W. W. Norton, 1977).

1979 *The Four Fundamental Concepts of Psycho-Analysis*. Edited by J.-A. Miller and translated by A. Sheridan. Harmondsworth: Penguin Press.

Lakoff, George, and Mark Johnson

1980 *Metaphors We Live By*. Chicago: University of Chicago Press.

1987 *Women, Fire, and Dangerous Things: What Categories Reveal about the Mind*. Chicago: University of Chicago Press.

Lakoff, George, and Mark Turner

1989 *More Than Cool Reason: A Field Guide to Poetic Metaphor*. Chicago: University of Chicago Press.

Lam, Janneke

1997 "Structural Trauma: A Crisis of Cultural Semiosis. Subjectivity Between Annihilation and Creativity." Special issue of *European Journal for Semiotic Studies*, ed. M. Bal and Mario Caro, 9-1: 33-52.

Laplanche, Jean

1976 *Life and Death in Psychoanalysis*. Translated and with an introduction by Jeffrey Mehlman. Baltimore: Johns Hopkins University Press.

Lauretis, Teresa de

1983 *Alice Doesn't: Feminism, Semiotics, Cinema*. London: McMillan.

1987 *Technologies of Gender: Essays on Theory, Film, and Fiction*. Bloomington: Indiana University Press.

Lefebvre, Henri

1991 *The Production of Space*. Translated by Donald Nicholson-Smith. Oxford/Cambridge, MA: Basil Blackwell.

Loreck, Hanne

1995 "Explications." 77–82 in *David Reed*. Köln: Kölnischer Kunstverein.

MacKinnon, Catherine

1983 "Feminism, Marxism, Method and the State: Toward Feminist Jurisprudence." *Signs* 8, 4: 635–58.

Man, Paul de

1979 *Allegories of Reading: Figural Language in Rousseau, Nietzsche, Rilke, and Proust*. New Haven: Yale University Press.

Marin, Louis

1977 *Détruire la peinture*. Paris: Éditions Galilée (English: *To Destroy Painting*. Translated by Mette Hjort. Chicago: University of Chicago Press, 1995).

Mead, Margaret

1932 "Note from New Guinea." *American Anthropologist* 34: 740.

Merleau-Ponty, Maurice

1958 *Les relations avec autrui chez l'enfant.* Paris: Centre de Documentation Universitaire.

1964 *The Primacy of Perception and Other Essays on Phenomenological Psychology, the Philosophy of Art, History, and Politics.* Edited and introduced by James M. Edie. Translated by Carleton Dallery. Evanston, Ill.: Northwestern University Press.

Merrim, Stephani, ed.

1991 *Feminist Perspectives on Sor Juana Inés de la Cruz.* Detroit: Wayne State University Press.

Messenger, Phyllis Mauch, ed.

1989 *The Ethics of Collecting Cultural Property: Whose Culture? Whose Property?* Foreword by Brian Fagan. Albuquerque: University of New Mexico Press.

Mitchell, W. J. T.

1985 *Iconology: Image, Text, Ideology.* Chicago: University of Chicago Press.

Modleski, Tania

1987 *The Women Who Knew Too Much.* New York: Methuen.

Montrelay, Michèle

1978 "Inquiry into Femininity." *m/f* 1: 83–101.

Muller, J. P., and W. J. Richardson, eds.

1988 *The Purloined Poe: Lacan, Derrida, and Psychoanalytic Reading.* Baltimore: Johns Hopkins University Press.

Nagy, Gregory

1979 *The Best of the Achaeans: Concepts of the Hero in Archaic Greek Poetry.* Baltimore: Johns Hopkins University Press.

Nouvet, Claire

1991 "An Impossible Response: The Disaster of Narcissus." *Yale French Studies* 79: 103–34.

Oosten, Jarich, and David Moyer

1982 "De mythische ontkenning: een analyse van de sociale code van de scheppingsmythen van Genesis: 2–11." *Antropologische verkenningen* I (1): 1–34.

Ovid

1994 [1916] *Metamorphoses: Books 1-8.* With an English translation by Frank Justus Miller, revised by G. P. Goold. Cambridge: Cambridge University Press.

Owens, Craig

1984 "The Allegorical Impulse: Toward a Theory of Postmodernism." 203–35 in *Art After Modernism: Rethinking Representation.* Edited by Brian Wallis. New York and Boston: The New Museum of Contemporary Art and David R. Godine, Publisher, Inc.

Parker, Patricia

1992 "Preposterous Events." *Shakespeare Quarterly* 43, 2: 186–213.

Paz, Octavio

1988 *Sor Juana, or, the Traps of Faith.* Translated by Margaret Sayers Peden. Cambridge: Harvard University Press (expanded version of *Sor Juana Inéz de la Cruz, o, las trampas de la fe,* 1982).

Peirce, C. S.

1955 "The Scientific Attitude and Fallibilism." *Philosophical Writings.* Edited by J. Buchler. New York: Dover.

Penley, Constance

1988 *Feminism and Film Theory.* London and New York: Routledge.

1994 "Feminism, Psychoanalysis, and the Study of Popular Culture." 302–24 in *Visual Culture: Images and Interpretations.* Edited by N. Bryson, M. Holly, K. Moxey. Hanover and London: Wesleyan University Press.

Perelman, Chaim

1979 *The New Rhetoric and the Humanities: Essays on Rhetoric and its Applications.* Translated by William Kluback. Boston: D. Reidd Publishing Co.

Plaza, Monique

1980 "Our Costs and Their Benefits." *m/f* 4: 28–39.

Popper, Karl

1972 (1959) *The Logic of Scientific Discovery.* London: Hutchinson.

1982–83 *Postscript to the Logic of Scientific Discovery.* London: Hutchinson.

Posner, Donald

1971 "Caravaggio's Homo-erotic Early Works." *Art Quarterly* 34, 3: 301–24

Preziosi, Donald

1989 *Rethinking Art History: Meditations on a Coy Science.* New Haven: Yale University Press.

Prince, Gerald

1983 *Narratology: The Form and Function of Narrative.* The Hague: Mouton.

Proust, Marcel

1954 *A la recherche du temps perdu.* Paris" Gallimard (Edited by Pierre Clarac and André Ferré. Paris: Gallimard. (English: *Remembrance of Things Past.* Translated by C. K. Scott Moncrieff and Terence Kilmartin. New York: Vintage Books, 1982).

Reed, David

1992 *Two Bedrooms in San Francisco.* San Francisco: The San Francisco Art Institute.

Ricoeur, Paul

1979 *The Rule of Metaphor: Multi-disciplinary Studies of the Creation of Meaning in Language.* Translated by Robert Czerny with Kathleen McLaughlin and John Costello. Toronto: University of Toronto Press.

Rimmon-Kenan, Shlomith

1981 *Narrative Fiction: Contemporary Poetics.* London: Methuen.

Rorty, Richard

1979 *Philosophy and the Mirror of Nature.* Princeton: Princeton University Press.

Rose, Jacqueline

1986 *Sexuality in the Field of Vision.* London: McMillan.

Rossum-Guyon, Françoise

1970 *Critique du roman: essai sur "La Modification" de Michel Butor.* Paris: Gallimard

Rudolph, Herbert

1938 "'Vanitas': Die Bedeutung mittelalterlicher und humanistischer Bildinhalte in der niederländischen Malerei des 17. Jahrhunderts." 405–33 in *Festschrift Wilhelm Pinder zum 60. Geburtstag.* Leipzig.

Salomon, Nanette

1983 "Vermeer and the Balance of Destiny." 216–24 in *Essays in Northern European Art Presented to Egbert Haverkamp-Begemann.* Doornspijk: Dawaco.

1991 "The Art Historical Canon: Sins of Omission." 222–36 in *(En)Gendering Knowledge: Feminism in Academe.* Edited by Joan E. Hartman and Ellen Messner-Davidow. Knoxville: University of Tennessee Press.

1999 "Vermeer's Women: Shifting Paradigms in Midcareer." 44–59 in *The Practice of Cultural Analysis.* Edited by Mieke Bal. Stanford: Stanford University Press.

Schama, Simon

1987 *The Embarrassment of Riches: An Interpretation of Dutch Culture in the Golden Age.* New York: Alfred A. Knopf.

Schor, Naomi

1980 "Le détail chez Freud." *Littérature* 37: 3–14.

1987 *Reading in Detail: Esthetics and the Feminine.* New York: Methuen.

Schwartz, Gary

1985 *Rembrandt: His Life, His Paintings.* Harmondsworth: Penguin.

Sebeok, Thomas A.

1994 *Signs: An Introduction to Semiotics.* Toronto: University of Toronto Press.

Sedgwick, Eve Kosofsky

1990 *The Epistemology of the Closet.* Berkeley/Los Angeles: University of California Press.

Silverman, Kaja

1983 *The Subject of Semiotics.* New York: Oxford University Press.

1988 *The Acoustic Mirror: The Female Voice in Psychoanalysis and Cinema*: Bloomington: Indiana University Press.

1989 "Fassbinder and Lucan: A Reconsideration of Gaze, Look and Image." *Camera Obscura* 19: 54–84.

1992 *Male Subjectivity at the Margin.* New York: Routledge.

1996 *Threshold of the Visible World.* New York: Routledge.

Sor Juana Inés de la Cruz

1955 *Obras completas de Sor Juana Inés de la Cruz.* Vol. 3. Autos y Loas. Edited and with a preface and notes by Alfonso Méndez Plancarte. Mexico: Fondo de Cultura Económica.

Spivak, Gayatri Chakravorty

1987 *In other Worlds: Essays in Cultural Politics.* New York: Methuen.

1993 *Outside in the Teaching Machine.* New York: Routledge.

1994 "Echo." *New Literary History* 24: 17–43.

1999 *A Critique of Postcolonial Reason: Toward a History of the Vanishing Point.* Cambridge, MA: Harvard University Press.

Steiner, Wendy

1988 *Pictures of Romance: Form Against Context in Painting and Literature.* Chicago: University of Chicago Press.

Sternweiler, Andreas

1993 *Die Lust der Götter: Homosexualität in der Italienischen Kunst von Donatello zu Caravaggio.* Berlin: Rosa Winkel GmbH.

Stewart, Susan

1984 *On Longing: Narratives of the Miniature, the Gigantic, the Souvenir, the Collection.* Baltimore: Johns Hopkins University Press.

Stock, Brian

1983 *The Implications of Literacy: Written Language and Models of Interpretation in the Eleventh and Twelfth Centuries.* Princeton: Princeton University Press.

Sweetser, Eve

1989 *From Etymology to Pragmatics: The Mind-as-Body Metaphor in Semantic Structure and Semantic Change.* Cambridge: Cambridge University Press.

Thiher, Allen

1984 *Words in Reflection: Modern Language Theory and Postmodern Fiction.* Chicago: University of Chicago Press.

Torgovnick, Marianna

1990 *Gone Primitive: Savage Intellectuals, Modern Lives.* Chicago: University of Chicago Press.

Turner, Mark

1987 *Death Is the Mother of Beauty: Mind, Metaphor, Criticism.* Chicago: University of Chicago Press.

Vandenbroeck, Paul

1987 *Beeld van de andere, vertoog over het zelf.* Antwerp: Museum voor Schone Kunsten.

Varga, A. Kibédi

1989 *Discours, récit, image.* Brussels: Pierre Amanda.

Wheelock, A. J., Jr.

1981 *Jan Vermeer*. New York: N. Abrams, Inc.

White, Hayden

1973 *Metahistory: The Historical Imagination in Nineteenth-Century Europe*. Baltimore: Johns Hopkins University Press.

1978 "Interpretation in History." 51–80 in *Tropics of Discourse*. Baltimore: Johns Hopkins University Press.

1978 "The Forms of Wildness: Archeology of an Idea." 150–82 in *Tropics of Discourse*. Baltimore: Johns Hopkins University Press.

Wittgenstein, Ludwig

1953 *Philosophical Investigations*. Translated by G. E. M. Anscombe. New York: MacMillan Press.

1961 [1921] *Tractatus Logico-Philosophicus*. Translated by B. F. McGuinness. New York: The Humanities Press.

Woodhull, Winifred

1988 "Sexuality, Power, and the Question of Rape." 167–76 in *Feminism and Foucault: Reflections on Resistance*. Edited by Irene Diamond and Lee Quinby. Boston: Northeastern University Press.

Zappler, Georg

1990 *Official Guide to the American Museum of Natural History*. New York: American Museum of Natural History.

Other forthcoming titles in the Critical Voices series

Practice: Architecture, Technique and Representation
Essays by Stan Allen. Commentary by Diana Agrest

The Information Subject
Essays by Mark Poster. Commentary by Stanley Aronowitz

Framing Formalism: Riegl's Work
Essays by Hans Sedlmayr, Julius von Schlosser, Richard Woodfield, Andrew Ballantyne, Joaquín Lorda, Stefan Muthesius, Joseph Masheck, Ivo Hlobil, Frauke Laarman, Benjamin Binstock, Matthew Rampley, Giles Peaker. Commentary by Richard Woodfield

Music Inside Out: Going Too Far in Musical Essays
Essays by John Rahn. Introduction and Commentary by Benjamin Boretz

Looking Back to the Future
Essays by Griselda Pollock. Introduction and Commentary by Penny Florence